In memory of:

JEAN MURPHY PFAHLERT

Presented by:

Alma L. Rick

-1997-

THE GREAT BASEBALL PLAYERS

FROM McGRAW TO MANTLE

WITH 248 HISTORIC PHOTOGRAPHS FROM
THE ARCHIVES OF PHOTO FILE, INC.

Bert Randolph Sugar

DOVER PUBLICATIONS, INC.
Mineola, New York

Published in Canada by General Publishing Company, Ltd., 30 Lesmill Road, Don Mills, Toronto, Ontario.
Published in the United Kingdom by Constable and Company, Ltd., 3 The Lanchesters, 162–164 Fulham Palace Road, London W6 9ER.

Bibliographical Note

The Great Baseball Players from McGraw to Mantle is a new work, first published by Dover Publications, Inc., in 1997.

Special Notice

Library of Congress Cataloging-in-Publication Data

Sugar, Bert Randolph.
 The great baseball players from McGraw to Mantle / Bert Randolph Sugar.
 p. cm.
 Includes index.
 ISBN 0-486-28924-9
 1. Baseball players—United States—Biography. 2. Baseball players—United States—Portraits. 3. Baseball players—United States—History.
GV865.A1S882 1997
796.357'092'2—dc21
[B] 96-39656
 CIP

Book design by Carol Belanger Grafton

Manufactured in the United States of America
Dover Publications, Inc., 31 East 2nd Street, Mineola, N.Y. 11501

PREFACE

SOMEONE, WE FORGET WHO, once said there are many more great pictures of athletes than pictures of great athletes. In baseball, there are hardly any pictures of great athletes. Or so it seems. A case in point is the Macmillan *Baseball Encyclopedia.* In its hundreds upon hundreds of pages, every great, near-great and never-was—including those not even household names in their own households—is listed, over 14,000 in all, complete with a line-by-line encapsulation of the entire career of each, down to the smallest detail. And beyond. But, alas, no pictures, even of the greats. There one can find the names and records of such historically significant players as Joe Tinker and Johnny Evers, as inseparable as two hangers, Sunny Jim Bottomley, whose name lit up the twenties, and Johnny Vander Meer, author of two consecutive no-hitters. And there are other players, going all the way back to the time when Father Adam was dispossessed by the apple salesmen, players like Cy Young, Chief Bender and "Home Run" Baker. But all are faceless, so unrecognizable they could escape detection in a police lineup, even in full uniform. And, if you were keeping score, you could write "ditto" beside the name of every other great player in the *Baseball Encyclopedia,* all as familiar to the eye as Whistler's Father.

And so it was that we decided to make up for arrearages by putting faces to some of the most visually unknown well-known athletes in the world: the many greats of baseball from the turn of the century to the 1960s. Fortunately, both for us and for baseball, we found the keeper of baseball's visual flame, Photo File, which possesses files and files of those great pictures of great baseball players that have been so sorely missing in every baseball reference book. The result is this Dover complement to the *Baseball Encyclopedia* and every other baseball reference book: *The Great Baseball Players from McGraw to Mantle.*

It is hoped that not only will it provide visual bread crumbs to baseball's great past, but that, together with the sketches of the careers and accomplishments of these 249 greats, it will once again reinforce how great the game and its greats once were.

BERT RANDOLPH SUGAR
Chappaqua, New York
June 7, 1996

KEY TO CAPTION HEADS

The name that first appears in each caption is that by which the player is best known, whether it was his real name or a nickname. Following in brackets are his real name; any well-known nickname(s) if not already given as the principal name; major position(s) he played; years of his major league career (**followed by an asterisk [*] if he was elected to the Hall of Fame**); and the major league teams on which he played (given by city or state and league).

ABBREVIATIONS

POSITIONS

C	Catcher	SS	Shortstop
P	Pitcher	3B	Third Base
1B	First Base	IF	Infield
2B	Second Base	OF	Outfield

TEAMS' CITIES (STATES)

ATL	Atlanta	CLE	Cleveland	MIN	Minnesota		
BAL	Baltimore	DET	Detroit	NWK	Newark		
BKN	Brooklyn	HOU	Houston	NY	New York		
BOS	Boston	IND	Indianapolis	PHI	Philadelphia		
BUF	Buffalo	KC	Kansas City	PIT	Pittsburgh		
CAL	California	LA	Los Angeles	SF	San Francisco		
CHI	Chicago	LOU	Louisville	STL	St. Louis		
CIN	Cincinnati	MIL	Milwaukee	WAS	Washington, D.C.		

LEAGUES

A	American League
AA	American Association
F	Federal League
N	National League
P	Players League

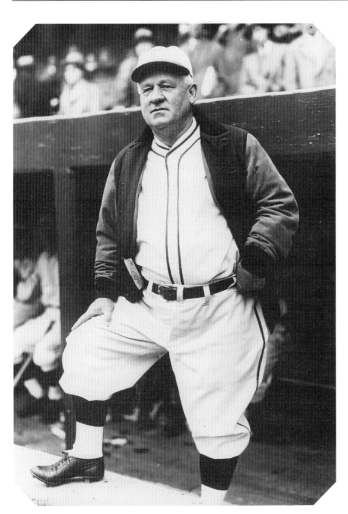

1. JOHN McGRAW *(Left)* **[John Joseph McGraw; "The Little Napoleon"; 3B; 1891–1906*; BAL (AA), BAL (N), STL (N), BAL (A), NY (N)].** In those rollicking, roisterous days of yore, known as "The Gay Nineties," where anything went, nothing went farther than a little, pouter-pigeon-proud man named John McGraw, an arrogant, abrasive and abusive man who played and later managed with a proverbial chip on his shoulder. In those days, before Vince Lombardi enunciated his philosophy that "Winning isn't the most important thing, it's the only thing," McGraw had put it into practice. Playing third base for the legendary Baltimore Orioles, McGraw would hold the belts of baserunners trying to get past his corner, obstruct the base and bait the lone umpire to get his way. His underhanded ways in the field were matched by his surehanded ways in the batter's box, where he batted over .300 in nine seasons—once hitting as high as .391—and twice leading the National League in runs scored. But it was as a manager that he was to gain his everlasting fame. Known as the "Little Napoleon" to his legion of fans, and by any name that came to mind to his detractors—including the hated name "Muggsy"—almost all as picturesque as himself, McGraw constantly had run-ins with the so-called "establishment." Refusing to join the Brooklyn team after Baltimore had assigned him to the Dodgers in 1899, McGraw instead joined St. Louis, agreeing only after the reserve clause was removed from his contract, and then became the player-manager of the new American League franchise in Baltimore. But, once again running afoul of authority—namely the authority in the American League, Ban Johnson—McGraw made a Giant leap of faith by jumping the Orioles' sinking ship in the midsummer of 1902 and crossing over to the National League and the New York Giants. But he didn't just leave the team; he took it with him, raiding the Baltimore franchise of many of its stars. And although his first edition finished in last place, McGraw went on to win ten National League pennants and three World Series in his 33-year managerial career—a career that saw him finish no lower than second place 21 times!

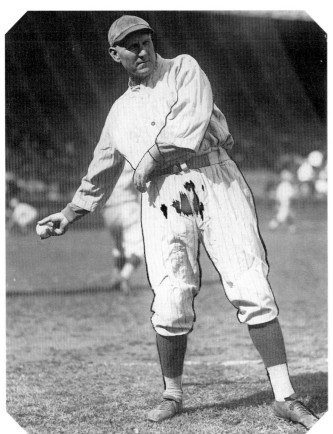

2. AMOS RUSIE *(Left)* **[Amos Wilson Rusie; "The Hoosier Thunderbolt"; P; 1889–95, 1897–98, 1901*; IND (N), NY (N), CIN (N)].** Back in the days of old, Amos Rusie stood alone as pitching's king of the hill. A favorite of the New York faithful, Rusie won an average of over 28 games in his eight seasons with the Giants and was immortalized in song and verse. With an overpowering fastball and a blazing curve—described by contemporaries as "a fast ball with a tail on it"—the perpetually gyrating Rusie led the National League in wins once, ERA twice, most games started twice, strikeouts five times and shutouts four—all within the space of eight seasons. It has been suggested by several historians that Rusie's power pitching was the primary reason for the pitcher's mound being moved back from its old distance of 50 feet to its present distance of 60 feet 6 inches in 1893. Continually feuding with Giants owner Andrew Freeman, Rusie held out the entire 1896 season rather than pay fines levied by Freeman that he called "unfair." He returned in 1897 only after his salary and the moneys he had been fined were restored. And proceeded to win another 29 games. After tearing the muscles in his shoulder he retired after the 1898 season with 243 lifetime wins, but attempted a comeback in 1901 after being traded to Cincinnati for a young pitcher named Christy Mathewson. Mathewson would go on to win 373 games, but Rusie's comeback went for naught and he came up with an aught in his three pitching appearances in a Reds uniform.

3. CHARLIE COMISKEY *(Right)* **[Charles Albert Comiskey; "Commy," "The Old Roman"; 1B; 1882–94*; STL (AA), CHI (P), CIN (N)].** In 1882 Charlie Comiskey came up to the joke nine of the old-old American Association, the St. Louis Browns, a mere broth of a boy straight from the Dubuque Rabbits. By the end of his second year the 23-year-old Comiskey, by then the starting first baseman, had been made manager and over the next four years won back-to-back-to-back-to-back pennants, as much by his play at first base—where he revolutionized the style of play by playing off the bag and making the pitcher come over to take throws—as by his handling of such great stars as Arlie Latham, Tip O'Neill and Dave Foutz. When he finally retired as both player and manager in 1894, with a lifetime batting average of .264 and a managerial won-lost average of .607, the third-highest in baseball history, Comiskey hooked up with sportswriter Ban Johnson to form the Western League, the precursor of the American League. Comiskey purchased the Sioux City, Iowa, franchise, first moving it to St. Paul and then, in 1900, to Chicago, where he named it the "White Stockings." In its very first year, 1901, Chicago won the newly-minted junior circuit's first pennant. And by 1902, Comiskey had won the reputation of being a pinchpenny, Davy Jones remembering his first sight of "The Old Roman" (a contraction of "The Noblest Roman of Baseball," as he had been called), as Jones sat on the bench waiting for the game to begin on a rainy Saturday: "He was out there in the infield, with his pants rolled up, soaking up water with a couple of sponges and wringing them into a pail, trying to get the diamond in shape to play." Comiskey's pinchpenny tactics were to become legendary, especially in light of the 1919 "Black Sox" scandal when writers pointed out that the White Sox were woefully underpaid, their meal allowance and clothing allowance the lowest in the majors, and that White Sox pitching ace Eddie Cicotte, whose contract contained a clause calling for a bonus if he won 30 games, had been held out the last week of the season after winning his 29th. Although his team became a second-tier team after the scandal and the suspension of eight of his players, Comiskey continued merrily on his parsimonious way, denying a $500 raise to Dickie Kerr in 1922 after Kerr had won 19 in '21, and giving future Hall of Famer Harry Hooper his release in 1925 after Hooper refused to take a salary cut from $13,500 to $7,000 after having what he called "five darn-good years with the Sox, best I ever had." Nevertheless, the champion Scrooge of baseball was elected to the Hall of Fame in 1939 for "exceptional ability among players whose active careers ended prior to 1900" and also as "a builder of baseball," with nary a word said about his building of character—or his miserliness.

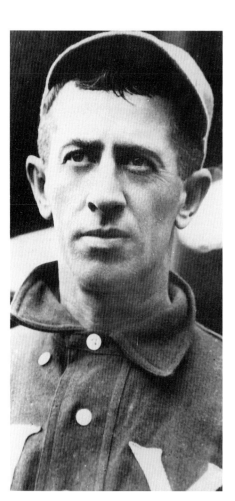

4. WILLIE KEELER *(Left)* **[William Henry Keeler; "Wee Willie"; OF; 1892–1910*; NY (N), BKN (N), BAL (N), NY (A)].** With a motto that read like a wall sampler, "Keep your eye on the ball and hit 'em where they ain't," little (five-foot-4½-inch, 140-pound) Willie Keeler spent 19 years in the majors doing just that: hitting "'em where they ain't." Wielding his short bat like a toothpick, with a choked-up hold, Keeler was able to punch the ball to any field where the fielders "ain't," with over 1,000 hits in his first five full seasons and 2,962 lifetime. Playing for the old Orioles, Keeler posted astronomical numbers, putting together back-to-back-to-back seasons of .391, .392 and .432 and compiling the highest batting average for *any* pre-1900's player, .387. An ideal leadoff man, Keeler regularly made contact with the ball—historian Ernest Lanigan finding that, in those days before strikeouts were part of the official stats, Keeler had gone through an entire season without once striking out. He was an exact bunter, master of the hit-and-run, a precise place hitter, and inventor of the aptly named "Baltimore Chop"—a ball hit in front of home plate that bounced high off the hardened dirt. And he stole 495 bases. His .343 lifetime batting average serves as living testimony to his playing maxim.

5. HUGHIE JENNINGS *(Below)* [Hugh Ambrose Jennings; "Ee-Yah"; SS; 1891–1903, 1907, 1909, 1912, 1918*; LOU (AA), LOU (N), BAL (N), BKN (N), PHI (N), DET (A)]. One of the most colorful characters ever to come down the baseball pike, Hughie Jennings gained his initial fame as the shortstop for Ned Hanlon's great Baltimore Oriole teams, winners of the National League pennant in 1894, '95 and '96. During that three-year run, playing alongside such greats as John McGraw, Willie Keeler, Kid Gleason and Wilbert Robinson, Jennings averaged .373—including a high of .398 in 1896, the record for shortstops—with an average of 139 runs scored, 53 stolen bases and 118 runs batted in. In addition, he led the league in putouts all three years and in fielding average twice, while also setting a record for being hit by pitches—49 in one season. But it was as a manager that Jennings gained his lasting fame. And name. Coaching from the third-base box, and punctuating his coaching with taunts, whistles, gyrations and his famous cry of "Ee-Yah," Jennings led his Detroit Tigers team to pennants in each of his first three years as manager and in 14 years won 1,131 games at the Tiger helm, even on occasion inserting himself into the lineup, as he did, at the age of 43, in the famous "Ty Cobb Strike Game" in 1912, when the Tigers called a strike to support their star after he had been suspended for going into the stands to take on a heckler.

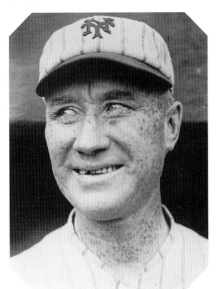

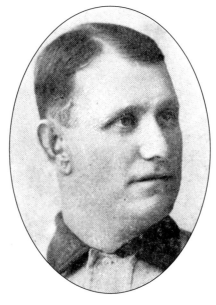

6. ED DELAHANTY *(Above)* [Edward James Delahanty; "Big Ed"; OF; 1888–1903*; PHI (N), CLE (P), WAS (A)]. "Big Ed" was one of the biggest names and biggest players in those antediluvian days before the age of modern baseball. One of five baseball-playing brothers, Delahanty was a power hitter who hit for average. Five times he led the league in doubles, once in triples and once in home runs, and batted .400 three times. Twice he led the league in batting, once each in the National and American Leagues—the only man to lead both leagues in batting—and on July 13, 1896, hit four home runs in one game. Never one to allow training to contribute to his success, Delahanty was suspended for breaking the training rules in June of 1903 and left his club in Detroit to take a train for New York. Although the facts are shrouded in mists as heavy as those surrounding the place of his demise, somewhere near the International Bridge near Niagara Falls he was put off the train for being drunk and disorderly and, staggering along the tracks, he fell through an open drawbridge to his death in the falls below.

7. CONNIE MACK *(Below)* [Cornelius Alexander Mack (born McGillicuddy); C; 1886–96*; WAS (N), BUF (P), PIT (N)]. Although he played 11 years as a catcher, Connie Mack gained his fame as manager of the Philadelphia Athletics, where he served as manager-owner for half a century. His team, in the then-fledgling American League, won six of the first fourteen pennants, including three World Series. But after suffering a disastrous sweep at the hands of the "Miracle Braves" in 1914 and faced with the loss of some of his great stars to the upstart Federal League and with rising player salaries, he dismantled his great team, selling his remaining great players. Thus the A's fell from first to last in 1915, and dwelt there for the next six years. Gradually he built another winning team, adding such stars as Lefty Grove, Jimmie Foxx and Mickey Cochrane, and by 1927 was once again challenging for the top of the American League mountain. By 1929, his A's had climbed to the top, dethroning the mighty Yankees with a team called by many historians the greatest team in baseball history. However, the Depression, bad investments and high salary demands once again forced Mack to divest himself of his rolling stock, and, by the mid-thirties, the A's had once again plummeted into the second division, where—with the exception of one first-division finish in 1948—they stayed for the remainder of his reign. A tactician who inaugurated such practices as pregame meetings, Mack directed his team from the bench, where he could be seen sitting erectly in a suit waving a scorecard to move his players into position. When he retired, after managing the A's through thick and thin for 50 years, he had compiled a managerial record of winning 3,776 games—more than anyone in the history of baseball.

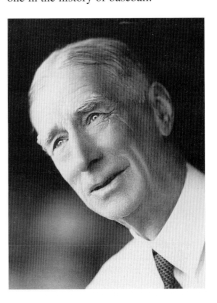

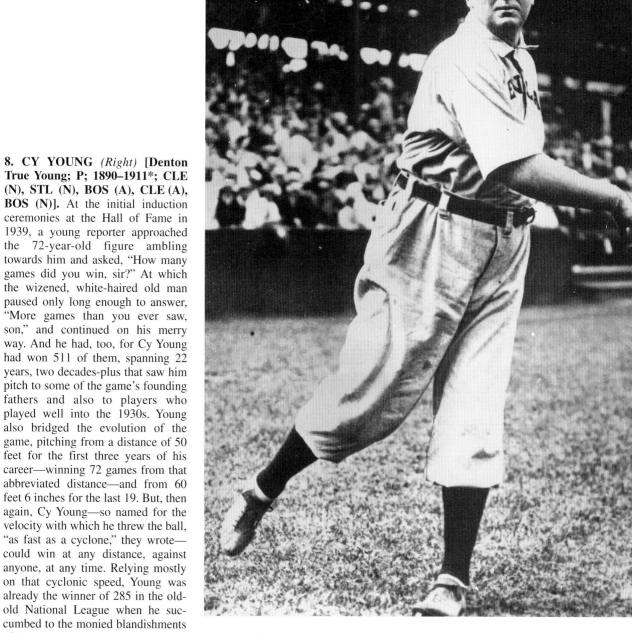

8. CY YOUNG *(Right)* **[Denton True Young; P; 1890–1911*; CLE (N), STL (N), BOS (A), CLE (A), BOS (N)].** At the initial induction ceremonies at the Hall of Fame in 1939, a young reporter approached the 72-year-old figure ambling towards him and asked, "How many games did you win, sir?" At which the wizened, white-haired old man paused only long enough to answer, "More games than you ever saw, son," and continued on his merry way. And he had, too, for Cy Young had won 511 of them, spanning 22 years, two decades-plus that saw him pitch to some of the game's founding fathers and also to players who played well into the 1930s. Young also bridged the evolution of the game, pitching from a distance of 50 feet for the first three years of his career—winning 72 games from that abbreviated distance—and from 60 feet 6 inches for the last 19. But, then again, Cy Young—so named for the velocity with which he threw the ball, "as fast as a cyclone," they wrote— could win at any distance, against anyone, at any time. Relying mostly on that cyclonic speed, Young was already the winner of 285 in the old-old National League when he suc- cumbed to the monied blandishments of the newly-minted American League in 1901. Now having devel- oped a curve to go with his fast ball, Young quickly became the junior circuit's leading pitcher in the first three years of its exis- tence, winning 33 and 32 in his first two seasons, the fourth and fifth times he had reached the 30-win level. The 1903 edition of his Boston Pilgrims team won the American League pennant and played in the very first World Series ever, with Young losing the first game and coming back to win two others as the Pilgrims beat the Pittsburg—then without an "h" to hiss in—Pirates, five games to three. But perhaps the most noteworthy game Young ever pitched was the one he pitched on May 5, 1904, against the Philadelphia Athletics. And against their ace pitcher, Rube Waddell. Earlier that season Waddell had pitched a near-perfect game against Boston, allowing a lead-off bunt and then mowing down 27 Boston batsmen in a row. Now the headstrong Waddell promised more of the same. But Young, who had been watching the brash Waddell and knew him to be "a damn fine pitcher, but he ran his mouth quite a bit," knew he "better do something about it." And with that he went out to the mound and threw a perfect game, allowing just six balls to be hit out of the infield. Young took no lip from anyone, not even Ty Cobb, the most famous, and feared, baiter in baseball history. Once Cobb had started baiting the by- now-venerable Young from the mound. Young simply answered the cocky Cobb with, "It's too bad Sherman didn't do more to Georgia when he was down your way." Young continued respond- ing to all such challenges, well into his 45th year until his by-now- generous potbelly prevented him from reaching bunts. After he had lost his last game, Young walked proudly off the mound forever, winner of more games than almost anyone had ever seen.

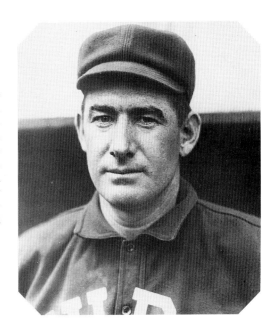

9. ROGER BRESNAHAN *(Right)* **[Roger Philip Bresnahan; "The Duke of Tralee"; C; 1897, 1900–15*; WAS (N), CHI (N), BAL (A), NY (N), STL (N)].** Originally a pitcher, Bresnahan would gain his reputation as one of the greatest catchers of his era—and leave as his legacy the invention of the batting helmet, shin guards and the modern face mask. The fiery on-the-field leader of the great Giant teams of the early twentieth century, the five-foot-nine-inch, 200-pound Bresnahan was agile enough to lead off and steal more bases than any catcher in history as well as play every position on the field—pitching and catching in the same game long before Bert Campaneris and Cesar Tovar.

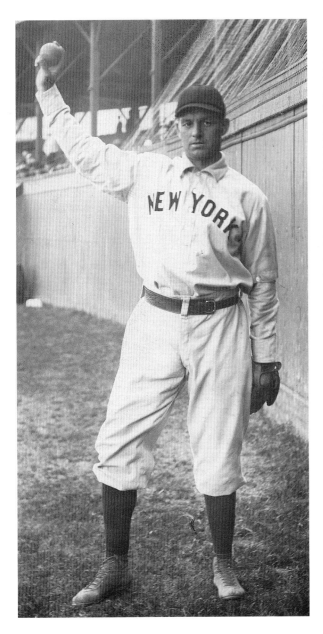

10. JOE McGINNITY *(Left)* **[Joseph Jerome McGinnity; "Iron Man"; P; 1899–1908*; BAL (N), BKN (N), BAL (A), NY (N)].** Those very few old-timers who have yet to collapse under the weight of their collective memories and remember the name Joe McGinnity will be able to tell you he was called the "Iron Man" and that he once pitched and won three doubleheaders in one month. And little else. But there was more to Joe McGinnity, much more. For although McGinnity's major league career measured but ten years, this righthander with a sidearm pitching motion and a sneaky curve—delivered via a quick-return pitch—won a total of 247 games, five times leading his league in wins, and averaged an incredible 346 innings pitched a season during his one decade in the majors. Back in the first years of the twentieth century, when players were jumping from team-to-team with all the frequency of a Calaveras County hoppy-toad, McGinnity shuttled between teams, following John McGraw to the New York Giants where he became the workhorse on McGraw's great early Giants teams, winning 20 games five years in a row—the first year, 1901, winning 20 games split between two last-place teams and twice winning 30-plus games. By 1908, McGinnity, having lost some of his arm's strength and having pitched but 186 innings during the season in both starting and relief roles, was relegated to the "coacher's box," where he became a bit player in two of baseball's greatest moments: the "Merkle Boner" game and the ensuing playoff game. In the game forever known as the "Merkle Boner" game, when Chicago Cub second baseman Johnny Evers called for the ball from the outfield to tag second to force out Merkle after he ran to the clubhouse rather than touching second, McGinnity claimed he took the outfield throw and, before anyone could do anything with it, threw it as far as he could into the left field stands. In the subsequent playoff game, which was caused by Evers' producing a ball from God-knows-where to retire Merkle, McGinnity was given the assignment by McGraw of baiting Cub manager and first baseman Frank Chance into a fight before the game. McGinnity called Chance names, stepped on his toes, even spat at him. But all to no avail, as Chance wouldn't fall for the ruse and the Cubs beat the Giants in the playoff for the 1908 pennant. By 1909, McGinnity was back in the minors, winning a league-leading 29 games for Newark. In 1910 he won another 30 for Newark, and over the next 15 years won another 148 games in the minors until, at the advanced age of 54, he won six games pitching for Dubuque in the Mississippi Valley League ("I was part-owner as well as manager of the team," he said. "Sorta protectin' my investment, you might say."), giving him a total of 235 wins in the minors to go with his 247 wins in the major leagues.

11. NICK ALTROCK *(Right)* [Nicholas Altrock; P; 1898, 1902–9, 1912–15, 1918–19, 1924, 1929, 1931, 1933; LOU (N), BOS (A), CHI (A), WAS (A)]. Back in 1901, between pitching engagements in the majors, Nick Altrock was honing his skills, such as they were, with an outlaw team on the Pacific Coast. In one game, he deliberately walked the first seven batters to face him and then promptly picked each and every one off first, giving as his reason, "It was the only way I could get those S.O.B.'s out." But Altrock had more to his arsenal than just a pick-off throw—much more. Coming to the White Sox in 1903, Altrock developed into one of the mainstays of the pitching staff that carried the so-called "Hitless Wonders" to the 1906 World Championship. Three times in succession, 1904, '05 and '06, he appeared in 38 games and won 19, 22 and 20 in those same years—five of his wins in '06 coming in relief. In the 1906 Series against the Chicago Cubs, the same Cub team that won a record 116 games, Altrock appeared twice, winning the first game on a four-hitter over Three Finger Brown, 2-1, and then, in game four, losing to Brown, 1-0. Soon after 1906, Altrock's arm went dead and, with his pitching career behind him, he joined the Washington Senators as a coach. Over the course of 22 seasons he would alternate between the "coacher's box" and the mound and the batter's box, appearing 14 times as a pitcher and 14 more times as a pinch-hitter. In between, he would entertain the fans as part of a comedy duo with first, Germany Schaefer, and then, Al Schacht. In one of his last at-bats, on the last day of the '24 season, Altrock, at the advanced age of 48, became the oldest player ever to get an extra-base hit, tripling—one of two times he went 1.000-for-the-season, both times one-for-one.

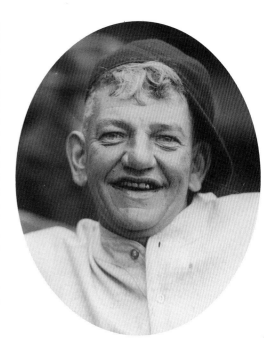

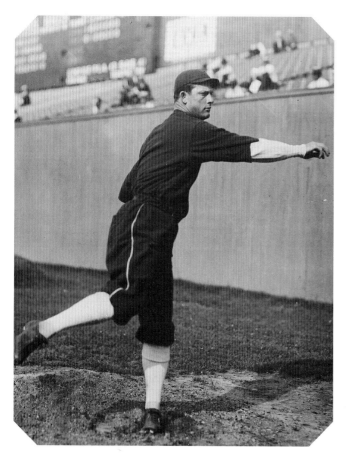

12. ED WALSH *(Left)* [Edward Augustine Walsh; "Big Ed"; P; 1904–17*; CHI (A), BOS (N)]. Coming up to the White Sox in 1904, Ed Walsh pulled as his roomie a rolling stone named Elmer Stricklett. While at Sacramento, Stricklett had been tutored in the fine art of the "spitter" by George Hildebrand, who had learned how to throw "the wet one" by watching a teammate. Stricklett stayed in Chicago for exactly one cup of java but he passed on the secrets of the pitch, like a family heirloom, to Walsh. And nobody ever threw it better than the man they called "Big Ed." For Walsh got every bit of his strapping 6 foot 1 inch, 200-pound body behind the pitch. With his cap worn far down on his face, Walsh would open his mouth to apply the juices from his cud of slippery elm to the ball, causing an ever so imperceptible muscular tightening of the jaw—and announcing to one and all that his "spitter" was on the way. Then he would rear back and fire, the ball flashing to the plate in a spray that framed his face—doing justice to a fountain statue of Neptune spewing water into the air. As the ball neared the plate, heavy with saliva, it still moved with a lightness, veering down quickly—and proving all but impossible to hit. Walsh's spitball was described by Sam Crawford as "disintegrating on the way to the plate. I swear, when it went past the plate it was just the spit went by . . . and the catcher put it back together again." Pitching with pomp, Walsh took his place on the mound at every turn, starting and relieving. And posted amazing numbers. In 1907 he led the American League in ERA, with a 1.60 average, in games pitched, in games started, in games completed and in innings pitched. But his career season was 1908 when, as the workhorse of the White Sox staff, he went to the mound 66 times, starting 49 games and finishing 42 of those as he won 40 games—45.5% of Chicago's total of 88 wins, an American League high for percentage of a team's wins, and a total number of wins not approached since—and led the league in winning percentage, innings pitched, strikeouts and shutouts. Before his arm went dead from overwork in 1913, Walsh had led the league in games pitched five times and in strikeouts and shutouts three, and posted an ERA of under 2.00 for five consecutive seasons. He would pitch for five more semi-productive seasons, his ERA under 3.00 for four of them, and finish with an ERA of under 3.00 for 13 of his 14 big league seasons and a lifetime ERA of 1.82 in over 2,964 innings pitched—the all-time "low" in the field.

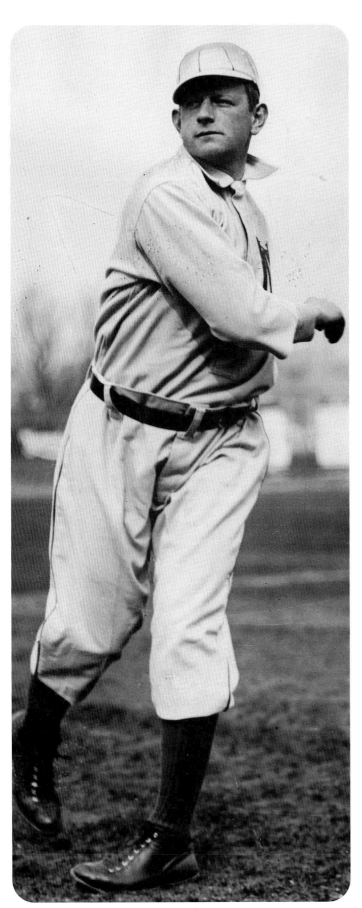

13. JACK CHESBRO *(Left)* **[John Dwight Chesbro; "Happy Jack"; P; 1899–1909*; PIT (N), NY (A), BOS (A)].** One of the first pitchers to master the spitball, Jack Chesbro is today remembered—when he is remembered at all—as the man who threw away the 1904 pennant when one of his "wet ones" sailed over his catcher's head on the last day of the season to give the Red Sox the game—and the pennant. However, that is an unfair assessment of the man who won a record 41 games for his team—a 44.6% percentage of the Highlanders' total wins, the third-greatest percentage in history—completed his first 30 starts and pitched 454 innings for the second-place club. Moreover, Chesbro, who had led the Pirates to their first two pennants, in 1901 and '02, is the first man to lead both leagues in wins and the only man to lead both leagues in winning percentage. All in spite of one pitch that got away.

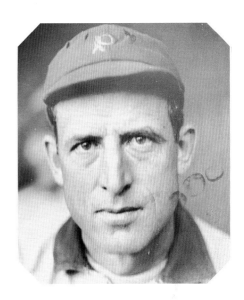

14. FRED CLARKE *(Above)* **[Fred Clifford Clarke; "Cap"; OF; 1894–1911, 1913–15*; LOU (N), PIT (N)].** Fearless and daring, Fred Clarke was the National League's version of Ty Cobb. At bat he would do anything to get on base, from his very first major league game, when he went five-for-five, to 11 seasons batting over .300—once, in 1897, hitting .406. On the base paths, he was known as the most wicked slider in the NL, leaping into the air, feet spread wide apart, spikes agleaming as he tried to take out anyone foolish enough to get in his way—on his way to stealing 506 bases during his career. But it was as a manager that Clarke made his name. Back in the first decade of modern baseball, when the National League was divided into "haves" and "have nots," and Pittsburg(h) was one of the "haves," Clarke led the Pirates to four pennants and three second-place finishes. Part psychologist and part chess grandmaster, Clarke ran his team with an iron hand encased in a soft outfielder's glove. From shifting an aspiring outfielder named Honus Wagner to shortstop to taking off his smoked sunglasses and stooping down to tie his shoelaces as a sign for a pitcher to warm up, Clarke managed 938 wins during that first decade, a .635 winning percentage. When his aching, aging legs finally rebelled in 1911—after he had batted .324, the fourth-highest average in the league—Clarke abruptly retired to take his place in the "coacher's box." After four more seasons as Pirate manager, Clarke finally retired to his farm in Kansas, taking with him a lifetime .315 batting average after 21 years, and 1,602 wins as manager after 19 seasons.

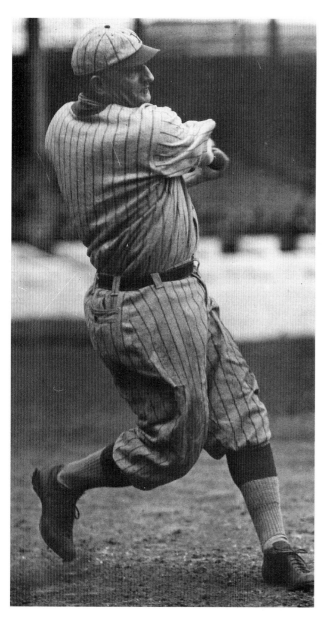

15. HONUS WAGNER *(Left)* **[John Peter Wagner; "The Flying Dutchman"; SS; 1897–1917*; LOU (N), PIT (N)].** Like the proverbial camel put together by committee, Honus Wagner looked like one of nature's irregularities. His legs hardly looked like they could fulfill the obligations they had been foresworn to uphold, so bowed were they that one writer noted, "They took off at the ankles in a curving sweep to meet in surprise at his waistline." They were anchored by size-14 violin cases, more familiarly known as feet. Grafted onto his huge barrel chest were two long arms that flowed out of his uniform at odd spots, dangling so low they almost scraped the ground. And from the end of those long arms hung two hands better described as "shovels" by archrival Johnny Evers. But when it came to assessing the worth of Wagner, you didn't examine the package's shape, only the package as a whole—the value of which far outweighed that of any single part. For the man called by John McGraw "the greatest player of the twentieth century," and by Ed Barrow, who managed Babe Ruth, "the greatest player ever," was a complete player, one who led the National League in batting eight times, in doubles seven, in RBI's five, in stolen bases four and in triples three. A notorious bad-ball hitter, Wagner was all the more dangerous with men in scoring position, never giving the pitcher a chance to waste a pitch. When the great Christy Mathewson asked his first-ever catcher, Jack Warner, what Wagner's weakness was, Warner answered back, "A base on balls." On the basepaths, this human caricature with legs going loose at the ends was, incredibly, a speedster, stealing a total of 722 bases during his 21-year career. But it was in the field that Wagner earned his name. And his fame. For, in the name of challenge, Wagner picked up every ball batted at him, sometimes roaming far back of third to retrieve a ball and then, taking little or no time, rifling the ball over to first, or wherever, together with all the pellets, smithereens and quidbits of dirt and grass he had picked up along with the ball in his massive hand. The first baseman would then have to pick out the baseball from all the grassy flybys that came his way, almost as if in the middle of a threshing machine. He was so good that in 1915, at the advanced age of 41, he was still leading National League shortstops in fielding. Wagner finally retired in 1917, after 2,789 games, 10,441 at bats, 3,418 hits, 643 doubles and 252 triples, with a lifetime .327 batting average. He was elected into Baseball's Hall of Fame in its very first pledge class, right behind Ty Cobb, his only rival for the title of baseball's greatest player for the first quarter-century of modern baseball.

16. SAM CRAWFORD *(Right)* **[Samuel Earl Crawford; "Wahoo Sam"; OF; 1899–1917*; CIN (N), DET (A)].** The all-time record holder for career triples, with 312, "Wahoo Sam"—who took his nickname from his birthplace, Wahoo, Nebraska—was one of baseball's early long-ball hitters. Twice he led his league in home runs—the only man ever to lead both leagues in homers. Three times he led the American League in RBI's, and when he retired in 1917, just 36 hits shy of the magic number of 3,000, he held the American League career home-run record with the then-astonishing total of 70.

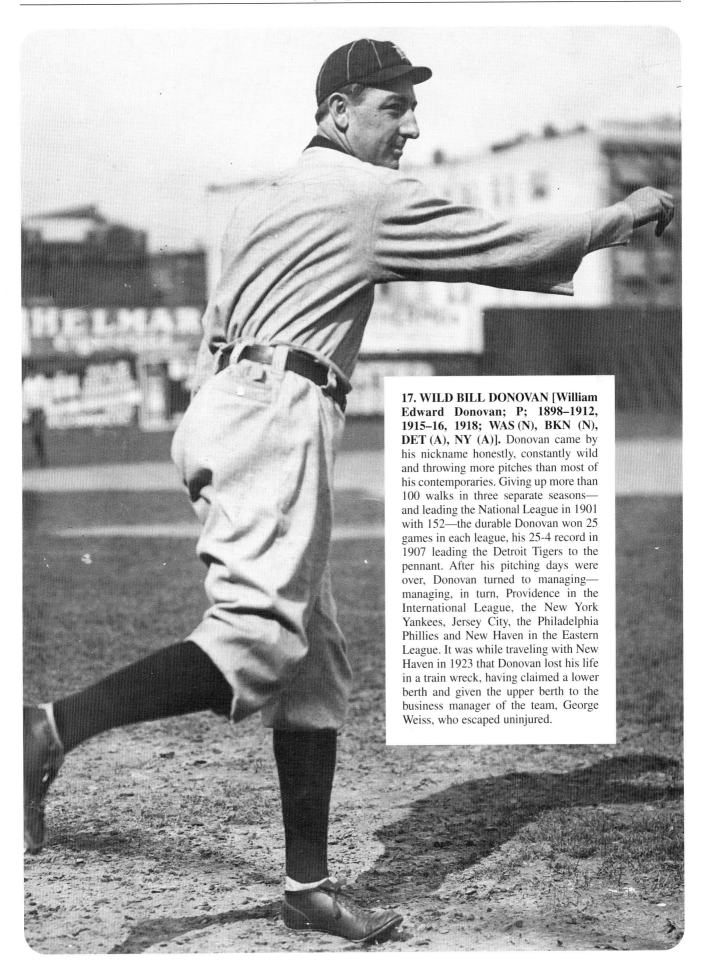

17. WILD BILL DONOVAN [William Edward Donovan; P; 1898–1912, 1915–16, 1918; WAS (N), BKN (N), DET (A), NY (A)]. Donovan came by his nickname honestly, constantly wild and throwing more pitches than most of his contemporaries. Giving up more than 100 walks in three separate seasons—and leading the National League in 1901 with 152—the durable Donovan won 25 games in each league, his 25-4 record in 1907 leading the Detroit Tigers to the pennant. After his pitching days were over, Donovan turned to managing—managing, in turn, Providence in the International League, the New York Yankees, Jersey City, the Philadelphia Phillies and New Haven in the Eastern League. It was while traveling with New Haven in 1923 that Donovan lost his life in a train wreck, having claimed a lower berth and given the upper berth to the business manager of the team, George Weiss, who escaped uninjured.

18. DAVY JONES *(Left)* **[David Jefferson Jones; "Kangaroo"; OF; 1901–4, 1906–15; MIL (A), STL (A), CHI (N), DET (A), CHI (A), PIT (F)].** One of the fastest men in the early-early American League—he beat Archie Hahn, who had won three gold medals in the 1904 Olympics in the 60-meter, 100-meter and 200-meter dashes, several times in college—Davy Jones was the third member of the famous Detroit Tiger outfield, playing seven years alongside Ty Cobb and Sam Crawford. And he often kept the peace between the mean-spirited Cobb and the surly Crawford. Batting leadoff—and called by Crawford "the best leadoff man in the league. I've seen a lot of leadoff men, but I never saw one who came close to being Davy's equal"—Jones stole 140 bases and scored 412 runs for the Tigers and was one of the most important, and often unsung, parts in their string of three American League pennants in 1907, '08 and '09. It was in that first year, 1907, that Jones, batting leadoff, became the first man to face Walter Johnson in a major league game, predictably striking out, the first of Johnson's 3,508 strikeouts.

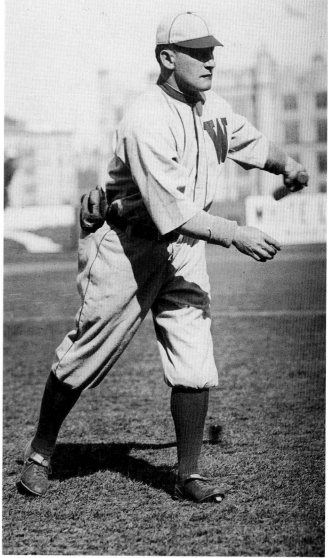

19. GERMANY SCHAEFER *(Right)* **[Herman A. Schaefer; 2B; 1901–2, 1905–16, 1918; CHI (N), DET (A), WAS (A), NWK (F), NY (A), CLE (A)].** Germany Schaefer was proof positive that baseball not only builds character, it builds characters. For Schaefer was a player who lit up baseball's skies during the first decade of the twentieth century. During one of those times when baseball's skies were darkened by a steady rain, Schaefer, then playing second for the Detroit Tigers, donned high rubber boots, a raincoat, a bright yellow fisherman's hat and an umbrella. Coming to the plate, he said to umpire Tom Connolly, "I have a very bad cold and it's now bordering on pneumonia. If I get rid of my rubber boots, raincoat, hat and umbrella, I'll be in the hospital in less than two hours. And," he capped his plea, "I'll sue you and the league for damages." With that Connolly suspended the game. On another occasion—by then he was playing with the lowly Washington Senators, whose entire offense consisted of a bunt and a stolen base—Schaefer was aperched on first with speedy Clyde Milan on third with the score tied in the bottom of the ninth. With two out, Schaefer took off for second, but drew scant attention from the White Sox catcher. On the very next pitch, he reversed his path, dashing back to first and sliding into the bag in the hopes of drawing a throw and allowing Milan to gallop across the plate with the winning run. Only trouble was, it didn't work; the catcher was having none of Schaefer's shenanigans. But Schaefer again tried, going down to second on the next pitch, and by this time, the White Sox catcher, sufficiently rattled, threw down to second, allowing Milan to score. Although the gimmick was soon outlawed by the powers-that-be, Germany Schaefer will always be remembered as baseball's forerunner of "Wrong Way" Corrigan.

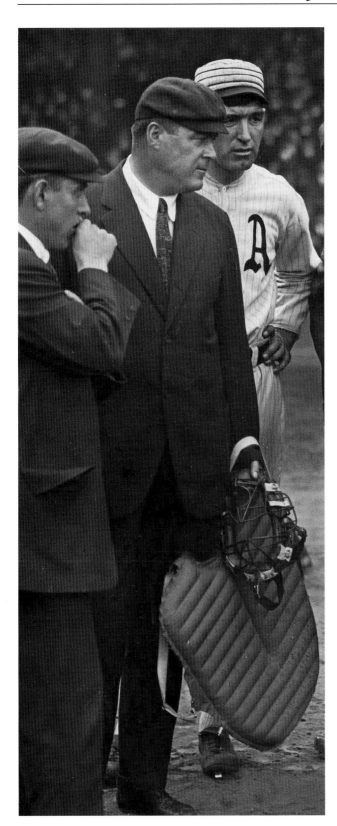

21. NAP LAJOIE *(Below)* **[Napoleon Lajoie; "Larry"; 2B; 1896–1916*; PHI (N), PHI (A), CLE (A)].** One of the greatest and most popular stars of the first decade of the twentieth century, Lajoie's jump to the American League in 1901 gave instant credibility to the newly-minted circuit. In his first year with the Philadelphia Athletics, not incidentally also the first year of the league itself, Lajoie led the fledgling league in hits, doubles, home runs, runs batted in and batting average, his .422 a record 82 points over the second-place finisher and still the American League record. Lajoie went on to lead the American League in batting two of the next three years as a member of the Cleveland Blues—in '05 named the "Naps" in his honor—but is best remembered for the batting title he did *not* win. The year was 1910 and the country was caught up in the hotly contested race for the American League batting title—as well as for the Chalmers automobile that went with it—between the popular Lajoie and the equally unpopular scourge of the league, Ty Cobb. The race came down to the last day of the season, when Lajoie, in a double header against the St. Louis Browns, had seven bunt singles and a triple in eight at bats to finish the season with a league-leading 227 hits and an "official" .3841 batting average. Cobb, however, had finished with a .3848 average and was declared the winner of the batting race and the Chalmers. Chalmers awarded cars to both Cobb and Lajoie. It was later revealed that the Browns' infield had been instructed by manager Jack O'Connor to play deep to "give" Lajoie a chance to reach base safely, for which O'Connor was subsequently fired. (And it was later—much later—revealed by researchers that Cobb had been wrongly credited with two two-for-three games, inflating his average, which *should* have been .382 instead of .385.)

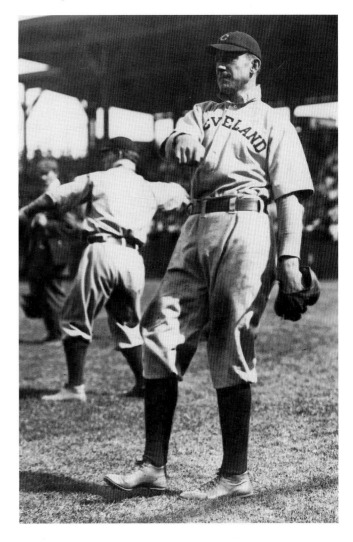

20. BILL DINNEEN *(Above)* **[William Henry Dinneen; "Big Bill"; P; 1898–1909; WAS (N), BOS (N), BOS (A), STL (A)].** Four times a 20-game winner and the winner of the first World Series game ever won by the American League, in 1903—a Series in which he won three games, two of those wins shutouts—Bill Dinneen was known by a later generation as one of the junior circuit's top umpires, working as an American League umpire for 29 years and serving as an arbiter in 45 World Series games.

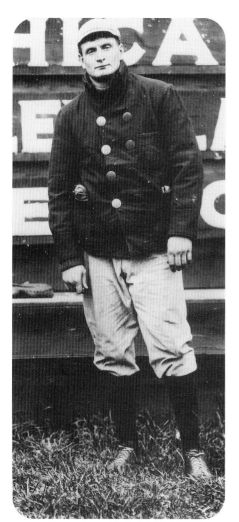

22. RUBE WADDELL *(Left)* [George Edward Waddell; P; 1897, 1899–1910*; LOU (N), PIT (N), CHI (N), PHI (A), STL (A)]. Plato didn't know "Rube" Waddell when he wrote, "Of all the wild beasts, the boy is the most difficult to manage." But had he wanted references, he could have asked Waddell's manager, Connie Mack. For Mack, who had managed—or, more correctly, *tried* to manage—Waddell for six years, remembered his magnificent screwball thusly: "He gave me fits. But that fellow could pitch. He could really pitch." Tommy Leach, who played with Waddell at Louisville, remembered him as "Nutty! He was just an overgrown boy. But I used to stand there at third base and watch him throw. I wasn't playing, I was watching! 'How can a man throw that hard?' I used to wonder to myself. He had a terrific curve ball, too, and great control." Waddell brought that hard fast one, his curve and his control to the American League in 1902 and for the next six years, in an Athletics uniform, led the league in strikeouts every year, twice striking out 300 batsmen a year—including a then-record 349 in 1904—and won an average of 22 games a year, including 20 four times. But Waddell's enduring fame rests not on his pitching accomplishments, which were many, but on his antics, both on and off the field. Teammates remember him pitching one day and then not seeing him for three or four days thereafter. He'd just disappear, go fishing or be off playing ball with a bunch of twelve-year-olds in an empty lot. On those rare days he'd show up at the ballpark, always when he was scheduled to pitch, he would announce, "I've got so much speed today I'll burn up the catcher's glove if I don't let up a bit," and then go over to the water barrel and pour ice water over his left arm. One time, during an exhibition game, Waddell called in the outfield and struck out the side just to prove he "had it." One famous incident had him wrestling teammate Andy Coakley for a straw skimmer, which caused him to fall on his shoulder and miss the entire 1905 World Series after winning a league-leading 26 games during the season. By 1908, the even-tempered Mr. Mack, tired of his rube-foolery, had sent Waddell packing to the St. Louis Browns. But even there Waddell came back to haunt him, striking out 16 Philadelphia A's one July afternoon. And even though his numbers were almost an exact duplicate of his previous year's—19 wins, five more shutouts and another 232 strikeouts—it was to be Waddell's last big year. By 1910 he was back in the minors and by 1914, having caught pneumonia while piling sandbags during a flood in the spring of 1912, he died of tuberculosis. Fittingly, on April Fools' Day.

23. EDDIE PLANK *(Right)* [Edward Stewart Plank; "Gettysburg Eddie"; P; 1901–17*; PHI (A), STL (F), STL (A)]. In 1901 Connie Mack signed lefthander Eddie Plank right off the campus of Gettysburg College, hence the nickname, for his newly-minted Philadelphia Athletics of the equally new American League. And Plank rewarded Mack with 17 victories. The next year Mack added another lefthander, this one as different from Plank as night from day, Rube Waddell. Together Waddell and Plank formed a disparate pair: Waddell was a man-child who alternately and with equal ease roamed the diamond and the saloon; Plank was simply drab in comparison, a comparison that would dim his greatness and submerge his name. Contemplative and deliberate on the mound, to the point of disconcerting and annoying batters, Plank pitched with control of both himself and his opponent, able to open up a batter like a flowering rose for his sidearm curve—which he called his "cross-fire," a pitch that cut the plate at an odd angle. Together, the oil-and-water duo of Plank and Waddell dominated the American League for four years, winning a total of 190 games between them from 1902 through 1905, with Plank winning 94 of those. After winning more than 20 games in each of those four years, Plank tailed off to a "mere" 19 in 1906. Then he found himself again, winning 24 in 1907. He was to win more than 20 games twice more for the Athletics—and once more in the Federal League. But he did it quietly, never leading the league in wins and, in so doing, became the winningest pitcher never to lead his league in single-season wins. Still, this quiet man amassed 327 wins, the 10th-greatest number in history and the most by a southpaw until Warren Spahn passed him nearly half a century later.

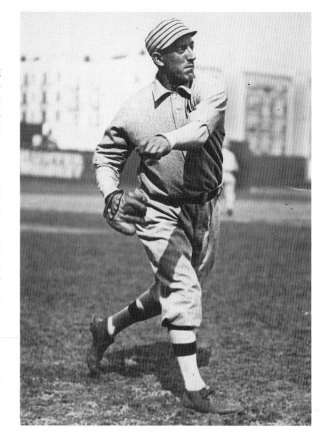

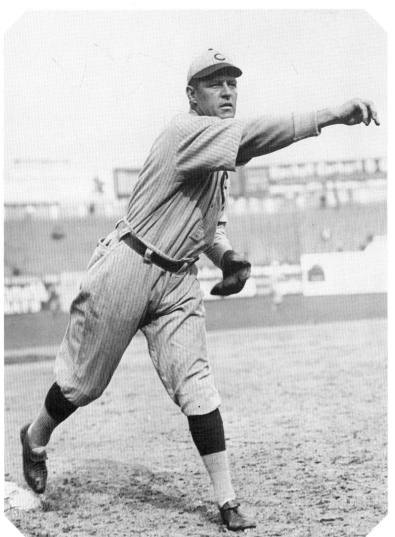

24. HARRY STEINFELDT *(Left)* [**Harry M. Steinfeldt; "Steiney"; 3B; 1898–1911; CIN (N), CHI (N), BOS (N)**]. When they come to naming the greatest infields of all time, one of the quartets that heads up most lists is that of Tinker, Evers, Chance and Steinfeldt. And yet Harry Steinfeldt was denied immortality when his name couldn't be worked into Franklin P. Adams' immortal verse, "Baseball's Sad Lexicon," along with the names of Tinker, Evers and Chance. ("These are the saddest of possible words: 'Tinker to Evers to Chance.' Trio of bear cubs, and fleeter than birds,/Tinker and Evers and Chance.") And so Steinfeldt remained another of baseball's unsung heroes, literally, despite the fact that he played in the majors for 14 years and alongside Tinker, Evers and Chance on four pennant-winning teams. But Harry Steinfeldt's statistics, if not his name, are enduring. For Steinfeldt joined the Cubs in 1906 and led the National League in hits and RBI's, not incidentally also leading the Cubs to the National League pennant with a record 116 wins. In 1907 he led the Cubs to victory in the Series with a .471 batting average, a high not only for that Series but also the third-highest mark ever for a five-game Series. And, in the four World Series in which the foursome played, the Cubs made a total of 17 double plays, but none of those *tours de baseball* went from Tinker to Evers to Chance; in fact, one went from Steinfeldt to Evers to Chance. But as the Fates and Franklin P. Adams would have it, Harry Steinfeldt remains just another "Who's he?" in baseball lore, the third baseman for the most famous infield threesome in baseball.

25. THREE FINGER BROWN *(Right)* [**Mordecai Peter Centennial Brown; P; 1903–16*; STL (N), CHI (N), CIN (N), STL (F), BKN (F), CHI (F)**]. Many's the name that just tends to lie there, giving neither definition nor direction to the person wearing it. But Mordecai Brown gained fame by his, "Three Finger," a reference to his right hand which was short the first finger, the result of a childhood argument with a feed cutter. With one finger less than the union scale and his third finger shorter than norm, Brown perfected an almost unhittable pitch, a spin released off his stub. Possessing an ungodly curve, wicked speed and abnormal control—his lifetime 2.06 ERA is best in National League history—Brown was the pitching ace of the great Cubs teams of the first decade of the twentieth century. And Chicago's answer to the Giants' Christy Mathewson, beating Matty nine straight times in head-to-head match-ups, including besting Mathewson in the 1908 play-off game necessitated by Merkle's so-called "Boner" (see photo 38). Ironically, the two would both make their last pitching appearance in the majors against one another in 1916, this one won by Mathewson.

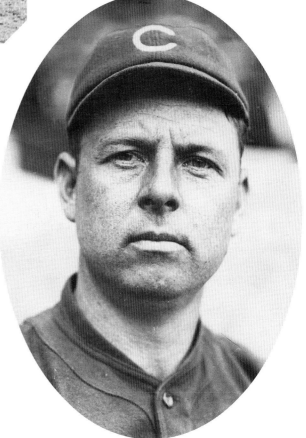

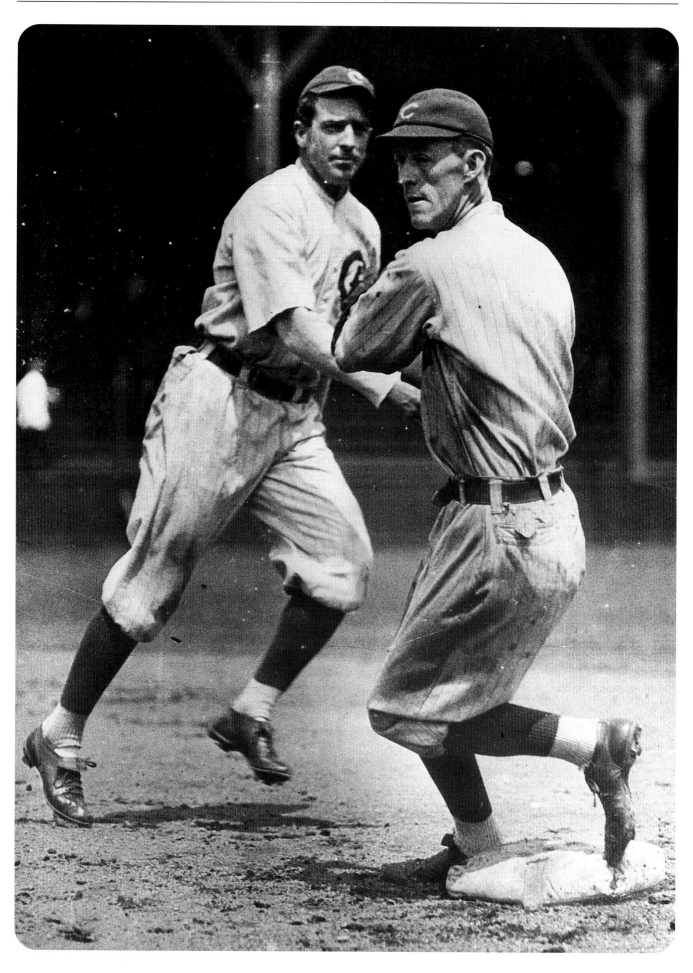

26. JOE TINKER *(Opposite)* **[Joseph Bert Tinker; SS; 1902–16*; CHI (N), CIN (N), CHI (F)]** *and* **JOHNNY EVERS [John Joseph Evers; "The Crab," "The Trojan"; 2B; 1902–17, 1922, 1929*; CHI (N), BOS (N), PHI (N), CHI (A)].** Bound together for better or verse, Johnny Evers (at right; rhymes with Tom Seaver, with a final "S") and Joe Tinker formed one-half of one of the greatest infields in baseball history—although only three, Tinker, Evers and Chance, were immortalized in Franklin P. Adams' poem, "Baseball's Sad Lexicon." Playing side-by-side for 11 years, Tinker and Evers were masters of the lost science of "inside" baseball, developed in the deadball era when one run was a precious commodity. Together they pulled off pick-off plays and the rotation play, and defended, as few could, against the bunt and the hit-and-run. Tinker was the more stylish fielder, four times leading the league in fielding, twice each in assists and putouts and once in double plays, while Evers, known as "The Crab" for his sidling movement in approaching grounders, was the team leader, one who knew how to steal signals—as he did by learning sign language to steal the Giants' signals to their pitcher, Luther Taylor (nicknamed "Dummy" for the reason he was deaf and dumb)—and memorizing the rule book, which he used to good advantage in the famed "Merkle Boner" game. While their offensive statistics were, at best, ordinary— lifetime batting averages .263 and .270, respectively and respectably—on the basepaths they were two of the smartest baserunners of the era, Tinker stealing 336 bases lifetime and Evers 324, 21 of those of home, a National League record, and three times executing double steals together in World Series play. The 11 Cubs teams they anchored had an amazing won-lost percentage of .635, with a .693 percentage for the five-year span from 1906 through 1911, when the Cubbies won four pennants in five seasons. (Compare that to another Hall of Fame keystone combination, Pee Wee Reese and Jackie Robinson, whose Dodger teams, in the nine years they played side-by-side, had a won- lost percentage of .614 and for their best five years, 1952–56, a .630 won-lost record.) Ironically, Tinker and Evers rarely, if ever, talked to each other, owing to an argument over a cab fare in 1905. But still they were linked together forever in baseball lore, being elected as a unit—along with Frank Chance, the party of the third part in the immortal trio—to the Hall of Fame in 1946.

27. FRANK CHANCE *(Above)* **[Frank Leroy Chance; "Husk," "The Peerless Leader"; 1B; 1898–1914*; CHI (N), NY (A)].** Forever remembered as part of a double-play combination, along with Joe Tinker and Johnny Evers, courtesy of Franklin P. Adams' poem, Frank Chance's credentials were such that he could stand on his own very well, thank you, as a one-of-a-kind player and manager. Originally a husky catcher (ergo, the nickname "Husk"), Chance, according to Christy Mathewson, "was always banged up because he never got out of the way of anything. If he had to choose between accepting a pair of spikes in a vital part of his anatomy and getting a put-out, he always takes the put-out and usually the spikes." That propensity for never backing down—which he carried over into argu- ments—and the suffering of several career-threatening injuries, plus the arrival of catcher Johnny Kling in his third year dictated his conversion into a first baseman, where he became the party of the third part of the Cubs' famous double-play combo. And the linchpin of their dynasty. Chance would play 100 or more games at first base for six seasons—from 1903 through 1908—and in four of those would bat over .300. And, in almost all, he led the National League in being hit by pitch- es, because, again Mathewson, "He lingered too long to ascertain whether the ball was going to curve, which is why he was hit in the head so often." In the middle of the 1905 season, Chance was named player-manager and, over the next nine seasons, took the Cubs to four pennants and compiled an overall .665 won-lost record as manager, the highest percentage ever compiled by a manager with one club—including a record 116 wins in 1906. But his career and his health were sorely compromised by his constantly being beaned—so much so that his hearing became affected and he developed a pitiful whine. In 1912, at the age of 35, he stepped down as player-manager. He would manage for three more years in the major leagues, with less than success, until worsening health, the result of taking too many beanballs, forced him to retire to California where he died at age 47.

28. JOHNNY KLING *(Above)* [John Kling; "Noisy," "Johnnie"; C; 1900–8, 1910–13; CHI (N), BOS (N), CIN (N)]. When *Collier's* Magazine asked Billy Sunday to pick his "All-American Baseball Team," Sunday selected Johnny Kling as his catcher because, as Sunday wrote, "Kling is a general, runs the team when behind the bat—the pitchers bank on his judgment." And for four years, 1906, '07, '08 and '10, Kling took the team that is usually remembered for its Tinker-to-Evers-to-Chance infield to the top of the National League mountain—even taking a break in 1909, sitting out the season in a salary dispute in his pool emporium back home in Kansas City as the Cubs finished second. Known as "Noisy," Kling would talk to batters, distracting them in any way he could. Behind the plate, he was known for his 88-mm. cannon, allowing him to rifle a ball to second with great accuracy. Between 1902 and 1908, Kling led the League in fielding four times and putouts six. In one game he cut down all four Cardinal runners attempting to steal second. And in the 1907 World Series he threw out seven Tigers in 14 attempts, holding the vaunted Ty Cobb to zero stolen bases. Kling also perfected the trick of picking players off second, which he worked in tandem with Johnny Evers and Joe Tinker. When a player was found taking too large a lead off the bag, Evers would dash in and Kling would bluff a throw down, but hold the ball. The runner, seeing Kling come down with his arm, would scamper back to the bag, and then seeing that Kling had not thrown, would walk away from it again. Evers would nonchalantly holler over his shoulder, "If the Jew had thrown that time, he would have had you," and as the intended victim turned his head for a fatal second to reply, Kling would whip the ball down to Joe Tinker, who had rushed in behind him from his shortstop position. It was just such a piece of chicanery that turned the tables in the famous playoff game, necessitated by the "Merkle Boner," between the Cubs and the Giants in 1908. In the Giant first, Chicago pitcher Jeff Pfeister hit the first batter and walked the second. When the next man up, Roger Bresnahan, struck out, Kling conveniently dropped the third strike at his feet. The runner perched on first thought an opportunity for advancement was at hand and, exhorted by screams of "Go on! Go on!"—which were later traced to Kling and Evers—took off only to be thrown out by Kling. Kling returned for the 1910 season, his salary demands met, and once again sparked the Cubs to a pennant. But, in the 1910 World Series against the Philadelphia A's, he was blamed by the losing Cubs for allowing their signals to be stolen, causing him to be traded to the Braves the next season. After two more seasons—including one managing the Braves to a last-place finish—Kling retired to his poolroom, this time for good, leaving behind the legacy of being, in the words of one-time batterymate Ed Reulbach, "one of the greatest catchers who ever wore a mask."

29. ADDIE JOSS *(Right)* [Adrian Joss; P; 1902–10*; CLE (A)]. Addie Joss was a long-legged, slatternly pitcher–hyphen–electric fan, who threw something called a "jump ball," one which, thrown overhanded, aimed at the level of the batter's knees and then, inexplicably, rose. The total effect, as one bemused batter tried to describe it, was: "The ball, coming downward with great speed, packs air below it. Just when the ball begins to lose speed, the elastic air cushion, for a fraction of a second, has equal power with the attraction of gravity and carries the ball horizontally for a few feet until the further loss of motion brings it to the ground." Whatever, the effect was worthy of a magician's misdirection. Especially when delivered with a corkscrew windup motion, like that of an early-day Luis Tiant, which found him turning away from the batter before pitching and then delivering the ball anywhere save through his legs. For nine years Joss threw his "jump ball," four times winning 20 or more, twice leading the league in ERA—in fact, posting the second-lowest ERA of all time, 1.88—completing 234 of the 260 games he started and throwing two no-hitters, one of those a perfect 27-men-up, 27-men-out game. Struck down by an attack of tubercular meningitis two days after his 31st birthday, Joss was elected to the Hall of Fame despite his having played only nine years in the majors, a credit to one of the great pitchers of the first decade of the twentieth century.

30. CHRISTY MATHEWSON *(Below)* [**Christopher Mathewson; "Big Six," "Matty"; P; 1900–16*; NY (N), CIN (N)**]. In an age when baseball had a reputation for the rough-and-tumble, its players were, in the words of one writer of the time, "tobacco-chewing, beer-guzzling bums," Christy Mathewson was seemingly made of sunshine, blood-red tissue and clear weather. A beau idol with a blond grassplot atop his head, Mathewson, six-foot-one-inch-plus, quiet as a deacon and dangerous as a six-shooter, was called by the New York press "Big Six" after the famed New York City fire engine of the same name. And treated with reverence by New York fans. His reputation was built on his famed "fadeaway"—a reverse curve released with his hand turned over until the palm faced the ground instead of facing upward toward the sky, twisting off his thumb with a peculiar snap of the wrist and twisting away from the batter as well—and on his uncanny control. Giving up but one and a half walks a game, Matty had such control that sportswriter Ring Lardner rhapsodized, "Nobody else in the world can stick a ball as near where they want to stick as he can." The cornerstone of Mathewson's fame lay in his three shutout wins over the Philadelphia Athletics in the 1905 World Series, three hills from which he would forever look down on the baseball world. The winner of 373 games, tying Grover C. Alexander for the most in National League history, and winner of 20 games 13 times and 30 games four times, "Matty" was, in the words of Connie Mack, "the greatest pitcher who ever lived. It was wonderful to watch him pitch . . . when he wasn't pitching against you." He was, as W. O. McGeehan wrote, "the best loved of all ballplayers and the most popular athlete of all time."

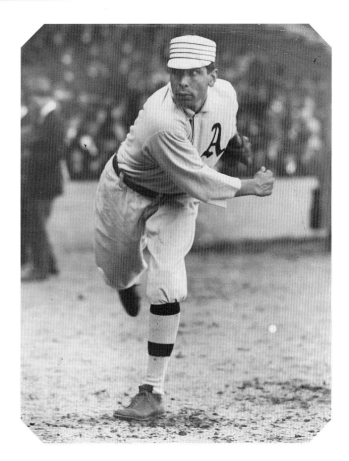

31. CHIEF BENDER *(Above)* [**Charles Albert Bender; P; 1903–17, 1925*; PHI (A), BAL (F), PHI (N), CHI (A)**]. Despite the many great pitchers he managed during his fifty-year managerial career, Connie Mack always said of the man he called Albert, "My greatest clutch pitcher was Albert Bender." A strapping six-foot-two-inch, 185-pound athlete, the part-Chippewa was a graduate of Carlisle, a government-operated school for Indians in Carlisle, Pennsylvania, one of those eastern schools that educated Native Americans in the idioms of football, baseball and other sports. It was while he was at Carlisle that Mack first saw him, pitching an exhibition game against the Chicago Cubs, and was so impressed he signed him immediately. And so, without any minor league schooling Bender jumped right to the majors. And into the win column as well, winning 17 games in his first year, 1903. Over the next 11 years, Bender was Mack's "stopper," his "go-to" pitcher, who combined a keen mind, sharp control, whistling fastball and sharp curve into 191 wins for the A's, six of them in five World Series—including a shutout in the 1905 Series, one of five pitched in that classic, three by Christy Mathewson. Bender faced Matty three times, head-to-head, in Series play, outpitching the Great One, allowing 16 hits to Matty's 21 and striking out 19 batters to Matty's 14. One of those who faced Bender's offerings was New York Giant leadoff batter Josh Devore, who could only marvel at Bender's fastball and say, "The Chief makes the baseball look like a pea. Who can hit a pea when it goes by with the speed of lightning?" Described by Giant catcher Chief Meyers, himself a fellow Native American, as "one of the nicest people you'd ever meet," Bender possessed a strength of pride that rivaled his strength on the mound and would greet the jibes of those who razzed him about his ancestry with a smile and return the compliment, calling them "foreigners." Bender retired in 1918, but would continue in the game for another 35 years as coach, manager and scout, including a year as player-manager for Richmond in the Virginia League, when he posted a 29-2 record.

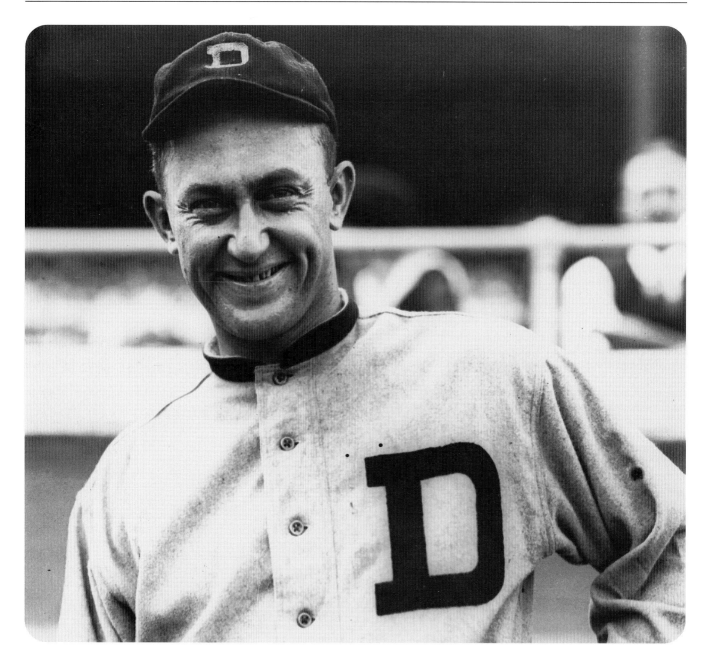

32. TY COBB *(Above)* **[Tyrus Raymond Cobb; "The Georgia Peach"; OF; 1905–28*; DET (A), PHI (A)].** Simply stated, Ty Cobb was the most sensational player in baseball. Ever. Subscribing to the theory that baseball is not unlike a war, Cobb played the game with an acid soul, endless spite and a burning rage. With every nerve exposed, Cobb waged a relentless war on the field and on the record books at the same time. His calling card was intimidation. He would sit in the Detroit Tiger dugout before the game sharpening his spikes. Or participate in that great baseball tradition of bench jockeying, pointing out defects in his opponents' spiritual makeup and liberally adding references to their ancestry. In the batter's box, Cobb, resembling a slight tuning fork, would crouch over the plate in a lefthanded stance, his hands a few inches apart on the bat, like a little kid holding up his hands while his grandmother winds the wool, all the better to control both bat and ball. Still, even Cobb would admit that he was never more than a natural .300 hitter. It was his speed and his daring that allowed him to beat out bunts and scratch hits and add another 50 points or so to his average. Combining his speed, daring and ability, Cobb staked out more claims to records than an Alaskan claim jumper, including more batting titles (12), highest career batting average (.367), more consecutive .300 seasons (23), most runs scored (2,245), et cetera, et cetera, et cetera. When he retired after 24 seasons—with, as he said, "many more hits left in my bat"—he had staked his claim to 93 records overall. But of all of Cobb's many achievements, the one he prided himself on most was the number of runs he scored. As Grantland Rice wrote, "Lord! How he concentrated on runs." And so, one night about a dozen years after he had retired, he was at the Detroit Athletic Club with Nig Clarke, the old Cleveland catcher. Talk begot more talk, and Clarke mentioned his patented act of rapidly tagging a man and immediately throwing his glove aside, signaling the third out. At that, Clarke laughed, "I missed many a runner who was called out. I missed you at least ten times at the plate, Ty." And that was all he got out, as his boast loosed the Tiger. Cobb, coloring up like an old gobbler, the cords tightening on the back of his neck, lunged at Clarke and began choking him. "You cost me ten runs—runs I earned," screamed the irate Cobb. There were strings in Cobb's heart that were better not to vibrate. And few tried during the twenty-four-year career of the most dominant—and sensational—player ever to play the game.

33. MILLER HUGGINS *(Below)* **[Miller James Huggins; "Hug," "The Mighty Mite"; 2B; 1907–27*; CIN (N), STL (N)].** Only five feet six inches tall and rumored to weigh only 140 pounds, little "Hug" played as tall as any second baseman in the first two decades of the twentieth century, leading the National League in walks four times in his leadoff position and finishing among the league leaders in runs scored in most of his 13 years playing for nondescript second division teams. In the field he was fast and sure-handed, leading the league at least once in each of the fielding categories: putouts, assists, double plays and fielding average. The cornerstone of his fame, however, rests on his managerial accomplishments. For Huggins shaped the careers of such future greats as Rogers Hornsby, Lou Gehrig, Tony Lazzeri, Earle Combs, Bob Meusel and Herb Pennock, and shaped the destiny of the New York Yankees, turning the perennial losers of the teens into the mighty "Murderers Row" of the twenties, winning six pennants and 1,067 games in a Yankee uniform.

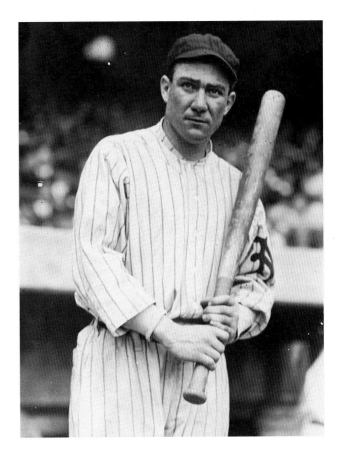

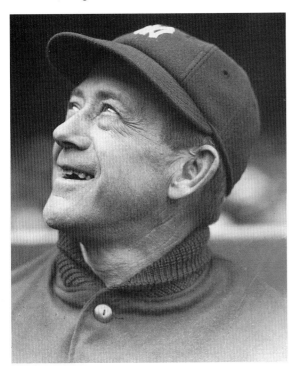

34. LARRY DOYLE *(Above)* **[Lawrence Joseph Doyle; "Laughing Larry"; 2B; 1907–20; NY (N), CHI (N)].** From the very first day he reported to the New York Giants as a callow 20-year-old, Larry Doyle became a fixture at second base. A favorite of John McGraw, Doyle responded with his famous "It's great to be young and a Giant"—and with his bat, leading the National League in triples once, in doubles once and in batting once, in 1915, when he hit .320 for the last-place Giants. However, during his 13 years with the Giants he was an important part of a team that won three National League pennants and finished second six other times.

35. BUCK HERZOG *(Right)* **[Charles Lincoln Herzog; "Charlie"; IF; 1908–20; NY (N), BOS (N), CIN (N), CHI (N)].** More dangerous in warfare than the most terrible Turks, Buck Herzog was the epitome of aggressiveness both on the field and off. A member of baseball's most talented pledge class, the class of the 1908 New York Giants—which included Larry Doyle, Art Fletcher, Fred Merkle, Otis Crandall and Fred Snodgrass along with Herzog—Herzog would play with the Giants three times during his 13-year career, returning, almost as if at one end of a rubber band to plug up some hole or other in John McGraw's infield. During his second tenure with the Giants, Herzog became a member of the quicksilver team that stole a record number of bases, 347 of them, contributing 22 in half a season of play. It was during his third tenure that the quick-tempered Herzog engaged in his most celebrated moment, a knock-down, drag-out fight with Ty Cobb in a Dallas hotel room during spring training, 1917. The fight was really no fight at all, with Cobb scoring a two-punch knockout, but it added to Herzog's notoriety. In the World Series that year, McGraw, a field general who always seemed to have his finger on the pulse of the game, confided to veteran sportswriter Fred Lieb that Herzog had sold him out by "consistently playing out of position for White Sox hitters." Unable to prove anything, McGraw filed no charges, but sent Herzog packing, this time for good. Herzog wound up his career with the Chicago Cubs, whence he was mustered out of the majors in baseball's giant housecleaning in 1920 after the "Black Sox" scandal.

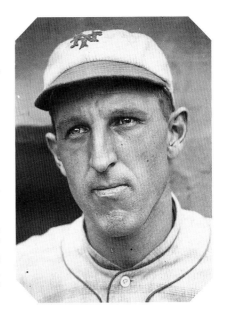

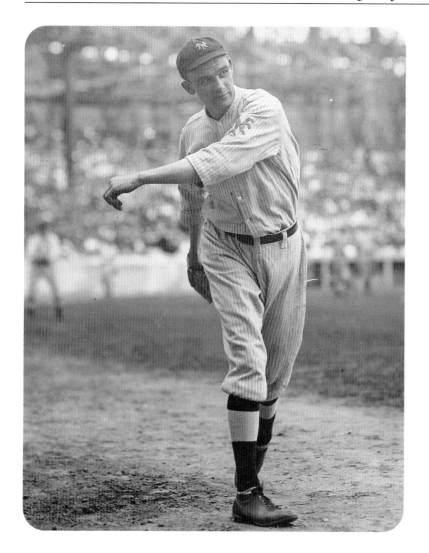

36. RUBE MARQUARD *(Above)* **[Richard William Marquard; P; 1908–25*; NY (N), BKN (N), CIN (N), BOS (N)].** Bought by the Giants in 1908 for the unheard-of price of $11,000, Rube Marquard was heralded by the press as the "$11,000 Beauty." But the injury-riddled Giants had been willing to pay that much to Indianapolis—where the star pitcher had won 28 games— to shore up their threadbare pitching staff. In a season known for the "Merkle Boner" (see photo 38), the Giants, with a pressing need for pitching help of any kind, threw Marquard into the pennant race, manager John McGraw telling his rookie to "go in and pitch" the second game of a doubleheader against Cincinnati. Marquard, worried whether "McGraw had picked up a gold brick with the plating on it very thin," made his weary way to the mound and prompt-ly plunked the leadoff man in the ribs. The next man up, Hans Lobert, tripled and, as he reached third, hollered, "You're identified, you're a busher!" Five innings, six hits and two walks later, to the cries of "Take him out!" Marquard was gone, the "$11,000 Beauty" now the "$11,000 Lemon." After two more years of mediocrity, McGraw turned his by-now sour phenomenon over to coach Wilbert Robinson. Marquard responded with a 24–7 record in 1911 and led the league in winning percentage and strikeouts. Then, in the Fall Classic of that year, the man called "Rube" (because of his resemblance to another lefty, Rube Waddell) helped give rise to another nickname, that of "Home Run" Baker, as Frank Baker of the Athletics caught one of Marquard's fork balls squarely on the meat end of his bat and drove it over the right field fence. But the brilliant and brilliantined Marquard rode his fork ball and control to a league-leading 26 wins the next year, 19 of those wins constituting a major league record of 19 consecutive wins (which would have been 20 under current rules; he relieved in a game with the Giants behind, won in the ninth by New York). Marquard joined the Dodgers and rejoined Robinson in 1915, helping Brooklyn to two pennants as he turned his label back into "$11,000 Beauty."

37. FRED SNODGRASS *(Opposite, top)* **[Frederick Charles Snodgrass; "Snow"; OF; 1908–16; NY (N), BOS (N)].** A feisty, aggressive player, Fred Snodgrass was one of that breed of player back in baseball's "deadball" era who would do anything, anything, to get on base—up to and including getting hit by a pitch. As he told historian Larry Ritter, "I used to lead the league in that. I had baggy uniforms, a baggy shirt, baggy pants—any ball thrown close inside, why I turned with it and half the time I wasn't really hit, just my uniform was nicked. Or the ball might hit your bat close to your hands and you'd fall down on your belly, and while you were down you'd try to make a red spot by squeezing your hand or something. If you had a good red spot there, the umpire might believe it hit you and off you'd go to first base." Snodgrass pulled his "trick" twice in the 1911 World Series, hit by pitches in the first and second games. But he is best remembered not for his abil-ity to turn a baggy uniform into bases but instead for his inability to turn his baseball glove into a catch, the infamous "$30,000 Muff" in the final game of the 1912 World Series. The play, which would forever mark him as one of the all-time Series "goats," occurred in the bottom of the tenth with the Giants ahead, by virtue of a run in the top of the inning. With God in His heaven and Christy Mathewson on the mound, the Giants looked like sure winners. But the Fates, jovial plotters against anything "sure," placed their fickle hands on the strings—and on Snodgrass' glove—and pulled. For the Red Sox leadoff batter in the bottom of the tenth, one Clyde Engle, lifted a high fly to Snodgrass in center field, a "can of corn" in the terminology of the day. But, as Snodgrass waved the other outfielders away and camped under it, the ball hit the heel of Snodgrass' glove and trickled off, Engle making it all the way to second. And even though Snodgrass raced to the farthest reach-es of center field to haul in Harry Hooper's line drive on the next pitch, Mathewson, still unsettled by Snodgrass' earlier "muff," walked the next bat-ter, Steve Yerkes, on four pitches, to put the poten-tial winning run on. Into the batter's box strode the fearsome Tris Speaker, who drove one of Matty's fastballs over first, scoring Engle and moving Yerkes over to third. After walking the next batter, Duffy Lewis, Matty gave up a long sacrifice fly to Larry Gardner to score the Series-winning run. New York sportswriters, echoing Hughie Fullerton's claim that "the world championship belongs in New York and Boston is perfectly aware of it," did everything possible to protect Mathewson, tying the can to Snodgrass' tail and making him the scapegoat for the loss. So much so that for the 1912 Christmas season one New York furrier came out with a line not of Snodgrass' baggy uniforms but of "Snodgrass Muffs."

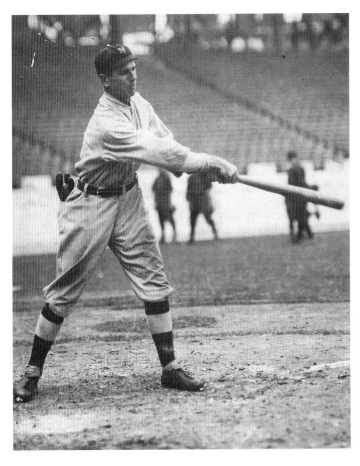

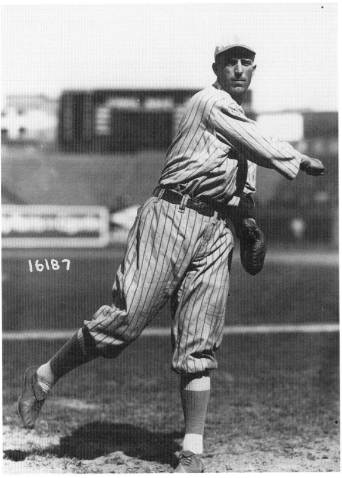

38. FRED MERKLE *(Left, bottom)* **[Frederick Charles Merkle; 1B; 1907–20, 1925–26; NY (N), BKN (N), CHI (N), NY (A)].** When baseball's camp followers hunker around the glowing embers to recount some of the game's greatest moments, the name Fred Merkle and his momentary lapse—forever called "Merkle's Boner"—will be part of the story-telling. How did one moment come to define the career of a man who played for 16 seasons, had a lifetime .273 batting average and played for six pennant winners? Return now to those thrilling days of yesteryear—and of loosely construed rules. The year was 1908 and the New York Giants, Merkle's team, were in a three-team race with the Pittsburg(h) Pirates and the Chicago Cubs for the pennant that would go down to the wire. And beyond. In a late-season game between the Cubs and the Giants, with the Giants at bat in the bottom of the ninth, the score tied at one-all and Moose McCormick on first with two outs, Merkle, then in but his second year in the majors, came to bat. Merkle singled, moving McCormick over to third and bringing up Al Bridwell, who drilled Cub pitcher Jack Pfiester's first pitch on a line past Cub shortstop Johnny Evers and out into right center field. As the ball streaked out toward center and McCormick crossed the plate with what looked like the winning run, all hell broke loose as the action spilled out onto the field. The players on the Giants' bench, having had their fill of being trampled by surging crowds in games before, began their traditional sprint to the clubhouse to stay one step ahead of the by-now jubilant crowd. Merkle, waiting only long enough to see McCormick cross the plate, took off with the rest of his teammates in the direction of the clubhouse, not in the direction of second. However, here Fate—and Johnny Evers—stepped in. For Evers, having witnessed Merkle take off and fail to touch second, began to jump up and down at second, calling for the ball. Somehow, someway, somewhere, in the surge of humanity, center fielder Solly Hofman exhumed the ball and threw it to Cubs third baseman Harry Steinfeldt who, in turn, threw it to shortstop Joe Tinker who ladled it over to Evers who triumphantly stepped on second. Umpire Hank O'Day, who had overruled a similar protest by Evers just a few weeks before, this time was primed for the situation and called Merkle "out" on a force play, negating both the run and the win. Despite protests by the Giants, O'Day's decision stood and necessitated a one-game playoff between the same two teams at the end of the season. This time the Cubs won 4-2, and with it the pennant—and left Fred Merkle forever belled with his baserunning "boner."

39. CHIEF MEYERS *(Right)* **[John Tortes Meyers; C; 1909–17; NY (N), BKN (N), BOS (N)].** A Mission Indian from California, John Tortes Meyers attended Dartmouth, dropping out to play organized ball for the Harrisburg club in the Tri-State League, where his manager, the great Billy Hamilton, told him to "put the stuff on" and turned him into a catcher. Coming to the majors at the advanced age of 28, Meyers replaced the popular Roger Bresnahan behind the plate and by 1910 was a regular member of the great New York Giants teams that won three pennants in the next four years. Meyers caught almost every game Christy Mathewson pitched for the seven years between 1909 and 1915. Meyers, according to Matty, "understands my style so well that in some games he hardly has to give me a sign." Ironically, Meyers could not catch Bugs Raymond, who threw a spitter, and they rarely, if ever, worked as a battery. Meyers was a righthanded hitter who ofttimes pushed the ball to right. During his six straight years as a 100-game catcher, Meyers batted .302, his .358 in 1912 being a full 100 points higher than the rest of the 15 starting catchers in the majors and second-highest in the National League—and was the highest batting average by a modern catcher until Bill Dickey eclipsed it in 1936. In the famed "Snodgrass Muff" World Series of 1912, Meyers continued his batting heroics, hitting .357. At age 35, Meyers caught 110 games for the Giants and then, in 1916, was sent to the Dodgers on waivers, where he helped Brooklyn win its first pennant. But as Meyers himself put it, "Once a Giant, always a Giant."

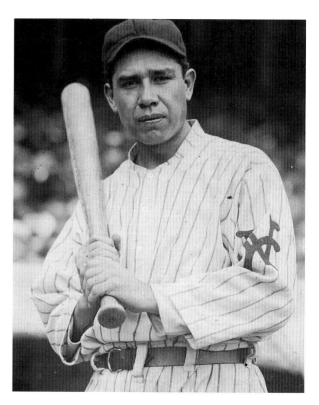

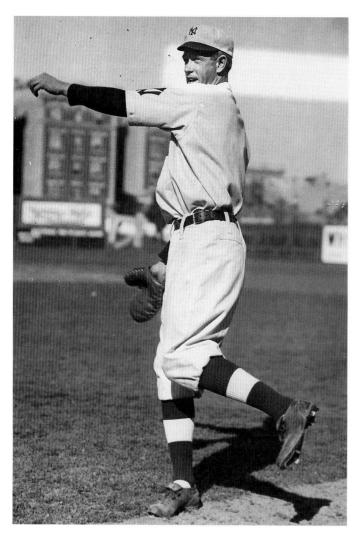

40. HAL CHASE *(Left)* **[Harold Homer Chase; "Prince Hal"; 1B; 1905–19; NY (A), CHI (A), BUF (F), CIN (N), NY (N)].** Baseball has disgraced no man. Unfortunately, some men have disgraced baseball—none more so than Hal Chase. Chase was a brilliant, lefthanded-fielding, righthanded-hitting first baseman with few peers as a fielder. It was suggested by many that Chase thought lefthanded as well. His "corkscrew mind," it was widely hinted, perfected the fine art of throwing baseball games as easily as he threw to second. Chase had started his career as a youth in the outlaw leagues of California and fallen in with gamblers, an association he was to share for the remainder of his career. That career saw him play eight-plus years for the New York Highlanders—even managing them for a little over a season after he had personally engineered shoving Highlander manager George Stallings off the managerial gangplank. But, despite his shortcomings, Chase gained a reputation as the finest-fielding first baseman in the majors. This made his many errors—leading the AL in errors seven times and setting the AL career mark for errors—all the more inexplicable. Chase was hardly a team player, and, when the Federal League formed in 1914, he jumped quicker than a claim jumper, seeking to gain his fortune with the new league. He also gained a reputation for skulduggery. And when the Federal League disbanded, no American League team would touch him. But the Cincinnati Reds bought his contract for the 1916 season and, even though manager Christy Mathewson suspected his shenanigans, Chase would go on to win the 1916 NL batting title with a .339 average, the only lefthanded-throwing, righthanded-hitting batter ever to do so. After two years and many hearings into his nefarious activities, Chase wound up with the New York Giants, where he would spend his last year in organized ball laying the groundwork for the infamous Black Sox fix in that year's World Series. At the end of the 1919 season, Chase was silently mustered out of baseball for "unspecified reasons." He returned to his native California, where, for the remaining 28 years of his life, he kept to himself just as he had on the field, keeping his secrets as well.

41. BILL McKECHNIE *(Below)* [**William Boyd McKechnie; "Deacon"; IF; 1907, 1910–18, 1920*; PIT (N), BOS (N), NY (A), IND (F), NWK (F), NY (N), CIN (N)**]. Despite having what might best be described as a second-rate major league career (seven teams, 11 years, a lifetime .251 batting average), Bill McKechnie possessed a first-class baseball mind, one he used as a manager for 25 years and 3,647 games. McKechnie's potential was first recognized by then Highlander manager Frank Chance who, when asked why he selected a .134 utility infielder to sit next to him on the bench, replied, "He's the only son-of-a-sea-cook on this club who knows what it's all about. Among this bunch of meatheads, his brain shines like a gold mine." Combining his knowledge of the game with a kindly, fatherly compassion and an understanding of defensive baseball, especially pitchers, McKechnie set a major league record by taking three different clubs to National League pennants: the 1925 Pittsburgh Pirates, the 1928 St. Louis Cardinals and the 1939–40 Cincinnati Reds.

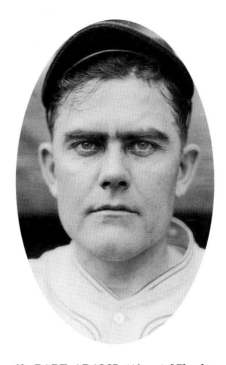

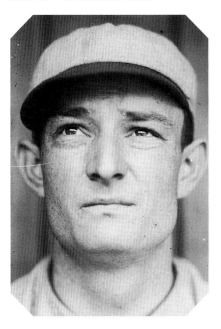

42. BABE ADAMS *(Above)* [**Charles Benjamin Adams; P; 1906–7, 1909–16, 1918–26; STL (N), PIT (N)**]. Still a rookie despite having been up for two cups of coffee and three losses in two previous seasons, Babe Adams was given the ball for the first game of the 1909 World Series to pitch against the feared Detroit Tigers. He more than acquitted himself with a six-hitter, winning 4-1. Five days later he came back to throw another six-hitter and win a second time, 8-4. And then, on two days' rest, he threw yet another six-hitter and shut out the Tigers for his third Series victory in the seventh and deciding game, the first pitcher to win three games in a seven-game Series. Over the course of his 27 innings Adams had allowed just six bases on balls, more than the normal quota for a man who would allow just 430 during a 19-year career in which he pitched almost 3,000 innings. In fact, Babe Adams is the all-time, all-time leader for allowing the least number of walks per nine innings in a season, just 18 in 263 innings in 1920 for a percentage of .62. He still ranks in the top ten among all-time Pirate pitchers in wins, games, innings pitched and strikeouts, and leads in all-time shutouts with 47. Adams would end his career almost where he started—except for one appearance and loss for the Cardinals in 1906—with the Pirates. Sixteen years after his first appearance in a Series, Adams appeared as a 43-year-old relief pitcher in the 1925 World Series, giving up no runs and, not surprisingly, no walks in the fourth game.

43. HARRY HOOPER *(Below)* [**Harry Bartholomew Hooper; OF; 1909–25*; BOS (A), CHI (A)**]. One-third of the famed "Million Dollar Outfield," along with Tris Speaker and Duffy Lewis, Hooper was the leadoff batter of four Red Sox World Series–winning teams. One of the best-fielding right fielders of all time, Hooper introduced the rump slide, allowing him to grab short flies and block those he could not reach. He also introduced sunglasses into baseball, using them to play Fenway's difficult sun field. In the 1912 World Series he made one of the greatest catches in baseball history—a barehanded catch of Larry Doyle's drive to deep right as the ball was going over the fence, to save the game, and the Series, for the Red Sox. But perhaps his greatest contribution to baseball came when he persuaded general manager Ed Barrow to play the best lefthanded pitcher in baseball, Babe Ruth, in the outfield on an everyday basis.

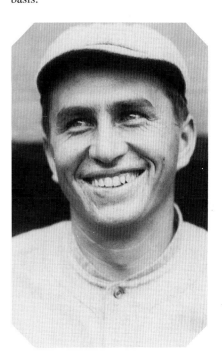

44. CLYDE MILAN *(Right)* **[Jesse Clyde Milan; "Deerfoot"; OF; 1907–22; WAS (A)].** The story of Clyde Milan begins in 1907 with a little-known catcher named Cliff Blankenship who played for an even lesser-known group of athletes called the Washington Senators. All season long Washington manager "Pongo" Joe Cantillon had been bombarded with letters from a traveling salesman extolling the virtues of a semipro pitcher from "Idaho's Snake River Valley League" named Walter Johnson. Finally, after consigning many of these letters to his filing cabinet–hyphen–waste receptacle, and with Blankenship, who had been injured, just sitting around waiting for his bones to mend, Cantillon pressed his disabled catcher into duty to take a look-see at the phenomenon. And just so the scouting expedition shouldn't be a total waste, Cantillon gave his catcher-scout further instructions to continue his scouting odyssey to Wichita to "look in on" a young outfielder then leading the Western Association in batting and sign him "if he doesn't come too high." And so Blankenship made one of the most successful scouting trips in baseball history, bringing back both Johnson and Milan—who would not only report to the Senators that 1907 season, but become roommates and stay roomies for the next 16 years. While Johnson would go on to lead the American League in ERA and strike-outs by 1912, winning 32 games for the by-now competitive Senators, Milan would become the AL's leading base stealer, his 88 thefts in 1912 breaking the record of 83 set the previous season by Ty Cobb. Milan was faster than Cobb or Eddie Collins or Tris Speaker or any other base stealer in the first part of the twentieth century, as a player nicknamed "Deerfoot" should be, and the next season stole another 75 to lead the league again. His 495 total career thefts ranks him 15th on the all-time leader list, behind only Cobb and Collins among the early American League base stealers. Milan also used his exceptional speed in center field and was as durable as he was fast, setting an American League record for outfielders by playing in 511 consecutive games from 1910 through 1913.

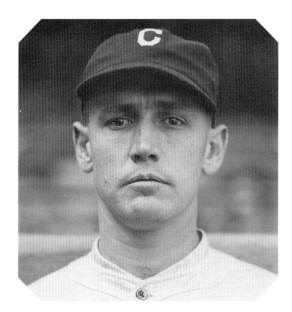

45. SMOKY JOE WOOD *(Above)* **[Joe Wood; "Smoke"; P; OF; 1908–15, 1917–22; BOS (A), CLE (A)].** The year was 1912, the Year of the Pitcher, and Rube Marquard was on his way to winning 19 straight in the National League and over in the American Walter Johnson had just won 16 in a row. On the day that Johnson, considered by anyone who had ever seen him—and some who had just heard his pitches go by—to be the fastest pitcher in baseball, was outdueled by a youngster on the Boston Red Sox staff named "Smoky" Joe Wood, 1-0, for Wood's fourteenth consecutive win, he was asked one of those improbable questions newsmen were fond of asking even back then. Johnson rephrased it by answering, "Can I throw harder than Joe Wood? Listen, my friend, there's no man alive who can throw harder than Smoky Joe Wood." And so it seemed as the 22-year-old with the baby face—so baby-faced, in fact, that he had started his playing career six years before pitching for the early female team the Bloomer Girls—posted numbers that could stand up against those registered by any pitcher in history: 34 wins and only five losses; 16 wins in succession; 35 complete games; 258 strikeouts; 10 shutouts; a 1.91 ERA; and an .872 won-lost percentage, a record that was to stand for another 19 years. His three World Series wins that fall is another record that has been tied, but never broken. On the cusp of greatness, Wood slipped on the grass in an early-1913 game, breaking the thumb on his pitching hand. Never again would he be able to throw his hummer with the hop on it with the same velocity Johnson had seen on the afternoon he had said, "there's no man alive who can throw harder than Smoky Joe Wood." Nor could he throw anything without excruciating pain in his shoulder. He led the American League again in won-lost percentage in 1915, winning 15 while losing only five, but he pitched only half a season, sometimes waiting three weeks between starts. Constantly in pain and frustrated, Wood called it quits at the still-tender age of 25. Two years later, after contacting his ex-roomie, Tris Speaker, who by now was with the Cleveland Indians, Wood essayed a comeback. But all he got for his efforts was one start and five appearances. Then, in 1918, with the ranks of the majors depleted by the Great War, Wood got a second chance, this time as an outfielder. In one early-season game against the Yankees, he hit two home runs, the second coming in the 19th inning to win the game. And from that day on and for the next five years, Wood played in the outfield for the Indians, hitting .298 in his second career.

46. HIPPO VAUGHN *(Below)* **[James Leslie Vaughn; "Jim"; P; 1908, 1910–21; NY (A), WAS (A), CHI (N)].** The relatively unattractive handle of "Hippo" was affixed to Vaughn as much for his size, six feet four inches, 215 pounds, as for his ungainly style of running. But "Hippo" Vaughn didn't make it on his running, but on his pitching, which for six seasons was overpowering. The workhorse of the Chicago Cubs staff, Vaughn averaged almost 292 innings a season between 1914 and 1919, twice leading the National League in innings pitched. He pitched with quality as well as quantity, five times winning 20 or more games—and another time, 19—and leading the league twice in strikeouts and once in shutouts, ERA and most wins. His best year was the war-shortened season of 1918—when the World Series started on September 5th because of the war restrictions. During that 129-game season, Vaughn won pitching's "Triple Crown," leading the National League in most wins (22), best ERA (1.74) and most strikeouts (148). He also led the league in most innings pitched and in shutouts, with eight. But Vaughn is best remembered for a game he *didn't* win. For on May 2, 1917, pitching against Fred Toney of the Cincinnati Reds, Vaughn pitched a no-hitter against the Reds. Only trouble was Toney returned the favor, also pitching one against the Cubs. And so the double no-hitter went into the tenth inning when, after Vaughn had retired the first man up, he gave up a single to Reds' shortstop Larry Kopf, followed by a two-base error and a slow roller back to Vaughn hit by the speedy Reds' outfielder, Jim Thorpe, that scored the only, and winning, run in baseball's only double no-hitter.

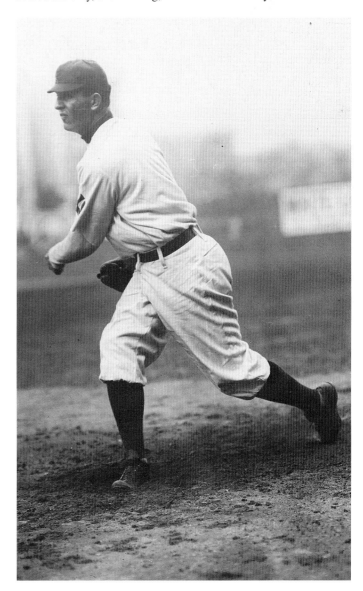

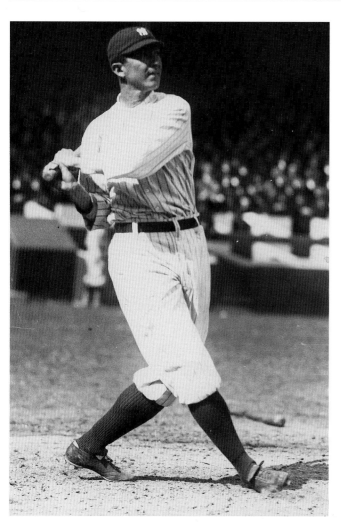

47. FRANK BAKER *(Left)* [**John Franklin Baker; "Bake," "Home Run"; 3B; 1908–14, 1916–19, 1921–22*; PHI (A), NY (A)**]. Before the 1911 World Series, this lefthanded batter with the muscular wrists, arms and shoulders was known simply by his abbreviated nickname, "Bake." But the 1911 Series would forever label him as "Home Run" Baker. Baker had led the American League in home runs that year—the first of four consecutive seasons he would lead the American League in that department—and was considered one of the few long-ball threats in baseball in an era when a long ball was a triple, not a home run. In the second game of the Series, against Rube Marquard, Baker caught one of Marquard's fastballs on the meat end of his bat and drove it, on a line, over the right field wall, putting the A's ahead 3-1 and ending the scoring for the afternoon. The next morning the New York *Herald* carried an article under the byline of Christy Mathewson which read, in part, "Marquard made a poor pitch to Frank Baker on the latter's sixth-inning home run. There was no excuse for it. In a clubhouse talk with his players, Manager McGraw went over the entire Athletics' batting order, paying special attention to the lefthanded hitter, Frank Baker. We had scouted Baker, knew what pitches were difficult for him to hit, and those he could hit for extra bases. Well, Rube threw him the kind of ball that Baker likes." That afternoon Mathewson the author was to become Mathewson the pitcher, and he would have a chance to show Marquard how to pitch to Baker. Through the first eight-and-a-third innings, Matty shut down the A's on five hits and was just two outs away from a 1-0 victory. But now he found himself face-to-face with the subject of his article that very morning: Frank Baker. Behind two-and-one, Matty laid in the next one, a curve that "cut the plate better than I intended," and the next sound he heard was not unlike that of surf cracking sand as the ball took off for the right field stands. Baker had done it again, this time skewering the Great Matty. On the basis of those two home runs in the 1911 Series, Frank Baker had taken his bat and had dubbed himself, for all time, "Home Run" Baker, becoming, in the process, baseball's first home-run idol.

48. JACK BARRY *(Right)* [**John Joseph Barry; "Black Jack"; SS; 2B; 1908–17, 1919; PHI (A), BOS (A)**]. Signed by Connie Mack right off the Holy Cross campus, Jack Barry almost immediately became part of the fabled Philadelphia Athletics' "$100,000 Infield," consisting of Barry at short, Home Run Baker at third, Eddie Collins at second and Stuffy McInnis at first. And although not as celebrated as the other members of what many baseball historians call the greatest infield in history, Barry's steady play won him a place in the hearts of A's fans and a place on Connie Mack's all-time Athletic team as its shortstop. For six-plus years Barry played a steady game at short and provided many a clutch hit from his seventh place in the batting order, helping the A's win four pennants and three World Series in five years. John McGraw, whose New York Giant teams lost two of those Series to the A's, rated the A's double-play combination of Barry and Collins as better than their more famous National League counterparts, Joe Tinker and Johnny Evers. After the A's were swept in the 1914 Series by the Boston Braves, Mack cleaned house, selling Barry to the Boston Red Sox where he helped the Red Sox win two more World Series. Barry retired in 1919 to become the coach at his alma mater, Holy Cross, where he served for over three decades becoming, in 1952, "College Coach of the Year."

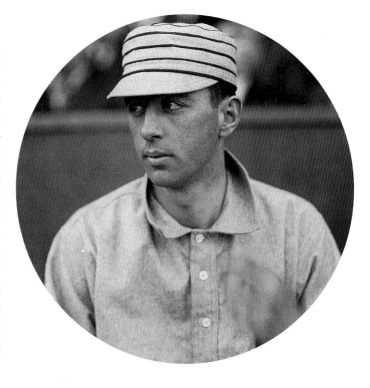

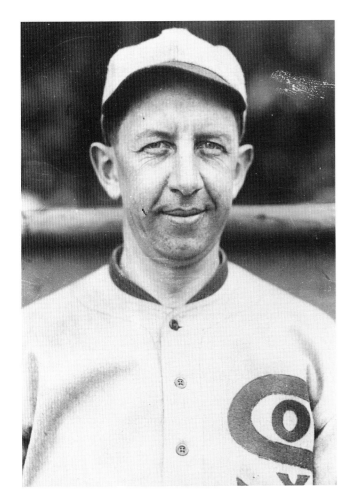

49. EDDIE COLLINS *(Above)* [**Edward Trowbridge Collins; "Cocky"; 2B; 1906–30*; PHI (A), CHI (A)**]. One of the best ever to play the game, Eddie Collins played it well enough for twenty-five years, twenty as a regular—the longest active career in American League history—to be called by many, including his longtime rival, Ty Cobb, "the greatest second baseman of all time." Confident of his abilities (hence his nickname, "Cocky") and capable of winning a game in the batter's box, on the base-paths, in the field or even on the bench (as one of baseball's best sign-stealers), Collins was the centerpiece of Connie Mack's famed "$100,000 Infield," high praise indeed when measured in terms of pre–World War I dollars. Between 1910 and 1914, Collins was the leader of a Philadelphia A's contingent that won four pennants and three World Championships in five seasons. Devastated by the loss of his team to the Boston Braves in the 1914 World Series and faced with defections by many of his stars to the upstart Federal League, Mack disbanded his great team, sending Collins to the Chicago White Sox after the '14 season for the then-unheard-of sum of $50,000. Collins, without missing a beat, picked right up where he had left off, leading the Sox to two pennants and one World Championship. Known as a slashing lefthanded batter who excelled in the bunt, the sacrifice, the hit-and-run and base stealing (he led the league in stolen bases four times, the last at age 37), Collins was equally adept in the field, leading the league's second basemen in fielding nine times. He was also known for a strange quirk he had, of placing his chewing gum on the button atop his cap while in the batter's box. A lifetime .333 hitter, Collins had the highest hit total, 3,311, for a player who never led his league in batting—finishing second to Ty Cobb three times and in the League's top five batters ten times, the last two in the "live ball" era, proving Collins was one of the best in any era.

50. STUFFY McINNIS *(Below)* [**John Phalen McInnis; 1B; 1909–27; PHI (A), BOS (A), CLE (A), BOS (N), PIT (N), PHI (N)**]. In those antediluvian days before the "Golden Glove" awards were made to the best fielders at each position, one man came with his own golden glove: Stuffy McInnis. Wearing the small glove of his era, unlike the butterfly nets of today, McInnis set still-standing fielding records for major league first basemen by making only one error in 152 games for the 1921 Red Sox; accepting the most consecutive chances without an error, 1,700, from May 31, 1921, through June 2, 1922; going the most consecutive games without an error, 103; and tying the all-time record for most chances accepted in a game, 22. But McInnis' real claim to fame was anchoring the great Philadelphia Athletics' "$100,000 Infield," which won four pennants in the five seasons between 1910 and 1914. Playing alongside Eddie Collins at second, Jack Barry at short and Frank "Home Run" Baker at third, McInnis, replacing the popular Harry Davis at first, batted .321 over those five years and led American League first basemen in fielding for two years. With A's owner Connie Mack forced to dismantle his great team, McInnis was peddled to the contending Boston Red Sox in 1918—the last regular dealt off by Mack, just as first baseman Jimmie Foxx was the last player dealt away by Mack the second time he broke up his winning team in the '30s—where he helped the Red Sox win the pennant and the last World Series they ever won. Seven years and several fielding records later, McInnis was picked up by the Pittsburgh Pirates as first base and first-place insurance and batted .368 to help the Pirates win the National League pennant. Then, playing in four games in the Series, he hit .286 to help Pittsburgh win its first Series since 1909—and its last until 1960.

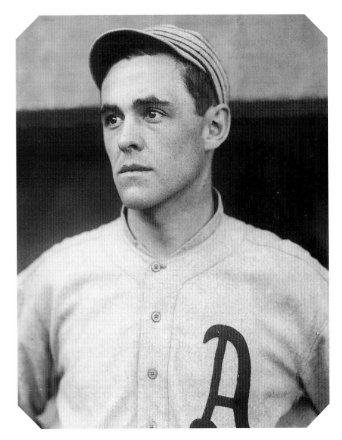

51. JIMMY AUSTIN *(Below)* **[James Philip Austin; "Pepper"; 3B; 1909–23, 1925–26, 1929; NY (A), STL (A)].** Exiting the cranky old elevator at the old-old *Sporting News* offices in downtown St. Louis in the long ago, a visitor would have his attention grabbed by one of the most famous pictures in baseball history, a blowup of Ty Cobb roaring into third, face contorted, teeth bared, his left shoulder knocking the pins out from under a third baseman who was in the process of both dropping the ball and falling on his *keister*. The party of the second part in the picture was Jimmy Austin, one of the stellar third basemen in the American League at the time of his on-the-field meeting with Cobb. Austin had had many such meetings with Cobb, who fully believed, in his own words, that "the basepath was mine," and recalled to author Larry Ritter one meeting previous to that depicted in the picture: "Ty was on first one day and Sam Crawford hit a single out to right field, on which Ty comes all the way around to third. I just stood there, nonchalant, as though nothing's happening. At the last minute here comes the ball as Ty is sliding in, and I grabbed it real quick and in the same motion pushed his foot off the bag as I tagged him. Well, the umpire called Ty out. Ty didn't move a muscle. Just lay there on the ground. Then he looked up at me and said, 'Mister, don't you ever *dare* do that again,'" But Austin, a real live pepperpot, called "The Pepperpot Kid" by his first manager, George Stallings, would dare anything. And frequently did. A nattering, chattering take-charge player, Austin came to the majors at the advanced age of 29-plus and played his last game when almost 50. In between, he made the so-called "Hot Corner" a little cooler for both the Highlanders and Browns, leading the American League five times in total chances per game, four times in double plays, twice each in putouts and assists and once in fielding average in the 11 years he played as regular. For three years he served as Branch Rickey's "Sunday Manager," Rickey turning over the managerial reins to Austin on the Sabbath to fulfill a youthful promise to his mother never to go near a ballpark on a Sunday. And once he managed on his own, in 1923, before spending ten years as a full-time coach and part-time player with the Brownies—where he played in one late-season game in 1929, handling two chances perfectly. But by then Cobb had already been gone from the scene for a year, so there was no chance of Austin's dropping one.

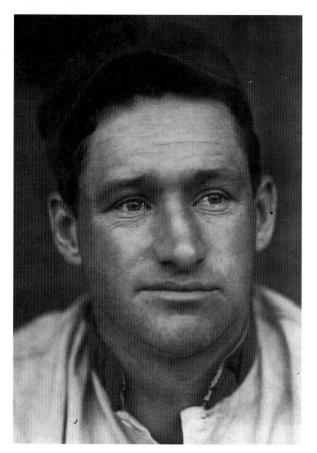

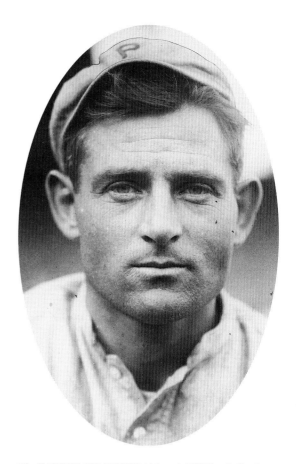

52. GAVVY CRAVATH *(Above)* **[Clifford Carleton Cravath; "Cactus"; OF; 1908–09, 1912–20; BOS (A), CHI (A), WAS (A), PHI (N)].** A crusty, tobacco-chewing, cussing player, Gavvy Cravath was the biggest bat in the so-called "deadball" era, six times leading the National League in home runs and setting the modern mark of 24 in a season in 1915—a record broken by Babe Ruth four years later. So dominant was Cravath that his league-leading total of 128 RBI's in 1913 and 115 in 1915 were 33 and 28 more than those of the runners-up in those two seasons, two of the largest differentials between a leader and runner-up in baseball history.

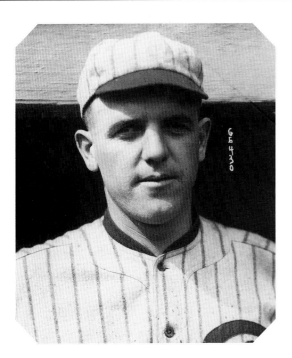

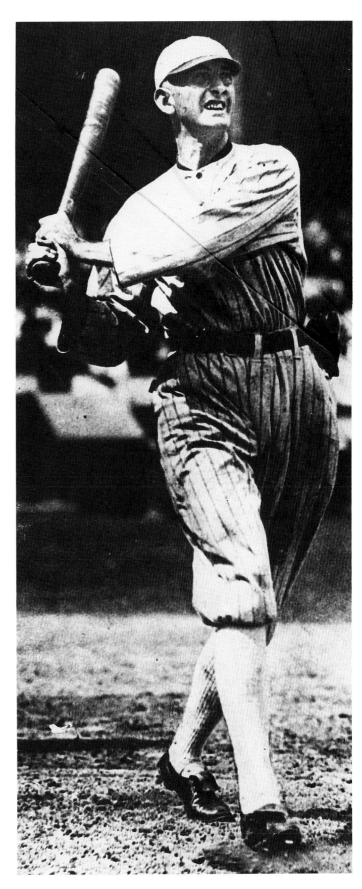

53. EDDIE CICOTTE *(Above)* **[Edward Victor Cicotte; P; 1905, 1908–20; DET (A), BOS (A), CHI (A)].** Eddie Cicotte was one of baseball's premier pitchers during the second decade of the twentieth century. With a deceptive array of pitches—including his famous "shineball," thrown after rubbing his fingers on a transparent paraffin coating on his trouser leg, causing the ball to break just as it reached the plate—and uncanny control, Cicotte won 162 games from 1910 through 1919, third on the decade's most-wins list behind all-time greats Walter Johnson and Grover Cleveland Alexander. However, his control mysteriously deserted him in the 1919 World Series when, as one of nine members of the infamous "Black Sox," he conspired to throw the Series to the Cincinnati Reds, beginning with his hitting the Reds' leadoff man, Morrie Rath, in the very first inning of the first game to signal that "the fix is in." Cicotte would later admit that "I played a dishonest game and lost." And, in so doing, lost a place of honor in baseball history—as baseball lost one of its great pitchers.

54. JOE JACKSON *(Right)* **[Joseph Jefferson Jackson; "Shoeless Joe"; OF; 1908–20; PHI (A), CLE (A), CHI (A)].** Here is baseball's most tragic figure. To say that Joe Jackson was not a Harvard graduate would be understating the case. Unable to read or write, Jackson often hid behind his shroud of ignorance, preferring instead to let his bats, all 18 of them, do his talking for him. And more than sometimes he talked back to them, treating them as if they were persons and giving each a pet nickname, such as "Black Betsy," "Old Ginril," "Big Jim" and "Caroliny." And each, at least according to Jackson, had certain virtues as well as certain shortcomings. But as a batter, Jackson himself had few shortcomings. A lefthanded hitter with perhaps the most fluid swing ever seen in baseball—and one that Babe Ruth admitted he copied—Jackson hit .408 in his very first full year in the majors and followed that with years of .395 and .373, down through his final year, when he batted .382. But that final year was to be final in more ways than one. For although Jackson had hit .375 in the 1919 Series—the top batting mark for both teams—he was found to have accepted $5,000 for his part in "throwing" the Series in the infamous "Black Sox" scandal. And, in so doing and being forever barred from the game, was indirectly responsible for adding the expression "Say it ain't so, Joe" to the language.

55. SWEDE RISBERG *(Below)* **[Charles August Risberg; SS; 1917–20; CHI (A)].** Although his playing career spanned only four seasons, Charles "Swede" Risberg left an indelible mark, a black one, on the game. Called by baseball writer Fred Leib "a shortstop with great range," the Swede's range extended far beyond the white lines into foul territory. Most foul. As early as Risberg's rookie year, 1917, rumors began circulating that everything on the field wasn't on the up-and-up; in fact, there were hints that some of the goings-on were downright dirty. And the team most often hinted at was the Chicago White Sox. By 1919 those rumors erupted into actuality as Risberg, acting as the lieutenant to the ringleader, Chick Gandil, conscripted six other members of the pennant-winning White Sox to form an unholy alliance with gamblers to throw the 1919 World Series. Risberg more than held up his part of the dirty bargain, playing with a palsied glove and a bat up for adoption as he batted .080 and made four errors to help the by-now-labeled "Black Sox" lose the Series to the Cincinnati Reds. When the scandal finally came to light the following season and eight "Black Sox" were indicted for conspiring to "fix" the Series, one of the conspirators, Joe Jackson, testified to the grand jury, "Risberg threatens to bump me off if I squawk. . . . And the Swede is a hard guy. . . ." Risberg far outranged his fellow conspirators in lifespan as well. The last surviving member of the "unholy octet," he remained hard and defiant to the end.

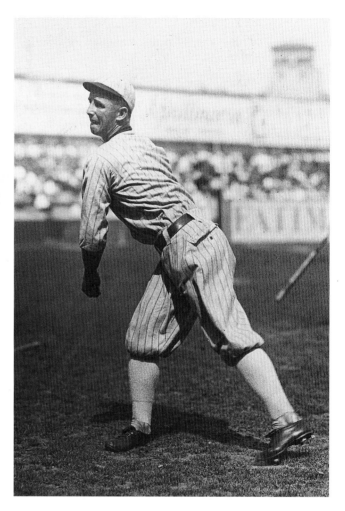

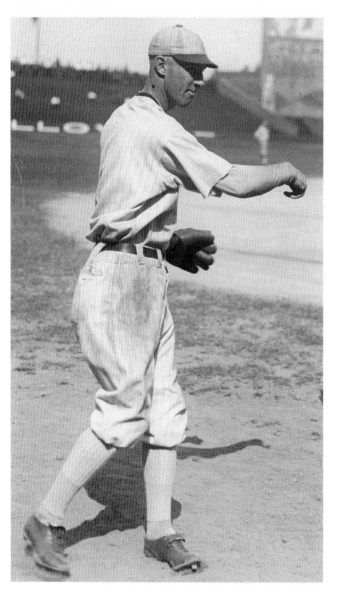

56. LEFTY WILLIAMS *(Above)* **[Claude Preston Williams; P; 1913–20; DET (A), CHI (A)].** Before the opening game of the 1919 World Series, Chicago White Sox manager Kid Gleason called a clubhouse meeting. Addressing the American League pennant winners, Gleason said, "Now, I've heard that some of you fellows have arranged to throw the Series." With that, the innocent players—later called "the lily whites"—all raised their heads with a "what-the-hell's-this?" look while, according to one of them, the players who would ultimately be charged with fixing the Series all kept their heads down. One of those who kept his head down, and should have, was pitcher Lefty Williams. During the 1919 season, Williams had started more games than any pitcher in the American League and won more than any left-hander. Moreover, Williams was known for his control, allowing fewer than two walks per game. And yet, obviously comforted greatly by a sack of cash under his pillow the night before the second game of the Series, Williams walked three Reds in one inning, the sixth, and then gave up a triple to their light-hitting shortstop, Larry Kopf, to lose 4-2, one of only four hits he gave up. Afterwards, while some White Sox fans murmured "Poor Lefty, the breaks just went against him," catcher Ray Schalk, one of the "lily whites," accused Williams of throwing the game. Williams came back to pitch the fifth game, again giving up just four hits, but again losing. And then, in the final game of the Series, this time threatened by gamblers that he'd be killed if he won—including some dark hints that he'd be gunned down on the mound—Williams again gave up four hits, this time to the first five men he faced before Gleason had seen enough and took him out. By the end of the next season, all of baseball and Commissioner Kenesaw Mountain Landis had seen—and heard—enough and took him out. Permanently.

57. HAPPY FELSCH (*Below*) [**Oscar Emil Felsch**; **OF; 1915–20; CHI (A)**]. To those few remaining souls who haven't keeled over under the weight of their memories and who recall seeing "Happy" Felsch play, he was a fun-loving ball player who could play the dickens out of center field—sharing records for most double plays by an outfielder in a season and assists in a game—and could hit with the best of them. But to most of the rest of us, and to history, he will always be remembered as one of the eight infamous "Black Sox" who threw the 1919 World Series. As he was to tell author Eliot Asinof years afterwards: "There was so much crookedness around, you sort of fell into it. I never believed it would happen . . . and the next thing we knew, we were all tied up in it." So tied up, in fact, that once in the grips of the gamblers Felsch threw several games during the 1920 season and was barred from baseball forever after.

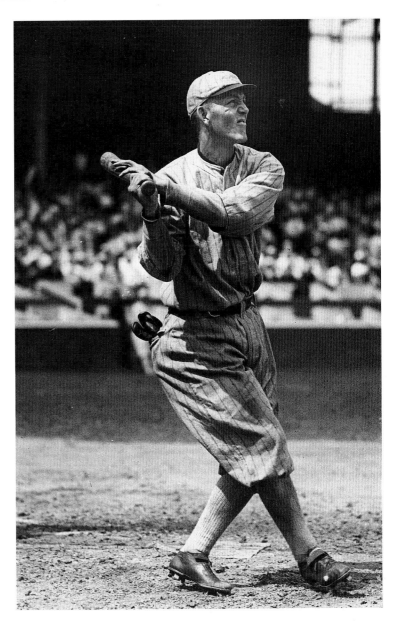

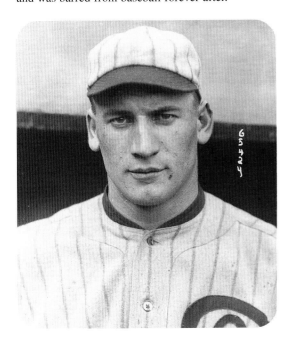

58. BUCK WEAVER (*Above, right*) [**George Daniel Weaver**; **3B; 1912–20; CHI (A)**]. The records of Buck Weaver, one of the most forgotten players in baseball, are pressed between the pages of the *Baseball Encyclopedia*—and his name pressed in the book of infamy. Unfairly, according to most of those at the time, the time being 1919. One of the best-fielding third basemen in the first two decades of the twentieth century, Weaver originally came up as a shortstop. But it didn't make any difference what position he played to veteran observer Fred Lieb, who wrote that Weaver was "an All-Star player whether he played third base or shortstop." By 1919 Weaver was poised for superstardom with a super team, the 1919 White Sox. With a cast of characters that included the likes of Weaver, Joe Jackson, Eddie Collins, Red Faber, Ray Schalk, Eddie Cicotte, Lefty Williams and Hap Felsch, the 1919 edition of the Sox was called by many the greatest team ever assembled. But a funny thing happened to the team on its way to immortality: the 1919 World Series. Well, not exactly funny; *tragic* might be the word the most punctilious wordsmith would use. For eight of the so-called "Black Sox" were found to have conspired with gamblers to throw the Series, and one of those so named was Weaver. But while Weaver had admittedly sat in on meetings with the gamblers, he had refused to go along with any "deals" and during the Series not only had 11 hits, the second-highest total of any player,

behind Jackson, but also the second-highest batting average of any player in the Series, .324, and had played flawless ball in the field. Nevertheless, the new Commissioner, Judge Kenesaw Mountain Landis, blacklisted him from baseball. Citing his play afield and supported by the Chicago District of the Masonic Brotherhood and its 20,000 members, Weaver demanded that he be allowed to continue at his livelihood. Landis called Weaver to his office in Chicago and said to him, "Buck, I'm going to ask you only two questions: Did you sit in on a conference with gamblers and dishonest players who thought of ways in which to throw the Series?" to which Weaver replied, "Yes, I did, Judge, but during the Series I played my best." Then Landis asked, "Three days before the Series there was another conference. Were you there?" Weaver again replied, "I did attend that meeting, Judge, but I played my best throughout the Series and I didn't get a penny out of it." The Judge responded, "If you attended two such meetings, you knew everything that was going on. And if you did not so inform your club, I hold you as guilty as the actual plotters and the men who took money for throwing the Series." And with that, Judge Landis rang down the curtain on the most notorious act in the annals of baseball. And rang it down on Buck Weaver as well, a great promise unkept.

59. ZACK WHEAT *(Right)* **[Zachary Davis Wheat, "Buck"; OF; 1909–27*; BKN (N), PHI (A)].** Zack Wheat's career was, in actuality, two careers: one in the "deadball" era and one in the livelier-ball era, after 1920. For the first 11 years of his career, in the "deadball" era, from 1909 through 1919, Wheat batted over .320 only once, that in 1918, when he won the National League batting title with a .335 average. From 1920 on, hitting the souped-up ball, he averaged .339 during the last eight years of his career. And yet this superb lefthanded line-drive hitter—who was particularly adept at handling the curveball—was the seventh-leading producer of base hits during the teens. It was just that his efficiency increased in the twenties, as seven times in eight seasons he topped the .320 mark, including back-to-back .375 seasons in 1923 and '24, finishing second to Rogers Hornsby in both years. By the time the fire in his legs had become a dull ache and they gave out at the age of 41, Wheat had 2,884 hits—and still rates as the all-time Dodger leader in games, at bats, hits, doubles, triples and total bases.

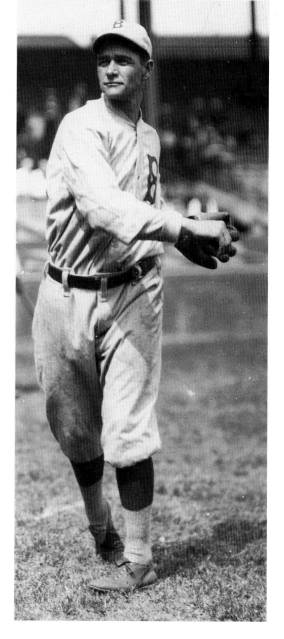

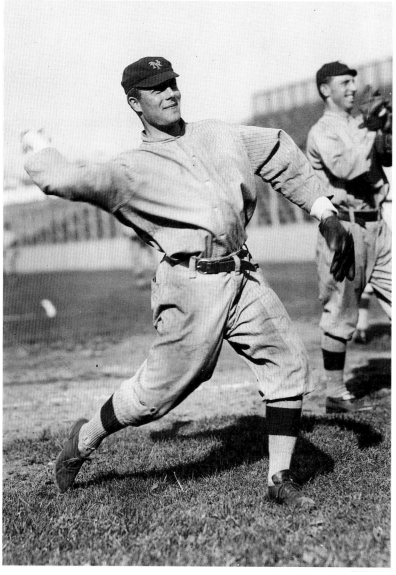

60. GEORGE BURNS *(Left)* **[George Joseph Burns; OF; 1911–25; NY (N), CIN (N), PHI (N)].** The perfect table-setter for John McGraw's great Giant teams, Burns led off and led the league in runs five times and in stolen bases twice—and still ranks among the Giants' top ten in all-time games, at-bats and runs and as their all-time stolen base leader. A favorite of the Giant faithful, Burns played on five Giant pennant winners and was popular enough to have the Polo Grounds' notorious sun-drenched left field dubbed "Burnsville" by his rooters.

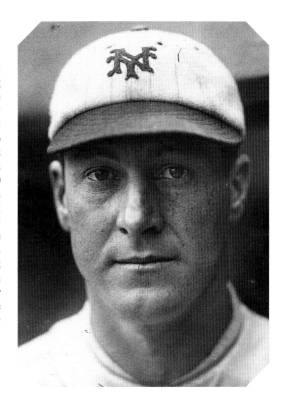

61. BENNY KAUFF *(Right)* **[Benjamin Michael Kauff; OF; 1912, 1914–20; NY (A), IND (F), BKN (F), NY (N)].** During the brief two-year tenure of the Federal League, their one superstar was Benny Kauff, who won the accolade "The Ty Cobb of the Federal League" by leading the third league in both batting average and stolen bases both years. John McGraw, who always had an eye for talent, picked up Kauff for the Giants when the league dissolved in 1915 and for the next two years Kauff played in all but one of the Giants' games, stealing 70 bases, scoring 160 runs and batting .286—substantially less than his combined .357 during the two years of the Federal League's existence, but still the highest average on the 1917 pennant-winning Giants' team. A dandy by any stretch of the imagination, complete with diamond stickpin, spats, brilliantined hair and boater, Kauff fell in with the wrong crowd and by 1920 was implicated in a stolen car ring. Although cleared of criminal charges, he was excused from further major league play in the aftermath of the "Black Sox" scandal and the subsequent housecleaning by Commissioner Kenesaw Mountain Landis.

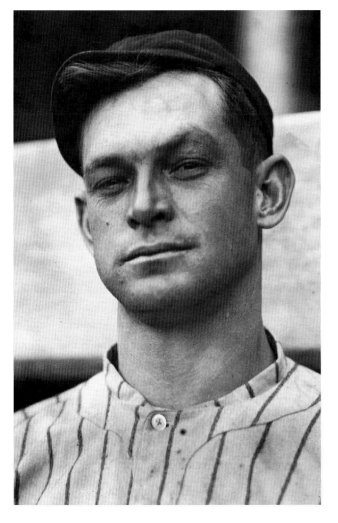

62. JEFF TESREAU *(Left)* **[Charles Monroe Tesreau; P; 1912–18; NY (N)].** Joining the pitching-rich New York Giants in 1912—with a staff that included the likes of Christy Mathewson, Rube Marquard, Red Ames and Hooks Wiltse—the 225-pound, spitball-pitching Tesreau made a name for himself immediately, that of a "freshman phenom." Throwing his spitter with the speed of a fastball, Tesreau led the League in ERA with 1.96 and won 17 games—two of those cause for more than some dispute. One of them was a no-hitter against the Phillies. However, the official scorer had charged Tesreau with one hit. But under pressure from sportswriter Sid Mercer, backed up by Giants' first baseman Fred Merkle, who told the scorer the one hit was really his (Merkle's) error, the scorer allowed himself to be swayed and between games of the doubleheader reversed himself, giving Tesreau credit for the no-hitter. The other source of controversy came in a game when Rube Marquard, then working on a consecutive-win streak that would "officially" be counted as 19 straight, relieved Tesreau in the eighth inning of a game the Giants were losing, 3-2. In the ninth, Heinie Groh singled and Art Wilson homered, giving the Giants and Tesreau the win instead of Marquard. Giant manager John McGraw rewarded his rookie with the ball in the first game of the 1912 Series, but even though Tesreau pitched a six-hitter, he was bested by the equally phenomenal "Smoky" Joe Wood. Twice more Tesreau would face Wood in the Series, and split the wins with the pitcher who had won 34 that year for the Red Sox. The next year, 1913, Tesreau was even better, leading the National League in games started and winning 22. In 1914 he again led the National League in starts, won the second-greatest number of games in the league, 26, and led the league in shutouts with eight. In 1915, proving he could win with a losing club, he won 19 for the last-place Giants. After an 18-win season in 1916 and a 13-win season for the 1917 pennant-winning Giants, Tesreau ended his career with a 4-4 record in 1918, the only time he failed to win more than he lost. He retired to Hanover, New Hampshire, where he became the coach at Dartmouth College—and once ran for sheriff in the local elections, but lost when he used the name he was born with, "Charles Monroe Tesreau," voters not knowing that it was good old "Jeff."

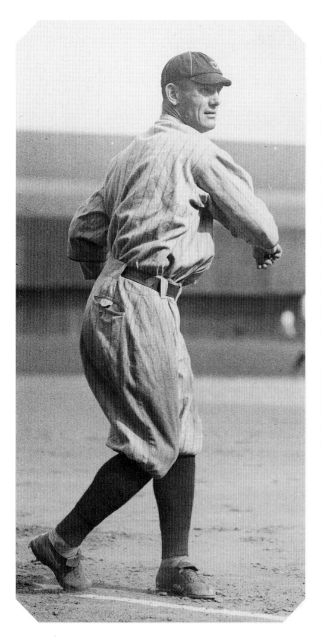

63. RAY CHAPMAN *(Left)* [Raymond Johnson Chapman; "Chappie"; SS; 1912–20; CLE (A)]. Subscribing to the theory that "if you got to knock somebody down to win a ballgame, do it!" Carl Mays had made a living throwing at a batter's head with his rising submarine ball. On the afternoon of August 16, 1920, Mays, pitching for the New York Yankees, took the mound against the Cleveland Indians as they both battled for their first championship. With the Indians leading 3-0 after four innings, Cleveland's star shortstop Ray Chapman led off the fifth. The speedy Chapman, fastest man in the league, had affected the most exaggerated crouch in the majors, actually leaning over the plate, all the better to get on base, whether by drag bunt, walk or getting hit by a pitch, all areas he was extremely gifted at. With the count one ball and one strike, Mays, his hand almost scraping the ground, let fly with a rising fast ball on the inside, designed to prevent the righthanded Chapman from pushing the ball down the line. There was a resounding "thwack" as ball hit batter with a report heard throughout the Polo Grounds. Mays, thinking the ball had hit the handle of Chapman's bat, picked up the ball dribbling out to the mound and threw to first. Only then did he run back to the plate and see umpire Tom Connelley calling first to the Indians' dugout for help for the fallen Chapman and then to the stands for a physician. Helped by his Indian teammates, Chapman staggered to his feet, instinctively took two steps toward first and then, shaking like an aspen, dropped in a heap, his left eye hanging out of its socket. Several of those who had seen the pitch hit Chapman, like Cleveland pitcher Ray Caldwell, thought that Chapman had actually "ducked his head into the path of the ball." Others, that Chapman, enchained in his own indecision, had simply frozen. Tris Speaker, in the on-deck circle at the time, believed that "there was time for Chappie to duck, but he never moved." The stricken Chapman never regained consciousness, dying the next morning—the only ballplayer ever to be killed by a pitched ball in a major league game.

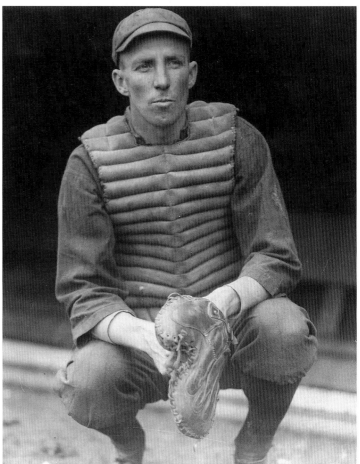

64. HANK GOWDY *(Right)* [Henry Morgan Gowdy; C; 1910–17, 1919–25, 1929–30; NY (N), BOS (N)]. A journeyman catcher whose greatest fame came from being the first major leaguer to enlist in World War I, Gowdy enjoyed two fleeting moments in the baseball spotlight, both coming in World Series play. His first came as a member of the 1914 "Miracle Braves," a team that resided in last place as late as July 18 and then, putting together the greatest comeback in baseball history, went on to win the pennant by 10½ games, capping their miracle season by defeating the heavily favored Philadelphia Athletics in the first-ever sweep in Series history—with Gowdy contributing mightily, getting six hits in 11 at-bats for a .545 batting average and a 1.273 slugging average, the second-highest figures for both in World Series history. His second moment came in 1924 when he filled in for the injured Pancho Snyder and, in the seventh and deciding game, tripped over his own mask and lost a foul pop-up off the bat of Washington's Muddy Ruel, allowing the ball to fall harmlessly to the ground. Given a second chance, Ruel celebrated his reprieve by doubling and, seconds later, scoring the Series' winning run.

65. DUFFY LEWIS *(Right)* **[George Edward Lewis; OF; 1910–17, 1919–21; BOS (A), NY (A), WAS (A)].** One-third of what baseball historian Fred Lieb called, "on the basis of fielding ability alone, the greatest outfield of all time," Duffy Lewis played left field next to Tris Speaker and Harry Hooper for the great Boston Red Sox teams of the first half of the second decade of the twentieth century. But Lewis did more than just play left, he tamed it. For the left field area in Boston's Fenway Park was hazardous terrain indeed, with an embankment that rose some eight feet in front of the wall, starting its rise about 25 feet in front of the fence. It was that embankment, labeled "Duffy's Cliff" by the Fenway faithful, that Lewis mastered, going back for a fly ball while running up the embankment, all the while keeping his eye on the falling object. Or gracefully playing the caroms off the fence down the embankment. Called a "money player" by teammate Tris Speaker, Lewis was equally adept with his bat. Hitting fourth behind Speaker, Lewis batted .288 during his eight years in a Sox uniform, winning many games with his timely hitting—including the famed 1912 matchup between "Smoky" Joe Wood and Walter Johnson, with a double, and the third game of the 1915 Series, with a bottom-of-the-ninth single off Grover Cleveland Alexander. After serving in the military in World War I—and relinquishing his left field spot to a young outfielder named Babe Ruth—Lewis became the first of many players sold by Red Sox owner Harry Frazee in December of 1918 in his giant rummage sale to the Yankees, called by disheartened BoSox fans "the Rape of the Sox." After two years with the Yankees, he was traded to the Washington Senators, again relinquishing his position to Babe Ruth.

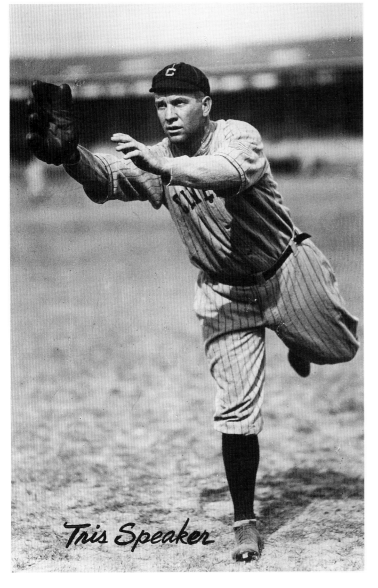

Tris Speaker

66. TRIS SPEAKER *(Left)* **[Tristram E. Speaker; "The Grey Eagle," "Spoke"; OF; 1907–28*; BOS (A), CLE (A), WAS (A), PHI (A)].** Any and all discussions about the greatest outfield for the first 50 years of the game begins and ends with the triumphant triumvirate of Babe Ruth, Ty Cobb and Tris Speaker. For Speaker was, without a doubt, one of the greatest center fielders ever to play the game. His Hall of Fame plaque is proudly inscribed: "The greatest center fielder of his day." But that doesn't quite tell the whole story of the 22-year career of the man they called "The Grey Eagle" because of his prematurely grey mane—and "Spoke," the past tense of "Speak," as in Speaker. Playing an exceptionally shallow center field, but able to go back on long drives, he patrolled the outfield like few before him—and none after him. Consider his fielding achievements: he held the American League record for most putouts, most years leading the League in putouts, most career assists, most assists in one season, most years leading the league in assists, most years leading the league in chances and most unassisted double plays. In fact, Speaker has the only unassisted double play by an outfielder in World Series history, that coming in the seventh game of the 1912 Series when he raced in from short center to grab a line drive off the bat of the Giants' Art Fletcher and kept on running to double up Art Wilson at second. But if his play afield was exceptional, his work in the batter's box was no less so. Eleven times he batted .340 or over, including .386 in 1916 to lead the league and break Ty Cobb's run of nine straight batting championships. Twice he finished second in batting and third another eight times—almost always behind Cobb—and, at the age of 37 hit a career high of .389. By the time his career had wound down, Speaker had amassed 3,515 hits, 793 of them doubles, the all-time record—ten times hitting 40 or more and five times 50 or more—and had a .345 lifetime batting average, then the fourth-highest ever (now, after nearly six decades, still the fifth-highest).

67. WALTER JOHNSON *(Above)* [**Walter Perry Johnson; "Barney," "The Big Train"; P; 1907–27*; WAS (A)**]. Walter Johnson may have looked like one of nature's irregularities, a gangly six-foot-and-change pitcher with long, stringy arms that flowed out of his uniform at odd angles and long wrists as loose as if he were shaking them out. But when he threw his fastball in a whiplike fashion, coming sidearm by way of third base with an easy motion, he was the greatest pitcher baseball had ever seen. Sam Crawford, who faced Johnson in his very first game in the majors, said that Johnson "reminded me of one of those compressed-air machines . . . comes in so fast when it goes by it swooshes. You hardly see the ball at all. But you hear it, swooooosh. . . ." Johnson continued to swoosh his pitches past batters, pitches that begot two whistles, one as they came in and the other from the appreciative batters in admiration. It was this pitch with the sound of a train's yowl that inspired Grantland Rice to call him "the Big Train," and then add, "How do you know what Johnson's got? Nobody's seen it yet." That "swooshing" fast ball won 416 games for Johnson, the most in modern baseball, with 12 20-game seasons and two 30-game seasons, most with a woebegone, tatterdemalion Washington team. He also holds the record for most shutouts, with 110, most times winning pitching's triple crown (most wins, best ERA and most strikeouts), with three, and most times leading the league in complete games, innings pitched, games won, strikeouts and shutouts. Also one of the best-hitting pitchers of all time, Johnson batted .433 in 1925, with 42 hits in 97 at bats, and made his last major league appearance on September 30, 1927, as a pinch hitter for pitcher Tom Zachary, who only the inning before had given up Babe Ruth's 60th homer.

68. GROVER CLEVELAND ALEXANDER *(Below)* [**Grover Cleveland Alexander; "Alex," "The Great Alexander," "Pete"; P; 1911–30*; PHI (N), CHI (N), STL (N)**]. "The Great Alexander" lived up to his nickname, winning a record 28 games in his rookie season, 30 in three consecutive seasons and a National League high of 373 in his twenty-year career. In 1916 he set the major league mark by throwing a record 16 shutouts and, with 90 lifetime shutouts, is second only to Walter Johnson in all-time shutouts. Part of the reason for Alexander's success was his quick delivery—making it seem as if he returned the ball to his catcher as soon as he got it. Asked why he pitched so quickly, Alexander snapped, "What do you want me to do? Let those sons of bitches stand up there and think on my time?" Alexander is best remembered for his performance in the 1926 World Series, one of the greatest spot-pitching performances in baseball history. After winning his second complete game of the Series to even it up at three games apiece, Alex went on a celebratory bender, visiting almost every one of New York's many speakeasies. Called upon the next afternoon to relieve in the seventh inning of the seventh game with the bases full of Yankees and the Cardinals clinging to a slim one-run lead, he was still suffering the wrath of grapes. As he shuffled slowly towards the mound, Cardinal manager Rogers Hornsby came out towards him to meet him. Handing him the ball, Hornsby peered into his bloodshot eyes and asked Alexander, "How are you?" Alexander grabbed the ball and responded, a little hesitantly, "Okay, but no warm-up pitches. That would be the give-away." Then he proceeded to strike out the dangerous Tony Lazzeri on four pitches—one of which was a long, long foul into the left field stands—to end the rally. And then pitched two more scoreless innings, facing only six men, to give the Cardinals their first-ever Series win.

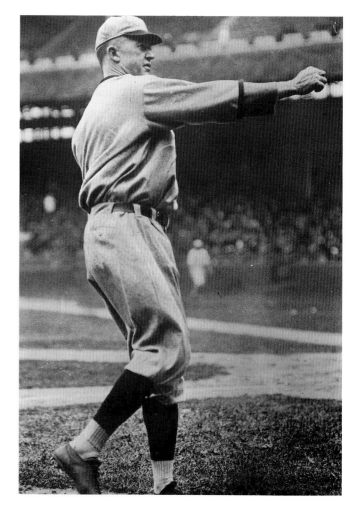

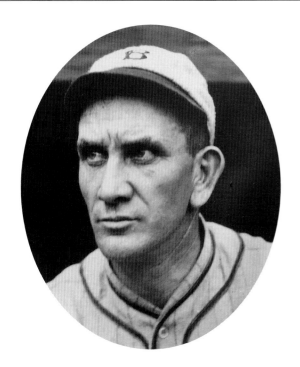

69. RABBIT MARANVILLE *(Above)* **[Walter James Vincent Maranville; "The Rab"; SS; 2B; 1912–33, 1935*; BOS (N), PIT (N), CHI (N), BKN (N), STL (N), BOS (N)].** Standing barely five-foot-five, if he were to stand on tippy-toe, Rabbit Maranville was as agile as the lagomorph for which he was named. For almost a quarter of a century he delighted National League fans with his agile scampering, his quick fliplike throws and his vest-pocket catches of pop flies. *The New York Times,* describing him, wrote, "This energetic little parcel of humanity jumped all around the edge of the diamond with the celerity of a grasshopper." Rabbit was the spirit of the 1914 "Miracle" Braves—the team that came from last place on July 4th to win the pennant and go on to sweep the powerful A's in four games in the Series—and led National League shortstops in assists and set the putout record, with 407, in only his second year as a regular. He went on to lead the National League in assists four years, fielding average five and most putouts seven. A natural comic and mimic, full of antics and fun off the field, Maranville was a carouser of the first water—and scotch as well—and many's the time he would take the field suffering from the night before. Finally, after bouncing around from team to team during "Prohibition," and having been sent down to Rochester by the Cardinals to dry out, he announced to one and all: "There is much less drinking than there was before 1927, because I quit drinking on May 24, 1927." And the temperate Rabbit would go on to play over 140 games in each of five more years, leading the NL in fielding as a shortstop in 1930 and as a second baseman in 1932. In 1934, the still-spry 42-year-old Maranville, trying to score in a spring training game, broke his leg and sat out the season. At the age of 43 he tried a comeback with one of the worst teams in baseball history, the '35 Braves—which also had on its roster another aging superstar, Babe Ruth—but, as Red Smith wrote, he played "Like the Ancient Mariner . . . an aging shortstop who now stoppeth one in three," and retired after just 23 games. Although Maranville split his duties between short and second, he still rates first among shortstops in all-time putouts with 5,139 and is second in total chances with 13,124. He was elected to the Hall of Fame in 1954, just a few months after he passed away, which prompted Johnny Mize to observe: "Rabbit Maranville was working with kids for the *Journal-American* when he died in January of 1954. The next summer he was voted into the Hall of Fame. Why did his record get so much better after he died?" It didn't; Maranville was *that* good.

70. JIM BAGBY *(Below)* **[James Charles Jacob Bagby, Sr.; "Sarge"; P; 1912, 1916–23; CIN (N), CLE (A), PIT (N)].** Although he had won 75 games in his previous four-plus seasons in the Bigs, nothing indicated that Jim Bagby would have the kind of year he had in 1920, a career year. For "all" Bagby did that season was win 31 games and lead the American League in wins, games, complete games, innings pitched and winning percentage. And, not incidentally, lead the Cleveland Indians to the American League pennant, their first ever. The slim Bagby, six feet tall and barely 170 pounds, lost the second game of the World Series and then came back in Game 5. It was one of baseball's most unforgettable games with Elmer Smith hitting the first grand slam home run in World Series history and Bill Wambsganss turning in an unassisted triple play in support of Bagby, who pitched a 13-hitter and became the first pitcher to hit a home run in Series play, as the Indians beat the Dodgers in the game and in the Series as well. Bagby would go on to win just 21 more games in his major league career. But his 31 games still stands—along with Lefty Grove's 31 in 1931 and Denny McLain's 31 in 1968—as the most wins in a season since 1916.

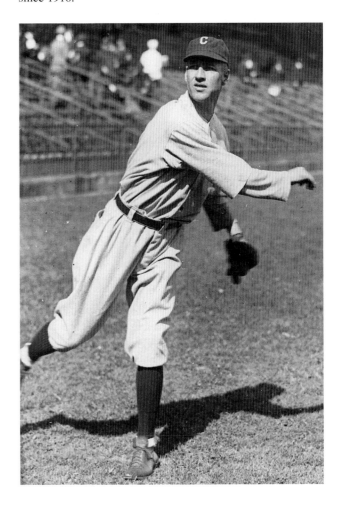

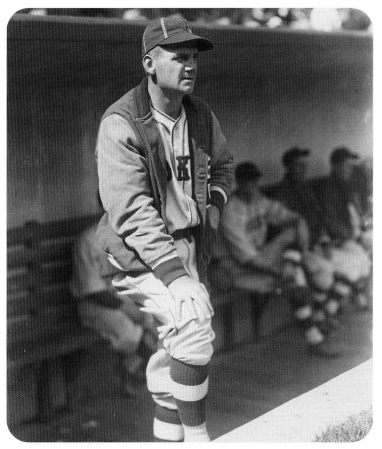

71. MAX CAREY *(Left, top)* **[(born) Maximilian Carnarius; OF; 1910–29*; PIT (N), BKN (N)].** One of the greatest-fielding center fielders of all time, Max Carey led the National League in putouts and total chances for 9 of his 17 years with the Pirates and holds the National League career records for outfield assists and double plays. But it is as a switch-hitting bunter that Carey is most remembered, leading the National League in stolen bases ten times—including 1922, when he stole 51 bases in 53 attempts—and scoring 42% of the time he reached base.

72. ROGER PECKINPAUGH *(Left, bottom)* **[Roger Thorpe Peckinpaugh; "Peck"; SS; 1910, 1912–27; CLE (A), NY (A), WAS (A), CHI (A)].** The very name Roger Peckinpaugh conjures up memories of the 1925 season. It was then that the Washington Senator shortstop was first named the American League Most Valuable Player for his work during the regular season helping the Senators win their second-straight pennant. Then, in the Series against the Pittsburgh Pirates, he proved worthy of the same MVP honors in the National League by plowing up the infield in search of the ball and its handle and making eight—count 'em, eight—errors as the Pirates came back from a 3-1 deficit to win the Series, five of their runs coming as a result of Peckinpaugh's miscues. Peckinpaugh first came up to Cleveland and by 1913 had been traded to the New York Highlanders, where he became their regular shortstop—and, in the final days of 1914, their manager as well for all of 17 games, the youngest manager in the history of baseball at the ripe old age of 23. After helping the by-then Yankees to their first pennant in 1921, Peckinpaugh—his name now contracted by claustrophobic headline writers to just plain ol' "Peck"—was traded by the Yankees to the Boston Red Sox for pitchers Sad Sam Jones and Bullet Joe Bush. But even before he had unpacked his bags, Peck was on the move again, this time courtesy of a three-cornered trade among the Red Sox, the Athletics and the Senators that brought Peck to the Senators and Joe Dugan to the Red Sox. At Washington Peckinpaugh became a part of an all-star infield that included Joe Judge at first, Bucky Harris at second and Ossie Bluege at third, and carried the Senators to two straight pennants. But by 1925 the normally sure-handed Peck was on the downside of his mountain, and proved it by booting away the '25 Series. By 1928, his playing days over, Peckinpaugh turned again to managing, taking over the Cleveland Indians. He managed into the 1933 season when he was replaced by former teammate Walter Johnson. However, he resurfaced one last time, in 1941, when he was called back by the Indians after the famous "Cry Babies Revolt" of 1940 had undermined both Cleveland's chances of winning the pennant and manager Ossie Vitt's position with the team. Peck managed the Indians for only one season before he was replaced by *his* shortstop, Lou Boudreau, who at a youthful 24 became the second-youngest manager in baseball history—just behind the man he replaced, Roger Peckinpaugh.

73. STAN COVELESKI *(Below)* [Stanley Anthony Coveleski; P; 1912, 1916–28*; PHI (A), CLE (A), WAS (A), NY (A)].** One of five ball-playing brothers, Stan Coveleski came out of the coal fields of western Pennsylvania for the proverbial cup of java with the Philadelphia Athletics in 1912, pitching a three-hit shutout in his debut. But the A's, rich in pitching talent, sent him back down to Portland for more seasoning. There, he mastered the spitball, a pitch he would ride to stardom, winning a total of 215 games, including 20 in five seasons and three in the 1920 World Series.

74. RED FABER *(Above)* [Urban Charles Faber; P; 1914–33*; CHI (A)].** One of baseball's last legal spitball pitchers—18 of whom were allowed to continue throwing their specialty after the pitch was banished in 1920—Faber won 254 games pitching for threadbare White Sox teams decimated by the loss of their stars after the 1919 "Black Sox" scandal. (The hero of the 1917 Series, when he won three games against the Giants, Faber sat out the infamous 1919 Series with a sore arm and the flu.) In fact, Faber's best years came in 1920, '21 and '22, when he won 23, 25 and 21 games, with the ChiSox finishing seventh and fifth in the League in two of those years.

75. EDD ROUSH *(Right)* [Edd J. Roush; OF; 1913–29, 1931*; CHI (A), IND (F), NWK (F), NY (N), CIN (N)].** Wielding a shorter, heavier, 48-ounce bat with a big handle, Edd Roush was one of the most dangerous hitters of the so-called "deadball" era, able to hit to all fields. Twice National League batting champion, Roush hit over .300 13 times and during one four-year period, 1921 through 1924, averaged .350, the second-highest average (behind Rogers Hornsby). Roush cut his batting teeth in the Federal League and then, upon its collapse after the 1915 season, was sold, along with Bill McKechnie and Benny Kauff, to the New York Giants. However, Roush didn't care for New York or the dictatorial manner of John McGraw. In Roush's words, "if you made a bad play he'd cuss you out, yell at you, call you all sorts of names." Traded to Cincinnati, along with Christy Mathewson and McKechnie in the only trade ever that included three future Hall of Famers, Roush was immediately put in center field by Mathewson, the new Reds manager, who had been told by McGraw, "if you put Roush in center field you'll have a great ballplayer." Roush responded by winning the batting crown in his first full year in a Cincinnati uniform. Averse to spring training, Roush would hold out every year until the week before the season opened, instead doing what he called "my *own* spring training, hunting quail and rabbits." Traded back to the Giants after the '26 season, Roush at first refused to report, telling them he wouldn't play with the Giants for "any kind of money." But when McGraw offered him a three-year contract calling for $70,000 and a promise to allow him to play his own game, he reported to camp and over the next three years hit .304. Still Roush always was proudest of being a member of the Cincinnati Reds, a feeling that was reciprocated by Reds fans who, in the early sixties, called him the most popular player ever to wear a Reds uniform.

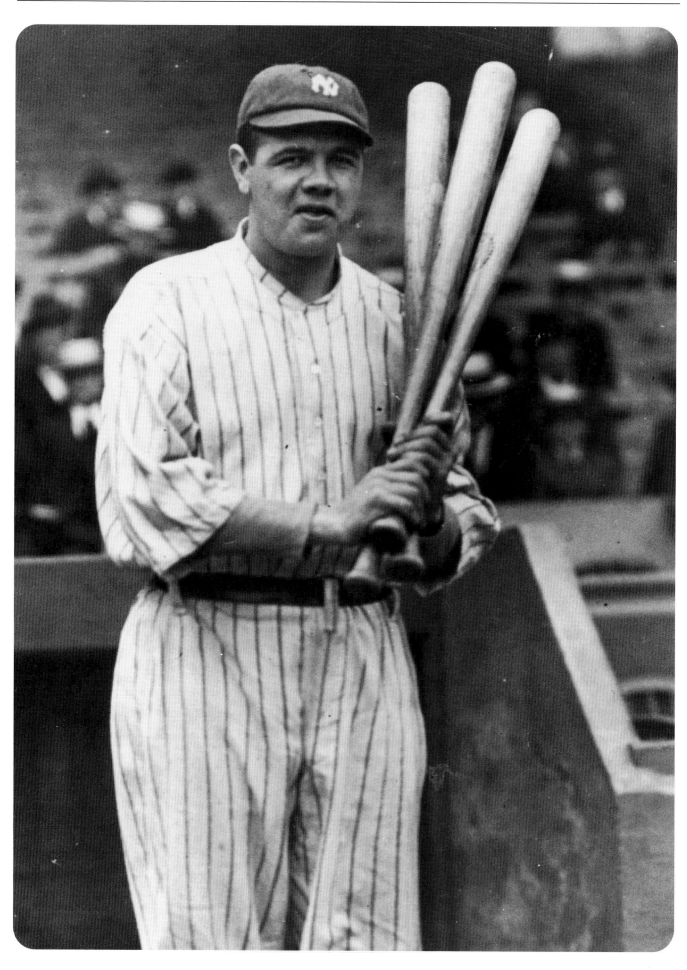

77. JACK QUINN *(Left)* [John Picus Quinn; "Paykos"; P; 1909–15, 1918–33; NY (A), BOS (N), BAL (F), CHI (A), BOS (A), PHI (A), BKN (N), CIN (N)]. When the Joint Major Leagues Rules Committee abolished the "spitball" before the 1920 season, along with other "freak" pitches, they granted 18 pitchers who had been throwing such pitches dispensation to continue to use them until "the end of their careers" without the police being called. One of those 18 was John Picus Quinn, who continued dealing up his spitter until the end of his lo-o-ong career, which didn't come for another 15 years after the Rules Committee allowed him to serve up his wet one—by which time he had won a total of 247 games in the majors and another 100 in the minors. The ancient spitballer stayed around so long he set several records under the category "oldest": the oldest man ever to start a World Series game (at the age of 46 starting the famous fourth game of the 1929 Series and giving up seven hits and four runs to the Cubs in four-plus innings, to be taken off the hook when the A's scored 10 of their own in the seventh); the oldest pitcher ever to lead in a major pitching category (with eight saves in 1932 at the age of 49); the oldest player ever to hit a home run (at 45 years and 11 months); the oldest player ever to hit a double (at 47 years and 11 months); and the oldest player ever to drive in a run (ditto).

76. BABE RUTH *(Opposite)* [George Herman Ruth; "The Bambino," "The Sultan of Swat," "Jidge"; P; OF; 1914–35*; BOS (A), NY (A), BOS (N)]. The very name Babe Ruth brings back memories to that dwindling number of fans who saw this Gargantuan figure on toothpick-thin legs boom parabolic shot-after-parabolic shot into the stands and then mince his way around the bases with catlike steps. To the typical adult, he is a legendary figure who gave color to his age much as John L. Sullivan gave color to his. To the younger generation, he is merely a name, spoken in reverential terms by their elders and used as a benchmark for modern ballplayers like Aaron and Maris. But Babe Ruth was more than a mere name. He was an institution; a deity. One prominent Methodist minister even suggested at the time, "If St. Paul were living today, he would know Babe Ruth's batting average." Legions of sportswriters formed a cult, spreading the Ruthian gospel. They called him "The Sultan of Swat," "The Wizard of Whack," "The King of Clout," "The Behemoth of Big" and, of course, "The Bambino." He was the idol of American youth and the symbol of baseball the world over. He saved the game after the Black Sox scandal and raised it to a new level of excitement, removing it from the suffocating bunt-and-stolen-base game of the deadball era. And as each day brought new accolades and exaggerated stories about the man who had become a legend—up to and including his beau geste, his "called shot" in the 1932 World Series, a moment that will never be satisfactorily explained—Ruth continued to contribute to the lore by writing and rewriting the record books with every swing of his size-42 bat. Once a great pitcher, when Ruth turned to the outfield he rewrote the record books with his exploits at bat. And by the time he was through he owned every line in those books under home runs, RBI's and even strikeouts—as his every missed swing brought "ooohs" and "aaahs" from adoring fans. Babe Ruth was the greatest of all sports heroes in "The Golden Age of Sports" and his presence and his feats made the "Roaring Twenties" roar a lot louder. Everyone was caught up in the Babe Ruth story line, best expressed by *New York Times* writer John Kernan who, on the occasion of Ruth's sixtieth home run in 1927, penned these immortal words: "From 'One Old Cat' to the last 'At Bat,' was there ever a guy like Ruth?" To anyone who ever saw him, the answer must be a resounding *no.* There was only one Babe Ruth and there never will be anyone like him again.

78. WAITE HOYT *(Above)* [Waite Charles Hoyt; "Schoolboy"; P; 1918–38*; NY (N), BOS (A), NY (A), DET (A), PHI (A), BKN (N), PIT (N)]. Coming up to the Yankees in 1918 right out of Brooklyn's Erasmus High, Hoyt came by his nickname honestly. He came by his blazing fastball just as honestly, winning 157 games for the Yankees during their days of total dominance of the American League, and winning six World Series games in six years—including two in the '21 Series, when he tied Christy Mathewson's unbeatable record with an 0.00 ERA. But, as must happen to all pitchers after 12 years, his speed began to desert him and by 1929 the former "Schoolboy's" fastball was little more than a rumor. One afternoon, after being tagged for a game-winning home run by that game-breaker, Jimmie Foxx, Hoyt was asked by a teammate, "Whatever became of that fastball of yours?" Without missing a beat, Hoyt retorted, "You'll probably find it bouncing around upstairs at Shibe Park right now." Hoyt would go on to spend his last seven years in the National League, leading the league in relief wins twice, one of those wins coming in Babe Ruth's "Last Hurrah," the game in which Ruth hit his farewell three home runs. Hoyt was a Yankee to the core. One afternoon, by now a member of the Pirates, he found himself facing the Chicago Cubs, one of the most rollicking, boisterous crews this side of the H.M.S. *Bounty.* Tiring of their verbal abuse and remembering how the Cubs had fallen to the Yankees in four straight the previous year, Hoyt strode over to the Cubs' dugout and, confronting his tormentors, shouted to one and all, "Better cut that out or I'll put on my old Yankee uniform and scare the s--- out of you." That was Waite Hoyt, as quick with the lip as with a pitch.

79. HERB PENNOCK *(Left)* **[Herbert Jefferis Pennock; "The Squire of Kennett Square"; P; 1912–17, 1919–34*; PHI (A), BOS (A), NY (A)].** The winningest lefthander in the American League during the twenties, Pennock came by his nickname honestly, hailing, as he did, from the rich rolling hills of Kennett Square, Pennsylvania, where he had participated in the sport of the landed gentry, fox hunting. On the mound Pennock hunted down batters in the same manner, with guile and patience, his style one of efficiency and economy. And damned effective. Having been recommended to Connie Mack by Mack's son, Earle, Pennock broke into the pitching-rich Athletics in 1912. By 1914 he had posted an 11-4 record, the first of his five .700-plus won-lost seasons, and gotten into his first World Series, pitching three scoreless innings in the last game against the "Miracle" Braves as the A's went down to defeat in four straight. By 1915, Pennock, along with most of the A's, was gone as Mack broke up his great team. After five years and 59 wins with the Red Sox, Pennock was again bundled off by the destitute Sox to the Yankees for three nondescript players plus a much-needed $50,000. Pennock blossomed under the wing of Yankee manager Miller Huggins, winning 19 games and losing but six in 1923 for a league-leading .760 won-lost percentage. He added two more wins in the '23 Series as the Yankees won their first-ever World Series. Over the next nine years with the Yankees, Pennock won 127 more games and in ten seasons finished 263 of the 323 games he started, a complete-game percentage of over 80%. He started five games in four Series for the Yankees, winning all five and saving another three—his masterpiece the third game of the 1927 Series when he retired the first 22 Pirates to face him.

80. BOB MEUSEL *(Right)* **[Robert William Meusel; OF; 1920–30; NY (A), CIN (N)].** The third part of the famed "Murderer's Row" outfield of Ruth, Combs and Meusel, during his ten seasons with the Yankees Bob Meusel put up numbers that would qualify him to join his two teammates in the Hall of Fame, but, according to those who watched him play with a cold, almost indifferent detachment, they could have been better—much better. Still, indifferent or no, Meusel managed to drive in over 100 runs in four seasons and lead the American League in RBI's and home runs in 1925, the year of Babe Ruth's "bellyache." And, along with Babe Herman of the National League, he is the only player to hit for the cycle three times. A big, strapping six-foot-three, Meusel had one of the best throwing arms of his day, twice leading the American League in assists. And on the basepaths he used his long-legged stride to advantage, twice finishing in the top five base stealers in the American League, five times leading his club in stolen bases and once stealing second, third and home in an inning. Playing in six World Series—three times against his older brother, Irish, his opposite number as the left fielder for the New York Giants—Meusel stole home twice, once in 1921 and once in 1928, the only player ever to do so. But despite his many achievements— his lifetime doubles, triples, total bases, RBI's, extra-base hits, batting average and stolen-base totals all still among the all-time Yankee leaders—Bob Meusel was an immensely unpopular Yankee, his manner surly, his face a clenched fist, his personality that of a dead fish. During his last year with the Yankees, when he had apparently mellowed and affected a friendlier manner, sportswriter Frank Graham wrote: "He's learning to say 'hello' when it's time to say 'good-bye.'"

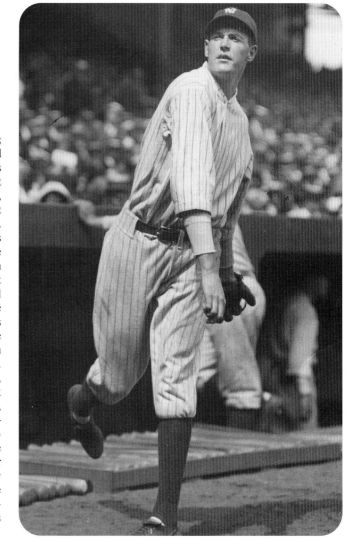

82. BOB SHAWKEY (*Below*) [**James Robert Shawkey; "Sailor Bob"; P; 1913–27; PHI (A), NY (A)**]. Coming up to the pitching-rich Philadelphia Athletics in 1913, Shawkey was able to elbow his way into a pitching rotation that included the likes of Eddie Plank, Chief Bender, Herb Pennock and Joe Bush, winning 28 games over two-plus years—but losing the fourth and deciding game of the 1914 sweep by the "Miracle Braves." Sold to the New York Yankees in the middle of the 1915 season by Connie Mack, then in the midst of dismantling his once-great team, Shawkey became the workhorse of the Yankee staff, winning 24 games in his first full season in a Yankee uniform and leading the league in saves and games won in relief. Over the next 11 years—and five pennants—Shawkey won 20 games three more times and, in 1920, led the league in ERA. Shawkey's lifetime statistics in a Yankee uniform place him in the top ten in almost every Yankee pitching category. Fittingly, he won the first game ever played at Yankee Stadium, a 3-1 win over the Red Sox, won, appropriately enough, by a Babe Ruth home run. Shawkey once again donned a Yankee uniform three years after his playing career ended, this time in 1930 as manager. However, after a third-place finish, he was replaced by Joe McCarthy.

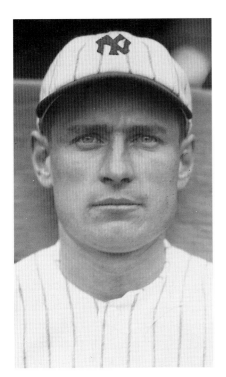

81. WALLY PIPP (*Above*) [**Walter Clement Pipp; 1B; 1913, 1915–28; DET (A), NY (A), CIN (N)**]. Possessor of the most famous headache in baseball history, on June 2, 1925, Wally Pipp told Yankee manager Miller Huggins, "I don't feel equal to getting back in there," still suffering from a beaning the day before. Huggins inserted a rawboned Columbia graduate named Lou Gehrig in Pipp's place and the rest was history: Gehrig would go on to play 2,130 consecutive games at first base and by the end of the year Pipp, twice league home run leader, would be shunted off to Cincinnati. It would turn out to have been, in Pipp's words, a case of "the two most expensive aspirins in history." Some 14 years later, Pipp, by then a salesman in Grand Rapids, Michigan, was making a business trip down to Detroit and decided to take in a ballgame. Ironically, the game he attended, on May 2, 1939, was the very game in which his replacement voluntarily took himself out, ending the streak he had started as Pipp's replacement.

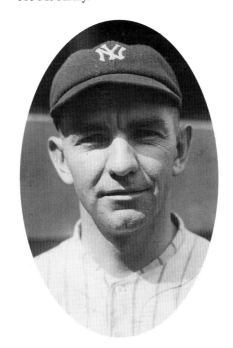

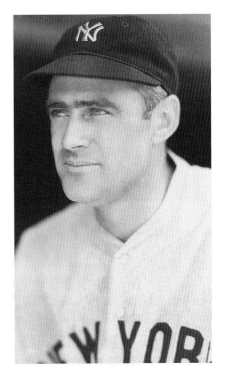

83. EARLE COMBS (*Above*) [**Earle Bryan Combs; "The Kentucky Colonel"; OF; 1924–35*; NY (A)**]. From his very first full season in the majors, when he replaced Whitey Witt in centerfield and stroked 203 hits (151 of them singles), it was obvious that Earle Combs was the ideal leadoff man for the Yankees team that would soon become known as "The Greatest Team in Baseball History." As he went on to collect over 1,000 hits in his first five full seasons—one of the few men in major league history to do so, along with Wee Willie Keeler, Paul Waner, Chuck Klein and Kirby Puckett—Combs always seemed to be on base to be driven in by the likes of Ruth, Gehrig and Lazzeri, scoring 100 runs in eight consecutive seasons. He also patrolled the spacious greensward of Yankee Stadium with a "Trespassers Will Be Prosecuted" mentality, constantly leading the league's outfielders in putouts. Ironically, it was his kamikaze fielding style that shortened his career when, in 1934, he ran into the wall at Sportsman's Park and fractured his skull.

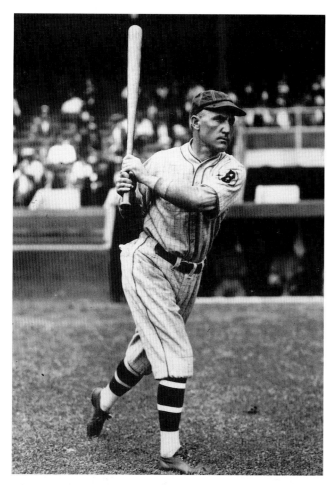

85. GEORGE KELLY *(Below)* **[George Lange Kelly; "High-pockets," "Long George," "Kell"; 1B; 1915–17, 1919–30, 1932*; NY (N), PIT (N), CIN (N), CHI (N), BKN (N)].** In an age when the average ballplayer stood five-ten-and-a-half and the average first baseman a shade over six feet, at six-foot-four, tree-top-tall George Kelly provided enough shade for the entirety of the Polo Grounds. A member of the New York Giants through their glory years of four pennants (1921, '22, '23, '24) and two World Championships ('21 and '22), Kelly was one of John McGraw's stalwarts, his cutoff man, giving outfielders a helluva target to throw to, as well as one of the team's leading batsmen. As agile as he was tall, Kelly set single-season records for putouts, assists and double plays and was known for his deadly-accurate and powerful right wing. In 1923 he made what writer Damon Runyon called "an astonishing play, perhaps one of the most sensational plays ever seen in a World Series," when he made a stop of a drive by Babe Ruth behind the bag with one hand at a seemingly impossible angle and threw out Joe Dugan trying to score to preserve the game for the Giants. Kelly was as adept with the bat as he was with the glove, averaging .306 in his five seasons as the regular Giant first baseman and occasionally breaking out in a rash of home runs—as he did in 1921 when he led the league; in 1923 when he hit three home runs in one game and set an NL record for most total bases in a game; and again in '24 when he hit seven in six successive games. In 1925, McGraw, to make room for Bill Terry's big bat, moved the righthanded Kelly over to second and thus fielded one of only two all–future–Hall of Famer infields (along with Terry, Travis Jackson and Freddie Lindstrom, plus utility infielder Frankie Frisch). After being traded to Cincinnati in 1927 for Edd Roush, Kelly put in parts of five more years before folding his tent and his long, rangy branches and going off into the sunset and the Hall of Fame.

84. DAVE BANCROFT *(Above)* **[David James Bancroft; "Beauty"; SS; 1915–30; PHI (N), NY (N), BOS (N), BKN (N), NY (N)].** The 1915 Philadelphia Phillies were strikingly similar to the 1914 edition—Grover Cleveland Alexander was the dominant pitcher in the National League, leading the league in wins both years; Gavvy Cravath was the League's leading home-run hitter both seasons; and Erskine Mayer won 21 games each season. However, there were two major differences: the 1914 Phillies finished fifth; the 1915 Phillies won the pennant. And the 1915 Phillies had a rookie shortstop who played every game, the slick-fielding Dave Bancroft. A classic shortstop with quick hands and quicker feet, he also possessed a quick wit. In the words of baseball historian A. D. Suehsdorf, "In his time, he was considered by most to be better than [Rabbit] Maranville, which meant he was the best." After five and a half seasons with Philadelphia, Bancroft was dealt by the cash-poor Phillies to the New York Giants where he blossomed, both as the Giants' field leader and at bat, leading the Giants to three pennants in three years. A skillful switch-hitter, Bancroft batted over .300 in all three years of his stay at the Polo Grounds, also leading National League shortstops in putouts and assists in 1921 and 1922. In the off-season after 1923, Giant manager John McGraw traded Bancroft to the Boston Braves as a favor to both Braves president Christy Mathewson and Bancroft himself, where he became their playing manager. However, the favor was no favor at all as, try as he might, both at bat and in the field, Bancroft could not raise the dead, the Braves finishing in the second division for all four seasons he was there. After Bancroft spent two seasons with the Dodgers, McGraw finally brought him back to the Polo Grounds, where he finished out a career that fully justified his nickname.

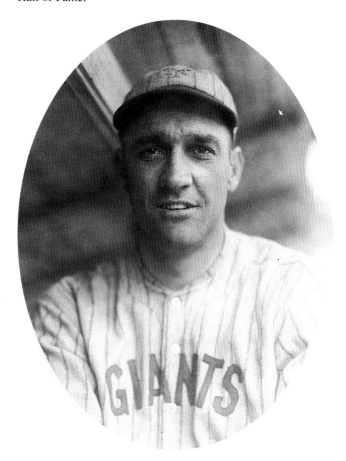

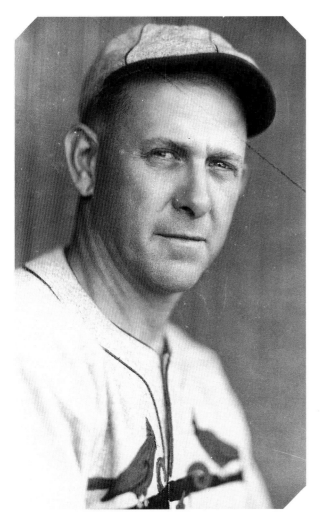

87. JIM BOTTOMLEY *(Below)* [**James LeRoy Bottomley; "Sunny Jim"; 1B; 1922–37*; STL (N), CIN (N), STL (A)**]. One of the first players to be developed in the St. Louis farm system, "Sunny Jim" was known for his signature, a slightly off-center cap bill, tilted over his left eye, and for his hot bat. The major league record holder for most runs batted in in a single game, with 12, he is one of only five men both to lead their league in home runs and triples and to have 20 home runs, triples and doubles in the same season. For Bottomley, that was 1928, a season he capped by being named National League MVP.

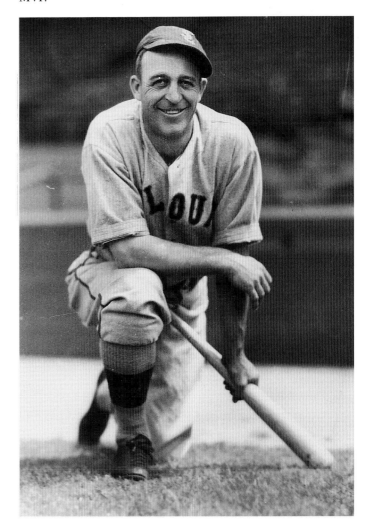

86. JESSE HAINES *(Above)* [**Jesse Joseph Haines; "Pop"; P; 1918, 1920–37*; CIN (N), STL (N)**]. With the exception of one game with the Cincinnati Reds, Jesse Haines spent the rest of his major league career, 18 years in all, in a St. Louis Cardinals uniform, longer than any pitcher in Cardinal history—and long enough to gain the nickname "Pop." Brought up at the rather ancient age, for a rookie, of 26, Haines became the mainstay of the pitching-poor Cardinal staff, working more than 300 innings in his rookie year and leading the league in games pitched. He would go on to win 210 games—more than any other St. Louis pitcher save for Bob Gibson—and three more in World Series play. One of those Series wins came in the seventh game of the '26 fall classic when, after pitching a shutout against the "Murderer's Row" Yankees in game three, he returned to pitch into the seventh inning of the final game. But, with two outs and the bases full of Yankees, he was forced out of the game with a blister on his throwing hand, compliments of his knuckler. In one of baseball's greatest moments, Grover Cleveland Alexander came in to strike out Tony Lazzeri and preserve Haines's win.

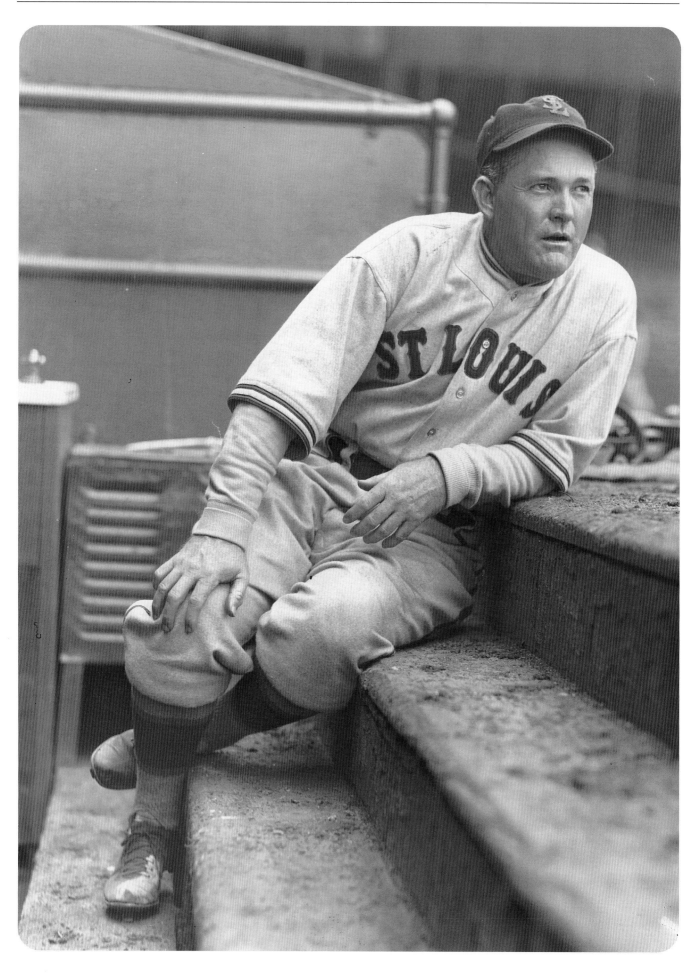

88. ROGERS HORNSBY *(Opposite)* **[Rogers Hornsby; "Rajah"; 2B; 1915–37*; STL (N), NY (N), BOS (N), CHI (N), STL (A)].** The greatest righthanded hitter in the history of baseball. Period, end of sentence. Standing deep in the batter's box, hands far down at the end of his long, 35-inch club, Hornsby's perfectly level swing and diagonal stride was a beautiful thing to behold—a perfect, all-powerful, smoothly timed movement as bat met ball and sent it screaming on a line to the far reaches of any field. Seven times he led the National League in batting, six of those in succession, from 1920 through 1925—six seasons that saw him post an amazing six-year average of .397—and three times he batted over .400, including .424 in 1924, the modern record. Twice a triple crown winner, he hit more home runs in 1922 and 1925 than even Babe Ruth. Called by Christy Mathewson "the fastest man in baseball," his speed afoot and in the field made him one of the greatest-fielding second basemen of all time. Outspoken, Hornsby continually ran afoul of owners, and was traded by St. Louis after leading them to their first-ever World Series as playing manager in 1926. Then, after one year with the Giants, he was shuffled off to Boston for two journeymen. In all he had six tours of duty as a manager, his longest stint lasting just over three full seasons. His lifetime .358 batting average is second only to Ty Cobb's .367, and it can be argued that, were it not for Cobb, Hornsby would be acclaimed as the greatest all-around player in baseball history.

90. JOE SEWELL *(Right)* **[Joseph Wheeler Sewell; SS; 1920–33*; CLE (A), NY (A)].** Few indeed have been the players who have had to face the daunting baptism into the majors faced by Joe Sewell. Called up from New Orleans by the Cleveland Indians late in the 1920 season with fewer than 100 games under his professional belt, little (5 foot 6½ inch) Joe Sewell found himself immediately inserted into the Indians' starting lineup to take the place of veteran shortstop Ray Chapman, who had been killed by a Carl Mays fastball just two weeks earlier. Sewell responded to the challenge, batting .329 in the stretch drive and helping the Indians win their first pennant by two games. Over the next eight years Sewell would anchor the Indians' infield, four times leading the league in both assists and putouts and twice in fielding average. But it was in the batter's box that he earned not only his spurs but his fame. For Sewell was the pluperfect contact hitter, striking out an average of but eight times a year—and, in three seasons, striking out just four times a season. After having his consecutive playing streak come to an end at 1,103 straight games in 1930, then one of the longest in baseball history, Sewell was released by the Indians at the end of the season. But Sewell's career was far from finished and he was signed by the Yankees before the '31 season to take the place of another Chapman, this one Ben Chapman, whom the Yankees wanted to move from third base to the outfield. Over the next three years Sewell batted .282 and struck out just 15 times, leaving a final monument to efficiency and economy, having struck out just 114 times in 14 major league seasons.

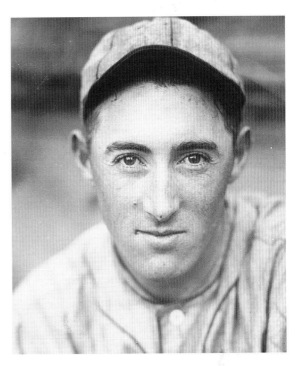

89. CHICK HAFEY *(Above)* **[Charles James Hafey; OF; 1924–35, 1937*; STL (N), CIN (N)].** A line-drive hitter with an equally line-drive arm, Hafey was one of the first products of Branch Rickey's newfangled farm system. Over eight years with the Cardinals Hafey hit .326, six times batting over .300 and, in 1931, winning the closest batting race in history—hitting a league-leading .3489 to Bill Terry's .3486 and Jim Bottomley's .3482. After Hafey held out for $17,000 in 1932, Rickey traded him to the Cincinnati Reds during spring training, assured that he had another great outfielder in the so-called "Rickey's Chain Gang," Joe Medwick, to take his place. Suffering from poor eyesight and a chronic sinus condition, Hafey saw (or didn't see, as the case may have been) the handwriting on the wall while playing for the Reds in the first-ever night game in 1935—the dampness affecting his sinuses and the lighting his eyesight—and retired during the '35 season only to try a comeback in '37.

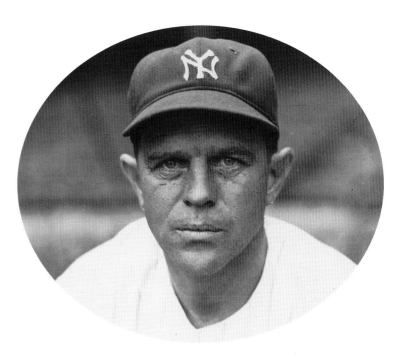

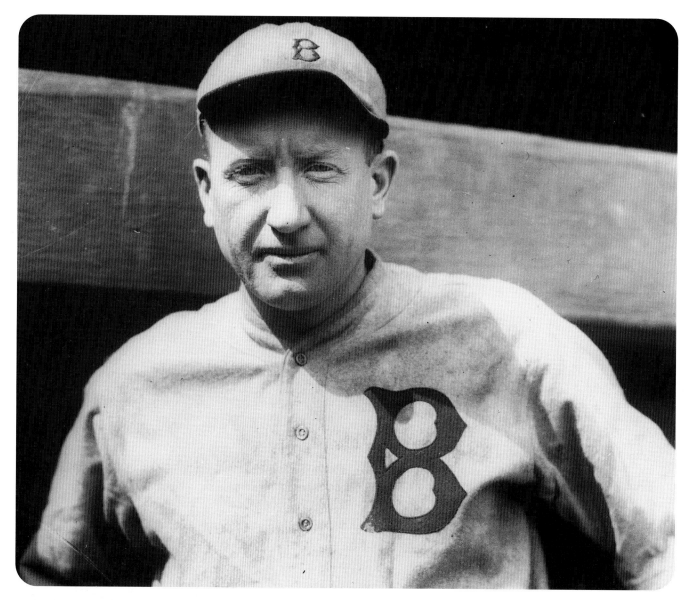

91. DAZZY VANCE *(Above)* **[Clarence Arthur Vance; "Daz"; P; 1915, 1918, 1922–35*; PIT (N), NY (A), BKN (N), STL (N), CIN (N)].** His given name was Clarence Arthur Vance, but he was called "Dazzy," as much for his dazzling fastball as for his being a member of Brooklyn's storied "Daffiness Boys." With a face that looked like he had won the W. C. Fields look-alike contest, and a wit to match, "Dazzy" Vance lit up the majors for ten glorious years. But for a time it had looked like he would be permanently consigned to the lower depths of the minors. Then, after an arm operation and an understanding manager who allowed him to start on four days' rest instead of his previously prescribed three, Vance made his way back to the majors at the advanced age of 30. And proceeded to make up for lost time by leading the National League in strikeouts in his rookie year—the first of seven consecutive years he would lead the NL in K's, a league record. In 1924 he won pitching's "Triple Crown," leading the league in wins, ERA and strikeouts (his 262 K's 127 more than the runner-up Burleigh Grimes's, the largest margin ever). Vance was rewarded for his efforts by being voted the league's MVP, beating out Rogers Hornsby, who had hit an all-time high of .424 that year. Vance's style was unique: he would rear back, the ball swaddled in his mammoth freckled hand, kick his left leg high, waggle his foot and let fly. With a curveball that started at the shoulders and broke around the knees, he was damned-near impossible to hit. All the more so since he would cut the bleached sleeve of his undershirt into ribbons, causing it to swirl as the arm moved plateward. On Mondays the batter stood no chance, since that was the day when the Ebbets Field neighborhood hung out its wash, and the diapers, undies and sheets flapping on the clothesline made the ball all-but-impossible to see. But Vance was nearly impossible to hit on just about any day—his fastball invisible and his curveball one of the wickedest ever thrown, breaking like an apple rolling off a crooked table. Although the league was to outlaw his tattered sleeve, they couldn't do anything to disarm his waggish sense of humor. Perhaps the one day it shone most brightly was the day Babe Herman tripled into a triple play; or doubled into a double play. Whatever. For the lead baserunner on that day when three men wound up on one base was none other than "Dazzy" Vance who, along with the two other baserunners, held a meeting on third. As the dust and confusion swirled around the bag and the third base-man tagged everyone in sight, Vance, lying on his back after sliding back into third, raised his head and addressed one and all: "Mr. Umpire, Fellow Teammates and Members of the Opposition," he intoned, "if you carefully peruse the rules of our National Pastime, you will find that there is one and only one protagonist in rightful occupancy of this hassock—namely, yours truly, Arthur C. Vance." There was only one rightful owner of the name "Dazzy" as well.

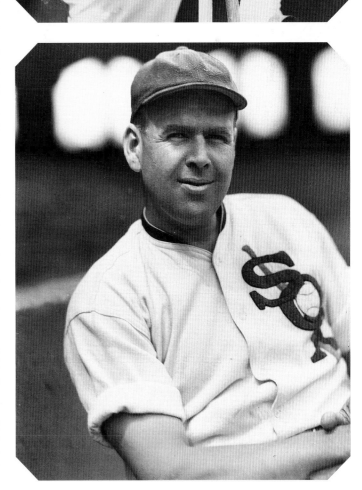

92. JIMMY DYKES *(Right, top)* **[James Joseph Dykes; IF; 1918–39; PHI (A), CHI (A)].** The Philadelphia Athletics of the late teens were a god-awful team, one that looked like they had just emptied out the mission houses and put a few of the less-able-bodied in uniforms, their ranks filled with cast-offs, never-wases and never-will-bes who weren't household names even in their own households. It was this group of fugitives from the law of averages, then in the midst of a six-year residency in the American League cellar, that a young 21-year-old Jimmy Dykes joined after just 79 games in organized ball. And he fit right in, batting just .188, with 35 hits and 21 errors in 59 games. But by 1920 he had become the A's' regular second baseman. And as the A's slowly climbed up the standings, Dykes's batting average also climbed, reaching .323 in 1925—when he tied the record for most hits on the first pitch in a game, with five—and had reached his final destination, third base. By 1929 Connie Mack was saying of his team's most valuable player, "Having one Dykes is like having five or six players and only one to feed, clothe and pay." And Dykes proved it in that year's World Series, leading all batsmen with a .421 average and getting two hits in the A's 10-run seventh inning in game four, including the go-ahead runs, as the A's came back from an 8-0 deficit to beat the Cubs in one of the greatest games ever. After three more outstanding years at third, two pennants and one World Series, Connie Mack, beginning to feel the pinch of the deepening Depression, dispersed his stars to the north, south and west. All for cash on the barrelhead, of course. One of the first to go was Jimmy Dykes, who was sent to the White Sox, along with outfielders Al Simmons and Mule Haas, in September of 1932 for the not inconsiderable sum of $150,000 in Hoover dollars. In his second season with the Sox Dykes was named manager, beginning a second career that would last through 21 seasons and 2,960 games. After being fired by the White Sox after an unlucky 13 years, Dykes came back to the A's as a coach and the heir presumptive to Mr. Mack. Mack welcomed him back with a "Jimmy, I'm afraid we can't pay you enough money." To which the impish Dykes—who had once opined, "Without Ernie Banks the Cubs would finish in Albuquerque"—replied, "Keeeripes! Do we have to start in where we left off sixteen years ago?" Dykes would go on to manage the A's for three of their last four years in Philadelphia and then, after a few more managerial pit stops along the way, wind up his career as the manager of the Cleveland Indians, where he had gone in the only trade of managers in baseball history, having been traded by Detroit to Cleveland in 1960 for Indian manager Joe Gordon.

93. GEORGE EARNSHAW *(Right, bottom)* **[George Livingston Earnshaw; "Moose"; P; 1928–36; PHI (A), CHI (A), BKN (N), STL (N)].** The "other" big gun on the great Philadelphia Athletics teams of 1929–'31, the six-foot-four-inch Earnshaw provided the righthanded pitching to complement Lefty Grove's portside offerings, with 67 wins over the three years to Grove's 79. Using just a fastball and a curve—"I didn't fool around with those junk pitches"—Earnshaw won a league-leading 24 games in '29, 22 in '30 and 21 in '31 as the other half of one of baseball's all-time great pitching duos.

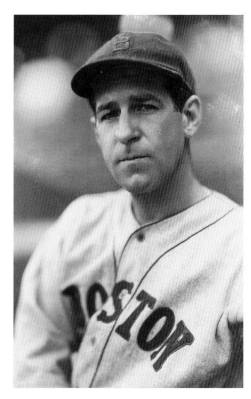

94. DICKIE KERR (*Below*) **[Richard Henry Kerr; P; 1919–21, 1925; CHI (A)].** The improbable hero of the 1919 World Series for the "Black Sox," rookie Dickie Kerr had been pressed into action when one of the big three of the White Sox staff, "Red" Faber, had been scratched from the Series because of illness. He responded with two of the White Sox's three wins—one a shutout—while pitching mates Eddie Cicotte and Lefty Williams were throwing the rest to the Reds. In his second year the little lefthander won 21 games and, in 1921, for a dispirited seventh-place team, by now shorn of its stars, all barred for life after the scandal was unearthed, he won another 19. Denied a $500 raise by the pinchpenny owner, Charley Comiskey, Kerr took his talents and wares elsewhere, pitching for independent teams rather than the unappreciative White Sox. He was to make a brief reappearance in 1925 and then turned his talents to managing in the minors where he converted an injured 19-year-old pitcher named Stan Musial into an outfielder. This time his efforts *were* appreciated, Musial naming his first son "Richard" in tribute to Kerr.

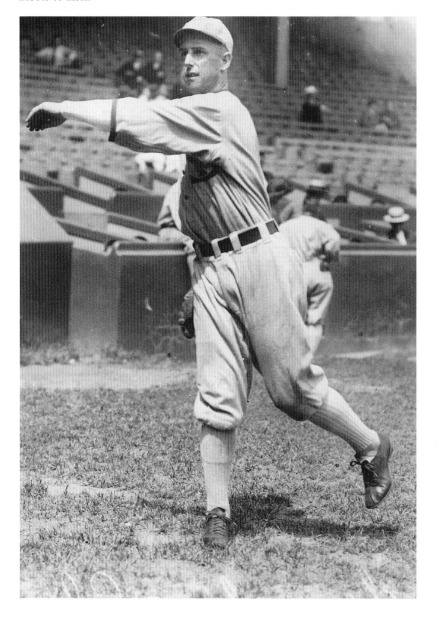

95. BUCKY HARRIS (*Above*) **[Stanley Raymond Harris; "The Boy Manager"; 2B; 1919–31*; WAS (A), DET (A)].** Clark Griffith, the owner of those perennial non-rans, the Washington Senators, changed managers with the frequency the Romans changed emperors in the wake of Nero. And so, when he named his star second baseman Bucky Harris to manage his 1924 edition, the Senators' fifth manager in as many seasons, it looked more like the watering of last year's crops than the hopeful harvesting of anything more than the usual second-division finish. However, the 27-year-old "Boy Manager," urging his troops to "go out and make me look good," surprised all by taking the Senators to their first-ever pennant and a World Series win in one of the greatest games in Series history. Led by Harris in the field and at bat—with 11 hits in the Series and three in the deciding seventh game—and Walter Johnson, who finally won his first World Series game after 376 regular season wins, the Senators defeated John McGraw's Giants in 12 innings. Harris repeated his magic in 1925, but lost the Series in seven games to the Pittsburgh Pirates. He would go on to manage for 27 more years, winning again with the '47 Yankees, and record 2,159 wins as a manager, fourth-highest number in baseball history.

96. AL SCHACHT *(Right)* [Alexander Schacht; "The Clown Prince of Baseball"; P; 1919–21; WAS (A)]. He always claimed to have been born on the exact spot where Yankee Stadium now stands. But, then again, Al Schacht was a master storyteller who never let a few facts get in the way of a good tale. Seems that, pitching for Jersey City in the International League right after World War I, Schacht was putting up some impressive numbers. Only trouble was: nobody was paying him or his numbers much attention. So Schacht took up his own cause, and pen, bombarding Washington Senator manager Clark Griffith with missives. "That guy Schacht is going great. Why don't you grab him?" went one letter. Others followed, all signed, modestly, "Just a Fan." Griff's curiosity was sufficiently aroused for him to make a personal scouting trip to witness just what the "Fan" had been writing about and he came away impressed enough to purchase Schacht's contract. Schacht, at least according to Schacht in his book *My Particular Kind of Screwball*, made his major league debut against the fearsome-hitting Detroit Tigers, a team with "an infield hitting about .360 and Ty Cobb over .400. But he ain't the best. Harry Heilmann's leading the league at .412." In the ninth, the Tigers had rallied to tie up the score and, with the winning run on third and Heilmann at bat with a count of 3-0 on him, Schacht was brought in to pitch. Catcher Patsy Gharrity met the newcomer on the mound and, handing him the ball, said, "You're in a helluva spot, kid. You got the winning run on third and three balls on the batter." "*I got,*" Schacht remembered screaming. "It was all there when I came in." Gharrity gave him one more bit of advice: "All you have to do, kid, is get the ball over the plate." And so Schacht did as Gharrity recommended and got the ball over the plate. And Heilmann doubled to left, almost killing the third baseman in the process. For three seasons, before he came up with a sore arm, Schacht pitched for the Senators, winning a total of 14 out of 24 decisions and pitching in a total of 53 games, 35 of those in relief. After retiring from active play he became a coach for the Senators where he teamed up with fellow coach Nick Altrock to revive several of the routines Altrock had once performed with Germany Schaefer, including a pantomime pepper act, all done in a battered top hat and tattered frock coat. Later Schacht took his act on the road as a solo. Ultimately he opened up one of the swankiest "cracker-barrel leagues" as he called it, a watering-hole-cum-restaurant right off Park Avenue in New York where for years "The Clown Prince" held court. Nonstop.

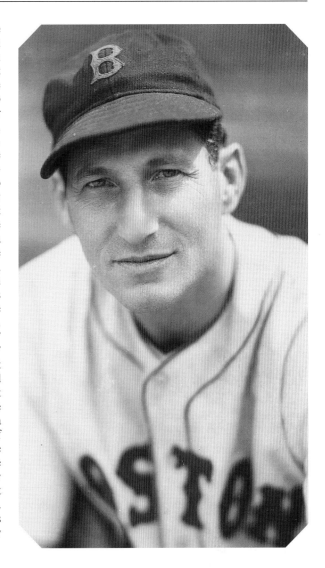

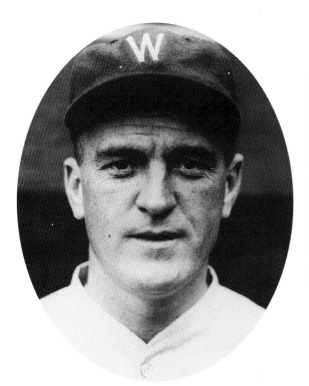

97. JOE JUDGE *(Left)* [Joseph Ignatius Judge; 1B; 1915–34; WAS (A), BKN (N), BOS (A)]. Although he stood but five-eight and change, the diminutive Joe Judge stood tall indeed as a first baseman—for 20 years, tying the major league record for first-base longevity. Handling the bag with a sure-handedness and grace, Judge led the American League six times in fielding, an AL record. His agility saved Walter Johnson's only no-hitter when, on the afternoon of July 1, 1920, against Boston, he made a diving stab at a wicked bounder off the bat of Harry Hooper for the final out. But not to be overlooked was Judge's lefthanded stickwork. Nine times he batted over .300, including .324 and .314 averages in the Senators' pennant-winning years of 1924 and '25—and contributed ten hits in the '24 Series to lead the Senators to their only World Series win.

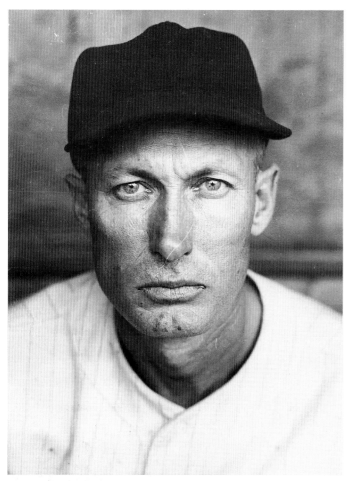

98. SAM RICE *(Left)* **[Edgar Charles Rice; OF; 1915–34*; WAS (A), CLE (A)].** Rare indeed is it when any of today's fans recognize the name Sam Rice. But only a handful of players, the name of every one of them memorized and spat out as part of baseball's mantra, had more hits than Rice's career 2,987. Sam Rice was a superstar in the 1920s, his hit total for the decade surpassed only by Rogers Hornsby. And his record for most singles in a season, 182, although since eclipsed, gives further testimony to his handiness with the bat—and to his manner of hitting: a slap single. Twice the lefthanded-hitting Rice led the American League in hits, once in doubles and once in stolen bases, and yet he never won a batting title even though he batted over .300 in 15 seasons—one of only five players with 2,500 hits and a career batting average of over .300 who never won a batting title. Rice was also an excellent fielder, swift and with a strong and accurate arm. Rice was the party of the second part to one of the most disputed—and one of the greatest—catches in World Series, and baseball, history. To set the scene: with a 4-3 lead in the third game of the '25 Series, Washington manager Bucky Harris moved the speedy Rice to right field lest one of Pittsburgh's lefthanded sluggers catch one of pitcher Firpo Marberry's fastballs and drive it into right. Sure enough, Pirate catcher Earl Smith caught hold of one and sent it sailing on a line toward right center, heading off in the direction of the temporary bleachers. Rice, taking off with the crack of the bat, back to the ball, caught sight of the ball about ten feet in front of the bleachers. Making a leap of faith, Rice backstabbed at the ball with his gloved left hand and then, coming down five feet in front of the wall, hurtled the three-foot protective barrier like a river without banks and disappeared, seconds later to emerge holding up his trophy. And although the Pirates were to argue loud and long that such a catch was "impossible," and that a fan had to have retrieved the ball and handed it to Rice, Smith was called out. (The controversy would continue until after Rice's death in 1974 when a letter left by Rice at the Hall of Fame would be opened and would reveal, in Rice's words, that "At no time did I lose possession of the ball.") Five years later, at the age of 40, Rice told *Baseball Magazine,* "I can still smack the ball" and then went out to prove it by batting .349 with 207 hits. He amassed another 354 hits over the next four years until, at the age of 44, he finally retired with several more hits left in his bat but still 13 shy of the magic 3,000-hit mark.

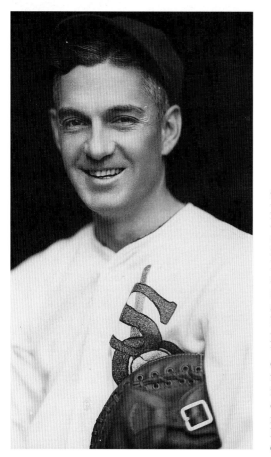

99. MUDDY RUEL *(Left)* **[Herold Dominic Ruel; C; 1915, 1917–34; STL (A), NY (A), BOS (A), WAS (A), DET (A), CHI (A)].** Called "Little Muddy from Big Muddy" by sportswriter Bill Corum, Muddy Ruel acquired his unique nickname as a child after falling into a mud puddle near his house in St. Louis. A 150-pound iron man, the five-foot-nine-inch Ruel shuttled among eight teams (including Boston twice and St. Louis twice) during his 19-year career, but was best known as Walter Johnson's batterymate during his eight-year stay with the Washington Senators. It was while at Washington that a young George Pipgras came to bat against Johnson and, after taking two pitches for called strikes, stepped out of the batter's box. Turning to a smiling Ruel, Pipgras said, "Muddy, I never saw those pitches." Ruel, who had heard the same plaint from others, responded, "Don't worry, he's thrown a few that Cobb and Speaker are still looking for." Ruel's greatest moment came in the seventh game of the 1924 World Series when, after going for the Series collar, he singled in the eighth inning to set up the tying run and then, in the twelfth, after being reprieved when Hank Gowdy tripped over his mask and dropped his high foul, doubled down the third-base line and later scored the winning run on Earl McNeely's hit—the one that struck a pebble and bounced over Freddie Lindstrom's head—winning the game for his batterymate, Walter Johnson, even though he only batted .095 for the Series.

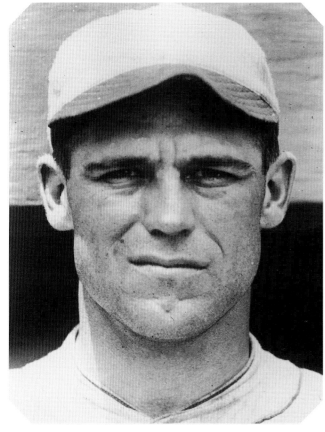

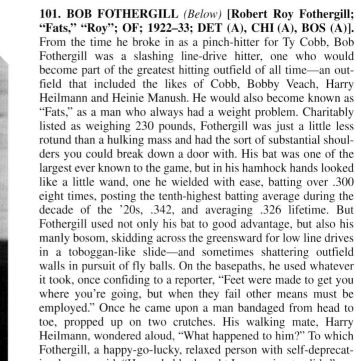

101. BOB FOTHERGILL *(Below)* **[Robert Roy Fothergill; "Fats," "Roy"; OF; 1922–33; DET (A), CHI (A), BOS (A)].** From the time he broke in as a pinch-hitter for Ty Cobb, Bob Fothergill was a slashing line-drive hitter, one who would become part of the greatest hitting outfield of all time—an outfield that included the likes of Cobb, Bobby Veach, Harry Heilmann and Heinie Manush. He would also become known as "Fats," as a man who always had a weight problem. Charitably listed as weighing 230 pounds, Fothergill was just a little less rotund than a hulking mass and had the sort of substantial shoulders you could break down a door with. His bat was one of the largest ever known to the game, but in his hamhock hands looked like a little wand, one he wielded with ease, batting over .300 eight times, posting the tenth-highest batting average during the decade of the '20s, .342, and averaging .326 lifetime. But Fothergill used not only his bat to good advantage, but also his manly bosom, skidding across the greensward for low line drives in a toboggan-like slide—and sometimes shattering outfield walls in pursuit of fly balls. On the basepaths, he used whatever it took, once confiding to a reporter, "Feet were made to get you where you're going, but when they fail other means must be employed." Once he came upon a man bandaged from head to toe, propped up on two crutches. His walking mate, Harry Heilmann, wondered aloud, "What happened to him?" To which Fothergill, a happy-go-lucky, relaxed person with self-deprecating humor, said, "He probably thought I was going to slide."

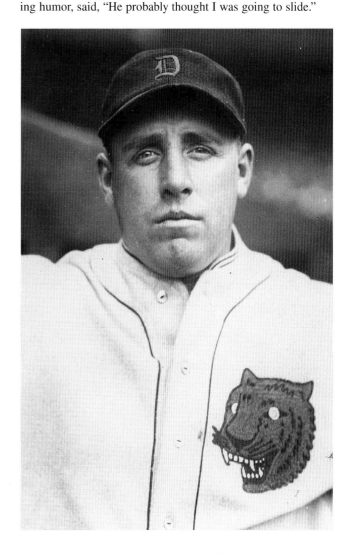

100. GEORGE SISLER *(Above)* **[George Harold Sisler; "Gorgeous George"; 1B; 1915–22, 1924–30*; STL (A), WAS (A), BOS (N)].** A much sought-after pitching prospect, the young Sisler followed the breadcrumbs and his college coach, Branch Rickey, from the halls of higher learning at the University of Michigan to the lower depths of the American League, joining the more-than-depleted ranks of the perennially second-division St. Louis Browns in 1915. But despite a 2.83 ERA in his rookie year, Rickey decided that Sisler's bat was far too valuable to keep out of the lineup and converted him into the Brownies' regular first baseman. Choking up on his bat and spraying hits to all fields, by 1917 Sisler had become the second-leading batsman in the American League and by 1920 the premier lefthanded batter in all of baseball. That season, playing every inning of every game, Sisler set the all-time, all-time record for most base hits in a season, with 257, and led the majors with a .407 batting average. Two years later, hitting in a then-record 41 consecutive games, he led the league in hits, doubles, runs, stolen bases and batting average (with .420), and took the Browns to within one game of the pennant. Over that three-year span, from 1920 through '22, Sisler eclipsed his crosstown rival, Rogers Hornsby, batting .400 to Hornsby's .390, to establish himself as the outstanding batter in baseball. However, before the '23 season, Sisler was afflicted with an eye ailment caused by severe sinusitis that forced him to sit out the season. And although he never regained his keen batting eye, he managed to hit .300 in six of his remaining seven seasons in the majors, finishing with a lifetime .340 average. As a gloveman he rated in a class with Hal Chase and Bill Terry, leading the league in assists eight times. A quiet, retiring sort, Sisler served as the Browns' playing-manager for three seasons, finishing in the first division twice, and is the only Hall of Famer to have two sons (Dick and Dave) who also played in the majors.

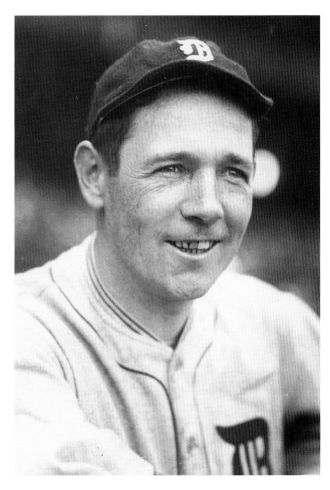

102. HARRY HEILMANN *(Right, top)* **[Harry Edwin Heilmann; "Slug"; OF; 1914, 1916–30, 1932*; DET (A), CIN (N)].** For the better part of six seasons Harry Heilmann labored—both in the batter's box and in the vineyards of the Detroit organization, rotating between the outfield and first base, where his glove was almost as lethal a weapon as his bat. But then, under the tutelage of new Tiger manager Ty Cobb, who took over in 1921 and showed Heilmann the finer points of batting, Heilmann went on to become one-third of Detroit's all-.300-hitting outfield and the American League's premier batsman. Twelve times a .300 hitter and one time a .400 hitter, Heilmann won four batting titles—almost like an alternating current, winning in 1921, '23, '25 and '27—and compiled the American League's highest batting average for the decade of the twenties: .364. After his playing days were over, Heilmann became the popular radio voice of the Tigers for 17 years.

103. CHARLIE DRESSEN *(Right, bottom)* **[Charles Walter Dressen; "Chuck"; 3B; 1925–31, 1933; CIN (N), NY (N)].** After playing for the Reds and the Giants for eight less-than-memorable years—and putting in three years as a quarterback in the fledgling National Football League—Chuck Dressen turned his attention, and his talents, to coaching and managing. Starting with Nashville in the Southern Association in 1932, Dressen's long odyssey took him to Cincinnati, Nashville, Oakland, Brooklyn, Washington, Milwaukee, Detroit and New York. But Brooklyn was where he had his greatest success—and greatest heartbreak—winning two pennants in three years and an almost-pennant, losing to the Giants and his former boss, Leo Durocher, on Bobby Thomson's famous "Shot Heard 'Round the World" in 1951. Dressen was one of the greatest practitioners of the now-lost art of signal stealing, a subtle form of larceny that enables teams to pilfer signs and, with them, games. Dressen, who put great faith in his own resourcefulness—even going so far as to tell his troops, "Stay close, boys, I'll think of something"—was so proud of his prowess that when he addressed his National League All-Star team before the 1953 game, he told them, "Don't worry about the signals. I'll give each of you the signals you use on your own team." However, Dressen's abilities failed him twice. Once, back in 1940, then coaching for Brooklyn, Dressen, who habitually stole the catcher's signs and the pitcher's delivery and communicated them to the batter from his third-base coaching position, began to signal to Joe Medwick, recently acquired from the Cardinals, telling him every pitch the Cardinal pitcher, Bob Bowman, was about to throw. Every time Bowman began to throw a curve Dressen saw it coming and whistled up to Medwick, telling him the curve was on the way. So Don Padgett, who was catching for St. Louis, went out to the mound and told Bowman to hold the ball like he was going to throw a curve and then throw his fastball. As Bowman went into his next delivery, holding the ball like a curveball but intent on throwing a fastball, Dressen whistled and Medwick stepped directly into the pitch, taking it in the head and precipitating a free-for-all. The second failure occurred in the 1953 World Series, when Dressen had the tables turned on him. Billy Martin, who had played under Dressen at Oakland, noticed that Dressen was flashing the sign for a squeeze bunt. Martin turned the stolen signal into a rally-killing out, assuring the Yankees of a victory over the Dodgers, in both the game and the Series. At the end of the '53 season, Dressen's wife stole the signals coming from Brooklyn president Walter O'Malley's office and had Chuck insist upon a multi-year contract instead of the one-year pact O'Malley usually tendered to his managers. O'Malley, hearing from the Dressens, also turned the tables—releasing Dressen and signing Walter Alston instead to a one-year contract.

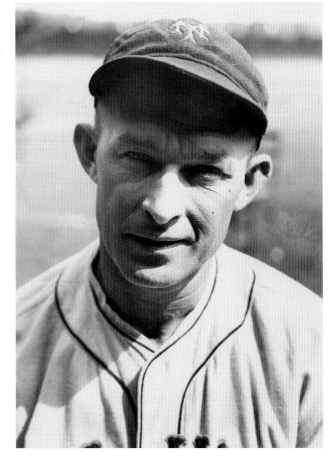

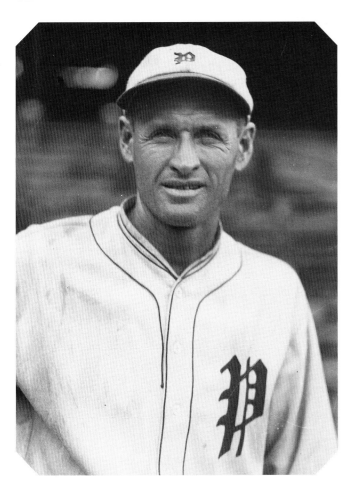

104. CY WILLIAMS *(Left)* **[Fred Williams; OF; 1912–30; CHI (N), PHI (N)].** One of the most overlooked players of the twenties—or any era for that matter—Cy Williams was the National League version of Babe Ruth. Williams played for one of the most god-awful teams of his day, the Phillies, who, during his 13 years there, finished 13 times in the second division, eight of them in last place, and changed managers almost as often as they changed their socks, once a year, Williams playing for 12 in 12 seasons. Williams was almost the entire Philadelphia offense, one time, 1927, out-homering the rest of the team. Opposing teams adopted special defenses just for him, including loading up the right side of the infield in the first "Williams Shift," years before Lou Boudreau ever thought of doing the same for another Williams, Ted. Still, with a swing tailor-made for the little Baker Bowl bandbox, the lefthanded pull-hitter led the National League in home runs four times and 11 times finished among the top three HR hitters in the league, setting records for grand slams, inside-the-park home runs and pinch-hit homers that stood for almost three decades.

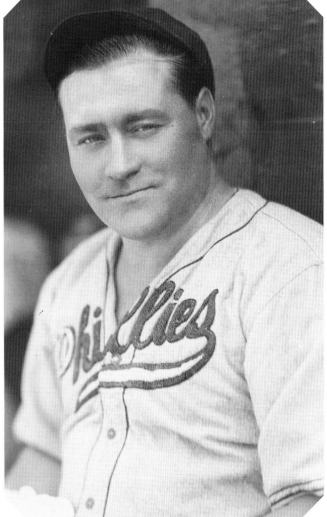

105. HACK WILSON *(Right)* **[Lewis Robert Wilson; OF; 1923–34*; NY (N), CHI (N), BKN (N), PHI (N)].** A little fireplug of a man who had a build referred to in ready-made clothing catalogues as "portly," Lewis Robert Wilson, better known as "Hack"—in tribute to the man reputed to be the strongest man in the world, wrestler George Hackenschmidt—combined the smallest feet (shoe size six), the biggest thirst and the heftiest swing in the history of baseball, both in one tightly-knit five-foot-six-inch package. A highball hitter both on the field and off, Wilson went on his merry, making the Roaring Twenties roar a little louder. But it was his exploits on the field that caught the eye of the baseball world and of the record bookkeepers. Four times this little man with iron-band-like muscles and the top-heavy torso of a blacksmith led the National League in home runs and twice in runs batted in. But it was the year 1930 that cemented his credentials as one of baseball's all-time all-timers, a season that saw this one-man wrecking crew set the National League record for most homers in a season with 56 and set the major league record for most ribbies in a season with 190, 35 more RBI's than games played that year. Sadly, by the next season, 1931, he had allowed gin to be his tonic and there was more than a slight leavening of his skills, his reign of terror turning into a drizzle. His home-run total fell to 13, his RBI total to 61 and his batting average from a once-healthy .356 to an anemic .261. Three years later, by now 35 going on Vat 69, Hack Wilson was out of the majors, finishing up his baseball career at Albany where he was cut to make room for a recently released inmate from Sing Sing, "Alabama" Roy Pitts—an ignominious ending to a once-glorious career.

107. TONY LAZZERI *(Below)* **[Anthony Michael Lazzeri; "Poosh 'Em Up"; 2B; 1926–39*; NY (A), CHI (N), BKN (N), NY (N)].** Playing for Salt Lake City in the Pacific Coast League in 1925, Lazzeri set records for batting productivity with 60 home runs, 222 runs batted in and 202 runs scored. Brought up to the Yankees the next year, Lazzeri anchored both the infield and the lower part of the batting order for the team that became known as "Murderer's Row." In the final game of the '26 Series, Lazzeri came to bat in the bottom of the seventh against Grover Cleveland Alexander with the bases full of Yankees and two out. With the count one-and-one, Alexander threw in a fat fastball that the righthanded-hitting Lazzeri drilled down the left field foul line, inches foul. Alexander came back with a low curve that one writer described as something even "the Singer Midgets couldn't have hit," and Lazzeri fished for it and missed. That, for all intents and purposes, was the game. And the Series. Later, when asked about Lazzeri's just-foul drive, Alexander replied to one pencil-pusher, "One foot makes the difference between being a hero and a bum." But Yankee manager Miller Huggins had the best postscript to Lazzeri's almost-heroic moment: "Anyone can strike out, but ballplayers like Lazzeri come along once in a generation." And for the rest of the generation, or for 12 years with the Yankees, Lazzeri posted Hall of Fame numbers, with seven 100-RBI seasons, becoming the first major leaguer to hit two grand slams in one game and setting the still-standing record for most RBI's in an American League game, with 11. This despite the fact that the popular Italian hero was an epileptic whose affliction would cause his death in a fall in 1946.

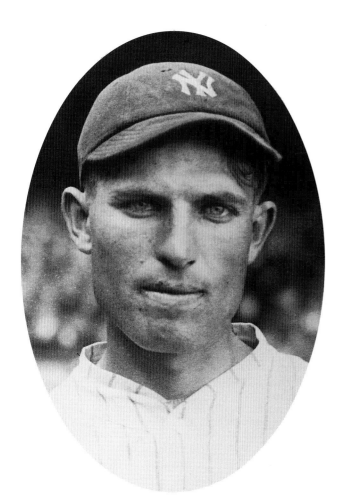

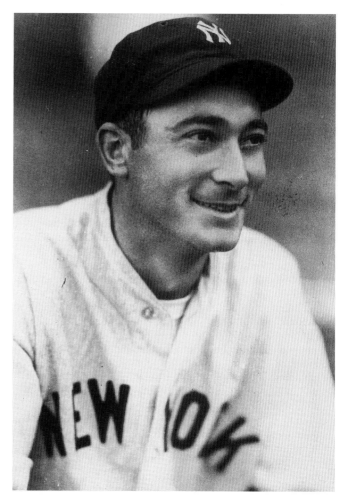

106. MARK KOENIG *(Above)* **[Mark Anthony Koenig; SS; 1925–36; NY (A), DET (A), CHI (N), CIN (N), NY (N)].** Mark Koenig is most identified with the "Murderer's Row" teams he played on, the 1926, '27 and '28 Yankees. And yet his place in baseball history is just as firmly fixed as being the "cause" of Babe Ruth's "called shot" in the '32 Series. For that was the year the Cubs' second-year shortstop, Billy Jurges, was shot and wounded at Chicago's Carlos Hotel by showgirl Villet Popovich Valli. The matter was hushed up, euphemistically reported in the papers as an "untimely injury." But whatever it was, it put the Cubs in the position of desperately seeking an experienced shortstop for their stretch drive. They came up with Koenig, then plying his trade with the San Francisco Missions in the Pacific Coast League to which he had been relegated, like last year's suit, by the Detroit Tigers at the beginning of the season. Brought up on August 5, 1932, all Koenig did was anchor the infield, hit a solid .353 in 33 games and spark the Cubs to the pennant. For his efforts Koenig was voted a mere half-share of the Cubs' pennant and World Series moneys. This sparked the ugly name-calling contest between his new teammates and his former teammates that went by the name of "World Series" and culminated in Ruth's "called shot."

108. FREDDIE LINDSTROM *(Right)* [Frederick Charles Lindstrom; "Lindy"; 3B; OF; 1924–36*; NY (N), PIT (N), CHI (N), BKN (N)].** Signed right out of Chicago's Loyola Prep, young Freddie Lindstrom made his debut for the pennant-winning Giants of 1924, just in time to fill in at third base for the injured Heinie Groh. In so doing, he became the youngest player ever to play in a World Series, at the age of 18 years, ten months and 13 days. Lindstrom would play all seven games of the Series, leading off and getting ten hits—many of them legged-out infield hits. He would also become party of the second part to a pebble. That historic meeting of pebble and player occurred in the seventh and deciding game of the Series versus the Washington Senators, first, in the bottom of the eighth inning when, with the Giants ahead 3-1 and the bases loaded, Washington manager–second baseman Bucky Harris bounced a sharp chopper down the third-base line. Just as Lindstrom reached down for the ball with the delicious expectation of a clerk grabbing at his weekly pay envelope, the ball hit a pebble and bounced over his head, allowing the Senators to score two runs, knotting the game at three-all. Four innings later, with Washington monument Walter Johnson having meanwhile held the Giants scoreless, the Senators mounted another rally. And, with runners at first and second and two outs in the bottom of the 12th, Earl McNeely slashed a bouncing ball down the third-base line, almost a twin brother to Harris' shot four innings before. Lindstrom again reached down to pick up the hopper when Mother Fate again intervened, rather heavy-handedly, and the ball again struck a pebble—who knows if it was the same pebble in which the Senators had already established a proprietary interest?—and again bounded over Lindstrom's head for the winning run. Lindstrom played another dozen years in the majors, seven times hitting .300—once, in 1930, hitting .379 as he set a major league record with three five-hit games during the season and once having eight hits in a double header. Hindered by a bad back, he was moved to the outfield in 1931 and, with his speed, became one of the leading ballhawks in the National League. Bitterly disappointed that Bill Terry and not he had been selected as John McGraw's

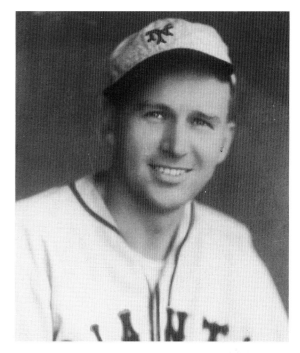

replacement in 1932, he asked Terry to trade him. His wish was accommodated during the '32 off-season as part of a three-cornered trade that saw him go to Pittsburgh. Four years later, as a member of the Brooklyn Dodgers, Lindstrom watched as a short fly fell in front of him for a hit on a ball he would once have caught with ease. After the game, Lindstrom strode into the clubhouse and announced, "I'll be a son of a gun. I heard about these things happening in Brooklyn, but I never thought they would happen to me. And I'll tell you, it's never going to happen again." And with that, the one-time "boy" third baseman took off his uniform and never put it on again.

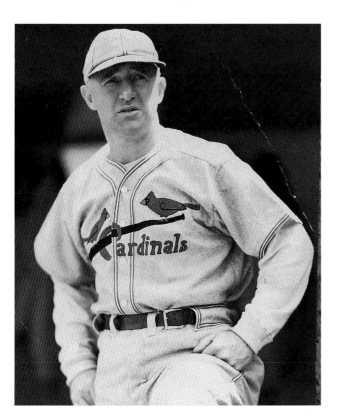

109. FRANKIE FRISCH *(Left)* [Frank Francis Frisch; "The Fordham Flash"; 2B; 1919–37*; NY (N), STL (N)].** Signed right off the Fordham campus, Frankie Frisch brought his hustle and competitive spirit right to the New York Giants, firing and inspiring them to four straight pennants in the early '20s. A cross-handed switch-hitter, Frisch batted over .300 13 years and led the National League in stolen bases three times— and still holds the record for second basemen for assists and chances in a season. Traded to the St. Louis Cardinals after the 1926 season for St. Louis' beau idol Rogers Hornsby, Frisch "didn't make them forget the Rajah, but he made them remember the Flash," said longtime St. Louis sportswriter Bob Broeg. Becoming playing-manager of the Cardinals in 1933, Frisch was a part of, and helped to fashion, the famous "Gashouse Gang," a team of American tintypes that included the likes of the Dean Brothers, Pepper Martin, Joe Medwick, Leo Durocher and Ripper Collins that went on to beat Mickey Cochrane's Tigers in the '34 World Series—the last time two full-time playing-managers met in the Series.

111. LEFTY GROVE *(Below)* **[Robert Moses Grove; "Mose"; P; 1925–41*; PHI (A), BOS (A)].** The man called "Mose" might have been the "mostest" pitcher ever to take his place on the mound. By the time this talented, volatile left-hander came up to the Athletics in 1925—part of a rookie pledge class that also included future Hall of Famers Mickey Cochrane and Jimmie Foxx—he had won 108 games pitching for Jack Dunn's great International League Baltimore Orioles team. The A's never regretted paying more than $100,000 for him as he immediately made his mark on big league batters with his rip-roaring fastball and crackling curve, leading the American League in strikeouts his very first year. That was to be the first of seven straight years he would lead the league in K's. Add to that his seven straight 20-game seasons, eight in all, nine times leading the league in ERA, the most-ever by any pitcher, and five times leading the league in winning percentage and you get an idea of why Ted Williams said of Grove, "Nobody could throw the baseball any harder." Or better, as attested to by his having more wins and the best winning percentage of any pitcher during the decade of the thirties. In fact, no pitcher with 300 wins has a better won-lost record than Grove.

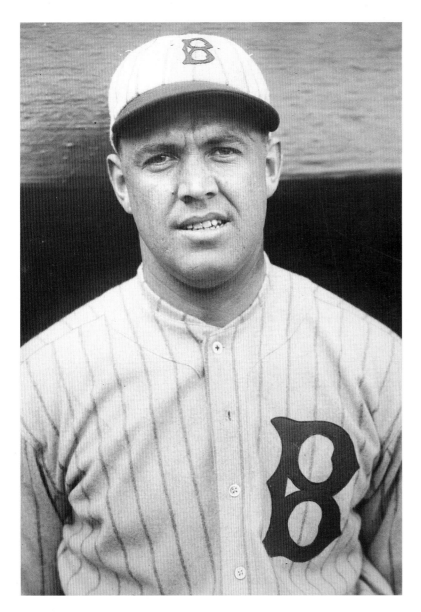

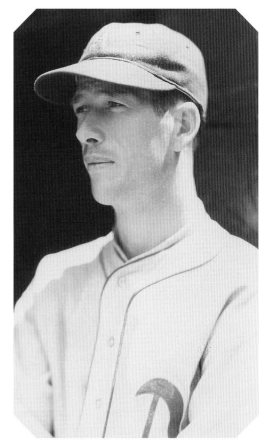

110. BURLEIGH GRIMES *(Above)* **[Burleigh Arland Grimes; "Ol' Stubblebeard"; P; 1916–34*; PIT (N), BKN (N), NY (N), BOS (N), STL (N), CHI (N), NY (A)].** Burleigh Grimes was an anachronism. The last of the legal spitball pitchers—a mixture of slippery elm and saliva—Grimes was also a throwback to the good old days when bench jockeying and baiting recalled the worse excesses of the French Revolution. Called "Ol' Stubblebeard" for his perpetual five-o'clock shadow which only added to his belligerent presence on the mound, Grimes was as black of heart as he was of beard, using his tongue as well as his spitball. Ornery and cantankerous, Grimes would employ language that would have caused a Billingsgate fisherman to blush. He also used a high hard one aimed at the head to keep a batter from digging in. In fact, it was said that Grimes's idea of an intentional pass was four pitches thrown at the batter's head. A five-time 20-game winner, Grimes had the most wins and second-most strikeouts of any pitcher during the twenties. And the most aggressive tongue in the history of baseball.

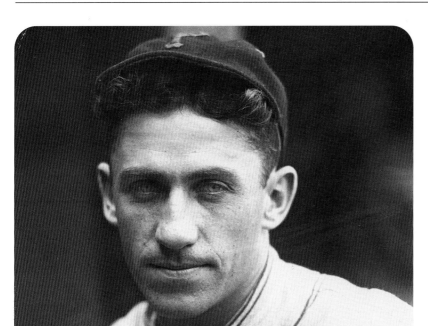

112. KIKI CUYLER *(Left)* **[Hazen Shirley Cuyler; "Cuy"; OF; 1921–38*; PIT (N), CHI (N), CIN (N), BKN (N)].** The man with the ear-pleasing nickname—a nickname he came by naturally, stemming as it did from the repetitive calling of his shortened last name, "Cuy," by other teammates calling out to him—more than sounded like a star, he was one. And looked like one. With his pants lined around his knees—not in the bloomer-like effect so common back in those days—Cuyler cut quite a dashing figure, both figuratively and literally, as he dashed around the field, lifting his legs high when he ran and giving the impression of a pacing horse. A fan favorite, Cuyler combined hustle with a free-swinging style, leading the National League in stolen bases four times and hitting .300 ten times on his way to a .321 lifetime average. And yet, in one of baseball's most puzzling incidents, the player who had won the 1925 World Series for the Pirates was benched before the '27 Series. As one of the stories of the time goes, rookie manager Donie Bush wanted Cuyler to move up in the batting order, from his normal third spot to the second position, and Cuyler bridled at the change. As a consequence, Bush benched him for his insubordination. Traded the following season to the Chicago Cubs, Cuyler returned to his normal third spot in the batting order and to his normal stats, posting five more .300 seasons and three more times leading the League in stolen bases as he helped the Cubs win two pennants.

113. PIE TRAYNOR *(Right)* **[Harold Joseph Traynor; 3B; 1920–35, 1937*; PIT (N)].** Considered by many as the all-time third baseman—at least until the coming of Brooks Robinson—"Pie" Traynor was the complete player, both afield and at bat. In the field Traynor set all the National League records for most putouts, including the all-time National League mark, and for double plays, leading the league four straight years. But it was at the plate that Traynor made his greatest marks, albeit his batting exploits were continually overshadowed by his teammates, Paul and Lloyd Waner. A line-drive hitter who constantly made contact—striking out only 278 times in 17 years, including only seven times in 497 at-bats in 1929—Traynor sprayed hits all over spacious Forbes Field. Ten times he batted over .300 and five times over .330, his average for the six years, 1925 through 1930, a healthy .342. Still, in his best year, 1930, his .366 average was eclipsed by "Big Poison" (Paul Waner), who outhit him by two points. Traynor finished his career with 2,416 hits, a .320 lifetime average and 2,291 putouts at third base and was elected to the All-Time Team in 1969, commemorating baseball's centennial.

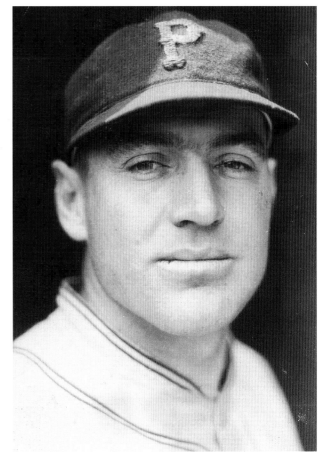

114. TED LYONS *(Right)* **[Theodore Amar Lyons; P; 1923–42, 1946*; CHI (A)].** Signed by the White Sox immediately after graduating from Baylor University, young Lyons, without ever pitching in the minors, pitched in the very first major league game he ever saw, retiring the first three men he faced. For the next seven years he was the workhorse of a perennial second-division team, twice leading the American League in innings pitched and in wins. In 1931, Lyons came up with a sore arm and lost his blazing fastball. After his manager, Donie Bush, pronounced his arm "dead," Lyons began experimenting and came up with a pitch that prolonged his career, a knuckler. No longer the mainstay of the pitching staff, Lyons instead became a "spot" pitcher, that spot being Sundays when, in a reverse Melina Mercouri syndrome, the White Sox used him only once a week, *always* and only on Sundays, thus saving his arm and taking advantage of his enormous popularity to attract adoring Sox fans. From 1939 through '42, pitching no more than 22 games a season, Lyons returned to the winning side of the ledger, capping his career by starting and finishing 20 games in 1942 and leading the American League in ERA at the age of 41, the oldest pitcher ever to do so. Lyons returned, at the age of 45, after serving three years in the Marines during World War II, to pitch in five more games during the '46 season, all five, as per invoice, complete games. And although he was to win only one, it was his 260th win, making him the then seventh-winningest righthanded pitcher in modern baseball—and, with the exception of Walter Johnson, the pitcher with the most wins on losing teams.

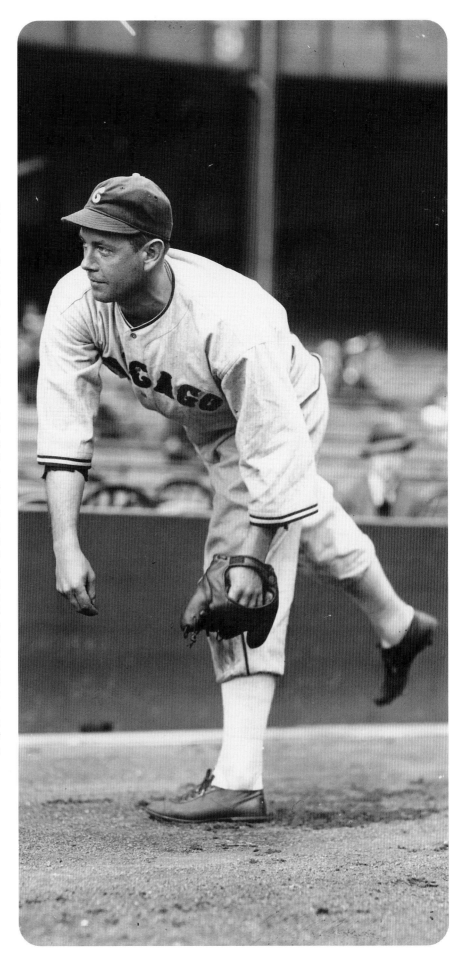

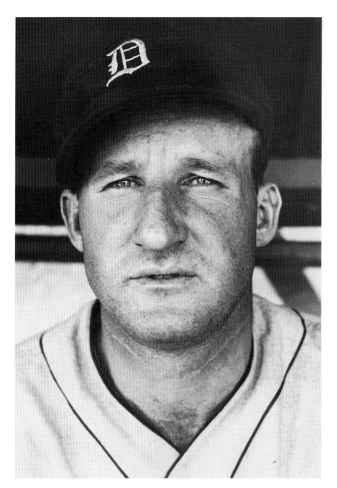

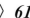

115. GOOSE GOSLIN *(Left)* **[Leon Allen Goslin; OF; 1921–38*; WAS (A), STL (A), DET (A)].** The "Goose" earned his nickname both from his last name and from his unique fielding style, one of chasing fly balls with his arms flapping, like a human goose chasing after his flock. But this no-field, all-hit outfielder more than made up for his inadequacies afield with his bat work, hitting over .300 11 times during his 18-year career, including a league-leading .379 in 1928, beating out Heinie Manush by just .0017 in one of the closest batting races in history. But it was in World Series play that the "Goose" flew highest, playing in five fall classics—three with the Washington Senators and two more with the Detroit Tigers—driving in a total of 18 runs with seven homers and winning the 1935 Series with a game-winning hit in the sixth game.

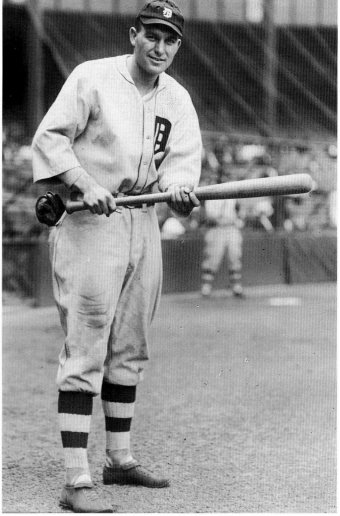

116. HEINIE MANUSH *(Right)* **[Henry Emmett Manush; OF; 1923–39*; DET (A), STL (A), WAS (A), BOS (A), BKN (N), PIT (N)].** Brought up by the Detroit Tigers in 1923 after batting .376 with Omaha of the Western League in '22, Manush broke into the talented Tiger outfield with a .334 batting average in his freshman year, the sixth-highest batting average by an American League rookie. And yet, it was the third-highest average that year by a Tiger outfielder, behind center fielder Ty Cobb's .340 and right fielder Harry Heilmann's league-leading .403. For the next four years, despite a combined .319 average—including a league-leading .378 in 1926—the slashing lefthanded Manush was overshadowed by his fellow outfielders and had to wait until he was traded, first to St. Louis and then to Washington, to gain fame as a hitter. In 1928, he again batted .378, but lost the batting title to Goose Goslin in one of the closest batting races in history, by .17 of a percentage point. In 1930 he was traded to the Senators for the same Goslin and in 1933, batting safely in 33 consecutive games, he finished second in batting to Jimmie Foxx and led the Senators to their last-ever pennant. In game four of the '33 Series, when Manush, protesting a call by umpire Charley Moran in the sixth inning, pulled the umpire's bow tie and let the elastic band snap back into Moran's neck, he was ejected, the first player ever thrown out of a Series game. Eleven times Manush batted over .300, twice leading the league in doubles and once in batting, six times scoring 100 or more runs and twice batting in over 100. But he will always be remembered for *not* being remembered as one of the future greats in a great Detroit Tiger outfield.

117. LOU GEHRIG *(Above)* **[Henry Louis Gehrig; "Columbia Lou," "The Dutchman," "The Iron Horse"; 1B; 1923–39*; NY (A)].** From the very first day Lou Gehrig took his place at first base—May 31, 1925, courtesy of the most famous headache in sports history, the one suffered by Wally Pipp—the youngster called "Columbia Lou" was destined to play in the rather ample shadow of the man he called "The Big Guy," Babe Ruth. For the next ten years he was to bat number 4 to Ruth's number 3 in the Yankee batting order. And for most of those ten years he was to stand behind the Babe in statistics and the public eye as well. By 1927 the two had become the heart of the Yankees' famed "Murderer's Row," with Ruth hitting 60 home runs and Gehrig a runner-up 47—the next closest home-run total being fellow Yankee Tony Lazzeri's 18. However, '27 was the season when Gehrig proved that he was a jewel in his own setting as he led the league in RBI's with 175 and was named the league's MVP. Still,

it usually seemed that Gehrig was forever doomed to be the crown prince in Ruth's sultanate—or to stand in someone's shadow, Ruth or no Ruth, as when in 1932 he became the first player in the twentieth century to hit four home runs in a game. Unfortunately, it happened the same day John McGraw stepped down as manager of the New York Giants after 31 years in the saddle. And it happened again when, finally, Ruth left the team and Joe DiMaggio came up. Still, until the day he asked to be taken out of the lineup, on May 2, 1939, Gehrig was baseball's "Iron Man," for 2,130 consecutive games. Two years later, the man who had proclaimed himself to be "the luckiest man on the face of the earth" died from the effects of the disease that still carries his name. But he is survived by his records—including his records of most grand-slam home runs and most RBI's for a season in the American League—and the legend of the quiet man who put in an honest laboring man's effort, each and every game.

118. LEFTY O'DOUL *(Below)* **[Francis Joseph O'Doul; P; OF; 1919–20, 1922–23, 1928–34; NY (A), BOS (A), NY (N), PHI (N), BKN (N)].** Originally signed by the San Francisco Seals in 1917 as a pitcher, O'Doul first saw his major league light of day in 1919 with the Yankees. But over the next three years he was thought to have little diamond presence and less of a future as Yankee manager Miller Huggins used him but five times in two seasons. Optioned back to San Francisco in '21, O'Doul put together a 25-6 year and came back up to the Yankees for one last look-see. But he was barely seen before he was sent packing to the pitiful and pitiable Boston Red Sox in a trade that fetched the Yankees third baseman Joe Dugan. While with the Red Sox, O'Doul had a day that was well worth the forgetting. Taking the mound on July 7, 1923 to face the Indians in the sixth inning, O'Doul faced 16 Cleveland batters and gave up 13 runs, a negative major league record that still stands. It was all too clear that O'Doul was now a finished pitcher, in the truest meaning of the phrase. The next year, sent back down, O'Doul announced to his manager that he was no longer a pitcher—a moot point—and was now an outfielder. He made his point, hitting .392 in 140 games for Salt Lake City and started his second career, one that propelled him back into the major leagues where, in seven years, he would bat .353, win the batting title twice and set the still-standing National League record for hits in a season, with 254. His lifetime batting average of .349 is the second-highest, behind Joe Jackson's .356, of any player *not* in the Hall of Fame. In later years O'Doul would become known as the Man in the Green Suit, a hero in his hometown of San Francisco where he managed the Seals of the Pacific Coast League from 1935 through 1951.

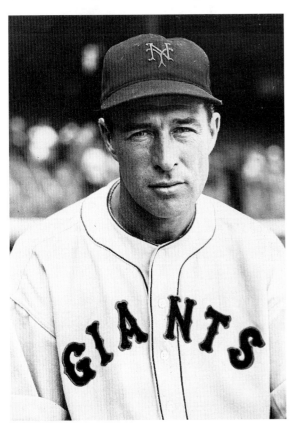

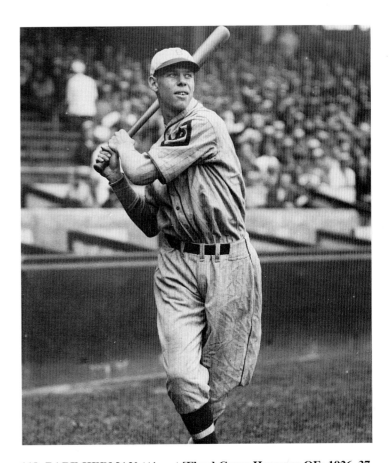

119. BABE HERMAN *(Above)* **[Floyd Caves Herman; OF; 1926–37, 1945; BKN (N), CIN (N), CHI (N), PIT (N), DET (A)].** Back in the mid-twenties, that decade known as "The Era of Wonderful Nonsense," none were more wonderful than the boys from Brooklyn, then called the Robins, after their manager, Wilbert Robinson. They were also named "The Daffiness Boys," a tribute to their exploits. And no one was to give that group of life's losing stuntmen more color than Floyd Caves "Babe" Herman. Teammate Dazzy Vance once said of Herman, "The Babe is a hard guy to outthink, because how can you outthink a guy who doesn't think?" Watching Herman run the bases—where he was twice passed by teammates who had hit homers, turning the four-baggers into outs—Vance called him "The Headless Horseman of Ebbets Field." But Herman was far from a slouch in the batter's box, Rogers Hornsby calling him "the perfect free swinger." The lefthanded-hitting Herman coupled a well-timed swing with tremendous power. Even today, more than a half-century after he last played, Herman still is the all-time Dodger leader in slugging percentage, with .557, and is credited with the highest-ever batting average for any Dodger, .393 in 1930. But Herman's fame rests not on his hitting, but on his other skills. Or lack thereof. For in that double-entry bookkeeping system that entraps all baseball enthusiasts, Babe Herman's deficiencies in the field and on the base paths leave his account sorely in the red. As John Lardner once wrote, "Floyd Caves Herman did not always catch flyballs on the top of his head, but he could do it in a pinch." Herman's most famous exploit came on August 15, 1926, when, running with his head down after a wall-cracking hit, he arrived on third with two bemused teammates. Despite rumors to the contrary, Babe Herman did not triple into a triple play; he merely doubled into a double play. Or, as sportswriter Jim Murray put it, "Herman doubled to load the base." Herman came back for a short encore during the war year of 1945, playing for Brooklyn, mostly as a pinch hitter. In his first at bat, he singled cleanly, only to fall over first base at the completion of his "trip." That, more than anything, summed up Floyd Caves "Babe" Herman.

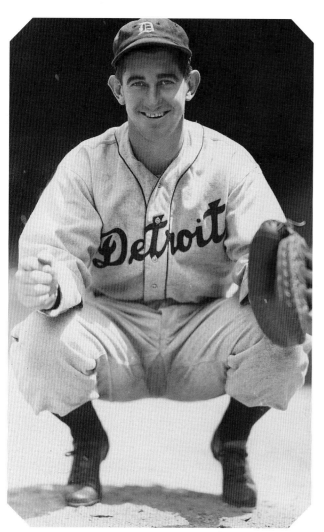

120. MICKEY COCHRANE *(Left)* [**Gordon Stanley Cochrane; "Black Mike"; C; 1925–37*; PHI (A), DET (A)].** Baseball lore has it that Connie Mack wanted the scrappy, lefthanded-hitting Cochrane so badly that he bought the entire Portland club of the Pacific Coast League in order to get the talented, all-around athlete who had once drop-kicked a 52-yard field goal for Boston University and was then hitting .333 for Portland. His investment, said to have run upwards of $200,000, paid off handsomely as Cochrane's leadership and fiery play led the A's to three consecutive pennants and two World Championships. During those three championship seasons, 1929 through 1931, Cochrane, batting third in the batting order, hit for an average of .345, drove in a total of 269 runs and scored 310 times. Averaging 129 games a season behind the plate, he led the League in fielding all three years. He followed that up in '32 by becoming the first catcher in history to both score and bat in more than 100 runs a season. But after one more season, Mack, forced by the Depression to sell off his stars in a rummage sale to stave off bankruptcy, sold Cochrane to the Detroit Tigers for the princely sum of $100,000. Installed as both their starting catcher and manager, Cochrane quickly turned the Tigers into winners, leading them to the 1934 and '35 pennants and capping his successful run by scoring the winning run in the '35 Series to beat the Cubs and bring Detroit its first-ever World Championship. Cochrane's active career came to a close in May of 1937 when his skull was fractured by an errant pitch thrown by Yankees pitcher Bump Hadley, leaving him unconscious for ten days.

121. CHARLIE GEHRINGER *(Right)* [**Charles Leonard Gehringer; "The Mechanical Man"; 2B; 1924–42*; DET (A)].** Charlie Gehringer was baseball's version of "The Quiet Man," a player who, according to his then-manager, Mickey Cochrane, "Says 'hello' on Opening Day, 'good-bye' on closing day and in between hits .350." Well, not quite .350 every year, attaining that mark only three of the 13 times he passed .300. But one of those times, in 1937, he hit a career-best .371, winning the batting title and the MVP award. However, Cochrane was right on with his reference to Gehringer's taciturnity. His silence was as well documented as his batting average, with few ever having heard him say an encouraging word—or a discouraging one for that matter. One time, as they used to tell the story, he and pitcher Chief Hogsett, another candidate for clam of the year, were dining together when Hogsett leaned across the table and said in the direction of Gehringer, "Charlie, please pass the salt." Gehringer stiffened and made no effort to comply with the request. The meal continued as it had started: in silence. Finally, a hurt Hogsett asked Gehringer, "Did I say something wrong?" Gehringer, after a moment's consideration, responded, "You could have pointed." But for 19 years baseball pointed to the best second baseman in the game, Charlie Gehringer, "The Mechanical Man," who was so mechanical, teammate Doc Cramer said, "You wind him up on Opening Day and forget him." Few did.

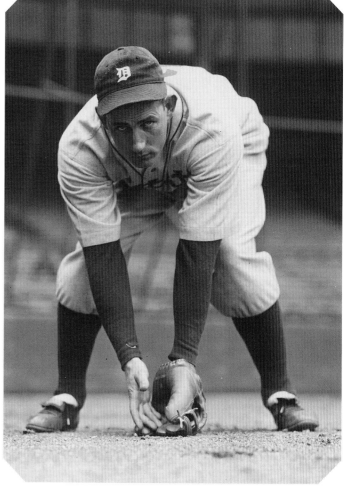

122. AL SIMMONS *(Right)* **[Aloysius Harry Simmons; "Bucketfoot"; OF; 1924–41, 1943–44*; PHI (A), CHI (A), DET (A), WAS (A), BOS (N), CIN (N), BOS (A)].** Al Simmons earned his nickname by virtue of his unusual batting style, one which saw him violate a basic tenet of hitting by stepping away from home plate and striding toward third—or, as old-timers would have it, "putting his foot in the bucket." But this imperfect style gave rise to a nearly perfect hitter, one who, during his 20-year career, smote more than 200 hits in each of six—five of them consecutive—seasons, and set records for most hits and most singles by a righthanded batter (253 and 174) in 1925, just his second year in the majors. His manager, Connie Mack, after watching his one-man wrecking crew at work, refused to alter Simmons' style. During his nine-year career with the great Athletics teams of the late twenties and early thirties, Simmons twice led the American League in batting and twice in hits, and batted .358 overall. Simmons was one of the lightning conductors in the greatest comeback ever staged, the ten-run rally in the fourth game of the 1929 Series that gave the A's a 10-8 win over the Chicago Cubs. Leading off in the seventh, with the score 8-0, Cubs, Simmons drove one of Charlie Root's fast ones high atop Shibe Park's left field roof. However, even Simmons was underwhelmed by his accomplishment, audibly muttering to himself as he returned to the dugout, "You dumb Polack, of all the times to waste a home run!" But Simmons' homer had sounded the first gun of a rallying army and nine men later Simmons himself came back to bat and his single continued the assault, setting an all-time World Series record for most total bases in an inning. Although he was to finish 73 hits short of his announced goal of 3,000 hits, Simmons' all-out aggressive play and warrior-like persona was appreciated by all who had seen him, most notably his manager, Connie Mack, who once, when asked who was the most valuable player he had ever managed in his 50-year career, said, without blinking an eye, "If I could only have nine players named Simmons."

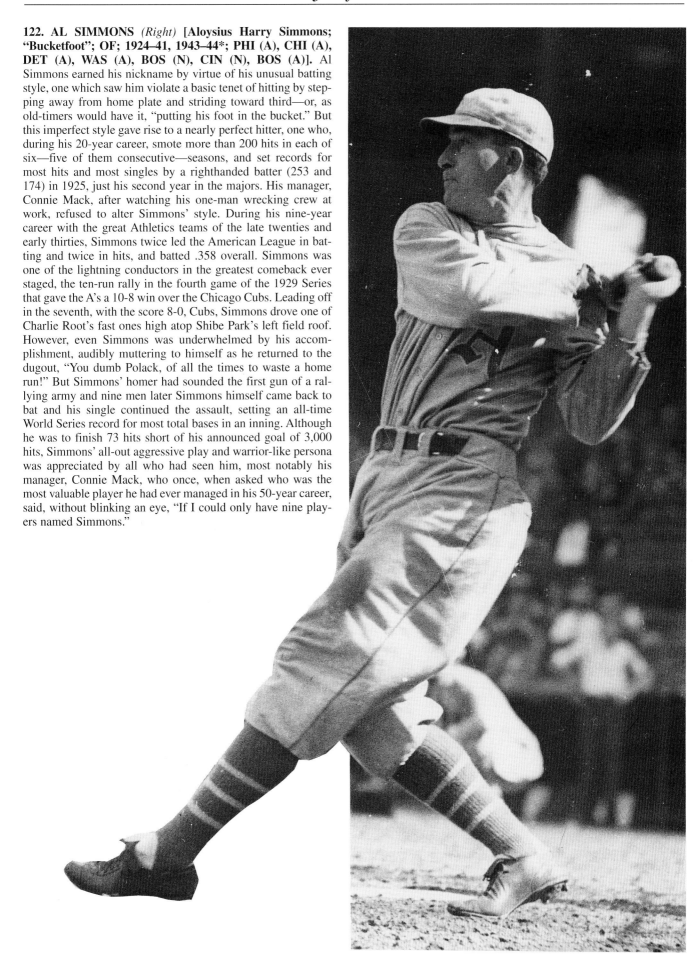

123. JIMMIE FOXX *(Right)* **[James Emory Foxx; "Double X," "Foxie," "The Beast"; 1B; 1925–42, 1944–45*; PHI (A), BOS (A), CHI (N), PHI (N)].** The man known as "The Beast" might well have been the most powerful slugger in baseball history, Babe Ruth included. With his sleeves cut off at the shoulders, all the better to bare his Sequoia-like arms, Foxx was the very picture of a home-run slugger: manly, muscular and menacing. It is not so much the mere number of drives he smote—he had 12 consecutive 30-home-run seasons, the most home runs in two consecutive seasons (106) and 534 lifetime—as the sheer power with which he smote the ball that earns him serious consideration as baseball's greatest slugger. In Chicago, they marked the spot where his ball cleared the double-decked Comiskey Park left field stands; in Yankee Stadium, his blast landed in the upper left field bleachers, breaking a seat; in Detroit, he hit one of the longest balls ever seen in the Motor City, way into the upper left field bleachers. Everywhere he went the righthanded-hitting Foxx drove Roy Hobbsian–like drives into the outer reaches. And beyond. But the man who could hit the twine off the ball could hit for average as well, 13 times hitting over .300 and twice winning the batting title and once the Triple Crown. Baseball's first three-time MVP winner, Jimmie Foxx was the broadest back in baseball's broad-back home-run attack back in the thirties, outdistancing the field with his long-distance shots—and hitting 68 more than Lou Gehrig, his nearest competitor during the decade.

124. PAUL WANER *(Opposite, left)* **[Paul Glee Waner; "Big Poison"; OF; 1926–45*; PIT (N), BKN (N), BOS (N), NY (A)].** If the Macmillan *Baseball Encyclopedia* ever listed "hangovers" among its many statistics, then the all-time leader in that category would easily be Paul Waner. For no player ever nursed more than Waner, who once, when asked how, if he was so hung over so often, he ever managed to meet the ball, answered, "I see three and hit the one in the middle." But Waner, who knew plenty about the brew of the night meeting the cold of the day, had his own remedy for sobering up before games. According to Buddy Hassett, his roommate with the Braves, Waner would do backflips, "fifteen or twenty minutes of backflips and he was cold sober, ready to go out to the ballpark and get his three hits." However, Waner didn't confine his tippling to off the field, but managed on the field as well, having a well-placed "gofer" bring him a bottle of beer every time he gave him a signal, whether in the dugout or in the clubhouse. But wherever he got it, it never seemed to bother Waner, who hit the ball at a merry clip, line drives to all fields, many of them doubles—62 in one season and 603 lifetime. Waner had his own philosophy for hitting doubles. As he told teammate Tommy Holmes: "Look, there are three men in the outfield. Why should we hit it where they are? Shoot for the foul lines. If you miss, it's just a foul ball. If you get it in, it's a double. And if it goes into the stands, don't worry, we don't pay for the baseballs." Together with his 603 doubles, Waner also had 190 triples and 3,152 hits, leading the National League in hitting three times and batting over .330 nine times. Not bad for a man who "hit the one in the middle." Once, after he had publicly proclaimed he was going on the wagon, his batting average plummeted into the .250 range. At that point, his manager personally escorted him to the nearest purveyor of spirits for a pick-me-up. Within a few short weeks, Waner's average had picked itself up to its normal .330-plus level. Waner was also known for something else as well: his maxims. An avid reader, he would come up with his own versions of truisms, such as, "You know, they say money talks. But the only thing it ever says to me is 'Good-bye!'" However, it wasn't something Waner said, but something said about him that gave him his nickname. One time at that outdoor psychiatric ward known as Ebbets Field, one Brooklyn fan moaned, "Them Waners!" speaking of Paul and his younger brother Lloyd. In that special dialect that passes for English and goes by the name of Brooklynese, he continued, "It's always the little poison on thoid and the big poison on foist!" And so, from that day on, Paul became "Big Poison" and his brother, "Little Poison." Big Poison once confided to a teammate: "I used to hold out every year, but if they'd known the truth of it, I would have played for nothing." An appropriate comment from the man christened Paul Glee Waner who did everything for the hell of it, both on and off the field.

125. LLOYD WANER *(Below)* [**Lloyd James Waner; "Little Poison"; OF; 1927–42, 1944–45*; PIT (N), BOS (N), CIN (N), PHI (N), BKN (N)**]. The younger member of one of the most famous brother acts in all of baseball, young Lloyd made his debut with Pittsburgh in 1927. And made history as well, with a rookie record 223 hits—197 of them singles, an all-time major league mark—leading the league in runs scored and batting .355, third highest in the league (behind Rogers Hornsby, with .361, and his older brother, Paul, with a league-leading .380). For the next two seasons "Little Poison," a line-drive hitter, sprayed hits all over spacious Forbes Field, one of the handful of major leaguers ever to have 600 hits in their first three years. Yet Lloyd never again batted as high as he had in his rookie season— although he batted .309 or better in ten of his 18 seasons. Always in the shadow of his older brother, "Big Poison" Paul, Lloyd played side-by-side with him in the Pirates' outfield for 14 seasons and then joined up with him twice more, with the Braves in 1941 and with the Dodgers in '44. He was elected into the Hall of Fame in 1967—15 years after his older brother, naturally.

126. BILL DICKEY *(Right)* **[William Malcolm Dickey; C; 1928–43, 1946*; NY (A)].** Bill Dickey was one of baseball's great unsung heroes. Always playing in the shadow of some other Yankee legend—be it his roommate, Lou Gehrig, or Babe Ruth or Joe DiMaggio—the quiet Dickey batted in their shadow as well, hitting behind them in the batting order. But as quiet as he was, Dickey, normally hitting sixth in the lineup, spoke eloquently with his bat, with a career average of .313, ten times hitting over .300 and, in 1936, batting .362, the highest average ever for a modern day catcher. Dickey, who averaged 120 games a season behind the plate for some of the greatest teams in baseball history—and never played another position during his 17-year career—was renowned as one of the best ever to handle a pitching staff, including the eccentric Señor, Lefty Gomez. And overshadowed as he was by the other members of "Murderer's Row," Dickey still managed, quietly, to hit 202 home runs during his career—four times hitting more than 20—and drive in more than 100 runs in four seasons and 24 more in World Series play. Quite an accomplishment for baseball's quiet man.

127. LEFTY GOMEZ *(Left)* **[Vernon Louis Gomez; "The Gay Castillion," "Goofy"; P; 1930–43*; NY (A), WAS (A)].** According to wit Heywood Broun, being lefthanded is merely a state of mind. However, one "lefty" who really thought lefthanded was Vernon "Lefty" Gomez, one of baseball's reigning pitchers—and reigning wits—for the better part of ten years. One time, asked to take a salary cut—as much the result of a poor season as the effect of the Depression—from $20,000 to $7,500, Gomez told Yankee General Manager Ed Barrow, "Tell you what, you keep the salary and pay me the cut." However, poor years were few and far between for the irrepressible lefty who won 20 games four times during the '30s, led the league twice in winning percentage, three times in shutouts, and twice in ERA. A member of seven pennant-winning teams, Gomez's 6-0 record in World Series competition is the most wins without a loss in World Series history. And his All-Star Game credentials include throwing the very first pitch in the very first game, starting five of the first six games, winning the most All-Star Games, three, and, despite his anemic lifetime .147 batting average—and admitting the only bat he ever broke was "backing out of the garage"—driving in the very first run in All-Star competition. As his fast ball lost its effectiveness—"I'm throwing as hard as I ever did, the ball's just not getting there as fast"—Gomez reverted to a slow, tantalizing curve ball, one he rode to a 15-5 record in 1941, one of those 15 wins being an 11-walk shutout, the most-ever allowed in a shutout. By that time his career was winding down, but even then he approached it with humor, saying, "I'm responsible for Joe DiMaggio's success. They never knew how he could go back on a ball until I pitched."

128. BEN CHAPMAN (*Below*) [**William Benjamin Chapman; OF; 1930–41, 1944–46; NY (A), WAS (A), BOS (A), CLE (A), CHI (A), BKN (N), PHI (N)**]. Always on the brink of falling into his own volcano, Ben Chapman was a league-leading base stealer and thrower of major league temper tantrums. Famous for his own specialized brand of derring-do on a Yankee team known as "Murderer's Row," Chapman's fiery baserunning and equally fiery play were the perfect complements to the team's raw power. Moved by new Yankee manager Joe McCarthy from third base to the outfield to take advantage of his speed and arm, Chapman roamed the outfield and basepaths with a verve unseen in the "liveball" era, leading the league in assists two years and stolen bases three—including 61 in '31, the most stolen bases in 11 years and a figure not to be reached again for another dozen. But his most memorable moment came in what *The New York Times* called "a rollicking melee" in 1933 when Buddy Myer of the Senators kicked Chapman in the back, setting off a riot, with both Myer and Chapman being ejected from the game. On his way off the field, Chapman lingered long enough in front of the Senators' bench to hear a few choice words from pitcher Earl Whitehill and the "melee" was on again, this time ending only when the police intervened. Finally, after five years of enduring Chapman and his outbreaks, McCarthy had had enough and traded him to the Senators in mid-'36. And it seemed that every year thereafter, despite batting around .300 every season, Chapman was always on the move, other managers and front offices unable to handle his outbreaks any better. After playing for six teams in six seasons, Chapman finally filtered down to Richmond in the Piedmont League as a pitcher-manager. But, in his first season as manager, he got into an altercation and was suspended for a year for punching an umpire. Chapman returned to the Dodgers as a pitcher during the war-depleted year of 1944 and by 1945 had surfaced as pitcher-manager of the Philadelphia Phillies, where his dark side took over once again. He is best remembered for his vicious baiting of Jackie Robinson—which included releasing a black cat across the rookie's path. Embarrassed by Chapman's volcanic eruptions, the Phillies, like all teams before them who had tried to control the uncontrollable, finally bade a not-so-fond "adieu" to this once-talented player.

129. RED RUFFING (*Above*) [**Charles Herbert Ruffing; P; 1924–42, 1945–47*; BOS (A), NY (A), CHI (A)**]. Brought up in 1924 by the woebegone Boston Red Sox, then languishing firmly in seventh, Red Ruffing would pitch on some of the awfulest teams in baseball history, the Red Sox of the late twenties—which, starting in 1925, finished in last place for his next five seasons, seasons in which Ruffing averaged over 18 losses a year, twice leading the league in that negative department. But, on May 6, 1930, the Red Sox, desperate, as always, for a cash transfusion, sold Ruffing to the New York Yankees for 50,000 Hoover dollars and substitute outfielder Cedric Durst. By the end of the year Durst was out of the majors and Ruffing, getting a second lease on life, had become the Yankees' big winner. For the remainder of the decade Ruffing would become the mainstay of the Yankees' pitching staff, leading the majors in most wins and most strikeouts by a righthander over the next ten years and leading the Yankees to four straight pennants in the late thirties—winning 20 or more games in each pennant-winning season, including a league-leading 21 in 1938. Despite a boyhood accident that cost him four toes on his left foot, Ruffing got a firm toehold at the plate, one of only three pitchers, Walter Johnson and Cy Young being the others, to have over 250 wins *and* over 500 hits. Eight times he batted over .300 and won the second game of the 1937 Series with two hits, singling in the go-ahead run and then doubling in two insurance runs while holding the Giants to one run and nine hits.

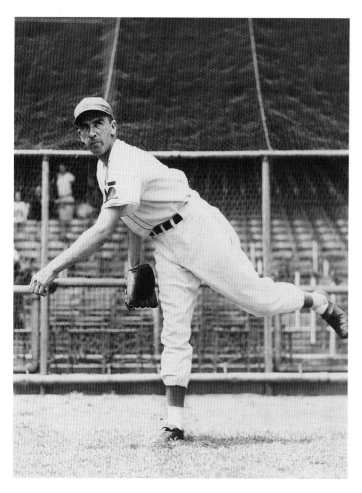

130. CARL HUBBELL *(Above)* **[Carl Owen Hubbell; "King Carl," "The Meal Ticket"; P; 1928–43*; NY (N)].** Carl Hubbell was known for one of the most villainous pitches ever thrown, a lefthanded variant of Christy Mathewson's famed "fadeaway," one that had the opposite effect of a normal lefty's curve, breaking down and in on lefthanded batters and outward and away from righthanders. The pitch—called, for reasons never fully explained, the "screwball"—became the inspiration for Larry Clinton's popular song of the 1930s, "The Dipsy-Doodle." Hubbell alternated the "screwball" with a breaking curve thrown with a slow, cartwheel-like delivery and excellent control, which he rode to the most wins in the National League during the decade of the thirties, racking up the lowest ERA in the majors and being twice voted the NL MVP. With batters unable to find his offerings with a Geiger counter, Hubbell won 20 games five years in a row. He holds the major league record with 24 consecutive wins—16 in a row in 1936 and eight more to open the '37 season—leading the National League in wins and winning percentage both seasons. Hubbell's greatest moment—and one of baseball's—came in the 1934 All-Star Game when he struck out, in order, five of the most feared hitmen this side of Cicero, Illinois—Babe Ruth, Lou Gehrig, Jimmie Foxx, Al Simmons and Joe Cronin, future Hall of Famers all. But it made no never mind to Hubbell, future Hall of Famer or no, as batter after batter watched the strange pitch and took their cuts, all looking as if they were shoveling smoke rather than swinging at the "screwball."

131. TRAVIS JACKSON *(Opposite, top left)* **[Travis Calvin Jackson; "Stonewall"; SS; 1922–36*; NY (N)].** John McGraw painstakingly built his great New York Giant teams player by player, almost as if they were building blocks, until he was satisfied he had constructed a team worthy of the name "Giants." And so it was when late in the 1923 season he inserted a youngster named Travis Jackson at shortstop to replace future Hall of Famer Dave Bancroft—much as he would bring in other soon-to-be-great rookies like Mel Ott, Freddie Lindstrom and Bill Terry in years to come and in so doing perpetuate the great Giant tradition of winning. Jackson soon proved himself to be the mortar of the team, batting over .300 six times and leading the league in assists four times, double plays an equal number of times, and in fielding average and double plays twice. And, to prove McGraw correct, he helped lead the Giants to four pennants and one World Series.

132. MEL OTT *(Opposite, bottom)* **[Melvin Thomas Ott; "Master Melvin," "Ottie"; OF; 1926–47*; NY (N)].** Sometime during the late thirties, so the story goes, famed New York restaurateur Toots Shor, then talking to Sir Alexander Fleming, the discoverer of penicillin, was told by the maître d' that Giant Mel Ott had just walked through the door of his watering hole. "'Scuse me," Shor growled at the giant of medicine, "somebody important just came in." Mel Ott was *that* important to New Yorkers of the 1930s. And to the whole world of baseball. From the day he first reported to the New York Giants in 1925 as a 16-year-old fuzzy-faced lefthanded catcher with the funny hitch-step in his swing, the man-boy referred to by the press as "Master Melvin" was something special. Manager John McGraw kept him seated on the bench next to him for the remaining part of the 1925 season and through most of the next, using him sparingly—and when he did, "Master Melvin" responded by getting 23 hits in 60 at-bats for a .383 average. By 1927 he was playing more and by 1928, at the tender age of 19 he had broken into the Giants' outfield, batting .322. He would hit 42 homers in '29 and over the next 16 seasons hit 20 or more homers 14 times, all coming off that peculiar right-foot-lifted-high-into-the-air swing, a perfect swing for the Polo Grounds' nearby 257-foot-high wall. Over the course of his career Ott would stroke 511 home runs, 323 of them coming in the Polo Grounds, the most home runs hit in one ballpark by any major leaguer. Ott would lead the National League six times in home runs—although, truth be told, he shared that lead with others three times. In 1942, the man who had sat, literally, at the knee of McGraw, took over as manager of the Giants upon Bill Terry's move to the front office. However, during his seven years at the helm of the Giants, his most lasting contribution to baseball lore came during the 1946 season when Dodger manager Leo Durocher, in answer to a question by sportswriter Frank Graham as to "Why won't you be a nice guy and admit you're wrong?" to some point or other answered in an arm-waving tirade that ended, "I don't want to be a nice guy. Who ever saw a nicer guy in baseball than Mel Ott?" pointing to the opposing dugout. "And where is he?" which Graham translated as the time-honored "Nice guys finish last." Ironically, when Ott was fired in 1948 he was replaced by, you guessed it! Leo Durocher.

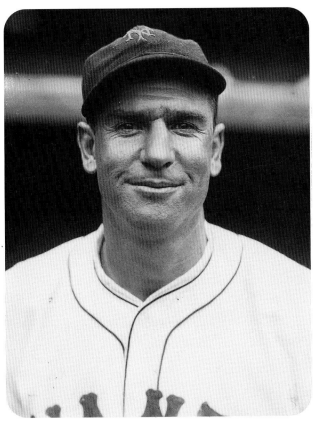

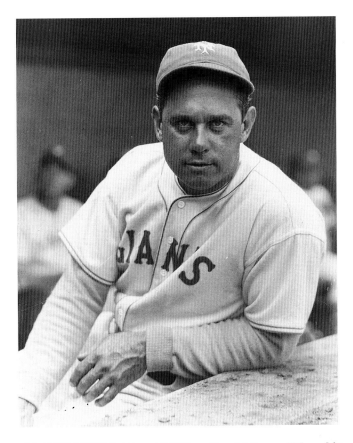

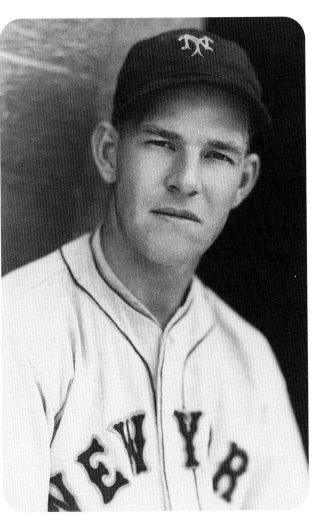

133. BILL TERRY *(Above)* [**William Harold Terry; "Memphis Bill"; 1B; 1923–36*; NY (N)**]. All anyone who has doubts about who the best hitter was during the decade of the thirties has to do is refer to the record books where the name Bill Terry is writ large—both as the last National Leaguer to hit .400 and the player with the highest batting average for the decade, .352. And if there was any question at the time, all one had to do was ask Bill Terry himself, who arrogantly would tell any and all within earshot that he was, simply, the best. But this proud and vain man also was crusty and unsociable, to the point where he rarely, if ever, talked to reporters beyond calling attention to his batting feats. He merely let his bat talk for him. And talk it did, as he batted over .300 11 times, winning the 1930 National League batting title with a .401 average—and tying the all-time National League hit record with 254—and losing the 1931 batting title to Chick Hafey in the closest race in National League history, by just .03 of a percentage point, .3489 to .3486. A lefthanded line-drive hitter, Terry exploited the cavernous Polo Grounds with its deep power alleys to line doubles and triples into the gaps rather than pull for its short right field stands. In his 11th season he stepped into the rather large shoes of John McGraw, who had stepped down on June 3, 1932, and, in his first full season as playing manager of the Giants, led them to the 1933 pennant and the World Championship. Unfortunately, the man who rarely spoke to the press did utter one comment that would come back to haunt him. Before the '34 season, when asked about Brooklyn's chances, he joked, "Is Brooklyn still in the league?" That ill-fated preseason taunt played itself out in the last two games of the season when the Dodgers beat the Giants in both games and cost the Giants the pennant. Or, as the press would have it, Terry's arrogance cost them the pennant. The press would more than repay Terry in kind for his high-handed treatment of them by refusing to vote him into the Hall of Fame during his years of eligibility, Terry having to wait 18 seasons after retiring from the game before the Old Timers' Committee recognized the importance of his contributions—if not of his self-importance.

134. LEO DUROCHER *(Below)* **[Leo Ernest Durocher; "The Lip"; SS; 1925, 1928–41, 1943, 1945*; NY (A), CIN (N), STL (N), BKN (N)].** Known during his playing days as "The All-American Out" as well as one of the brashest players ever to come down baseball's long turnpike, Durocher combined a weak stick—hitting over .260 only five times in 17 years—with acrobatic glovework. But it was as an umpire-baiting manager that Durocher made his name. And his fame. Beginning his managerial career in 1939, when he took over the reins of a Brooklyn team that had finished seventh the year before, Durocher brought his special brand of fire to the Dodgers, whipping, exhorting and cajoling them first to third place, then to second in his second season and, in his third, in 1941, to the top of the National League mountain. Over many of the next 24 years, with the exception of 1948 when he was suspended for "associating with known gangsters," the man who had labeled rival manager Mel Ott a "nice guy"—as in "Nice guys finish last"—proved his less-than-nice-guy approach to managing begot results. It certainly did in 1951 when he brought the Giants back from a 13½-game deficit to overtake the Dodgers in "The Miracle of Coogan's Bluff." All in all the fiery Durocher won 2,010 games, the 6th-most number of games won by a manager.

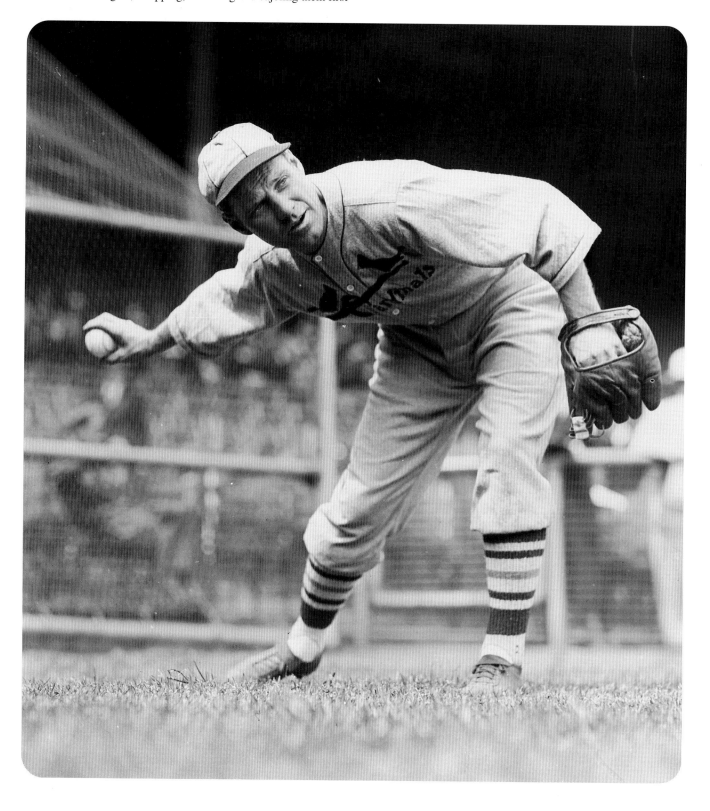

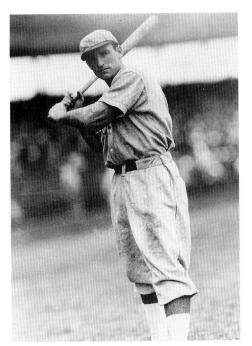

135. PEPPER MARTIN *(Left)* [**John Leonard Roosevelt Martin; "The Wild Horse of the Osage"; OF; 1928, 1930–40, 1944; STL (N)**]. If, as has been suggested by numerous writers, baseball is a microcosm of life itself, then it was no coincidence that the hero of the World Series of 1931—the bleakest year in our economic history—was a dirty-faced, underpaid, hungry-looking outfielder from the Oklahoma Osage, one who had entered baseball riding the rails of a freight train: John Leonard Roosevelt Martin, a player whose nickname was almost as picturesque as his exploits. "Pepper" Martin's achievements are accorded no special place of prominence in the Macmillan *Baseball Encyclopedia*. His 16 lines are sandwiched somewhere between the records of Jerry Martin, a National League outfielder some 30 years later, and Stu Martin, a Cardinal teammate. But no player so captured the fancy of the public, fan and nonfan alike, as the perpetual-motion machine who literally stole (single-handedly—*and* footedly) the 1931 World Series from the heavily-favored Philadelphia Athletics, with twelve hits in 24 at-bats, five runs scored, five batted in and five bases stolen. All with his patented belly-flop slide and without an athletic supporter. It seemed Martin stole everything but A's catcher Mickey Cochrane's wallet—and became, in the process, the toast of the country. His audacity even continued off the field. When Commissioner Kenesaw Mountain Landis, as caught up in the drama as any ordinary fan, sought out the hero of the Series and offered his hand, saying "Young man, I'd like to be in your place . . . ," the brash Pepper, in keeping with his nickname, just grinned and retorted, "Well, Judge, tell you what . . . I'll swap places. And salaries. My $4,500 for your $65,000." That was Pepper Martin, whose wildcatting, dare-as-you-please baserunning made him the hero of the thirties. And one of baseball's rare characters.

136. DIZZY DEAN *(Right)* [**Jerome Hanna Dean; P; 1930, 1932–41, 1947*; STL (N), CHI (N), STL (A)**]. Dizzy Dean was an American original, the most popular player of the '30s, a brazen, I-can-do-it braggart who put his arm where his mouth was years before Joe Namath and Muhammad Ali learned how to. A member of a group of ragtag renegades known as "The Gas House Gang," who looked like they had just stepped out of a Dick Tracy comic strip, Dean dominated National League batters for five full years with a blazing fastball and dazzling curve. And then, in the '37 All-Star Game, an Earl Averill line drive gave him a fractured toe to go with his fractured English. Coming back before his digit had healed, Dean altered his delivery and, by doing so, injured his arm. Traded to the Cubs before the '38 season for three players and $185,000, Dean relied on a slow curve and a tantalizing change-up to chalk up seven wins and help Chicago to the National League pennant. After two more seasons, and a combined 9-7 record, Dean was released, only to come back for one more major league appearance in a St. Louis uniform—this time with the Brownies—before turning to the microphone where he mangled the English language (saying things like "he slud into second") delighting a whole new generation of fans.

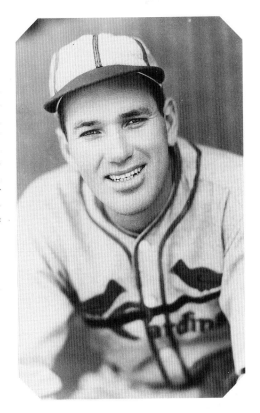

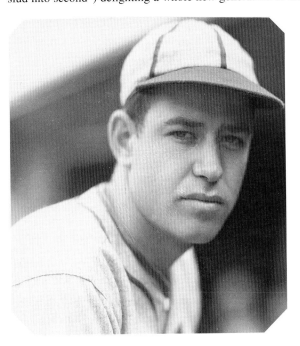

137. PAUL DEAN *(Left)* [**Paul Dee Dean; "Daffy"; P; 1934–41, 1943; STL (N), NY (N), STL (A)**]. When Paul Dean was brought up by the Cardinals in 1934, his older brother "Dizzy" brashly proclaimed, "Me 'n' Paul will win 45 games." They didn't; they won 49, 30 by Dizzy and 19 by his younger brother, by now called "Daffy" by the unimaginative press. "Daffy" would go on to win two games over the Tigers in the '34 Series, to go with his brother's pair, and win 19 more in his sophomore season. In '36 he held out and then, trying to pitch too soon, hurt his arm. He would win just 12 more games over the next seven years.

138. MOE BERG *(Right)* **[Morris Berg; C; 1923, 1926–39; BKN (N), CHI (A), CLE (A), WAS (A), BOS (A)].** A mediocre player who played 15 years in the big leagues, Moe Berg is the subject of two of the best baseball quotes ever. The first came in a telegram from Mike Gonzalez, who, after scouting Berg, sent a wire with four deathless words: "Good field, no hit." The other is attributed to outfielder Dave ("Sheriff") Harris, who, after being told that Berg, a graduate of Princeton, could speak seven languages, supposedly retorted, "Yeah, but he can't hit in any of them." Described by Casey Stengel as "the strangest man ever to play baseball," Berg served as a member in good sitting for five clubs, alternately performing as part-time raconteur, part-time catcher and full-time ballbag custodian—perhaps his most important task on the team, according to teammate Ted Williams, a chore that required him to watch over the team's baseballs in a day and age when baseballs, at $1.50 a throw, were the team's most precious commodity. Berg was a part-time spy as well. During an exhibition tour to Japan in 1934, the third-string catcher with the lifetime .243 batting average spent most of his time in the bell tower of Saint Luke's Hospital shooting pictures of downtown Tokyo, pictures that later were the basis of Jimmy Doolittle's bombing raid over Tokyo in 1942. Or so the story goes. During the War, Berg performed espionage work for the OSS, the predecessor of the CIA, work he would cryptically refer to in his storied story-telling sessions. When one critic chastised him in later life for having "wasted" his time playing baseball, Berg, who was also trained as a lawyer, replied, "I'd rather be a ballplayer than a justice on the U.S. Supreme Court."

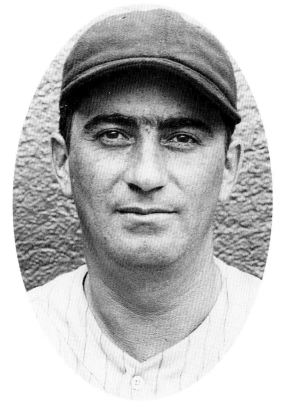

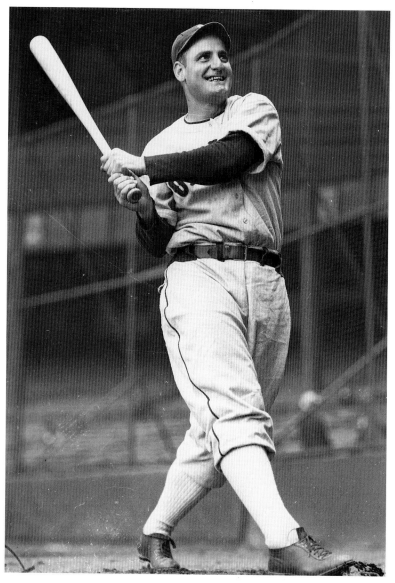

139. ZEKE BONURA *(Left)* **[Henry John Bonura; "Banana Nose"; 1B; 1934–40; CHI (A), WAS (A), NY (N), CHI (N)].** Called "Banana Nose"—as much for his family's business in New Orleans as for his schnozz—Zeke Bonura was a bunch of fun, a one-of-a-kind, happy-go-lucky player. His bat was a lethal weapon, enabling him to hit .300 in four of his seven seasons in the "Bigs" and become the White Sox' first home-run hitter, hitting 27 in his rookie year. Unfortunately, his glove was almost as lethal, as he waved at passing ground balls in what the press called a "Mussolini Salute," his feet permanently cemented near the bag. Bonura played enthusiastically, always pounding his infrequently used glove and shouting encouragement no matter what the situation. One time, with the bases loaded and two out, the batter dribbled a ball in Bonura's general direction. Zeke pounced on the ball and picked it up. But the ball failed to cooperate and popped out of his glove. Once more Bonura scooped it up, and once more it dropped out. Then he managed to kick it around a little, giving an imitation of Charlie Chaplin trying to pick up his hat. By the time Bonura had finally found the handle, all three base runners had crossed the plate and the batter was heading toward third. Zeke took a bead on third and promptly fired the ball into the opposing dugout, allowing the man who had hit the dribbler to score with the fourth run—all on what should have been the third out of the inning. As he returned to his position, Bonura pounded his glove and shouted to the pitcher, "Thataway, stick it in there, kid. We'll win this one for you!"

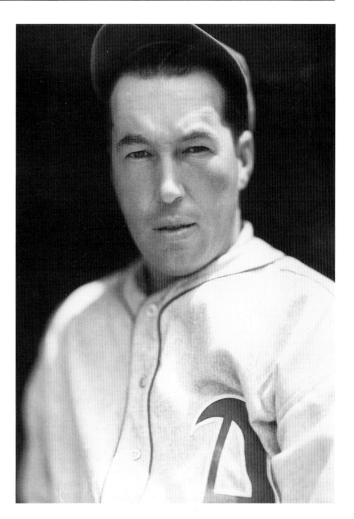

140. EARL AVERILL *(Below)* **[Howard Earl Averill; "The Earl of Snohomish," "Rock"; OF; 1929–41*; CLE (A), DET (A), BOS (N)].** From his very first at bat, when he hit a home run, Earl Averill was toasted and griddle caked and coffeed as one of the most popular players in Cleveland history. A left-handed, dead-pull hitter, Averill took dead aim on the cozy right field stands in old League Park, situated just 290 feet down the line from home plate, dropping in home run after home run. In his second season he became the first player to hit four in a double header, and he hit 32 homers in 1931 and '32. But Earl Averill is best remembered as a batter who batted for average, eight times hitting over .300. And as a run scorer more than a producer, nine times scoring over 100 runs. In 1937 he suffered a temporary paralysis in his legs, the result of a congenital spinal malformation, and was forced to change his batting style, thereby reducing his home run output. During that same season a wicked line drive off his bat broke Dizzy Dean's toe in the All-Star game, shortening the great righthander's career. After one more .300 season, the all-time Cleveland leader in home runs, runs, runs batted in, triples and total bases was dealt to the Tigers for a player who wasn't even a household name in his own household, angering Averill's loyal followers. After two-plus sub-par seasons, the one-time Cleveland legend retired from the game.

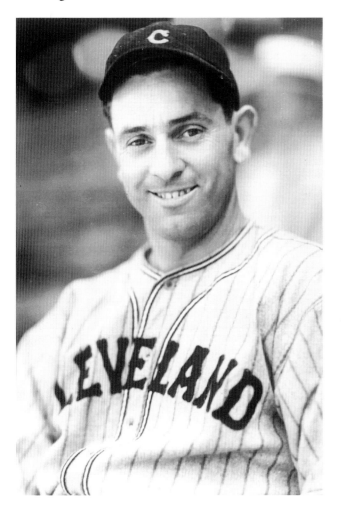

141. MULE HAAS *(Above)* **[George William Haas; OF; 1925, 1928–38; PIT (N), PHI (A), CHI (A)].** Nobody knows for sure how George William Haas came by his nickname, "Mule," but it may well have come from his most famous hit, in game four of the 1929 World Series when, in one of the greatest games in baseball history, the Philadelphia Athletics, behind the Cubs 8-0 going into the bottom of the seventh, rallied for 10 runs, three of those on a hit by Haas described by veteran sportswriter Fred Lieb as having the "kick of a mule." The A's had started the inning with a home run from their big stick, Al Simmons. Now, six batters and one out later, the score stood 8-4, Chicago. Cub manager Joe McCarthy, watching his team come unstuck, brought in little Artie Nehf to pitch to Haas with two men on. Haas hit one of Nehf's first offerings somewhere in the direction of Cub centerfielder Hack Wilson, who was out there somewhere, communing with nature. The ball shot past Wilson, who lost it in the sun, and as Wilson raced in pursuit of the elusive horsehide with all the agility of a man plowing his crops between twin spavines, Max Bishop and Joe Boley both scored in front of Haas to close the gap to 8-7 and give Haas three of his Series-leading six RBI's. The A's would go on to add three more runs to win what Lieb called "the most thrilling game in Series history." But then again, that A's team of 1929, '30 and '31 gave everyone thrills as Haas in center, Simmons in left and Bing Miller in right hit for an average of over .332 for the three-year period, scoring 908 runs and driving in another 926, more than a hundred a man each season. And Haas, usually batting second, proved to be a complete "team player," leading the league in sacrifice bunts in '30 and '31 and six seasons in all. After another .300 season in '32, Haas was dealt to the Chicago White Sox, along with Simmons, for $150,000. Small coin indeed for two-thirds of one of the greatest outfields of all time.

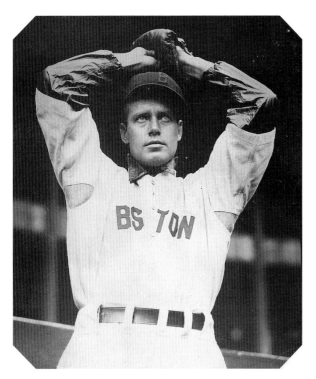

142. WES FERRELL *(Left)* **[Wesley Cheek Ferrell; P; 1927–41; CLE (A), BOS (A), WAS (A), NY (A), BKN (N), BOS (N)].** The younger brother of Hall of Fame catcher Rick Ferrell, Wes combined a blinding fastball, a fierce determination to win and a blazing bat into six 20-game seasons, three strikeout crowns and a 15-year career. The only pitcher in major league history to win twenty or more games in each of his first four full seasons, Ferrell more than helped himself with his bat, setting records for most home runs by a pitcher in a season (9), most times hitting two or more homers in a game (5) and most career home runs (38) as well as compiling a lifetime .280 batting average. Wes formed a battery with brother Rick with both the Boston Red Sox and the Washington Senators, the two even being traded in tandem in 1937 to the Senators for Bobo Newsom and Ben Chapman. But by then arm trouble had caused Wes Ferrell to change from a fastball pitcher to an off-speed and curveball specialist, pitching only in spot assignments. Still, he brought his bat with him and managed to hit .257 in his last five seasons in the majors.

143. ALVIN CROWDER *(Right)* **[Alvin Floyd Crowder; "General"; P; 1926–36; WAS (A), STL (A), DET (A)].** Nicknamed "General" after General Enoch Crowder, the Provost Marshal of the armed forces in the Great War, Alvin Crowder always seemed to be at war with himself on the mound, winning at almost a .600 clip and yet having a lifetime ERA of over 4.00. After being traded in his second season in 1927 by the Washington Senators to the St. Louis Browns for fellow North Carolinian Tom Zachary—just in time for Zachary to throw Babe Ruth his 60th-home-run pitch—Crowder blossomed into a 20-game winner, winning 21 times and losing just five for a league-leading .808 winning percentage. Characteristically, his ERA was 3.69. Two years later he was shuttled back to the Senators by the Browns as part of a three-player trade, along with Heinie Manush, for Goose Goslin. And immediately became the workhorse of the Senator staff, winning a league-leading 26 games in 1932 and 24 more in 1933. But his ERA was anything but winning, 3.33 in 1932 and 3.97 in '33, one of the highest for a 20-game winner in American League history. Crowder pitched twice in the '33 Series, but came away without a win and with a 7.36 ERA. Waived to the Detroit Tigers in 1934, Crowder found a new life under the wing of new manager Mickey Cochrane and became the fourth man in the Tigers' pitching rotation. In the 1934 Series, he went to the mound twice, pitching the first five innings of Game One and the last inning of Game Seven. Unfortunately, both times he faced Dizzy Dean, who came away with wins in both games. In 1935, he got a chance to redeem himself, and this time the 16-game winner pitched a five-hitter in Game Four for his only Series win. He closed out his career in 1936 with a typical performance: four wins in seven starts and an 8.39 ERA—giving him 167 wins and just 115 losses for a .592 won-lost record and an overall 4.12 ERA.

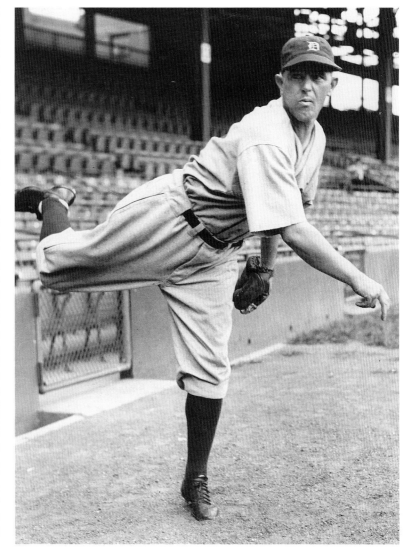

144. CHUCK KLEIN *(Right)* **[Charles Herbert Klein; OF; 1928–44*; PHI (N), CHI (N), PIT (N)].** Chuck Klein owed his statistical greatness as much to his booming bat as to the clubby confines of Baker Bowl, that little bandbox of a ballpark in which the Phillies played, called by anyone who ever visited it, "a horrible claptrap." With its corrugated right field fence but 280 feet from home plate, the lefthanded Klein found it an inviting target, rattling hit after hit off, and over, the wall. In his first five full seasons in a Phillies uniform, Klein stroked a total of 1,118 hits, most of those off that grate wall. Twice he led the league in hits, an equal number of times in doubles, four times in homers, thrice in RBI's and once in batting—winning the triple crown in 1932 when three of those departments, batting, home runs and RBI's, converged, along with the stolen base title, only the third time a home-run champ had led the league in SB's. After his triple-crown year, the financially hard-pressed Phillies sold him to the Chicago Cubs for $65,000 in hard-to-get Roosevelt dollars. But Klein's stats were hardly as heady in Chicago and, after two seasons, the Cubs sent him back to the Phillies where he picked up where he left off, becoming the first modern-day National Leaguer to hit four home runs in a game. He ended his career in a Phillies uniform, serving as a pinch-hitter during the manpower-depleted War years. But by that time the Phillies had taken their woebegone act over to Shibe Park and, without a friendly wall beckoning, his numbers no longer were exceptional.

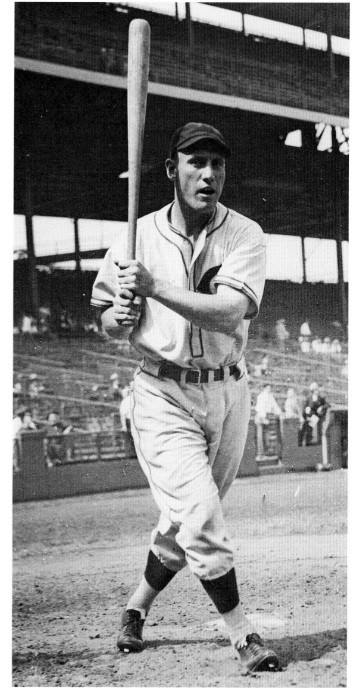

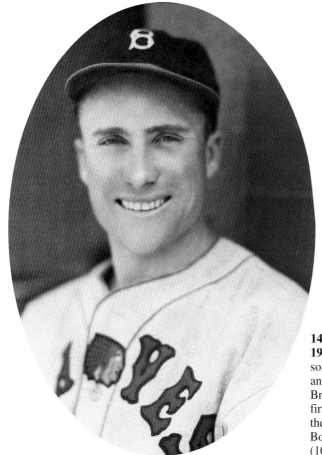

145. WALLY BERGER *(Left)* **[Walter Antone Berger; OF; 1930–40; BOS (N), NY (N), CIN (N), PHI (N)].** From his first season in the majors, when he hit 38 home runs—a then-rookie record—and drove in 119 runs, Wally Berger was the heart of the Boston Braves offense. The National League's starting center fielder in the first-ever All-Star Game and the only starter in the '34 Game not in the Hall of Fame, Berger is the all-time leader in home runs for the Boston Braves franchise and hit more homers in tough Braves Field (105) than any player in history.

146. HAL TROSKY *(Below)* **[Harold Arthur Trosky, Sr.; 1B; 1933–41, 1944, 1946; CLE (A), CHI (A)].** The 1930s were the era of the broad-backed first basemen, with the likes of Lou Gehrig, Jimmie Foxx and Hank Greenberg driving pitchers to distraction and balls out of the ballpark on a regular basis. But one of those who is overlooked in any such listing of first-base powerhouses is Hal Trosky of the Cleveland Indians who, in his rookie season, hit 35 home runs (to finish third in the American League behind Gehrig and Foxx), drove in 142 runs (to finish second behind Gehrig), had a total of 374 bases (again second to Gehrig) and posted a slugging average of .598 (to finish fourth behind Gehrig, Foxx and Greenberg). For the next five seasons Trosky would drive in over 100 runs a season—leading the league in 1936 with 162—and average 29 home runs a season. And yet Trosky is best remembered for his role in the 1940 Indians' "Crybaby Revolt," when he led an uprising against manager Ossie Vitt, who openly berated his players, the dissension causing the Indians, who had been heavily favored to win the pennant, to lose to the Tigers by one game. After a subpar year in 1941, Trosky, suffering constant migraine headaches, retired. He came back twice during World War II to play first base for the White Sox, but without the same productivity or power he had shown in his first seven seasons.

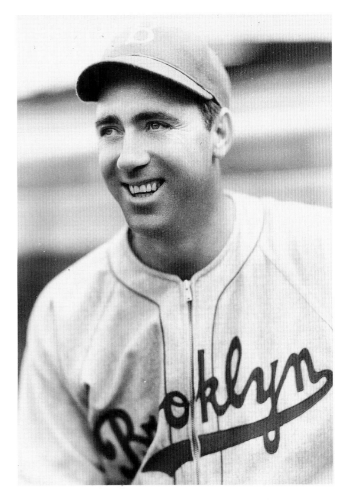

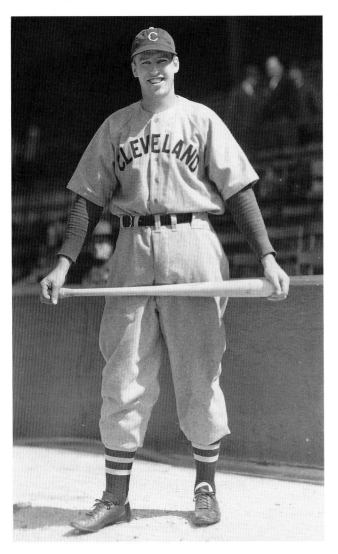

147. VAN LINGLE MUNGO *(Above)* **[Van Lingle Mungo; P; 1931–43, 1945; BKN (N), NY (N)].** The man with the most lilting name in all of baseball—so much so it was made a prominent part of a nostalgic recitation of names of players from the past—was in reality a big barnburner from South Carolina who was mentioned for his speed in the same breath with the likes of Bob Feller and Dizzy Dean. Billy Herman called Van Lingle Mungo "possibly the fastest pitcher I ever saw" and Burleigh Grimes said he "didn't know of anyone who was any faster." And during the mid-thirties, pitching for a Brooklyn club that could, at best, be described as mediocre, Mungo, a high-kicking fastballer with a world of stuff, threw his fast one past National League batters with regularity—striking them out the third-most often in the National League during the decade, behind only Hubbell and Dean. Mungo led the National League in strikeouts in 1936 and during that same season tied a modern record by striking out seven batters in succession. However, Mungo was a quarter-horse who couldn't go the full nine-inning distance. His idea of retiring batters was to strike them out, the earlier in the game, the better, leaving very little for later. Finishing only 47% of his career starts, Mungo would still average 16 wins over a five-year period, from 1932 through 1936, when he won nearly 25% of all Dodger games. As temperamental as he was talented, Mungo would more than occasionally disappear, not being seen for days at a time and, blaming his teammates for their shortcomings, resort to long sessions of finding solace and Southern comfort in the bottom of a glass.

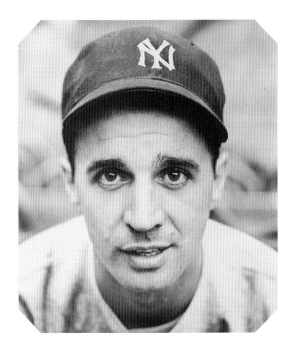

148. FRANKIE CROSETTI *(Above)* **[Frank Peter Joseph Crosetti; "The Crow"; SS; 1932–48; NY (A)].** One of baseball's longest-reigning figures—17 as a player and another 20 as a coach, all with the Yankees—"The Crow" was the lead-off man and mainstay of the great Yankee teams of the thirties. Hailing from the neighborhood of San Francisco that would also give the Yankees Tony Lazzeri and Joe DiMaggio, Crosetti was the constant companion of both. The three called one another "Wop," "Big Wop" and "Little Wop," with Crosetti being the party of the third part as well as the Yankees' on-the-field leader.

149. RED ROLFE *(Below)* **[Robert Abial Rolfe; 3B; 1931, 1934–42; NY (A)].** Called by Connie Mack "the greatest team player in the game," Red Rolfe was a regular for seven years with the New York Yankees, six of those pennant-winning teams. Arguably the best third baseman the Yankees ever had, Rolfe averaged 145 games and 121 runs scored and batted .293 during those seven years. In 1939 he set a major league record by scoring in 18 consecutive years and led the American League in runs scored, hits and doubles, batting .329— the highest batting average by a Yankee third baseman in the first 90 years of the franchise. After his playing days were over, Rolfe coached baseball and basketball at Yale and went on to become one of only two players (the other being Lou Boudreau) to manage a major league team (the Detroit Tigers, 1949–'52) and coach an NBA basketball team (the Toronto Huskies in the old-old BAA, the forerunner of the current NBA, in '47).

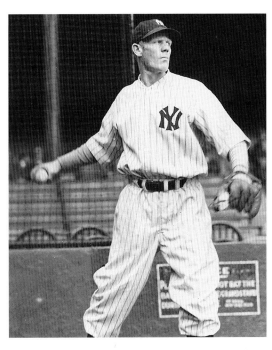

150. SCHOOLBOY ROWE *(Left)* **[Lynwood Thomas Rowe; P; 1933–43, 1946–49; DET (A), BKN (N), PHI (N)].** A big, lanky fireballing righthander, Schoolboy Rowe possessed what Tiger teammate Charlie Gehringer called "one of the finest fastballs I ever saw. Of course, he was so tall, and looking at that ball from second base, I swear it looked like it was going to hit the ground . . . but they were strikes. That ball would carry in there and it had plenty of smoke on it." Rowe smoked that fastball past his American League opponents for sixteen straight wins in 1934, tying the American League record for most consecutive wins and winning a total of 24 as he led the Tigers to their first pennant in 25 years. Before the '34 Series against the Cardinals, Rowe had the misfortune to utter the words "How'm I doin', Edna," to his bride-to-be in a radio interview, four words the Gashousers didn't let him forget during the seven-game Series. Still, Schoolboy won the second game of the Series, pitching a seven-hitter over 12 innings, and lost the sixth game in a pitching duel against Paul Dean. Rowe won 19 games the next two seasons and led the league in shutouts with six in '35 before he threw his arm out. After he won only one game over the next two seasons, the Tigers optioned him to Beaumont in the Texas League midway through the 1938 season, but brought him back up in 1939 and by 1940 his 16 wins helped the Tigers to another pennant— his 16-3 record leading the league in winning percentage with .842. In the Series that year against Cincinnati, Rowe lost two games, which, together with his loss in the '34 Series and two in the '35 Series, gave him five losses in Series competition, the second-most of any pitcher. An excellent hitter, Rowe had a career batting average of .263, with 18 home runs; as a pinch-hitter he had a .277 average, with a 15-for-49 pinch-hitting performance for the 1943 Phillies, a .300 average, highest on the team.

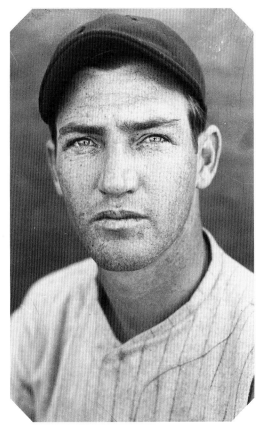

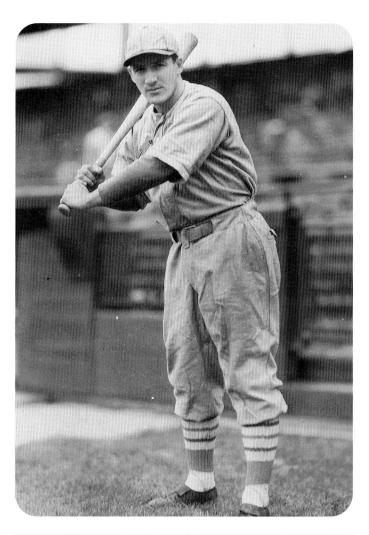

151. JOE MEDWICK *(Right, top)* **[Joseph Michael Medwick; "Ducky," "Muscles"; OF; 1932–48*; STL (N), BKN (N), NY (N), BOS (N)].** A product of Branch Rickey's famed "farm system," Medwick was brought up by the Cardinals midway through the 1932 season from Houston, where he was batting .354, to fill the rather sizeable shoes of leftfielder Chick Hafey, who had led the league in batting the previous year and had been dealt away after a salary dispute. Medwick filled the shoes of Hafey—and the bill—batting .349 in his abbreviated first year in the majors. In the years to follow, Medwick, a notorious bad-ball hitter, slashed balls to all fields, particularly doubles, as he led the National League in two-base hits three straight years and hit forty or more in seven consecutive seasons. He also tied a major league record by leading the National League in RBI's three straight seasons. In 1937 it all came together as Medwick led the National League not only in doubles, but also in hits, RBI's and batting, the last National Leaguer to win the so-called "Triple Crown." But perhaps the moment Medwick is most remembered for occurred in the seventh game of the 1934 World Series against the Detroit Tigers. For five and a half innings the Tigers faithful had sat sullenly through a long, frustrating afternoon watching their beloved Tigers get the bejabbers beaten out of them by Medwick and the Cardinals. Up 7-0 going into the sixth, the Cards added two more runs on a triple by Medwick, hit, of course, to the wrong field. As Medwick came aroaring into third, Tiger third baseman Marv Owen apparently spiked him and Medwick lashed back, kicking at Owen. As the smoke cleared, all that could be seen was Medwick lying on his back kicking at the hometown favorite. Figuring that there must be something in the Geneva Convention outlawing such doings, the Tiger fans greeted Medwick when he took his place in left at the bottom of the inning with a thunderstorm of trash, including lemons, tomatoes and heads of lettuce. Finally, after 20 minutes of watching the greengrocers in the left field bleachers hurl their wares in Medwick's direction, Baseball Commissioner Kenesaw Mountain Landis excused Medwick for the rest of the game—and the Series. Afterward Medwick was to say, "I knew *why* they threw it at me. What I can't figure out is why they brought it to the ballpark in the first place." Despite this incident and other troubles, the man called by the childish name "Ducky" because of his walk, racked up 15 years of .300-plus batting, six years of 100-plus runs batted in and 11 years of 30 or more doubles in his 17-year career.

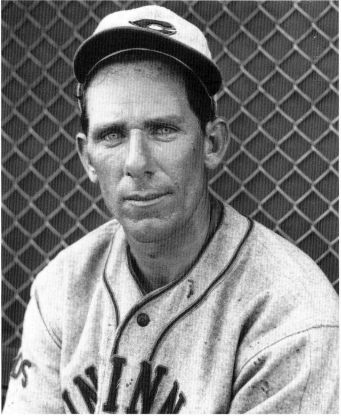

152. PAUL DERRINGER *(Opposite, bottom)* **[Samuel Paul Derringer; "The Duke," "Oom Paul"; P; 1931–45; STL (N), CIN (N), CHI (N)].** Only one pitcher, Hall of Famer Vic Willis, ever lost more games this century than Paul Derringer did in 1933—27, to be exact. But, then again, nothing Paul Derringer did could be measured by normal standards. From the time he broke in as a rookie with the Cardinals in 1931 and led the National League in winning percentage, winning 18 and losing only eight for a .692 won-lost percent, Derringer was marked as an unusual pitcher. With a high kick, body canted earthwards and ball almost touching the ground, the righthanded Derringer just reared back and threw, with amazing control for all his contortions. Handed the ball by Cardinal manager Gabby Street for the Series opener against the defending champion A's— only the second rookie so honored, after Babe Adams in 1909—Derringer lost to Lefty Grove, a feat he duplicated in Game Six. After a subnormal year in 1932, Derringer was handed his walking papers in '33, traded in a five-player deal to the woebegone Cincinnati Reds, ostensibly for one man, Leo Durocher. The Reds, then baseball's worst team, were making their third successful defense of last place in the National League, not having seen the light of the first division since 1926. With the lowest team batting average, the least number of homers and the least number of stolen bases, they backed up Derringer's pitching with a lack of support that could have been grounds for a suit, and Derringer staggered through 31 starts with 25 losses— which, added to his two losses in a Cardinal uniform, gave him 27 for the year. The next year, with the Reds again firmly entrenched in last, Derringer won 15 games. By 1935 they had moved all the way to sixth and Derringer had won 22 of their 68 games—one of those, on the evening of May 24, in the first night game ever played. After two more so-so years for both Derringer and the Reds, Derringer was joined in 1938 by Bucky Walters and the pair promptly won 32 between them, 21 of those belonging to Derringer who led the League in complete games and innings pitched. In 1939 the Reds won their first pennant in a score of years, with Derringer winning 25 games, again leading the league in winning percentage and finishing second in most wins behind Walters, who won 27. The 1940 season was a repeat performance for the Reds' pitching duo as Derringer won 20 and Walters another 22 and between them won four games in the Series to beat the Tigers. After two subpar years, Derringer was sold to the Chicago Cubs, where he finished out his career by winning 16 games for the pennant-winning '45 Cubs. However, despite his 27 losses in '33 and having the most losses for the decade of the '30s, Paul Derringer also shows up on the plus side of the ledger, finishing among the top ten pitchers in the decade for most wins, most strikeouts and best ERA, one helluva comeback. But then again, there was nothing normal about the man they called "Oom Paul."

153. JOE KUHEL *(Below)* **[Joseph Anthony Kuhel; 1B; 1930–47; WAS (A), CHI (A)].** Bench jockeying was part and parcel of the game in the early thirties, the jockeying marked by passions that recalled the worst excesses of the French Revolution, complete with language that would have caused an off-duty sailor to blush. And although only a rookie, Joe Kuhel had learned the first rite of passage to becoming a big leaguer and on this afternoon in question was riding Jimmy Dykes, then the third baseman of the Philadelphia Athletics. Dykes singled out the source of the jockeying and, when Kuhel took his turn in the batter's box, went over to his pitcher, Lefty Grove, then the fastest man alive, in a manner of speaking, and said, loud enough for Kuhel to hear, "Bore this guy in the back." Grove fired one high and inside, but missed Kuhel on his first pitch. Dykes screamed in, "What the hell's the matter? Losing your control?" Grove hollered back, "I won't miss him this time," and he didn't, hitting Kuhel in the back. Kuhel trotted down to first, gritting his teeth and the next time he saw Dykes he said, "Well, I learned my lesson: keep your mouth shut." And for 18 years that's how Joe Kuhel played, quietly, consistently and without flamboyance. At first base he was a quiet force, twice leading the league in fielding, putouts and double plays. At bat, he let his Louisville Slugger talk for him, three times hitting .300 or over and, in the Senators' pennant-wining year of 1933, outhitting future Hall of Famers Joe Cronin and Goose Goslin as he posted a career high of .322—although he ended the World Series against the Giants by taking a called third strike with the potential winning run on base. Kuhel ended his career as the manager of the last-place Senators in 1949, when he unclenched his teeth just long enough to deliver the lament of second-division managers everywhere: "What we're trying to do here is make chicken salad out of chicken s---."

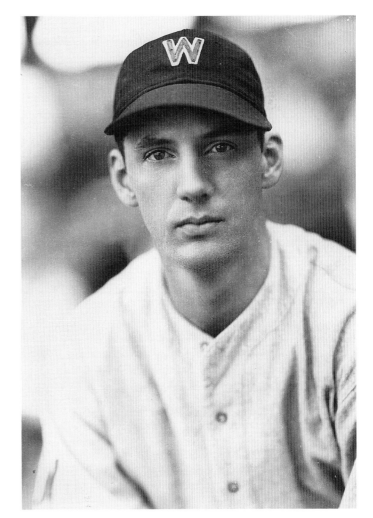

154. FRENCHY BORDAGARAY *(Right)* **[Stanley George Bordagaray; OF; 1934–39, 1941–45; CHI (A), BKN (N), STL (N), CIN (N), NY (A)].** The Brooklyn Dodgers were the "Daffiness Boys" franchise of the late twenties and early thirties, and no one captured that daffiness better than Stanley "Frenchy" Bordagaray, a free-spirited outfielder who once wore a mustache "just to be different"—and which his manager, Casey Stengel, made him shave off (saying, "If we're going to have any clowns on this team, it will be me"), which he blamed for his ensuing slump. In that double-entry bookkeeping that tallies all of baseball's debits and credits as precisely as an accountant's ledger, Bordagaray's deficiencies both afield and on the basepaths left his overall account sorely in arrears. Take for instance the time he was stationed on second during a close game during the '35 season. At least, he was stationed there momentarily until he was picked off, breaking up a promising rally. When Bordagaray returned to the bench, Stengel exploded in a torrent of four-letter expletives deleted, demanding to know what happened. "Gee, Case, I don't know," replied the more-than-slightly abashed Bordagaray, sounding like a little boy minimizing a bad school report. "I was standing out there, tapping the base with my foot, and I guess I got caught somewhere between taps." Such was the legacy of the man who batted .283 over 11 years and in 1937 had 20 pinch-hits in 43 at-bats for a record for pinch-hitting efficiency.

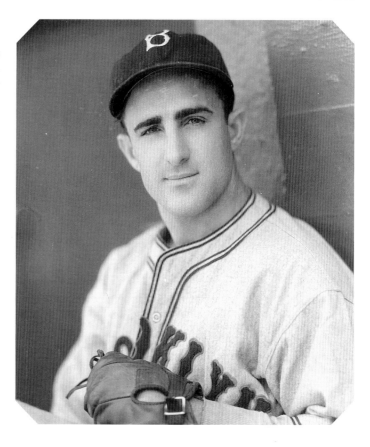

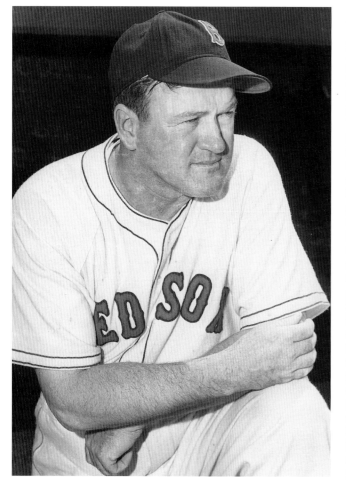

155. JOE CRONIN *(Left)* **[Joseph Edward Cronin; SS; 1926–45*; PIT (N), WAS (A), BOS (A)].** Red Smith summed up Joe Cronin's abilities as a ballplayer best, writing: "For twenty sinless years as a ballplayer in the majors, Joe Cronin was a good-enough shortstop, but it was his bat that got him into the Hall of Fame, not the way he handled hot grounders by Babe Ruth or Al Simmons. How much can an infielder slow down without taking root?" Cronin's fielding shortcomings were first recognized by Washington Senator owner Clark Griffith who, when told by a Senator scout that he had just signed Cronin to a Washington contract, could only gasp, "What? That sieve?" Cronin more than acquitted his reputation when, in 1929, his first full year as Senator shortstop, he led the League in errors with 62 miscues. However, by his second season, Cronin was using his bat more than his glove, hitting a lusty .346—the first of ten seasons he was to bat over .300—and was rewarded for his efforts by being selected as the league's Most Valuable Player. In 1933, Griffith named his by-now perennial all-star as the Senators' playing manager and Cronin rewarded Griffith's faith in him by leading the Senators to the pennant—in the process being the youngest manager ever to win a pennant. After Cronin spent one more year in a Senators' uniform—a year that saw him become a member of the Griffith "family" by marrying Griffith's niece, Mildred Robertson—the cash-strapped Griffith traded the "Boy Manager" to the Boston Red Sox for $250,000. Stepping into a Red Sox uniform, and into the managerial role as well, the righthanded-hitting Cronin three times posted slugging averages over .500 and led the BoSox to four second-place finishes, all behind the hated Yankees. His playing career finally came to an end in 1945 when he fractured his leg in an early-season mishap. Still, by now very still, he managed the Red Sox to the pennant in 1946, the first time Boston had appeared in the Series since the days of Babe Ruth. After one more season, and a third-place finish, Cronin finally retired, later to resurface as President of the American League.

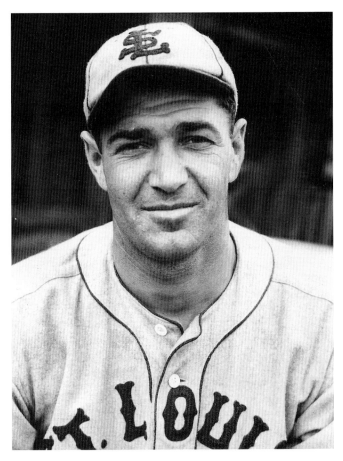

156. BOBO NEWSOM *(Above)* [**Louis Norman Newsom; "Buck"; P; 1929–30, 1932, 1934–48, 1952–53; BKN (N), CHI (N), STL (A), WAS (A), BOS (A), DET (A), PHI (A), NY (A), NY (N)].** During his 20-year career—a career that saw him hired 17 times over four different decades—Louis Norman "Bobo" Newsom nonchalantly marched through the majors. And always to his own drummer. Calling everyone "Bobo"—including the venerable Connie Mack, whom everyone else addressed as Mister Mack—Newsom was an odd combination of lungs of leather, nerves of brass and an arm of rubber. A throwback to pitchers of yesteryear, Newsom twice pitched both ends of a double-header and many's the time he would start the first game and relieve in the second. Showing different motions and several different pitches, he came at batters sidearm, overhand and three-quarters—and, on occasion, would punctuate his delivery with a triple wind-up—throwing a sharp curve, what was described as a "vivid" fastball, and even a "blooper" ball years before Rip Sewell made it famous. Three times a 20-game winner—including once winning 20 with the highest ERA of any 20-game winner in history, 5.08 in 1938—Newsom was also thrice a 20-game loser. In fact, he was the only modern lifetime 200-game winner to lose more games than he won (211-222). Predictably, he lost his only no-hitter, giving up two walks and a bad-bounce single in the tenth. Big and easygoing, Bobo was hell on managers, once telling Boston manager Joe Cronin, who had come in from his shortstop position to offer advice, "Listen, Bobo, you play shortstop and I'll do the pitching." A relentless self-promoter, Bobo would send clippings of his heroics to other clubs, seeking better employment, or merely proclaim his achievements in advance, like the time he announced to Washington president Clark Griffith that if he traded for him he'd pitch a no-hitter on his first start in a Senator uniform—and came within eight outs of keeping his promise. But, then again, Bobo always rose to the occasion, as he did in the 1940 World Series when he pitched three times in less than a week, winning two games for the Tigers and losing the seventh game of the Series, days after his father's death, 2-1 on two hits in the seventh inning. Bobo's career came to an end in 1953 when he told Mister Mack, "You cain't afford my wages, Bobo," and retired to South Carolina and his mules at the age of 46.

157. DOLF CAMILLI *(Below)* [**Adolf Louis Camilli; 1B; 1933–43, 1945; CHI (N), PHI (N), BKN (N), BOS (A)].** When Larry MacPhail bought the in-hock Brooklyn Dodgers from Brooklyn Trust in 1938, the first three things he did were to get short-stop Leo Durocher from the St. Louis Cardinals, hire Babe Ruth away from his easy chair at 110 Riverside Drive (where, sadly, the apartment building now bears a sign reading: "No Ballplaying Allowed") to coach and buy Dolf Camilli from the cash-starved Philadelphia Phillies. Camilli was to pay off, handsomely, bringing his big bat, slick glove and quiet demeanor to a team known for possessing none of the above. And turning the team into a winner. A quiet leader with a strong presence, the All-American Camilli was needed to serve as a counterpoint to the "All-American Out," the excitable Durocher. Having hit 20 or more home runs his previous three seasons at Philadelphia and driven in more than 100 runs the last two, Camilli picked up right where he left off, hitting 24 homers and driving in 106 runs. Named the team captain, Camilli provided the mortar that turned the Dodgers into winners—albeit, not instantly—quelling team disputes with looks more than words and leading by his deeds. By 1941 Camilli had become the league's as well as the team's Most Valuable Player, leading the NL in home runs and runs-batted-in and leading the Dodgers to their first pennant in 21 years. After another 20-home-run, 100-RBI season in '42, Camilli tailed off badly in '43 and was traded to the hated Giants, but refused to report and instead retired, only to come back for one more year in a Red Sox uniform.

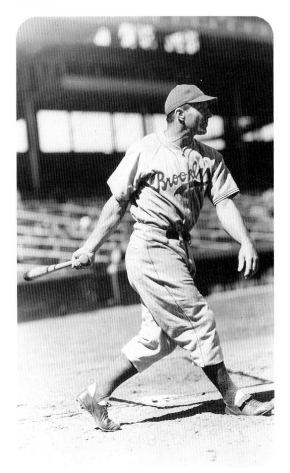

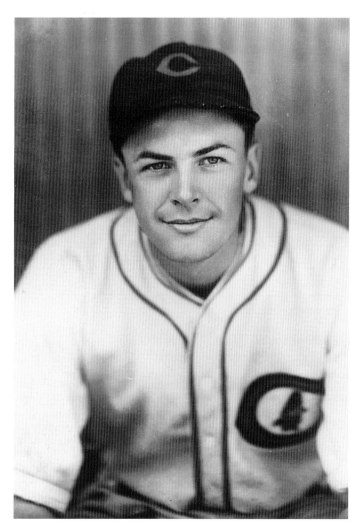

158. STAN HACK *(Left)* **[Stanley Camfield Hack; "Smiling Stan"; 3B; 1932–47; CHI (N)].** Only one Chicago Cub player, Ernie Banks, had his mail addressed to Wrigley Field longer than Stan Hack, who for 16 years had his delivered c/o Third Base, 1060 West Addison Avenue, Chicago, Illinois. And for 14 of those 16 seasons, excluding his first and last, Hack was a model of consistency, delivering a .280 or better batting average, an all-capturing glove and a captivating and winning smile—one caught in vanity mirrors sold by Cub concessionaires, complete with the slogan "Smile with Stan Hack." Having played for three Chicago Cub pennant winners (1932, '35 and '38), Hack abruptly retired in 1943 after a falling-out with manager Jimmie Wilson. But the next season, after Wilson left, new manager Charlie Grimm coaxed him out of retirement, and the 35-year-old Hack washed away the improbability of the calendar by sparking the Cubbies to their last pennant in 1945 with a career-high batting average of .323, while also leading the league in putouts, total chances per game and fielding average.

159. JOHNNY MURPHY *(Right)* **[John Joseph Murphy; "Fireman," "Fordham Johnny," "Grandma"; P; 1932, 1934–43, 1946–47; NY (A), BOS (A)].** Before there was a Hoyt Wilhelm, before a Rollie Fingers, before a Bruce Sutter or a Dan Quisenberry there was a Johnny Murphy, who almost single-armedly made the relief pitcher a part of baseball. During the thirties whenever the Yankees got into trouble in the later innings the cry went up to the bullpen, "Bring in Murphy," and the big righthanded curveballer would saunter in to quell the fire, thus giving all relief pitchers from that time forth and forevermore the nickname "Fireman." (Another nickname came from his having been the star of the Fordham nine, and the "Grandma" handle was handed him by fellow bullpen crony Pat Malone because he was so sedate and reserved.) During the time when the Yankees were almost all-winning and known as "The Window Breakers," Murphy led all American League relief pitchers in wins five times and saves four and at one time held the lifetime records for saves (107) and wins (73) in relief.

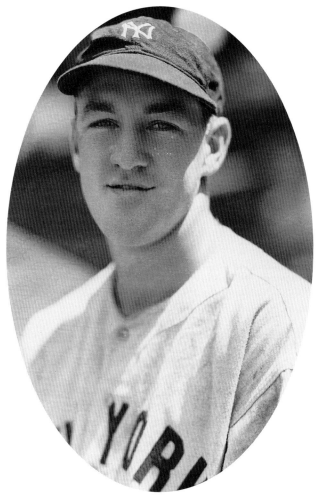

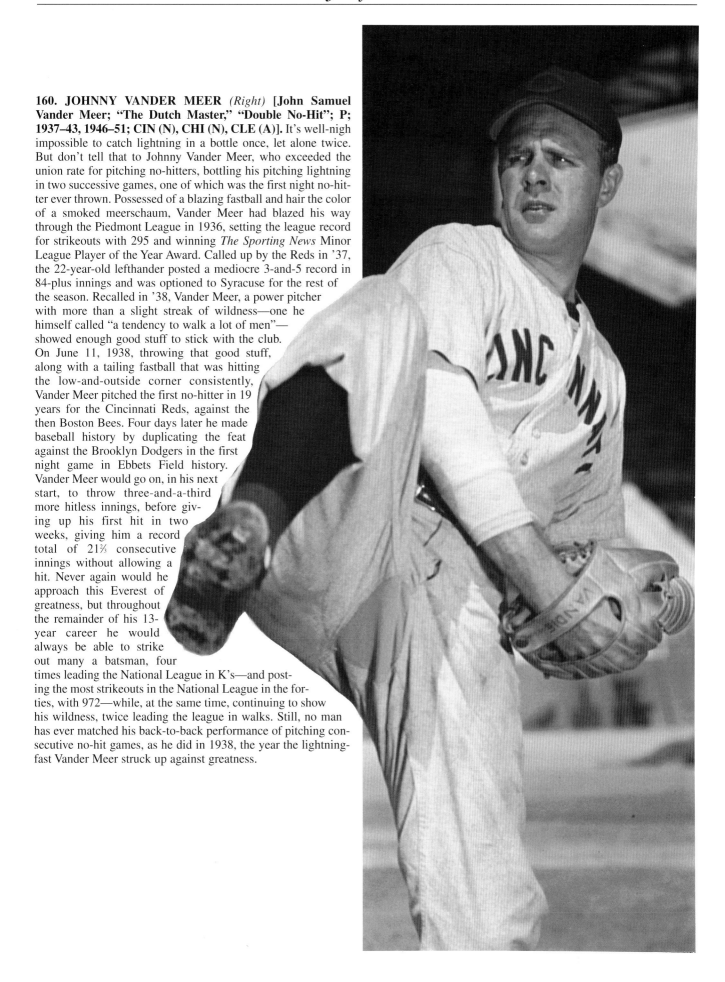

160. JOHNNY VANDER MEER *(Right)* **[John Samuel Vander Meer; "The Dutch Master," "Double No-Hit"; P; 1937–43, 1946–51; CIN (N), CHI (N), CLE (A)].** It's well-nigh impossible to catch lightning in a bottle once, let alone twice. But don't tell that to Johnny Vander Meer, who exceeded the union rate for pitching no-hitters, bottling his pitching lightning in two successive games, one of which was the first night no-hitter ever thrown. Possessed of a blazing fastball and hair the color of a smoked meerschaum, Vander Meer had blazed his way through the Piedmont League in 1936, setting the league record for strikeouts with 295 and winning *The Sporting News* Minor League Player of the Year Award. Called up by the Reds in '37, the 22-year-old lefthander posted a mediocre 3-and-5 record in 84-plus innings and was optioned to Syracuse for the rest of the season. Recalled in '38, Vander Meer, a power pitcher with more than a slight streak of wildness—one he himself called "a tendency to walk a lot of men"—showed enough good stuff to stick with the club. On June 11, 1938, throwing that good stuff, along with a tailing fastball that was hitting the low-and-outside corner consistently, Vander Meer pitched the first no-hitter in 19 years for the Cincinnati Reds, against the then Boston Bees. Four days later he made baseball history by duplicating the feat against the Brooklyn Dodgers in the first night game in Ebbets Field history. Vander Meer would go on, in his next start, to throw three-and-a-third more hitless innings, before giving up his first hit in two weeks, giving him a record total of 21⅔ consecutive innings without allowing a hit. Never again would he approach this Everest of greatness, but throughout the remainder of his 13-year career he would always be able to strike out many a batsman, four times leading the National League in K's—and posting the most strikeouts in the National League in the forties, with 972—while, at the same time, continuing to show his wildness, twice leading the league in walks. Still, no man has ever matched his back-to-back performance of pitching consecutive no-hit games, as he did in 1938, the year the lightning-fast Vander Meer struck up against greatness.

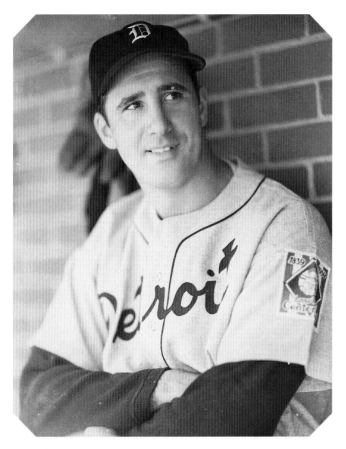

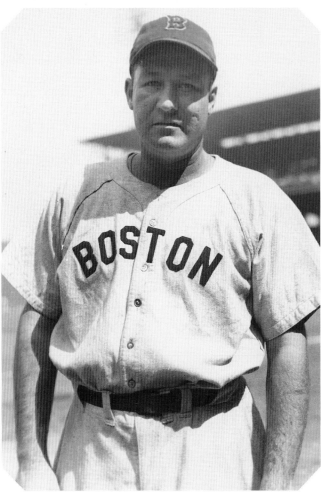

161. HANK GREENBERG *(Left, top)* **[Henry Benjamin Greenberg; OF; 1930, 1933–41, 1945–47*; DET (A), PIT (N)].** Raised in the shadow of Yankee Stadium, Greenberg signed with the Tigers, turning down a contract offer from the Yankees because he felt that Lou Gehrig would be "there forever." After one cup of coffee, of the instant variety, with Detroit in 1930, Greenberg was farmed out for two more years where, by 1932, he had shown the Tigers enough, leading the Texas League in homers, RBI's and runs scored, and leading his team, the Beaumont Explorers, to the league title. Brought up in '33, Greenberg made an immediate impression with his line-drive power and by 1934 led the league in doubles, helping the Tigers to their first pennant in 25 years. In 1935 he hit a league-leading 36 homers and won the league's MVP. After suffering a broken wrist in 1936, he rebounded in '37 to drive in the third-greatest number of runs in baseball history, 183. And the next year he made an attempt at Babe Ruth's Everest, hitting 58 homers, to tie Jimmie Foxx for the most-ever for a right-handed batter. Not long after being named the American League's MVP for a second time in 1940, Greenberg enlisted in the Air Corps for the duration, serving in the Pacific with distinction. Discharged midway during the '45 pennant race, he won it for the Tigers with a last-day grand slam and went on to hit two more in the Series against the Cubbies. He would lead the American League a fourth time in homers in 1946, with 44, and then jump to the Pittsburgh Pirates for the last year of his career, becoming, in the process, baseball's first $100,000 player.

162. RUDY YORK *(Left, bottom)* **[Rudolph Preston York; C; 1B; 1934, 1937–48; DET (A), BOS (A), CHI (A), PHI (A)].** A Cherokee, Rudy York was constantly referred to as "Part Indian, part first baseman." But that was only after the Detroit Tigers finally found a position for him and his big tomahawk of a bat. For years, despite having won the Most Valuable Player awards in both the Texas League and the American Association in 1935 and '36, York was a man without a position, unable to break into the Tiger lineup, their ranks filled to the gunwales with talent. Finally, in 1937, after Mickey Cochrane had been beaned by Bump Hadley and his career ended, something opened up for York: the catcher's spot. And he responded, hitting 18 home runs in August, breaking Babe Ruth's single-month record, and 35 for a partial season. In 1940, the Tigers finally found room at their overcrowded inn, moving Hank Greenberg to the outfield to make room for York. And he responded with 33 home runs, 343 total bases and 134 RBI's, finishing second in RBI's and total bases to the man he had dislodged and third in HR's, behind Greenberg and Jimmie Foxx. The big righthander's high-water mark came in 1943 when he led the American League in home runs, RBI's, slugging average and total bases, playing every game for Detroit at his adopted position, first. Considered a liability with a glove, York worked tirelessly with Tiger manager Del Baker to perfect his fielding skills. And became so proficient—especially at mastering the pivot to second, a difficult move for any righthanded first baseman—that he set the assists record for first basemen in 1943 and established a major league record for double plays in '44. York also led the majors in one other category: arson. According to one-time roommate Charlie Gehringer, "He would always go to bed smoking a cigarette. And he would fall asleep. If the cigarette burned his fingers, he'd wake up and put it out. But if it didn't, then he was in trouble. And so was his roommate. He burned up quite a few mattresses that way." Ironically, after the end of his career, when he had finished burning up the league and mattresses, York got a job with the Georgia Forestry Commission fighting fires.

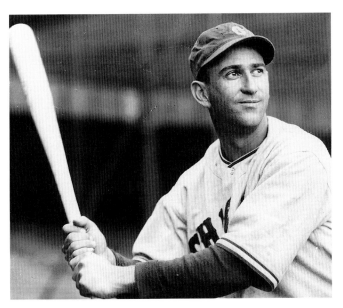

163. LUKE APPLING *(Above)* **[Lucius Benjamin Appling; "Old Aches and Pains"; SS; 1930–43, 1945–50*; CHI (A)].** Voted "The Greatest Living White Sox Player" in a 1969 fans' poll, Luke Appling was the heart and soul of the franchise for twenty long years, twenty seasons in which the ChiSox managed to finish in the first division only five times. And yet during that long Chicago drought, Appling was Chicago's only bonafide superstar, seven times leading the league shortstops in assists and setting records—since broken—for most lifetime putouts, assists and chances accepted by a shortstop. His batwork wasn't too shabby either, twice leading the league, his .388 in 1936 the American League record for shortstops. But what distinguished Appling was his ability to foul off pitches not to his liking, sometimes as many as ten to fifteen in a row before he got the pitch he wanted. One time, after he had asked Clark Griffith, the owner of the Washington Senators, for a couple of free passes for his family which was coming up from his hometown of High Point, North Carolina, to see him play, and been turned down by the parsimonious Griffith, Appling determined to "get even" with the Senator owner and, figuring baseballs cost $2.50 apiece, fouled off the first 24 thrown to him. "That'll take care of the cheap S.O.B.," he said, and promptly hit the next one into center for a double. Appling, hardly known as a long-ball hitter—with just 45 homers to his credit in twenty seasons—once hit a home run off Warren Spahn in an old-timers' game. Then, as he stood at the plate laughing, someone asked him if he wasn't going into his home-run trot. "Ah don't have a home-run trot," said Appling as he made his merry around the bases almost as if they were unexplored territory.

164. BOB FELLER *(Right)* **[Robert William Andrew Feller; "Rapid Robert"; P; 1936–41, 1945–56*; CLE (A)].** Signed by the Cleveland Indians for a bonus of $1 and an autographed baseball, Feller made his major league debut by striking out 15 St. Louis Brownies in his first start to come within one strikeout of the modern American League record and two of Dizzy Dean's major league record. After the game, plate umpire Red Ormsby, who had been umpiring since 1923, was asked if the 17-year-old phenom had shown more speed than Lefty Grove. "Yep," he answered. More than Walter Johnson (sacrilegious as it was to consider the alternative)? "Yes, sir," replied Ormsby. Feller was to exploit that superhuman speed, along with what pitching stablemate Willis Hudlin called "the hardest and best curveball I ever saw," to record strikeout after strikeout and set record after record, leading the American League in K's seven times and setting a record of 348 in 1946 by striking out every American Leaguer to face him with the exception of Barney McCosky. And even though his final career stats read 266 wins and 2,581 strikeouts, who knows what his final statistics would have been if, at the peak of his career, he hadn't served almost four full years in the military during World War II? Another 100 wins? Another 700 strikeouts? The author of three no-hitters—including the only Opening Day no-hitter in major league history (against the White Sox in 1940)—and a record 12 one-hitters, Feller became the first pitcher since Walter Johnson and Christy Mathewson to be elected to the Hall of Fame in his first year of eligibility.

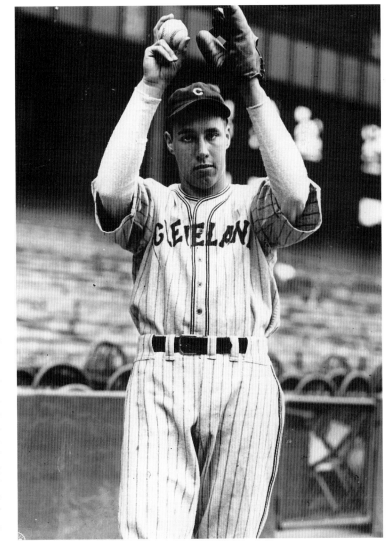

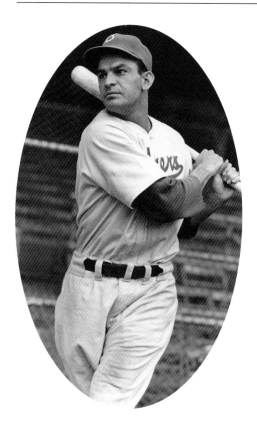

165. COOKIE LAVAGETTO *(Left)* **[Harry Arthur Lavagetto; 3B; 1934–41, 1946–47; PIT (N), BKN (N)].** In that mist of memories that comprises the whole of baseball, there are very few that stay with us. But one that does is Cookie Lavagetto's two-out, wrong-field double in the fourth game of the 1947 World Series, a hit that wrested victory from defeat and served as a reminder that any man can. The setting was this: the Brooklyn Dodgers, down two-to-one in both games and score, were just one out away from being no-hit by Yankee pitcher Bill Bevens. The Dodgers had two pinch-runners on base—courtesy of Bevens' ninth and tenth walks of the game. Down to his last out, Dodger manager Burt Shotton called back Eddie Stanky, perhaps the best getter-on-base in the league, and, having exhausted his supply of lefthanded hitters, sent up a righthanded model, one with enough power to bring home the two base runners, Harry "Cookie" Lavagetto. Lavagetto, who had just 18 hits during the regular season, only one of which was a double, swung at the first offering and missed. Now just two pitches away from a guaranteed safe conduct into the Hall of Fame, the righthanded Bevens reared back and came in with his 137th pitch of the game, a fastball up and over the plate. Lavagetto, with an obvious disinclination to become the final out in the first-ever Series no-hitter, swung again and sent the ball on a straight line toward right field. The ball took off, headed for Ebbets Field's right field fence, a crazy patchwork quilt of advertising signs, and struck a small parallelogram next to a sign advertising the movie *The Kid from Brooklyn,* just over the head of Yankee right fielder Tommy Henrich. As the ball caromed off at an angle, it skipped off Henrich's glove, allowing the two Dodger baserunners to come scampering home with the tying and winning runs. It was a once-in-a-lifetime moment for the man who bore the child-like nickname "Cookie" (being the nickname of the Oakland Oaks owner, where Lavagetto had started his professional career and where he became known as "Cookie's Boy," later contracted to just plain ol' "Cookie") and would become his last moment in professional baseball in this, his last year in the big leagues.

166. PHIL CAVARRETTA *(Right)* **[Philip Joseph Cavarretta; 1B; 1934–55; CHI (N), CHI (A)].** Phil Cavarretta has the distinction of being the only player to have played against both Babe Ruth and Henry Aaron. He played *that* long, coming up as an 18-year-old rookie and playing first base and outfield for the Cubs for the next 20 years. His .355 batting average in 1945 not only led all batters in the National League but also led the Cubs to their last-ever pennant. He led all hitters in the '45 World Series, with a .423 average, though the Cubs lost to the Tigers in seven games. Cavarretta also holds yet another distinction: he was the manager fired the earliest in a season, fired by Cub owner Phil Wrigley in spring training of '54 when he predicted the Cubs would finish in the second division, a prophecy they fulfilled without Cavarretta.

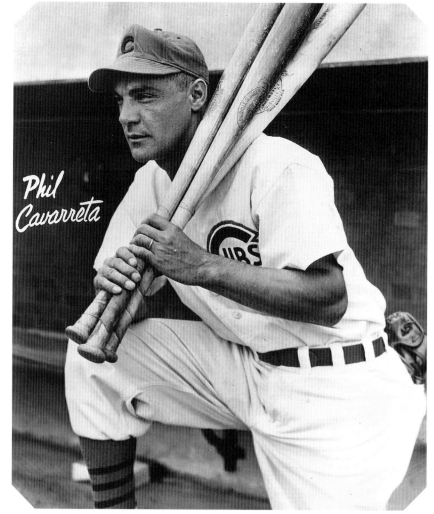

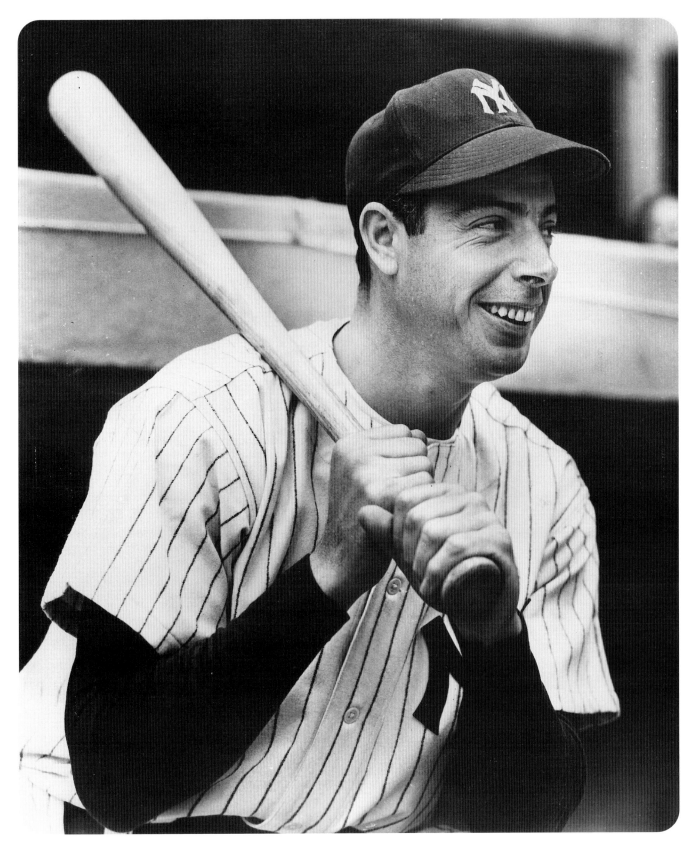

167. JOE DiMAGGIO *(Above)* **[Joseph Paul DiMaggio; "Joltin' Joe," "The Yankee Clipper," "DiMag"; OF; 1936–42, 1946–51*; NY (A)].** The Great DiMaggio was Hemingway's "grace under pressure," a player with no fault lines. Casey Stengel, who had seen them all, said: "Joe never threw to a wrong base in his career. And he was thrown out trying to take an extra base only once . . . and the umpire was wrong on that one. He made the rest of the players look like plumbers." From the moment he first appeared on the major league landscape, leading the Yankees to four pennants and four World Series in his first four years, through his incredible 56-game hitting streak of 1941, down through the times for which he was immortalized by Paul Simon as a long-lost hero in his song, "Mrs. Robinson," the legend of the great Joe D. has grown with each passing year.

168. CHARLIE KELLER *(Below)* **[Charles Ernest Keller; "King Kong"; OF; 1939–43, 1945–52; NY (A), DET (A)].** Marty Marion called him "the toughest looking player I ever saw." Others, "King Kong," an alliterative nickname taken from the oversized ape of movie fame. And for six full seasons the beetle-browed ball player with the menacing looks and potent bat scared the bejabbers out of opposing pitchers and players as one-third of the second coming of "Murderer's Row," a Yankee outfield composed of DiMaggio, Henrich and King Kong Keller. Brought up by the Yankees in 1939 from their Newark farm club, where he had decimated International League pitching for two seasons, this 22-year-old youngster with a well-knit body that repaid inspection repaid the Yankees as well, hitting .334, fifth-highest in the league. In the '39 World Series Keller became one of a handful of players ever to post a slugging average of over 1.000 in a Series, hitting three home runs and single-footedly winning the fourth and final game of the Series by kicking over Cincinnati Reds catcher Ernie Lombardi in a collision at the plate that allowed two runs to score in a moment that came to be known as "Lombardi's Snooze." However, his entire home-run output for his rookie season had been just 11. Yankee manager Joe McCarthy, giving of his experience, pulled Keller aside one day in his second season and asked his youngster, "Why do you think they built such a short right field in this ballpark?" "For Ruth," answered Keller, correctly. "That's right," said McCarthy. "You're a lefthanded power hitter, so why aren't you taking advantage of it?" And so, Keller became a pull hitter, aiming at the nearby right field porch. And began hitting home runs, 21 in 1940, 33 in '41, 26 in '42 and 31 in '43—becoming, in the process, the Yankees' leading home-run hitter. After a year-plus in the maritime service during World War II, Keller returned and picked up right where he had left off, with 30 home runs and 101 RBI's in 1946, his next full season. But a bad back badly compromised his swing and although he was to stay in the big leagues for another six years, he was reduced to part-time and pinch-hit duties. Finally, after returning to the Yankees for just two games in 1952, Keller retired to his horse farm in Maryland, called, naturally enough, "Yankee Farms." Most of his horses possessed baseball names, but none were ever called "King Kong," a name he was never comfortable with.

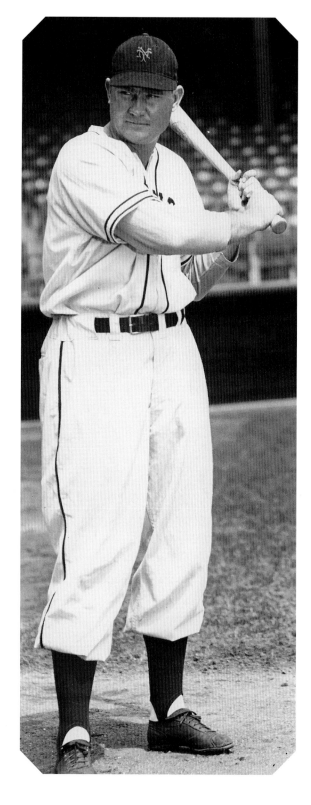

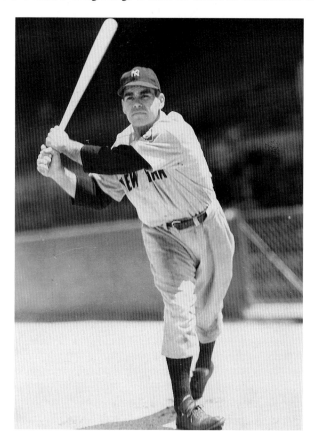

169. JOHNNY MIZE *(Opposite, right)* **[John Robert Mize; "The Big Cat," "Jawn"; 1B; 1936–42, 1946–53*; STL (N), NY (N), NY (A)].** Known as a home run hitter, Johnny Mize was, surprisingly, also one of the greatest contact hitters in the history of the game. The only player with fifty home runs in a season to strike out fewer times than he hit homers, this cousin of Ty Cobb was an amazingly consistent hitter at the plate. During his six years with the St. Louis Cardinals, he led the National League in home runs twice, in doubles and runs-batted-in once, and in batting average once, with a .349 average in 1939. His six-year average with the Cards was .336, the second-highest all-time average in the team's history, ahead of Joe Medwick and Stan Musial. Traded to the New York Giants, Mize put in one year in a Giant uniform, leading the National League in slugging average before spending three years in the Navy. Returning to the Giants in '46, Mize hit 113 home runs in the next three years, twice tying Ralph Kiner for the league lead—hitting 51 in '47 with a team that set the then-all-time record. In 1949, during a mid-season exhibition game between the Giants and the Yankees, Yankee manager Casey Stengel wandered over to visit with the big Giant first baseman. Stengel, like a con man selling encyclopedias, asked the bulk hovering over him, "How do you feel?" Mize answered, "All right, but I'm not playing much." Stengel, now having his answer and his opening as well, replied, "If you were over here, you'd play." Mize looked down at the little gnome standing next to him and said, "Well, make a deal," and walked away. Less than two months later the Yankees sent $40,000 over to the Giants for Mize's services and the 36-year-old helped spark the Yankees to their one-game margin of victory over the Boston Red Sox in one of baseball's most torrid pennant races. In 1950, Mize again helped the Yankees, hitting 25 home runs and driving in 72 runs as their starting first baseman. Ditto in 1951. In fact Mize helped the team win five straight World Series, twice having slugging averages of 1.000 or over in World Series play, tying Ruth and Gehrig as the only players who twice had 1.000 or better SA's in the Fall Classic. Mize set other records as well, including being the only man to hit three home runs in a game six times; homering twice in a game 30 times; hitting seven pinch-hit home runs—a record, with three of them in Series play; and homering in all 15 ballparks then in use during his major league career.

170. KEN KELTNER *(Below)* **[Kenneth Frederick Keltner; "Kenny"; 3B; 1937–44, 1946–50; CLE (A), BOS (A)].** Even before there was a Brooks Robinson, there was a Ken Keltner, a far-ranging third baseman with an acrobatic ability to dive to his right for ground balls. Nowhere was that talent more in evidence than on the night of July 17, 1941, when Keltner single-glovedly brought an end to Joe DiMaggio's 56-game hit streak by flagging down two down-the-line sizzlers and throwing DiMag out. An Indian stalwart for ten seasons, five times Keltner led the league in double plays—setting an AL record—four times in assists, three times in fielding and once in putouts. In 1948, as the Indians made their first run for the pennant in 28 years, Cleveland owner Bill Veeck decided that Keltner, who had just broken the record for the most games ever played at third in an Indian uniform could use a little bit of psychological encouragement and threw a "Kenny Keltner Night" to render aid and comfort to his third baseman. Keltner responded by putting together his greatest year at bat, a year that saw him hit more homers, score more runs and drive in more than he had in any of his previous nine years—and cap off his career year by hitting a single, a double and a three-run homer in the '48 playoff game against the Boston Red Sox to give Cleveland their first pennant since 1920. Keltner also made baseball history, of a sort, by becoming the first player ever to apply for unemployment insurance during the off-season—all of which prompted Chicago White Sox manager Jimmy Dykes to holler at him as he took his position in the field and went through his normal ritual of kicking the bag, "Look under it, Ken. You might find some loose change there."

171. LOU BOUDREAU *(Left)* **[Louis Boudreau; SS; 1938–52*; CLE (A), BOS (A)].** A former basketball All-American at the University of Illinois, Boudreau became the Indians' regular shortstop at the age of 21 and, by the tender age of 24, the youngest man ever to manage a major league team from the beginning of a season. In 1948 Boudreau put together one of those seasons players can only dream about: batting .355 with 106 RBI's and 18 home runs—two of those homers and two of those RBI's coming against the Boston Red Sox in the first play-off game in American League history—and then leading his team to a six-game win in the Series over the Boston Braves to become the last player-manager to win a World Series.

172. DIXIE WALKER *(Left)* **[Fred Walker; "The People's Cherce"; OF; 1931, 1933–49; NY (A), CHI (A), DET (A), BKN (N), PIT (N)].** After seven-plus seasons in the American League, where he had batted .295, the washed-up, banged-up, taped-up and just plain ol' upped-up Dixie Walker was picked up by the Dodgers on waivers in July of 1939. And immediately became a Flatbush idol—"The People's Cherce," in choice Brooklynese. A lefthanded hitter who batted .300 or over in seven of his eight seasons in a Brooklyn uniform—including a league-leading .357 in 1944 (his brother, Harry "The Hat," would similarly lead the league three seasons later)—Walker won the heart of Dodger fans with his clutch hitting, especially against the hated Giants, and for his ability to play the many-angled Ebbets Field right field wall. Unfortunately, while he put up impressive numbers—including being the National League's second-leading hit producer, the NL hitter with the third-highest average and the player with the fourth-most runs scored in the NL for the decade of the forties—Walker is best remembered for something else that happened during the decade, something off the field. For, true to his origins and nickname, Walker circulated a petition before Opening Day in 1947 stating that the "undersigned Dodgers" would not play with Jackie Robinson. And although he later recanted, and even took Robinson's side when fellow Southerner and friend Ben Chapman unmercifully rode the newcomer, Walker was gone by the end of the season, traded, for Preacher Roe, to Pittsburgh where he finished his career.

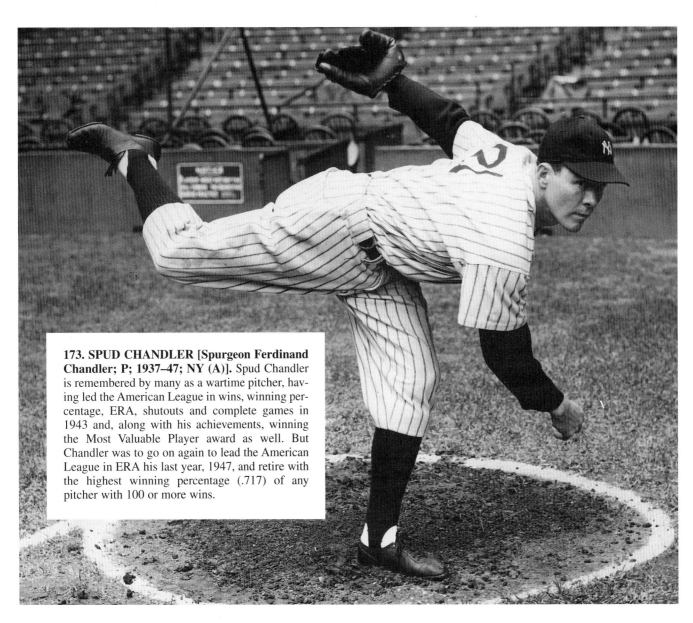

173. SPUD CHANDLER [Spurgeon Ferdinand Chandler; P; 1937–47; NY (A)]. Spud Chandler is remembered by many as a wartime pitcher, having led the American League in wins, winning percentage, ERA, shutouts and complete games in 1943 and, along with his achievements, winning the Most Valuable Player award as well. But Chandler was to go on again to lead the American League in ERA his last year, 1947, and retire with the highest winning percentage (.717) of any pitcher with 100 or more wins.

174. JOE GORDON *(Below)* **[Joseph Lowell Gordon; "Flash"; 2B; 1938–43, 1946–50; NY (A), CLE (A)].** During his seven years with the New York Yankees, Joe Gordon would be remembered for many things, from his acrobatic derring-do in the field to his timely feats with the bat. From the moment he came up to the Bronx Bombers to take Tony Lazzeri's spot at second, Gordon fit as snugly as a glove, becoming so dependable both in the field and at the bat that his achievements were rewarded by his being named the American League's MVP in 1942. But he is best remembered for two trades, the first one coming on October 19, 1946, when, after 1,000 games and 1,000 hits for the Yankees, Gordon was traded, along with journeyman third baseman Eddie Bockman, to the Cleveland Indians for pitcher Allie Reynolds. Hitting fourth behind Cleveland's playing manager, shortstop Lou Boudreau, and forming the Indians' double-play combination with Boudreau, the trade paid immediate dividends, with Gordon hitting 29 home runs and helping to propel the Indians to a fourth-place finish. The next year his career highs of 32 homers and 124 RBI's helped carry the Indians to their first pennant and World Series wins in 28 years. Gordon would go on to play two more years—compiling league records for most home runs by a second baseman in a career (246) and most in a season (his 32 in '48)—before turning to managing. It was as manager of the Indians that he became the party of the second part in the first-ever trade of managers when, in 1960, the Indians and Tigers traded managers, Gordon going from Cleveland to Detroit for Tiger manager Jimmy Dykes.

175. EDDIE JOOST *(Above)* **[Edwin David Joost; SS; 1936–37, 1939–43, 1945, 1947–55; CIN (N), BOS (N), PHI (A), BOS (A)].** With nine years in organized ball and after several proverbial cups of coffee, Eddie Joost replaced Billy Myers as the Cincinnati Reds' regular shortstop in 1941 and handled the position by mishandling 46 balls—even though he set a major league record for accepting 19 chances in one game. After butterfingering 50 balls in '42, he was traded to Boston, where he reduced his number of errors to 33 and his batting average to .185, the lowest average ever for a player with over 400 at-bats. Joost retired voluntarily in 1944 before coming back to the Braves in '45 as a utility infielder. He then spent a year at Rochester—where he sharpened his bespectacled eyes both at the plate, leading the International League in doubles, and afield, leading all shortstops in fielding—before coming up to the Philadelphia Athletics where he became part of an A's infield that included Ferris Fain, Peter Suder and Hank Majeski. A very valuable part, establishing, as he did, American League records for most consecutive errorless games (41) and most errorless chances without a miscue (226) and leading AL shortstops in putouts four times, to tie a league record. His bat also became more valuable; or, more correctly, his nonuse of a bat, as he walked more than 100 times in six consecutive seasons, twice getting more walks than hits. In his eighth season with the A's he was named manager and managed the very last Philadelphia entry in the American League as they lost 103 times and finished in eighth place on their way to Kansas City. Joost's last season in the "Bigs" was with the Boston Red Sox, where, in 39 games as an infielder, he batted .193, which is approximately where he had come in 19 years before.

176. EWELL BLACKWELL *(Right)* **[Ewell Blackwell; "The Whip"; P; 1942, 1946–53, 1955; CIN (N), NY (A), KC (A)].** This six-foot-six-inch beanpole was, in his prime, nearly unhittable, as he proved in 1947 when he came within two outs of duplicating Johnny Vander Meer's historic feat of pitching back-to-back no-hitters. Throwing a wicked sidearm delivery by way of third base, Blackwell won 22 games for the Reds during that career season—including 16 in a row to set a National League record for righthanders.

177. MORT COOPER *(Left)* **[Morton Cecil Cooper; P; 1938–47, 1949; STL (N), BOS (N), NY (N), CHI (N)].** Possessing what many described as a "scorching" fastball, one he was unafraid to throw tight, Mort Cooper was the dominant righthanded pitcher during the World War II years and one-half of the most famous brother battery in baseball history, the other half being his brother, Walker. After six less-than-promising seasons in the minors—only once winning more than he lost—Cooper came north to the "Bigs" in 1938 and immediately became a winner. After an operation for removal of a growth from his pitching elbow in 1941—which necessitated his chewing aspirin on the mound for relief from his aching elbow the rest of his career—Cooper turned in successive 20-win seasons in '42, '43 and '44, all three years leading the Cardinals to National League pennants. In '42 he led the NL in wins, ERA and shutouts, with 10—the most since Grover Cleveland Alexander threw his record 16 back in 1916—and finished second in strikeouts, accomplishments that won him the National League's MVP Award. In 1943, Cooper pitched successive one-hit games against the Dodgers and the Phillies on his way to a 21-win season and the league's leading won-lost percentage. Nineteen forty-four was a copy of the previous two seasons as he won another 22 games, second-highest number in the league, again led the league in shutouts and finished third in winning percentage and ERA. However, he was to win only three more games in a Cardinal uniform, the fifth game of the '44 Series and two games in the 1945 season, before the Cardinal front office, after suspending Cooper for leaving the club after a salary dispute, traded him to the Boston Braves for pitcher Red Barrett and $60,000. He would win only 23 more games over the next four seasons before following his by-now-faded arm into retirement.

178. ENOS SLAUGHTER *(Above)* **[Enos Bradsher Slaughter; "Country," "Eno"; OF; 1938–42, 1946–59*; STL (N), NY (A), KC (A), MIL (N)].** Even before there was a Peter Rose there was an Enos Slaughter, a player who gave 110% of himself. But it was not always thus. Playing at Columbus, Georgia, in 1936, Slaughter came running in from his right field position and, reaching the third-base line, casually strolled the rest of the way into the dugout. Manager Eddie Dyer, taking note of Slaughter's leisurely pace into the dugout, pointedly said to his charge, "Son, if you're tired, I'll get you some help." From that day on, Slaughter never again walked on a ballfield. For 19 years he always left the dugout running and came back the same way, running out everything he hit, whether it be a triple or a one-hopper back to the mound. Despite his many accomplishments, including a lifetime .300 average, the very cornerstone of Slaughter's fame was his nonstop running in the 1946 World Series. In the fifth game of that Series between the Cards and the Red Sox, Slaughter had been nicked on the right elbow by one of Joe Dobson's fast balls. Despite agonizing pain, Slaughter wouldn't "give nobody the satisfaction of knowin' I was hurt." But by the time he came to bat in the sixth, his elbow had taken on the look—and size—of an artificially colored tomato. Unable to swing the bat or throw, for the first time in his career Slaughter asked to be taken out of the game. Told by the team doctor that he had such a bad hemorrhage that if he were to be hit on his elbow again the chances were he'd lose the arm, Slaughter still played in Game Six, contributing a run-scoring single and knocking starting pitcher Tex Hughson out of the box to extend the Series to seven games. In that seventh game, Slaughter's all-out hustle gave the Cardinals the World Championship. For, with the score tied 3-3 in the bottom of the eighth, Enos opened the inning with a single. But when Whitey Kurowski popped out and Del Rice flied out, he seemed destined to remain anchored at first forever. However, Slaughter had other thoughts and, with Harry Walker at bat, took off for second on the pitch, all the better to be in scoring position. But as the ball crossed the plate Walker stroked it into center field. With a full head of steam, Slaughter, without breaking stride, headed for third and then, ignoring third base coach Mike Gonzalez's outstretched hands, came thundering home like a runaway train to score the winning run. Slaughter's mad dash not only carried the day but carried the man they called "Country" right into Cooperstown as well.

180. BOB ELLIOTT *(Below)* **[Robert Irving Elliott; 3B; 1939–53; PIT (N), BOS (N), NY (N), STL (A), CHI (A)].** The National League's premier third baseman for much of the '40s, Elliott came to the Braves in the fall of 1946 in a six-player trade and immediately became the favorite of Braves fans in the right field bleachers, called the "Jury Box" (so named by a writer who, one day, looking out in right field, counted just 12 fans in attendance). Elliott paid immediate dividends for the Braves, batting .317 and winning the Most Valuable Player Award in 1947 and then, in '48, leading the Braves to their first pennant in 34 years.

179. PETE GRAY *(Above)* **[Peter Gray; OF; 1945; STL (A)].** The year was 1945 and major league scouts were combing the countryside signing babes in swaddling clothes and throwing mosquito nets over anyone this side of the undertaker to fill out their War-depleted rosters. To fill their ranks the 1944 American League pennant winners, the St. Louis Browns, bought the contract of a one-armed outfielder named Pete Gray from the Memphis Chicks, where, in 1944, he had hit .333, stole a record-tying 68 bases and won the Southern Association's MVP award—and, in keeping with the war times, had been presented with a $100 war bond for being so named. He debuted on the afternoon of April 18, 1945 against the Detroit Tigers and their fireballing lefthander, Hal Newhouser, who retired Gray three times, one of those a called third strike—one of only 11 times that year Gray would strike out. Before he ended his major league career, on September 30th, facing the same pitcher, Gray compiled a batting average of .218. But for the 77 games he played, Pete Gray was more than a mere profile in courage, he was an exceptional player. And one who will be forever remembered as baseball's one-armed ballplayer, setting a record that will never be broken—there being no chance of players with fewer limbs playing major league ball.

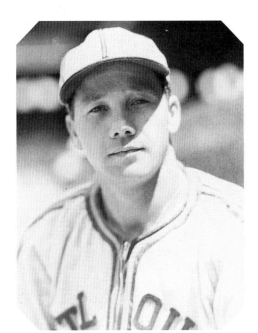

181. BOBBY ESTALELLA *(Left)* **[Roberto Estalella; OF; 1935–36, 1939, 1941–45, 1949; WAS (A), STL (A), PHI (A)].** There really is very little to recommend Roberto Estalella to anyone's attention: for parts of nine seasons he played in the majors, four of those during the War years, when he alternated between the outfield and third, averaging .285 for second-division teams, and then jumped to the Mexican League in '46. There is one thing, however, that commends Estalella to the attention of baseball historians: 12 years before Jackie Robinson broke baseball's so-called "color barrier," Roberto Estalella was what everyone in his native Cuba knew—and many, like Jose Valdivielso, acknowledged with a knowing wink, saying, "He was a mulatto"—the first black to play in the majors in the twentieth century.

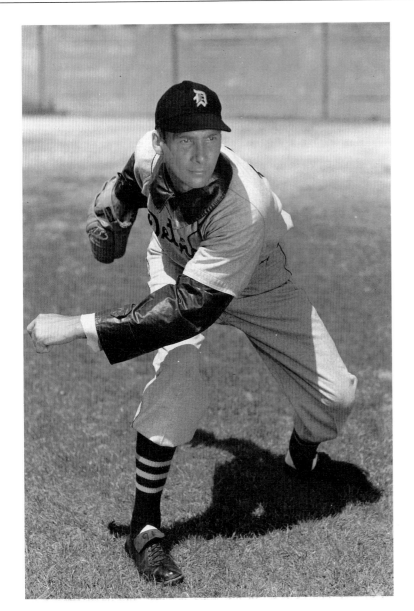

183. DIZZY TROUT *(Below)* **[Paul Howard Trout; P; 1939–52, 1957; DET (A), BOS (A), BAL (A)].** When one mentions the Detroit Tigers of the mid-forties, the one name that quickly leaps to mind is Hal Newhouser. But the "other" pitcher on the staff was Paul "Dizzy" Trout, a righthander who complemented the lefthanded Newhouser and gave the Tigers a one-two pitching duo, one that came the closest, in 1944, to two teammates' winning 30 games each than any pitching pair since Joe McGinnity and Christy Mathewson pulled off the feat in 1904. Like the fabled contortionist, Trout first came into his own in 1943 when his 20 wins and five shutouts led the league. But 1944 was to be his career year, the year he won 27 games, led the American League in ERA, games started, complete games, most innings pitched and shutouts, and had five home runs while batting .271 in 133 at-bats. Still, his 27 wins was only second best, both in the majors and on the team, Newhouser having won 29. The next year Trout contributed another 18 wins, and performed yeoman's duty down the stretch, pitching six games in the final nine. Over the next seven seasons he won an average of ten-plus games a season. Then, after retiring for five years, the fun-loving Trout, willing to try anything, came back to pitch twice for the Orioles at the age of 42.

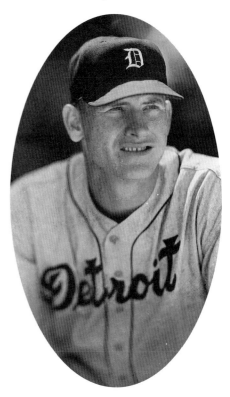

182. HAL NEWHOUSER *(Above)* **[Harold Newhouser; "Prince Hal"; P; 1939–55*; DET (A), CLE (A)].** With the exceptions of Lefty Grove and Sandy Koufax, no lefthander has so dominated his era as the pitcher known as "Prince Hal." For three years in the mid-forties, Newhouser put together back-to-back-to-back seasons of 29, 25 and 26 wins, leading the American League in wins all three seasons, in ERA two, in strikeouts two and in shutouts one. He was named the Most Valuable Player in 1944 and '45, the only pitcher ever to win two consecutive MVP's. And yet, for all his accomplishments, Newhouser is constantly referred to as a "Wartime pitcher," as if to disparage his achievements. Granted, his two greatest years came during the Second World War, when the talent was so inexpressibly dreary that beardless puppy-youths who could throw a baseball the length of a playpen and bearded grizzlies who had been around since the first game of grounders peopled the line-ups— most called ballplayers for the same reason raisins are called fruits, technically and only in a manner of speaking. (In fact, the most famous conscript to the baseball wars, Pete Gray, a one-armed outfielder with the St. Louis Browns, faced Newhouser in his first and last major league appearances.) However, Newhouser's career extended beyond the end of the War for five more seasons, five seasons in which he won 97 games, giving him a seven-season period in which he averaged 21½ wins a season. And during that seven-season span he finished 240 of the 276 games he started, an 86.95% completion rate—a fraction higher than that of his pitching rival, Bob Feller, during Feller's best seven seasons and higher even than that of Walter Johnson during his best seven-year period. To call Hal Newhouser a "Wartime pitcher" is like calling kittens born in an oven "biscuits." It ain't necessarily so. He was more, much more. Hal Newhouser was one of baseball's all-time great lefties, War or no.

184. BILL NICHOLSON *(Below)* **[William Beck Nicholson; "Swish"; OF; 1936, 1939–53; PHI (A), CHI (N), PHI (N)].** At one point on baseball's long timeline, sluggers from the state of Maryland had, among them, won more home run championships than those from any other state: Babe Ruth from Baltimore with 12; and three from the tiny Eastern Shore with ten—Home Run Baker, 4, Jimmie Foxx, 4, and Bill Nicholson, 2. The last member of this slugging Maryland quartet, Bill "Swish" Nicholson, was a free-swinging left-handed hitter who dominated National League power statistics during the War years of the early forties. During the first five years of the decade, Nicholson drove 134 balls out of assorted and sundry National League parks—most out of Chicago's Wrigley Field, where he once hit a prodigious drive that just missed the scoreboard. His mighty swing punctuated the air with an almost audible "swish," which was picked up on by those denizens of the open-air psychiatric ward known as Ebbets Field and hollered at his every miss of a pitch—and soon became his nickname around the league. The National League's second-most prolific home-run hitter and driver-in of runs during the decade, Nicholson tied a major league record by leading the league in home runs and RBI's back-to-back in 1943 and '44. In the latter year he hit four consecutive home runs in a double-header on July 22nd, prompting New York Giants manager Mel Ott to walk him intentionally with the bases loaded when he came to bat the next time. In the 1945 World Series, he tied a record by driving in eight runs in a seven-game Series. Failing eyesight, the result of diabetes, cut down his production and after the '48 season the Cubs dealt him to the Phillies, where he roomed with ex-teammate Eddie Waitkus. There, he became part of an incidental piece of baseball history when he gave Waitkus a note from a caller, later identified as Ruth Ann Steinhagen, who met Waitkus' knock at the door of her Edgewater Beach hotel room with a shotgun blast on that fateful day in 1949.

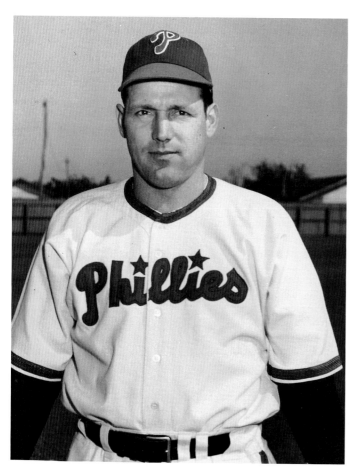

185. PETE REISER *(Opposite, left)* **[Harold Patrick Reiser; "Pistol Pete"; OF; 1940–42, 1946–52; BKN (N), BOS (N), PIT (N), CLE (A)].** Quite possibly the greatest natural talent ever to come to the Bigs, Pete Reiser's potential for greatness was derailed by injuries, injuries and more injuries. According to Boston Brave outfielder Tommy Holmes, "There wasn't a thing he couldn't do on that ball-field." And to many other observers, he could do it better than most. From the moment he showed up at the 1939 Brooklyn Dodger training camp he showed what he had, getting on base the first eleven times he came to bat. Writers, as is their wont, immediately appended the word "superstar" next to his name. After another year-and-a-half of seasoning at Elmira and Montreal, Reiser was brought up by the Dodgers, filling in at third and short and occasionally playing in the outfield. In 1941, by now moved to center field and having changed from a switch-hitter to an exclusively lefthanded one—after Paul Waner watched the phenom and told him, "Your lefthanded stroke is perfect"—Reiser burned up the league, leading the NL in doubles, triples, runs, slugging average and batting average with .343, becoming, in the process, the youngest NL batting champion. He also led the league in something else: twice being carried off the field on stretchers—the first of an estimated 11 times he would be carted away thusly. In '42 he picked up where he had left off and was assaulting NL pitchers to the tune of .383 in early July when he came in contact with Sportsman's Park's center field wall. He woke up in a St. Louis hospital where, after just two days, he checked himself out and hied himself to Pittsburgh just in time to drive in the winning run. But, rounding first, he fell on his face and again was carried from the field. The rest of the season was a blur to Reiser, as was the ball. Unable to pick up the ball, his batting average fell to .310. After three years in the military, Reiser returned to the Dodgers, batting .277 and for the second season leading the league in stolen bases with 34—seven of those steals of home, a major league record. In '47 he met up with a wall for the second time and was paralyzed for ten days. He returned to the lineup for the last two months of the season, just in time for the 1947 World Series, where, predictably, he fractured his ankle. Nevertheless, he was inserted as a pinch-hitter in the fourth game, the famous Cookie Lavagetto game, and was intentionally walked by Yankee manager Bucky Harris who, even though he knew of Reiser's broken ankle, still put him on as the potential winning run, saying, "He'll swing, ankle or no ankle." Reiser's career wound down after the '47 season, never to approach the greatness once predicted for him. His manager, Leo Durocher, sensing what had been lost, said: "Reiser might have been the best ballplayer I ever saw. He had everything . . . but luck."

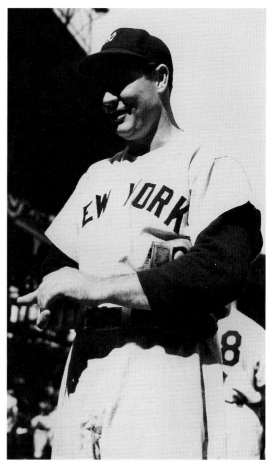

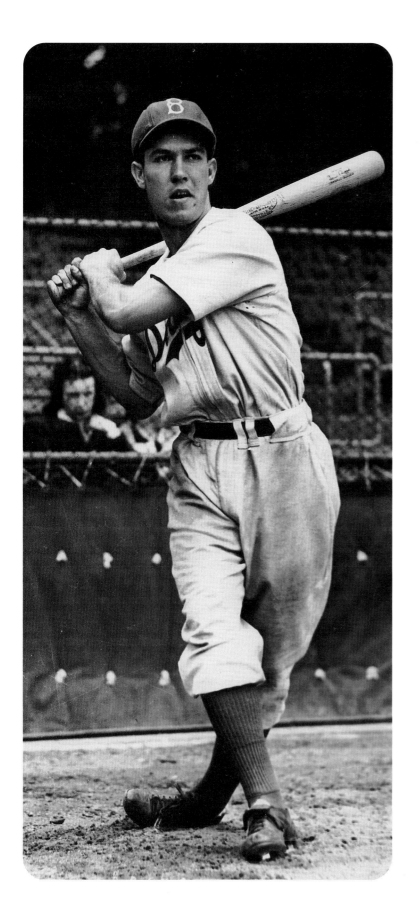

186. JOE PAGE *(Above)* **[Joseph Francis Page; P; 1944–50, 1954; NY (A), PIT (N)].** On May 26, 1947, Joe Page was just one pitch away from being sent packing back to Newark, and possibly permanent exile from the majors. Then, with the bases loaded with Red Sox and no one out, Page, with a count of 3-0 on Rudy York, threw three pitches past the big first baseman. He duplicated the scenario against Bobby Doerr, going to 3-0 before also striking out the clutch-hitting Doerr, and then he retired shortstop Eddie Pellagrini. The Yankees would go on to win the game from the defending champion Red Sox and Page, throwing what he later admitted was a "wet one," would go on that year to relieve in 54 games, winning 14 in relief, an American League record. In 1949 he would relieve 60 times, saving a record 27 games, as the Yankees edged out the Red Sox by one game in one of the most exciting American League pennant races of all time. Seven times he would relieve in World Series games, winning the clinching seventh game in '47 and the third game of the '49 Series, both against Brooklyn. A roustabout of the first water—and scotch—Page originally roomed with Joe DiMaggio. However, DiMag would not put up with Page's late-night shenanigans and moved out, taking a single room and paying the difference between single and double rates out of his own pocket just to get away from the happy-go-lucky Page. By 1950 Page's lifestyle had caught up with him and by the end of the season he was out of the majors, only to make a comeback four years later with the Pirates, then looking for a reliever. His comeback lasted all of seven games as he posted an 11.17 ERA and then went on his merry.

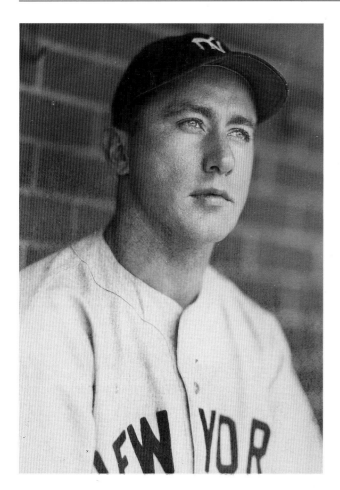

187. SNUFFY STIRNWEISS *(Above)* **[George Henry Stirnweiss; 2B; 1943–52; NY (A), STL (A), CLE (A)].** When Johnny and Frankie and Teddy and all the others came marching home from their military service in 1946, they replaced many of the wartime stars whose careers had been extended by the War. But one wartime star who not only stayed at his position but actually took the place of one of those prewar stars was Yankee second baseman George "Snuffy" Stirnweiss, whose play for the duration was reason enough for New York to unload its returning second baseman, Joe Gordon. Stirnweiss, a former University of North Carolina running back who had come up to the Yankees in 1943 after setting an International League base-stealing record, filled in at short and second his first season in the majors. By his second, 1944, Stirnweiss, who had been deferred from military service because of gastric ulcers and hay fever—two maladies that never affected his baserunning—led the American League in stolen bases, with 55; hits, with 205; runs, with 125; and doubles, with 16. The next season he not only repeated as the leader in bases stolen, hits, runs and doubles, but also added both the batting- and slugging-average titles—his .309 being at the time the second-lowest average ever to win a batting title. As quick with his glove as he was on his feet, Stirnweiss set several fielding records for second basemen, including most errorless games and most chances without an error and, in the same season, set the all-time fielding record for second basemen with a .993 fielding average. However, 1948 was to be his last full season as his legs began to give out, and four part-seasons later he retired with a .268 lifetime batting average, lowest ever for a batting champion. Unfortunately, his legs were still good enough for him to chase and catch a commuter train on the morning of September 15, 1958, boarding, in full flight, the last car, a car that plunged into Newark Bay, costing him his life.

188. JOHNNY SAIN *(Below)* **[John Franklin Sain; P; 1942, 1946–55; BOS (N), NY (A), KC (A)].** The 1948 Boston Braves' pitching staff was considered to be so tissue-thin that its rotation—or lack thereof—was ridiculed in a little verse penned by Boston sportswriter Gerry Hearn as being "Spahn and Sain and pray for rain." Despite the verse, however, it was vice versa: Johnny Sain was the real ace of the '48 Braves' staff. For that was the season Sain won 24 games, tops in the National League, and led the league in games started, games completed and innings pitched. And, aiding his own cause, it was also the year he set an all-time major league record by becoming the first pitcher in history to undisputedly lead his league in sacrifice hits, with 16. Four times Sain would win 20 games with a pitch he had perfected, one virtually unknown before World War II: the slider. Having spent four seasons in the lowest rung of organized ball, the Class D Northeast Arkansas League, Sain, who admittedly "never had overpowering speed," but had a lot of time, experimented with his "breaking stuff, big curves and short ones." Unable to convince batters with his power, he confused them with his "short curve," or slider. By the time he finally surfaced in the majors, after six seasons of servitude in the minors, Sain was throwing a ball that approached the plate like a fastball but which suddenly veered, or slid, a few inches to one side. After one year of relieving in the bullpen for the Braves and three years of serving in the military for Uncle Sam, Sain returned to win 20 games in 1946, then followed that up with 21 in '47 and 24 in '48, the year the Braves won their second-ever pennant. After an off year in 1949, Sain returned to the 20-game winners' circle in 1950 with his fourth 20-win season. Traded to the Yankees in mid-season '51 for $50,000 and a minor-league pitcher named Selva (Lew) Burdette, Sain became the Yankees' bullpen ace, saving a league-leading 22 games in 1954. Sain retired after the '55 season to become a pitching instructor for teams like the A's, Yankees, Twins, Angels, Tigers, White Sox and Braves, teaching others how to throw the "five-cent curve" and, in the process, turning pitchers like Denny McLain, Jim Kaat, Wilbur Wood, Jim Bouton and Clyde Wright, among others, into 20-game winners.

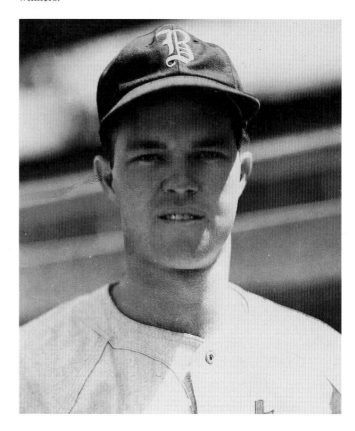

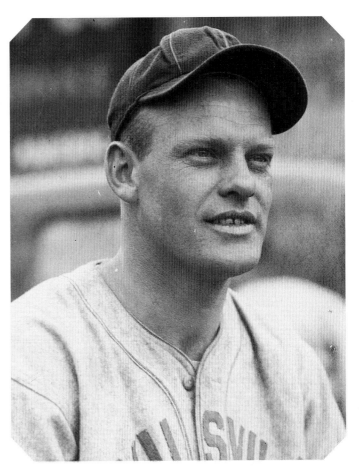

189. RIP SEWELL *(Right, top)* [**Truett Banks Sewell; P; 1932, 1938–49; DET (A), PIT (N)**]. Some pitchers are identified by their pitches almost as readily as a band by its musical signature—like Satchel Paige's "hesitation pitch," Christy Mathewson's "fadeaway" and Carl Hubbell's "screwball." But perhaps the most famous pitch of all was the "eephus" pitch, a frustrating, cloud-busting pitch thrown off the toes and released from the back of the head which held its line of flight to the plate owing to its backspin. And the possessor—or, as some hold, the patenter—of that famous pitch was Truett "Rip" Sewell. Sewell's "eephus" pitch was born during an exhibition game against the Detroit Tigers in 1943. Sewell had come in to pitch the final three innings and one of those he faced was Tiger rookie phenomenon Dick Wakefield. Sewell got two quick strikes on Wakefield and then looked in to catcher Al Lopez for a sign. Lopez called for a change of pace. Instead, Sewell threw a change of space. Wakefield stared at it, started to swing and stopped, swung, missed and fell down. After the game, newsmen wanted to know what Sewell called whatever it was he threw. It was then that reserve outfielder and full-time kibitzer Maurice Van Robays came by and volunteered that it was an "eephus ball" because, as Van Robays explained it, "eephus ain't nothing . . . and that's what it was, nothing." And so it became the "eephus ball," a larger-than-life blooper that almost made batters want to throw away their bats, clench their fists and punch it over the fence with their bare hands. Some disdained swinging at it at all. Whitey Kurowski merely spat tobacco juice at the ball as it came down from on high. But a few, a very few, like Stan Musial and Ron Northey, had some success hitting whatever it was. But they were rare indeed. "Only one in 15," Sewell would say, with a wicked chuckle in his voice. However, one batter did hit it, very well indeed. That moment came in the 1946 All-Star Game. Sewell had come in to pitch for the National League, then in the process of being chewed up by the American League, the score at 8-0 and counting. Sewell decided to "have fun" and with Boston slugger Ted Williams at bat went to his "eephus ball." Williams followed his first delivery with interest, allowing it to go by for a called strike. Now giggling, Williams challenged Sewell to throw yet another. Sewell, mixing a little deviltry with some so's-your-old-man daring, threw his famed pitch a second time. And Williams, timing not only his swing but also moving up in the batter's box a stutter step, all the better to hit it, thumped it over the center-field fence. It was the only home run ever hit off one of Rip Sewell's famous "eephus" offerings, a pitch he perfected to the tune of 143 wins in his major league career—including a league-leading 21 in 1943, the year he first discovered it.

190. WALKER COOPER *(Right, bottom)* [**William Walker Cooper; C; 1940–57; STL (N), NY (N), CIN (N), BOS (N), MIL (N), PIT (N), CHI (N)**]. Called by Cardinal teammate Enos Slaughter "one of the best behind the plate," Walker Cooper, for five years, was one-half of the famed Cooper brothers battery for St. Louis, with brother Mort. Named to every National League All-Star team between 1942 and 1950, Cooper joined the New York Giants in 1946 and in '47 added his right-handed muscle to the Giants' then-record 221 team home runs, hitting 35, third most on the team.

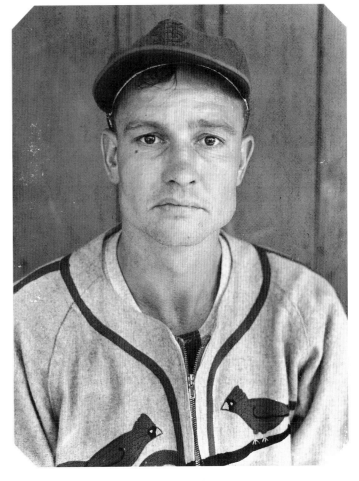

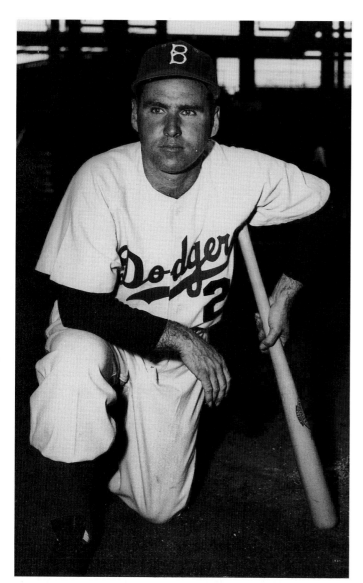

191. TOMMY HOLMES *(Left)* **[Thomas Francis Holmes; OF; 1942–52; BOS (N), BKN (N)].** If there ever was such a thing as a "career year," then Tommy Holmes had such a year in 1945. That season he led the National League in hits (with 224), doubles (with 47), slugging average and home runs (with 28)—becoming in the process the only player ever to lead his league in home runs and fewest strikeouts (with 9) in a year. And, from June 6 through July 8, he hit in a National League–record 37 straight games. Holmes would never come close to duplicating his 1945 effort. But 33 years later, he would be remembered as he was. On the memorable night in 1978 when Pete Rose broke his National League consecutive-game hit streak, Holmes said to Rose and the assembled crowd at Shea Stadium, "I want to thank Pete Rose for helping me relive my streak and for making me famous again when everybody had forgotten me."

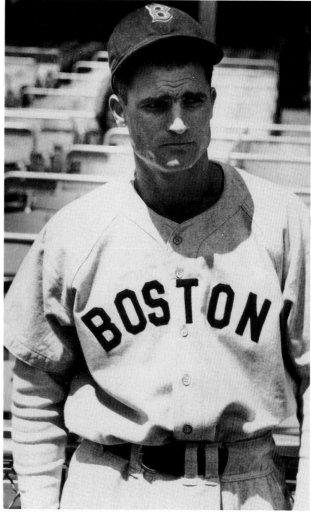

192. BOBBY DOERR *(Right)* **[Robert Pershing Doerr; 2B; 1937–44, 1946–51*; BOS (A)].** One of the surest-handed second basemen in modern baseball, Doerr was first spotted by Boston Red Sox superscout Eddie Collins on the same scouting trip that saw Collins sign Doerr's teammate on the San Diego Padres, Ted Williams. Doerr, then 18 years old, was leading the Pacific Coast League in hits and batting .342 but, ironically, it was not his bat but his glove that would win him fame—and election to the Hall of Fame. For although he never hit below .270 in any full season, from the first moment he took his place as Boston's regular second baseman he was compared to Charlie Gehringer as one of the league's best, leading the American League in double plays in his first full season and in four other seasons. In his only World Series, 1946, he set the record for most assists by a second baseman (31) in a seven-game Series and hit .409 in a losing cause.

193. JOHNNY PESKY *(Below)* **[John Michael Pesky (born Paveskovich); IF; 1942, 1946–54; BOS (A), DET (A), WAS (A)].** Having broken into organized baseball as the batboy for the Portland Beavers of the Pacific Coast League, young John Paveskovich absorbed all he could from past and future major leaguers and put it, combined with his natural talents, to good use, becoming one of the best-hitting infielders of the forties. When he came up to the Boston Red Sox in 1942, he led the American League in hits with 205 and, after three years in military service, returned in 1946 to pick up right where he had left off, leading the AL again in hits. Then, setting a record, he led the league in hits again in his third year in the majors—that third year hitting safely 207 times with only 35 extra-base hits, an American League record. A lifetime .307 hitter with six .300-plus seasons, Pesky was also known for his slick work afield, playing equally well at short, third and second and leading the league in assists at more than one position. But Pesky is best known for his part in the play that will forever be known as "Enos Slaughter's Dash for Home." The scene was this: the Red Sox and the Cardinals were tied three-all in the bottom half of the eighth inning of the seventh and final game of the '46 Series. With the Cardinals' Enos Slaughter on first and two outs and Bob Klinger pitching in relief, Slaughter timed Klinger's motion and took off for second with Harry Walker at bat. Walker swung and poked the ball in the direction of replacement center fielder Leon Culberson. While Culberson, a half-step slower than the man he had replaced, Dom DiMaggio, was busy chasing down the ball, Slaughter, paying no never mind to third base coach Mike Gonzalez's upraised arms, thundered around third on his way home. Pesky, having taken Culberson's relay over his left shoulder, turned as slowly as a door back toward the infield, fully expecting Slaughter to arrest his mad tear around the base paths and paying more attention to Gonzalez's upraised arms than to the runner, Slaughter. Third baseman Pinky Higgins ran out and shouted at Pesky, as did second baseman Bobby Doerr. But so did 36,143 other voices of those seated at Sportsman's Park, who had at first gasped at Slaughter's daring and now grasped its significance. With Higgins' and Doerr's shouts lost somewhere in the tumult of shouting, the unhearing Pesky turned toward second, toward Walker, rather than toward Slaughter. Finally, the urgency of the situation was impressed upon him, and Pesky, having turned halfway toward second, now had to turn again, off-balance, to throw the ball home. But Slaughter, still three furlongs in front of the ball and gaining, thundered down the basepaths ahead of Pesky's relay and scored the winning run.

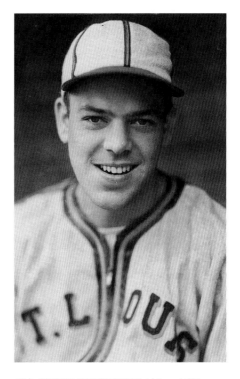

194. VERN STEPHENS *(Above)* **[Vernon Decatur Stephens; "Buster," "Junior"; SS; 1941–44; STL (A), BOS (A), CHI (A), BAL (A)].** With an exaggerated batting stance so wide you could drive a minivan through his outstretched legs, Vern Stephens was able to generate more power than any shortstop this side of Ernie Banks. Originally signed by the St. Louis Browns for a $500 bonus at age 17, by the age of 24 Stephens had become the premier shortstop in the American League during the talent-thin war years, a one-man powerhouse accounting for more than 26% of the Brownies' total run production, leading the League in RBI's and powering the 1944 Browns to their first, and only, American League pennant. Three years later, the Boston Red Sox sent six players and $310,000 to the cash-starved Browns for Stephens and pitcher Jack Kramer. Kramer repaid the BoSox for just one season, but Stephens kept paying dividends for the next three, as, batting behind Ted Williams, he assaulted both opposing pitchers and Fenway Park's friendly left field wall—the "Green Monster"—averaging 33 homers and 147 runs-batted-in a season and twice tying with teammates Williams and Walt Dropo for the League RBI lead. Seven times an All-Star, thrice the league RBI leader and once the home-run leader, Stephens ranked among the top RBI and home-run producers for the decade of the forties—a rarity among shortstops in any era.

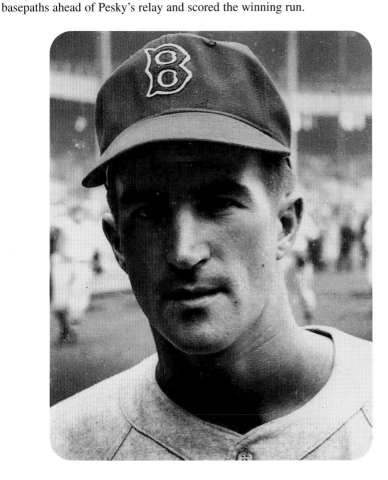

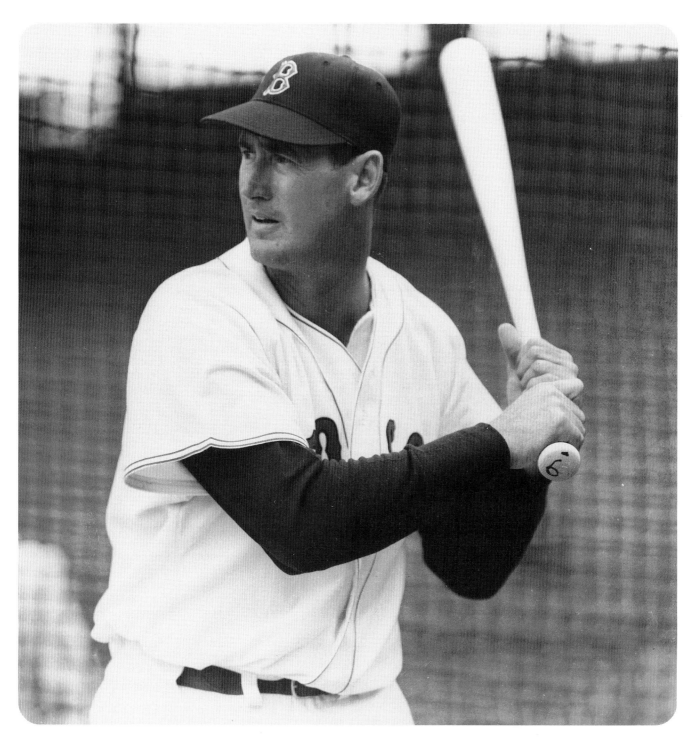

195. TED WILLIAMS *(Above)* [**Theodore Samuel Williams; "Teddy Ballgame," "The Kid," "The Splendid Splinter," "The Thumper"; OF; 1939–42, 1946–60*; BOS (A)**]. In one of his rare unguarded moments, Ted Williams once drew back the curtain and gave the world a brief glimpse of what made Teddy bat, saying "All I want out of life is that when I walk down the street folks will turn and say: 'There goes the greatest hitter who ever lived.'" And to many of those who saw this spindly six-foot-three-inch figure with the shape of a baseball bat with a severe thyroid condition, he was, as he re-edited the record books. Among the many records held by the man who called hitting a baseball "the hardest single feat in sports" are most consecutive playing years leading in runs scored (5); most consecutive playing years leading in bases on balls (6); most consecutive years with 100 or more bases on balls;

most intentional bases on balls, season (33); and most times successfully reaching first base safely (16 seasons). He also was the last man to hit .400, with a .406 batting average in 1941, and, in 1957, became the oldest man ever to win a batting crown when, at the age of 39, he won his fifth batting title with a .388 average and then broke the record the next year, at the age of 40, when he won his sixth with a .328 average. Six times the leader in total bases, six times in batting, four times in runs batted in—including a rookie record of 145—six times in runs scored, four times in home runs and nine times in slugging average, the man who fittingly homered on his last time at bat and finished with a lifetime .344 batting average and .634 slugging average might, just might, have been what he wanted to be: "the greatest hitter who ever lived."

196. PEE WEE REESE *(Below)* [**Harold Henry Reese; "The Captain," "The Little Colonel"; SS; 1940–42, 1946–58*; BKN (N), LA (N)**]. In his timeless tome, *The Boys of Summer,* Roger Kahn writes, "Three themes sound through the years of Harold Henry Reese. The first was his drive to win, no less fierce because it was cloaked in civility. A second theme was that civility itself. The final theme echoed wonder. He played shortstop for three generations of Brooklyn teams, and came to sport droll cockiness. Yet near the end, watching a brown telephone truck scuttle by, he said with total seriousness, 'I still can't figure why the guy driving that thing isn't me.'" But the man they called "Pee Wee" (a name given to him not because of his diminutive size but because, back in his hometown of Louisville, he was a champion marble shooter and a "pee wee" is a marble) was not a truck driver because of his leadership on the diamond, a leadership that manifested itself in his skill as an All-Star shortstop eight straight years, in his ability with a glove, leading the league in putouts, assists, double plays and fielding average at least once each, in his ability to reach base and score, as witnessed by his leading the league in walks, runs and stolen bases once each and in his excellent clutch hitting. But perhaps Reese's greatest contributions were off the field where, again according to Kahn, "He was Jackie Robinson's friend. They played hit-and-run together and cards and horses. Anyone who resented Robinson for his color or—more common—for the combination of color and aggressiveness found himself contending not only with Jack, but with the captain. Aware, but unself-conscious, Reese and Robinson came to personify integration. If a man didn't like what they personified, why, he had better not play for the Dodgers."

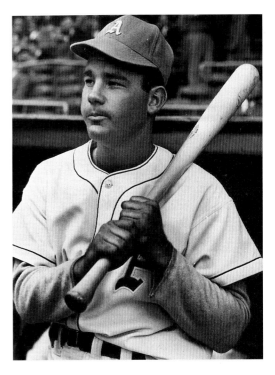

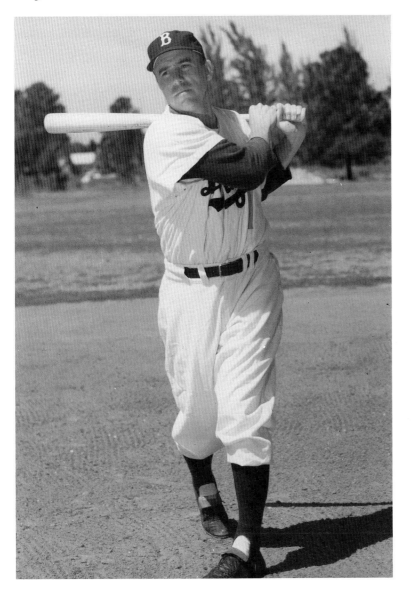

197. FERRIS FAIN *(Above)* [**Ferris Roy Fain; "Burrhead"; 1B; 1947–55; PHI (A), CHI (A), DET (A), CLE (A)**]. When Connie Mack drafted a kinky-haired first baseman (thus, his nickname) from the San Francisco Seals after the '46 season, he knew he was getting a far-ranging, slick-fielding first baseman. And for seven full seasons, fielding with an elegance and an eloquence, Ferris Fain performed up to the promise of his press clippings, four times leading the American League in assists and twice in double plays and total chances per game—in fact, he set the all-time double-play record with 194 in 1949, 31 more than the previous record, and ranks third in assists per game on the all-time list. And, despite his having led the league in errors five times, Fain was the first first baseman to regularly field bunts down the *third*-base line, in the words of writer Maury Allen, "doing wonders on a bunt play." But what Mr. Mack could hardly have realized was that the player who had averaged .270 over five seasons on the Pacific Coast League would become only the second player in the A's long history, after Al Simmons, to win back-to-back batting championships. For Fain reinvented the Ferris wheel, leading the American League in batting in 1951 and '52. He was also among the league's leaders in getting on base, walking 100 times or more five times and averaging over .400 in on-base percentage year after year, finishing at .425 lifetime. After Fain's second batting championship, Mack dealt him to the Chicago White Sox, just as he had Simmons twenty years before, only the second time in American League history the batting champion had been traded after leading the league. A knee injury, suffered during the '54 season, cut short Fain's career and he ended with a .290 batting average—the lowest lifetime average for any two-time batting champion who won his batting titles back-to-back.

198. JOE GARAGIOLA *(Below)* **[Joseph Henry Garagiola; C; 1946–54; STL (N), PIT (N), CHI (N), NY (N)].** To hear him tell it, whether at the podium or in his book, *Baseball Is a Funny Game,* Joe Garagiola's career behind the plate was one big joke. But, as Ira Gershwin said, "It ain't necessarily so." For during his prime Joe Garagiola was a pretty fair catcher, first at Fort Riley during World War II and then with the St. Louis Cardinals, where he came up as a rookie in 1946 to join a team that had won three pennants in the previous four years and beat out the likes of Del Rice, Ken O'Dea and Clyde Kluttz for the starting job. His three hits in the opening game of the '46 playoffs versus the Dodgers helped to win the game for the Cards, and his six hits in the '46 World Series—four in one game to tie the record—was a total surpassed only five times before by catchers in seven-game Series. By his fifth year, Garagiola seemed to be finding himself and was batting .347 in mid-June when he suffered a shoulder injury trying to avoid colliding with Jackie Robinson. Coming back for only 11 games, he finished the season with a more-than-respectable .318 batting average. The following season he was dealt to the woebegone Pirates whose manager, Billy Meyer, once addressed the team with the words, "You clowns could go on 'What's My Line?' in full uniform and stump the panel." His nine-year career came to an end in 1954 and by 1955 he began his second career broadcasting St. Louis Cardinal ballgames. Garagiola would go on to broadcast NBC's "Major League Baseball" and Yankee games and become the host of NBC's "Today Show" before becoming one of baseball's top raconteurs, regaling audiences with stories of his days as a member of the Pirates and his days as a boyhood friend of Yogi Berra's, careful to avoid any mention of his days with the Cardinals.

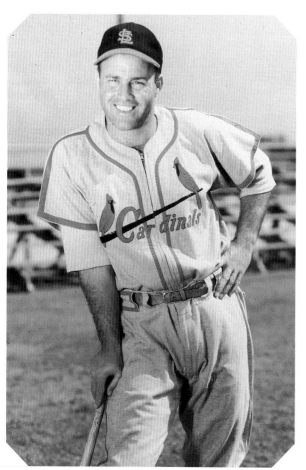

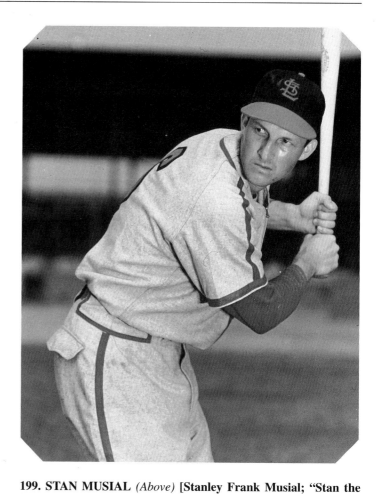

199. STAN MUSIAL *(Above)* **[Stanley Frank Musial; "Stan the Man"; OF; 1941–44, 1946–63*; STL (N)].** Take one part corkscrew, two parts carpenter's rule bent double and add a pinch of what pitcher Ted Lyons called "the look of a little boy peeking around the corner of a door" and you have the makings of Stan Musial's batting stance, less that of a classicist than a contortionist. But that odd batting stance was about as harmless as a powder magazine built over a matchstick factory, and produced results just about as pyrotechnic. One day during the 1947 season, Cincinnati Reds pitcher Ewell Blackwell threw one of his patented sidearm sizzlers past Musial for a third strike. Unfortunately he threw it past catcher Dixie Howell as well, allowing Musial to go all the way to second on the strikeout. In the Reds' dugout, manager Bucky Walters could be seen slamming his cap to the ground and heard groaning, among other muttered maledictions, "That guy Musial is so good that even when he fans you're lucky to hold him to two bases." Originally a pitcher, Musial injured his soup bone playing the outfield for Daytona Beach in the Florida State League. Manager Dickie Kerr, the same Dickie Kerr who had won two games for the White Sox in the infamous 1919 Series, reinvented the Musial wheel by converting him into a full-time outfielder. From that point on, he turned, as he said, "from a dead-armed left-handed pitcher in the minors to a wide-eyed outfielder in the majors." And held observers in wide-eyed wonderment at his list of accomplishments, which included, in his 22-year career, seven batting titles. Six times he led the National League in hits, five times in triples and runs scored, eight times in doubles, and twice in runs batted in. Ironically, with 475 home runs, he never led the National League in home runs. Musial became known as "Stan the Man"—or, more familiarly, just "The Man"—when one of the inmates who ran the asylum known as Ebbets Field where Musial regularly savaged Dodger pitching, trotted out the moan one afternoon during a double-header as Musial trotted up to the plate, "Here comes that man . . . that man. . . ." The press box picked up the cry, almost a keening, and so it became "Stan the Man." And the nickname became the man as well.

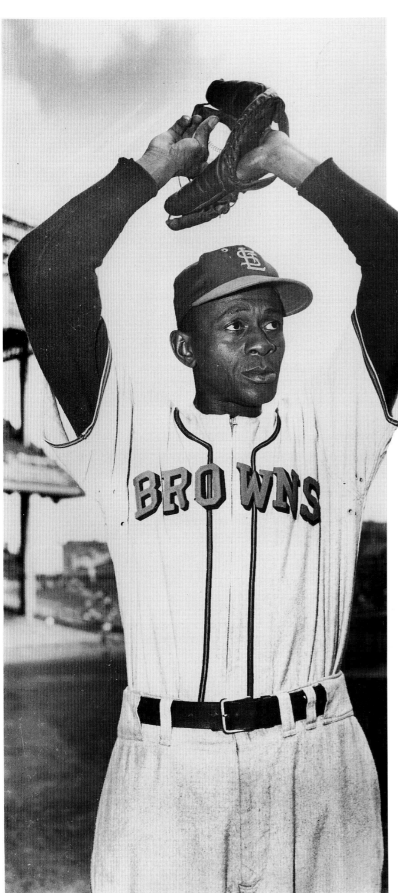

200. SATCHEL PAIGE *(Left)* **[Leroy Robert Paige; "Satch"; P; 1948–49, 1951–53, 1965*; CLE (A), STL (A), KC (A)].** Brought up to the majors at the advanced age of, supposedly, 42, the ageless Satchel Paige—literally, nobody quite knowing his exact age—brought with him an amazing arsenal of pitches, all with descriptive nicknames. His most famous one was his "hesitation pitch." This was delivered sidearm, with first his leg, having instincts of its own, stammering down. The follow-through with his arm was delayed and out of synch and left batters swinging at the motion of his foot. American League president Will Harridge banned this pitch as "deceitful." Other pitches Paige called "the two-hump blooper" (for his moving changeup), the "little Tom" (his medium fastball), the "long Tom" (his hard fastball), the "looper," the "nothing ball," the "bat dodger," the "hurry-up ball," the "trouble ball" and the "bee ball." For over two decades before he finally made it to the major leagues, Paige, in an age when Negro League records were not kept in "white men's record books," was estimated to have pitched in as many as 125 games a year, pitching as frequently as five to seven times a week, for a total of 2,500 appearances. The higher arithmetic guesstimates his totals as being somewhere around 2,000 wins and between 50 and 100 no-hitters in the Negro Leagues. Called "the Babe Ruth of the Negro Leagues," Paige had been the magnet that drew in the fans. The first black pitcher in the American League, Paige looked more like a father figure than an athletic figure. Still, he was able to draw the fans and pitch effectively, working 21 games for the pennant-winning '48 Indians, winning six, two of them shutouts, and posting a 6-1 record with a 2.48 ERA. Paige pitched in 31 games the next season, but then was gone the following, along with his patron, Bill Veeck, who had sold the Indians. Both resurfaced in 1951 with the ragtag St. Louis Browns, where Veeck, with his usual sense of the absurdity in all things, installed Satchel in his own rocking chair in the bullpen. There, like a cracker-barrel hugger, Ol' Satch would deliver of himself little homilies, ironies and prickly wisdoms, such as "The social ramble ain't restful," and "Don't look back, something might be gaining on you," along with several golden-aged pitching performances. Paige pitched two more years, winning 12 in 1952, the most of any on the Brownies' staff, and was gone after '53. Amazingly, he came back yet again in 1965 at the age of 59 going on Social Security to pitch one last game for Charley Finley and the Kansas City Athletics—becoming, in the process, the oldest player in major league history to appear in a game, regardless of his real age.

201. GEORGE KELL *(Left)* **[George Clyde Kell; 3B; 1943–57*; PHI (A), DET (A), BOS (A), CHI (A), BAL (A)].**
According to baseball historian Jack Kavanaugh, George Kell was "easily the best player to emerge during the WWII player shortage." And before his career ended, 15 years after his entry into the majors, he would become the outstanding third baseman in the American League, if not the majors. After Kell led organized baseball in batting, with a .396 average at Lancaster in 1943, the Athletics brought Kell up to their perennial eighth-place team at the end of the season, just in time to get into one game and get one hit. After two more seasons, Connie Mack dealt Kell off, as he did with most of his stars throughout the ages, sending him to the Detroit Tigers in May of 1946 where Kell became one of the leading batters in the league, batting over .300 in six straight years. In 1949, after changing his batting style by pulling the ball more instead of going to right field, Kell led the league with .343 in the closest race in major league history, beating out Ted Williams by just .0001, .3429 to .3428. In 1950, he led the AL in hits and doubles and finished second in batting with a .340 average. After a subpar .319 in 1951, Detroit manager Red Rolfe negotiated a major eight-player deal with Boston in June of '52, trading Kell and three other Tigers to the BoSox for five players. When Spike Briggs, president of the Tigers, was asked if he thought his manager had made a good deal, he snapped, "It had better be a good one." It wasn't, and Rolfe was gone soon thereafter. After two more .300 seasons, Kell was traded to the Chicago White Sox and two years thereafter to the Baltimore Orioles, where the Arkansas native ended his career by making way for another talented Razorback, Brooks Robinson, who would go on to lead the American League third basemen in fielding for 11 years, compared to the almost equally gifted Kell's seven.

202. DOM DiMAGGIO *(Right)* **[Dominic Paul DiMaggio; "The Little Professor"; OF; 1940–42, 1946–53; BOS (A)].**
They tell the tale about that portion of the press box up at Boston's Fenway Park known as "Earache Alley," peopled by the most vocal and caustic writers in Beantown, where, fed up with hearing their New York colleagues continually brag about *their* DiMaggio, the writers composed a ditty honoring Joe's kid brother, Dom. The lyrics, sung to the tune of "Maryland, My Maryland," went: "Better than his brother Joe . . . Dom-in-ic DiMaggio." Whether he was in fact or not is beside the point. For the bespectacled, small (five-foot-nine-inch) Dominic DiMaggio was a star in his own right, one who twice put together ministreaks that compared to his older brother's, in species if not degree, by hitting in 34 straight games in 1949 and another 27 straight in '51. Scoring more than 100 runs six times, he outscored his older brother four times. And even had a higher batting average than Joe twice, in 1946 and 1950. And, in the field, he was the equal of Joe. One time, after watching Dom make a catch off the bat of Joe that only a DiMaggio could have reached, sportswriter Sid Mercer said, "Joe should sue his old man on that one." Dom was twice part of an all-.300 outfield and twice led the league in runs scored, twice in times at bat, once in doubles and once in stolen bases, with the lowest total in history, 15. When asked how he had come to win the base-stealing championship with 15 stolen bases, Dom could only smile and reply, "Because [Johnny] Pesky missed the hit-and-run sign that many times."

203. PREACHER ROE *(Above)* **[Elwin Charles Roe; P; 1938, 1944–54; STL (N), PIT (N), BKN (N)].** When that tall, gangly bag of bones known as Preacher Roe first started his career in organized ball he found he was but one of several lefthanders in the Cardinal organization—which included the likes of Bob Weiland, Roy Henshaw, Max Macon, Clyde Shoun, Ernie White, Max Lanier, Al Brazle, Harry Brecheen and Howie Pollet, a total of ten lefties who among them would win a total of 810 major league games. And so, with no room at the lefthanded inn, Roe was sent down to the minors, where, in five seasons, he won 44 games pitching in Triple-A ball. In 1944, Frankie Frisch, who had been manager of the Cardinals in '38 when Roe had his first cup of major league coffee, wanted Roe for his Pittsburgh team and brought him up to the Pirates. In his very first major league start, Roe pitched a two-hitter and went on to win 13 games. The next year, he began experimenting with his style, throwing his slider away, his curve away, his fast one (or "hummer") in on the hands and his curve in on the hands, knowing "there was a strikeout in there somewhere," and led the National League in strikeouts. During the off-season, Roe, who part-timed as a math teacher and high-school basketball coach, got into an altercation with a refer-

ee back home in Arkansas and suffered a skull fracture for his efforts. For the following two seasons his productivity fell off, but he began "messing around with the wet one." It was a pitch that would make him a complete pitcher. Traded to the Dodgers in the winter of '47, Roe replaced his "hummer"—which, he told reporters, "if it hit an old lady in the spectacles, it wouldn't bend the frame"—with his spitter. According to Roger Kahn, "to 'load one up,' Roe wiped his left hand across his brow and surreptitiously spit on the meaty part of the thumb. Then, pretending to hitch his belt, he transferred moisture to his index and middle fingers. Finally, he gripped the ball on a smooth spot—away from the seams. The spitter consistently broke down." Alternating his "wet one" with the other pitches in his arsenal—and even coming up with a new one, his "fake spitter"—Roe won 12 games for the '48 Dodgers. In 1949 he led the league in winning percentage with a 15 and six record and won the second game of the World Series for Brooklyn's only victory over the Yankees in the five-game Series. In the early Fifties, Roe had the best winning percentage in the majors, winning 44 of 52 games between 1951 and '53—including a record 22-3 season in 1951 for the highest winning percentage for NL pitchers with more than 20 wins.

204. EARLY WYNN *(Below)* **[Early Wynn; "Gus"; P; 1939, 1941–44, 1946–63*; WAS (A), CLE (A), CHI (A)].** Believing "that space between the white lines, that's my office, where I conduct my business," Early Wynn protected it as few before him and fewer after, intimidating batters any way he could, up to and including throwing at them. When asked once if it were true he'd knock down anybody holding a bat, even if it were his mother, Wynn responded "Don't forget, mother was a helluva hitter." And for 23 years Wynn protected his office, to the tune of 300 wins and 2,334 strikeouts, five times winning 20 or more games. An angry, scowling pitcher with little more than a fastball, he toiled in virtual anonymity for the hapless Washington Senators for eight seasons, winning 72 and losing 87. Then, during the off-season before the 1949 season, the defending World Champion Cleveland Indians sent Joe Haynes, Eddie Klieman and Eddie Robinson to the Senators for Wynn and first baseman Mickey Vernon. Under the tutelage of pitching coach Mel Harder, Wynn developed some good breaking stuff to go with his fastball and became a winner, although not instantly, going through a mediocre 11-7 year in '49. But by 1950 the lessons had taken and Wynn won 18 games, leading the league in ERA. And, more importantly, became a member of one of the greatest pitching staffs in major league history, along with Bob Lemon, Mike Garcia and an aging Bob Feller. Together the foursome won 367 games over the five-year span from 1950 through '54, with Wynn winning 101 of those, an average of over 20 games a season. After a league-leading 23 wins in '54, Wynn won 20 more in '56 before moving over to Chicago in 1958 in one of those Cleveland–Chicago trades that had Minnie Minoso shuttling back and forth between the two clubs. In his first year with Chicago, Wynn led the league in strikeouts for his second straight year, the only pitcher to lead his league in K's in consecutive years for two different teams. And, at the age of 39, in 1959, he led the American League in wins, with 22, as he led the ChiSox to their first pennant in 40 years, also batting .244, an average higher than almost half the regulars. Four seasons later, again in an Indians uniform, Burly Early won his 300th game, his last in the majors. For the man with the charming, down-home nickname of "Gus," who once told Red Smith, "I hate the guy who hits back through the box. He's not only taking the bread and butter out of my mouth, he's trying to cut the legs from under me," protected his "office" for all it was worth, and he had gotten the most worth out of his talents, cutting the legs out from under the batters before they could cut his out from under him.

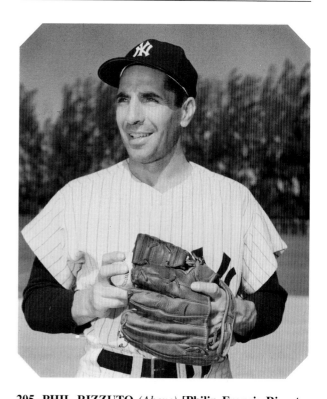

205. PHIL RIZZUTO *(Above)* **[Philip Francis Rizzuto; "Scooter"; SS; 1941–52, 1946–56*; NY (A)].** A shortstop in every sense of the word, Phil Rizzuto was as long on talent as he was short of stature. A native New Yorker, the young Rizzuto dreamed of being a ballplayer. Following his dream, he participated in tryout camps around the New York area. But always it seemed his small size was a big drawback. In his first tryout, Brooklyn manager Casey Stengel, watching the smallish hopeful get plunked in the back by an errant pitch on his very first swing, told him, "Go get a shoebox, kid, you're too small." The next year he tried out with the New York Giants. Same thing. Cardinals, if you were writing footnotes, you could write *ibid.* Finally, the New York Yankees offered him a contract for $75 a month with their Class D team in Bassett, Virginia, where, in just 67 games, he hit .310 and made the Bi-State All-Star team. The next season, at Norfolk, he hit .336. After two more years of seasoning—at Kansas City in the American Association, where he hit .316 and .347 and led all shortstops in putouts and assists—the Yankees brought him up to replace the aging Frankie Crosetti. Dragging a duffle bag twice his size to the Yankee's training facilities at St. Petersburg that February day in 1941, Rizzuto was met by the keeper of the clubhouse door, clubhouse man Pop Logan. Logan couldn't believe that the five-foot-six-inch youngster standing in front of him was a ball player and wouldn't admit him into the *sanctum sanctorum*. After a few anxious minutes, Yankee pitcher Lefty Gomez materialized and told Logan, "You better let him in, Pop, before the ducks walk all over him." And from that day on, and for 13 seasons, nobody, neither ducks nor opponents, walked over him, as the little man with the big glove handled his position as few others ever had—leading the league in double plays and errorless games—and deftly handling his bat as well, a master of the lost arts of bunting and squeeze plays. A .273 lifetime hitter, Rizzuto was rewarded for his all-around skills and career-high .324 by being voted the American League's Most Valuable Player in 1950—only the second time the Baseball Writers had elected a shortstop as the AL's MVP, and the smallest player ever so honored.

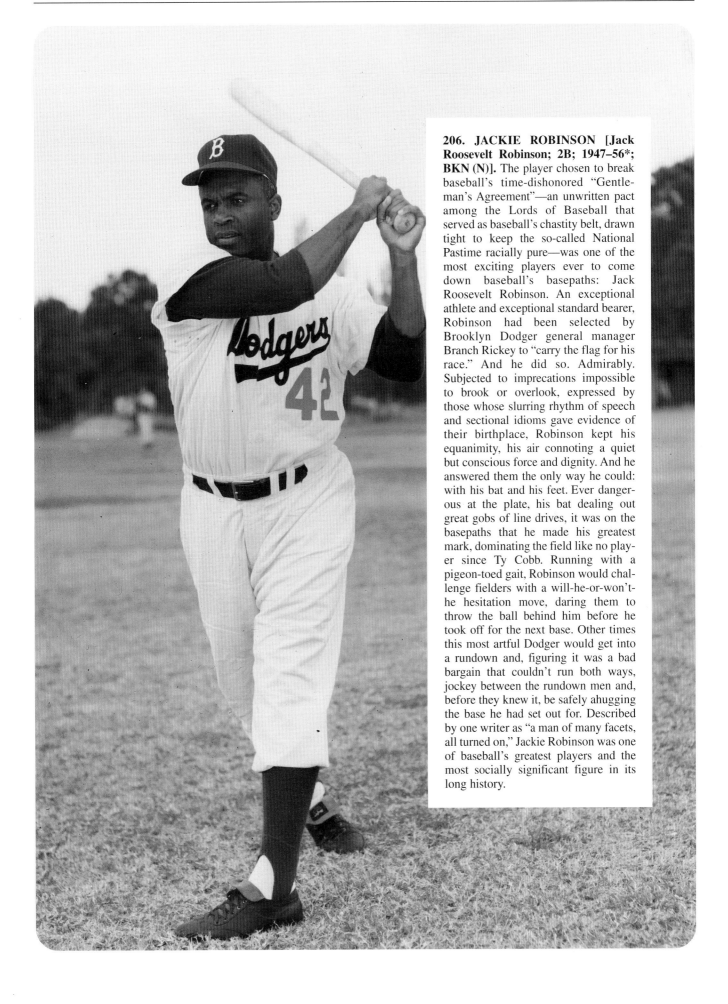

206. JACKIE ROBINSON [Jack Roosevelt Robinson; 2B; 1947–56*; BKN (N)]. The player chosen to break baseball's time-dishonored "Gentleman's Agreement"—an unwritten pact among the Lords of Baseball that served as baseball's chastity belt, drawn tight to keep the so-called National Pastime racially pure—was one of the most exciting players ever to come down baseball's basepaths: Jack Roosevelt Robinson. An exceptional athlete and exceptional standard bearer, Robinson had been selected by Brooklyn Dodger general manager Branch Rickey to "carry the flag for his race." And he did so. Admirably. Subjected to imprecations impossible to brook or overlook, expressed by those whose slurring rhythm of speech and sectional idioms gave evidence of their birthplace, Robinson kept his equanimity, his air connoting a quiet but conscious force and dignity. And he answered them the only way he could: with his bat and his feet. Ever dangerous at the plate, his bat dealing out great gobs of line drives, it was on the basepaths that he made his greatest mark, dominating the field like no player since Ty Cobb. Running with a pigeon-toed gait, Robinson would challenge fielders with a will-he-or-won't-he hesitation move, daring them to throw the ball behind him before he took off for the next base. Other times this most artful Dodger would get into a rundown and, figuring it was a bad bargain that couldn't run both ways, jockey between the rundown men and, before they knew it, be safely ahugging the base he had set out for. Described by one writer as "a man of many facets, all turned on," Jackie Robinson was one of baseball's greatest players and the most socially significant figure in its long history.

208. EDDIE STANKY *(Below)* **[Edward Raymond Stanky; "The Brat," "Muggsy"; 2B; 1943–53; CHI (N), BKN (N), BOS (N), NY (N), STL (N)].** Eddie Stanky's abilities were best summed up by his (two-time) manager, Leo Durocher, who said of his marginally talented player: "He can't run, he can't hit, he can't field . . . all that little S.O.B. can do is beat you." And for 11 years all this five-foot-eight-inch genetic throwback to the "Gashouse Gang" teams of yore did was beat the opposition. Here he could be seen constantly getting on base (three times leading the National League in walks), there stealing signals or kicking the ball out of a fielder's glove to break up a double play, or waving his arms to distract the batter from his second-base position (once causing a forfeiture of a game by doing so) and everywhere doing that voodoo he did so well: winning. The teams this lifetime .268 *toomler* played on became, almost as if by magic, instant winners, as witnessed by the Boston Braves' winning but their second pennant the year he joined them in '48 or the second-division Giants moving into the first division and then on to the pennant in the two years he played for them. This throwback to the anything-to-win player of the deadball era always seemed to make things happen—both on the field and in the standings. And he stands tall as a "winner."

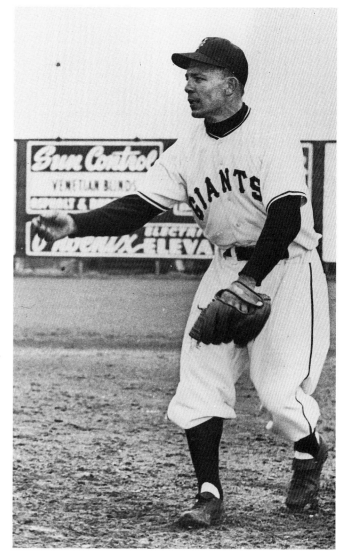

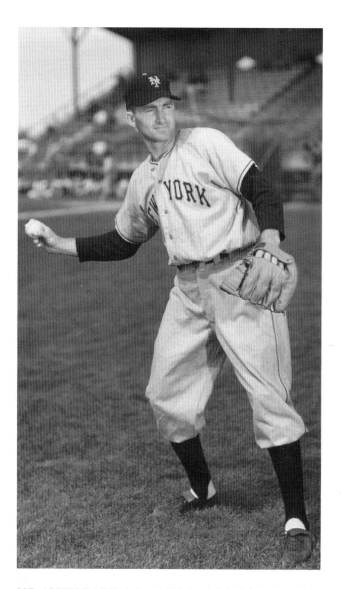

207. ALVIN DARK *(Above)* **[Alvin Ralph Dark; SS; 1946, 1948–60; BOS (N), NY (N), STL (N), CHI (N), PHI (N), MIL (N)].** A former football star at LSU, Dark first came up in 1946 for a "look-see" and then came back up, for good, in 1948, winning the Rookie of the Year Award and helping the Braves to their first pennant in 34 years. Traded after the '49 season, with Eddie Stanky, to the New York Giants, Dark immediately turned them into a winner, starting the rally in the ninth inning of the third game of the '51 playoff that climaxed in Bobby Thomson's "Shot Heard 'Round the World." After his 14-year career came to an end, Dark managed for another 13, winning pennants in both leagues.

209. WARREN SPAHN *(Right)* [**Warren Edward Spahn, "Spahnie"; P; 1942, 1946–65*; BOS (N), MIL (N), NY (N), SF (N)**]. Few lefthanders—nay, few pitchers—have ever dominated their era like the ageless Warren Spahn. Sometimes it seemed like two eras, for the hawknosed Spahn's march to greatness was as much a tribute to his total conquest of opposing batters as it was to his partial conquest of age. Spahn originally entered the baseball wars in 1942, stopping off for the proverbial cup of mocha before marching off to a bigger war in Europe, where he earned a Purple Heart. Returning in 1946, Spahn, by now a 25-year-old rookie, earned eight wins for the Boston Braves relying mainly on a fastball and a curve. The next season he began mixing up his pitches, using a screwball and a change of speed to keep batters off balance—and set them up for his fastball, delivered under their chins, winning 21 games to lead the NL in ERA and innings pitched. As the years began to fly by like signs on the Massachusetts—and later, the Wisconsin—Turnpike, Spahn, a workhorse who liked to pitch every fourth day and could, said teammates, pitch all day and all night if necessary, continued to dominate both the National League batters and the pitching records. Thirteen times he would win 20 or more games, a record eight times lead the league in wins, a record seven consecutive seasons lead the league in complete games and a record 17 consecutive seasons strike out 100 or more batters. Throughout the 1950s and on into the sixties Spahn, his arms flying back in tandem like a bird in mid-flight and then unfurling in sections and coming plateward, was an awesome sight on the mound as he continued his assault on record books and opposing batters. As the sands began to flow through his hourglass, Spahn went on his winning way, leading the Milwaukee Braves to the 1957 pennant and World Championship at the advanced age of 36 with a league-leading 21 wins, pitching his first no-hitter at the age of 39 and his second at the age of 40 and, at the age of 42, leading the NL in complete games and tying his career-high win total with 23. Along the way "Spahnie" developed a funnybone every bit as winning as his soup bone. As when his career, at long last, began to wind down and he found himself pitching again for Casey Stengel on the 1964 Mets, who, not incidentally, had been his first manager back with the Boston Braves. "I'm probably," he said, "the only guy who worked for Stengel before and after he was a genius." By the next season Spahn, at the age of 44, finally brought his career to a close. But before he called it a day, he set the career record for most wins by a lefthander, with a palindromic 363 wins, which, read backwards, is 363 wins.

210. LARRY DOBY *(Right)* **[Lawrence Eugene Doby; OF; 1947–59; CLE (A), CHI (A), DET (A)].** As overlooked as Whistler's father, Larry Doby broke the American League's "color barrier" just 11 weeks after Jackie Robinson made history by opening the season at first for the Brooklyn Dodgers. Discovered by Cleveland scout Bill Killefer while hitting over .400 with the Newark Eagles of the Negro National League and signed by Cleveland owner Bill Veeck, who said, "I am not interested in the color of his skin, I'm looking for good ball players," Doby also broke in at first for the Indians on July 3, 1947, fielding eight chances without a miscue and scratching out a single in four trips to the plate. For the rest of the '47 season he was used mainly as a pinch-hitter, batting just .156 with but five hits in 32 at-bats. The Indians decided to take advantage of Doby's strong arm, speed and quick reflexes by moving him to the outfield in 1948 and placing him under the watchful eye of all-time great Tris Speaker to hone his skills. Moved into right field to take the place of Pat Seerey, the man of whom it was said "spoke so low you almost had to lean over to hear him talk," began speaking volumes with his bat, hitting in 21 consecutive games, blasting tape-measure homers—including one in Washington that many observers believed to be the longest ball hit in Griffith Stadium in 22 years—and batting close to .400 from Labor Day through the end of the season as he brought his average up to .301 and helped bring Cleveland their first pennant in 28 years. In that fall's World Series Doby led all Cleveland batsmen with a .318 batting average, his single in Game Two providing Cleveland with its margin of victory, and his four-hundred-foot home run, the first-ever homer hit in the World Series by an African-American, winning the fourth game. Twice in his 13-year career Doby led the American League in homers and once each in runs, slugging average and RBI's as he went on to be named a member of the All-Star team seven times.

211. NED GARVER *(Left)* **[Ned Franklin Garver; P; 1948–61; STL (A), DET (A), KC (A), LA (A)].** For three seasons Ned Garver was the mainstay of the St. Louis Browns' pitching staff, a staff that lost a combined 299 games. And yet Garver managed to win 45 games for the Brownies, twice leading the league in complete games and once, in 1951, winning 20 for the last-place Browns, the only pitcher in the twentieth century to win 20 for a team losing 100 games and only the fifth pitcher in modern history to win 20 games for a last-place team. The following season Garver was waived to Detroit, the once-proud Tigers then in the midst of finishing last for the first time in their history. Only twice more, in ten seasons, would he post a winning record while playing for teams that never saw the light of the first division.

212. RICHIE ASHBURN *(Below)* **[Rich Ashburn; "Whitey"; OF; 1948–62*; PHI (N), CHI (N), NY (N)].** A player's batting stance is as expressive as his statistics. For no one is this truer than for Richie Ashburn, the first making the second possible. Bent double, his front right foot pointing toward third from his left-handed stance, the bat in his hand a tuning fork, Ashburn crouched ever at the ready to hit a frozen rope, a mini-poke or just a well-placed bunt down the third-base line—rumor having it that the lime running along Shibe Park's third-base line was piled extra high to keep his bunts from rolling foul. Whatever, Ashburn's singular stance produced the desired effect: singles, singles and more singles, all hit with a startling frequency and dismal monotony. In fact, only two batsmen with 2,500 or more hits had a higher percentage of singles in their total number of hits than did Ashburn, with 82.3% of his hits singles: Wee Willie Keeler who "put 'em where they ain't" 85.6% of the time and Lloyd Waner, 82.6%. To continue the comparison, Ashburn's totals are almost a photographic copy of those posted by Hall of Famer Waner, reputed to have been the greatest singles hitter of all time—Ashburn having 2,574 hits to Waner's 2,459; 2,119 singles to Waner's 2,032; 281 doubles to Waner's 317; 109 triples to Waner's 118; 29 home runs to Waner's 28; and a lifetime batting average of .308 to Waner's .316. Ashburn also led the National League in singles four times, the same number of times as Waner. He twice led the NL in batting, three times in hits, four times in walks, four times in on-base percentage and once in stolen bases. Ashburn would conclude his career with the hapless 1962 New York Mets, where he hit .306—the highest single-season average for a Metsie until 1969—and his lifetime high of seven home runs. Nevertheless, Ashburn decided to call it quits after playing bumper-tag with Elio Chacon all year. Chacon, who understood no English, would always race out from his shortstop position to collide with Ashburn in center after Richie called out "I've got it!" Told that the proper phrase to call off Chacon was "Yo lo tengo," Ashburn resorted to Spanish only to find that left fielder Frank Thomas, who understood no Spanish, now ran into and over him on every fly. And so, saying "Adiós,"—not wanting to get himself killed by his teammates—Richie Ashburn tangoed off into the sunset with his Hall of Fame numbers.

213. ROBERTO AVILA *(Above)* **[Roberto Francisco Avila; "Beto," "Bobby"; 2B; 1949–59; CLE (A), BAL (A), BOS (A), MIL (N)].** Already a star in his native country, Roberto Avila was signed by the Cleveland Indians out of the Mexican League for $17,500 in 1948. After one year at Baltimore in the International League, Avila was brought up by the Indians at the tail end of the '49 season. With what manager Al Lopez called a "a fine swing, a sharp eye and a world of confidence in himself," Avila replaced veteran stalwart Joe Gordon at second by the '51 season and by 1952 had established himself as one of the coming stars of the junior circuit, leading the AL in triples and batting .300 for the second consecutive year. In 1954 Avila had his career year as he became the first Latino to win a batting championship, hitting .341—21 points higher than runner-up Minnie Minoso, the largest winning margin in the American League since 1942. In that year's World Series, the two league batting champions, Avila and Willie Mays, faced each other, only the third time in Series competition such a face-off had happened—the other two times being 1909, when Cobb and Wagner faced each other, and 1931, when it was Hafey and Simmons. Unfortunately for both the Indians and Avila, both were outperformed, Mays outhitting Avila .286 to just .133 and the Indians faring just about as well as Avila, losing to the Giants in four games. After four more years with the Indians, Avila was dealt to three other clubs in seven months and retired after the '59 season to go into politics in Mexico and become the president of the Mexican League.

214. NELLIE FOX *(Right)* **[Jacob Nelson Fox; 2B; 1947–65; PHI (A), CHI (A), HOU (N)].** Simply stated, Nellie Fox is the greatest player eligible for the Hall of Fame *not* to be a member. Period, end of sentence. The holder of the major league record for most consecutive years leading the league in singles, most years leading in fewest strikeouts, most years appearing at bat 600 or more times and most consecutive games played at second base, Nellie Fox made the "Go-Go" Sox of the '50s go. With a chaw of tobacco the size of a baseball in his jaw and a take-charge demeanor, Fox was the favorite of Sox fans for 14 seasons.

215. MINNIE MINOSO *(Left)* **[Saturnino Orestes Armas Minoso; OF; 1949, 1951–64, 1976, 1980; CLE (A), CHI (A), STL (N), WAS (A)].** The man born Saturnino Orestes Armas Minoso y Arrieta—and known to his fans as just plain ol' "Minnie"—was a walking and running record book. One of only two men—the other being Nick Altrock—to play in five different decades, Minoso also was the oldest player ever to get a base hit, coming back 12 years after his career had seemingly come to an end to get a single at the age of 53 years and nine months. Four years later, at the age of 57, he again made baseball history, of sorts, by becoming the oldest man ever to come to bat, although this time he went without a hit. A decade later, the White Sox tried to bring him back for an at-bat in a sixth different decade, but this time the commissioner's office vetoed the move. In between his debut, in 1949, and his history-making appearances, Minoso played for 15 seasons, three times leading the American League in stolen bases, twice in triples and once each in hits and doubles. He also set another American League record, being hit by a pitch 189 times, many of those, as comedian Robert Klein recalled, "two-base hits that went farther into the outfield than his regular hits." One of the most popular of the "Go-Go" Sox, Minoso still ranks among the all-time White Sox leaders in runs, hits, doubles, triples, RBI's and total bases.

216. ROY CAMPANELLA *(Right)* **[Roy Campanella; "Campy"; C; 1948–57*; BKN (N)].** One of the dominant catchers in the Negro League, Campanella was the first catcher to break baseball's color line, coming up to the Dodgers in 1948. Over the next ten years, "Campy" would win the MVP three times and establish marks for most RBI's and home runs by a catcher (142 and 41) while handling a distinguished pitching staff with ease. His career was cut short by a near-fatal automobile accident in January of 1958, consigning this once solidly built physical specimen to a wheelchair for the rest of his life.

217. BILLY COX *(Left)* **[William Richard Cox; "Hoss"; 3B; 1941, 1946–55; PIT (N), BKN (N), BAL (A)].** Dodger captain Pee Wee Reese, who played alongside the gifted third baseman with the long and sad face (giving rise to his nickname among teammates of "Hoss"), called Cox the greatest glove and the least-likely-looking infielder he'd ever known. Others seconded the emotion, including Hall of Famer Billy Herman, who said: "The best third baseman I ever saw, for a couple of years, was Billy Cox. He made the most outstanding plays I've ever seen. He just made your eyes pop. You couldn't believe how quick he was, going in any direction. And an arm like a rifle." Roger Kahn called him "the most glorious glove on the most glorious team that ever played baseball in the sunlight of Brooklyn." In that special ball-player lingo, it was said that Cox had plenty of "cat," and Casey Stengel, in a backhanded compliment, said, in open-mouthed wonder, "That ain't no third baseman, that's a f-----' acrobat." Ironically, Cox started his career as a shortstop before being traded before the '48 season by the Pittsburgh Pirates to the Dodgers where, for seven seasons, he became a fixture at third and helped "The Boys of Summer" win three National League pennants.

218. CARL ERSKINE *(Right)* **[Carl Daniel Erskine; "Oisk"; P; 1948–59; BKN (N), LA (N)].** A favorite of Ebbets Field denizens, "Oisk"—Brooklynese for the first syllable of his last name, Ersk, made popular by comedian Phil Foster—teamed up with Don Newcombe to give the Dodgers one of the best pitching staffs of the early fifties, a staff that took "The Boys of Summer" to five pennants in eight years and two games away from two more. Erskine injured his shoulder during his rookie season and throughout the rest of his career pitched with pain. Still, pitching with pain, he was able to post a .610 won-lost record and throw two no-hitters. And his 14 strikeouts in the third game of the 1953 Series set a record that stood until Sandy Koufax broke it ten years later.

219. CARL FURILLO *(Left)* **[Carl Anthony Furillo; "Skoonj," "The Reading Rifle"; OF; 1946–60; BKN (N), LA (N)].** One of the famed "Boys of Summer," "Skoonj"—short for scungilli, Italian for conch—patrolled the right field area of Ebbets Field with a "Trespassers Will Be Prosecuted" mentality. With a rifle-like arm—hence his second nickname, "The Reading Rifle"—Furillo registered over 150 assists, once throwing out Reds pitcher Mel Queen at first on a 300-foot shot into the right field gap at Ebbets Field. He acted as a one-man shield in front of the famous "Hit Sign, Win Suit" sign erected by tailor Abe Stark below the Ebbets Field scoreboard, saving Stark innumerable suits with his fielding wizardry. Furillo is also remembered by those who saw it for his miraculous catch of Johnny Mize's bid for a homer in the fifth game of the '52 Series. But Furillo was just as handy with his bat, hitting .299 life-time and leading the National League in batting in 1953 with a .344 average. His career ended in 1960 when, while hurt, he was cut by the Dodgers after just eight games. He sued and won a settlement of $21,000, but was thereafter blacklisted by the game he had served so well for 15 years.

220. GIL HODGES *(Right)* **[Gilbert Raymond Hodges; 1B; 1943, 1947–63; BKN (N), LA (N), NY (N)].** The 1950s' version of "Gentle Ben," this strong, silent first baseman anchored the bottom portion of the batting order for the legendary "Boys of Summer" teams that won five pennants in nine years—and just as ably anchored their infield with an agility and a grace that won him three Gold Gloves. But it was his bat, part blasting cap, that made both Hodges and the Dodgers the scourge of the National League. For, over a seven-year period, from 1949 through 1955, the big righthander averaged 32.5 home runs and 112.5 RBI's a season, driving in more than 100 runs for seven consecutive seasons and hitting grand-slam homers in each to set a National League record. On August 31, 1950, against the Boston Braves, Hodges became the first modern righthanded hitter to hit four home runs in a nine-inning game, tying a major league record for total bases with 17. One of Brooklyn's most popular players, that fusion of fans known as followers of "Dem Bums" went into mourning for their beloved hero when he went 0-for-the-Series in 1952, offering up prayers for him everywhere in "The Borough of Churches." Hodges continued his quiet

success after his playing days were over, taking a woebegone Mets team from a ninth-place finish in 1968 to their "miracle" win in '69. Hodges managed for just two more seasons until, just two days before his 48th birthday, his great heart was stilled by a heart attack during the '72 spring training season.

221. DON NEWCOMBE *(Left)* **[Donald Newcombe; "Newk," "Big Newk"; P; 1949–51, 1954–60; BKN (N), LA (N), CIN (N), CLE (A)].** In the baseball-mad borough of Brooklyn that existed back in the early fifties, the Dodgers were Everyman's religion and obsession. Their existence defined by the four walls of Ebbets Field, they stood in permanent opposition to their proud neighbors over the East River, the hated New York Yankees. Oppressed with promises and never-to-happens, those "hardberled" fans singled out one player—unfairly at that—as the source of their constant torment: Don Newcombe. For, despite being the only player ever to win the Most Valuable Player, Cy Young and Rookie of the Year Awards, Newcombe was forever belled with the reputation of being a choke artist. The reason for it stemmed from a minor flaw in his otherwise excellent record: he had sallied forth to do battle with the Yankees five times in three World Series and been found wanting all five times. But for seven years Newcombe had been the strong right arm of the team forever known as "The Boys of Summer." Rocking back on his hind leg and waggling his spiked left shoe in opposing batters' faces, Newk had gotten every bit of his mammoth size behind his delivery, exploding his blazing fastball and, alternatively, his big, jug-handled curve, past batter after batter. Forgotten were his total of 149 career wins, 123 of them in a Brooklyn uniform, and also his having led the league twice in winning percentage and once each in wins and shutouts. All that was remembered was that he had gone 0-for-his-career against the Yankees in World Series play. Also forgotten in their rush to judgment of his one shortcoming was his excellent stickwork: Four times he batted over .300, posting a .271 lifetime average and hitting 20 home runs, many of them to win his own games. Bottom line, Don Newcombe was anything but a choke artist. He was the first great black pitcher—in fact, a part of baseball trivia for having faced Hank Thompson of the New York Giants on July 18, 1949, in the first black vs. black confrontation in major league history—and was a hard-working pitcher with great stamina and dedication. In the words of Ernie Banks, Newcombe was "a winning-type pitcher with tremendous drive." He deserves to be remembered for his many sterling accomplishments, not for his one nonaccomplishment.

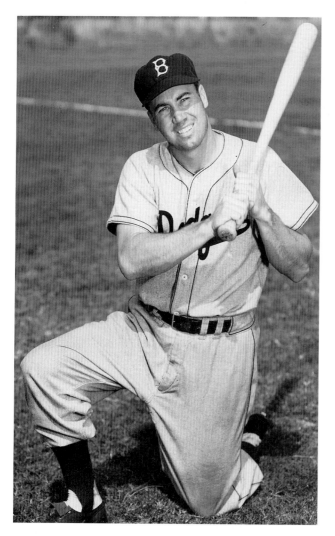

222. DUKE SNIDER *(Above)* **[Edwin Donald Snider; "The Silver Fox," "The Duke of Flatbush"; OF; 1947–64*; BKN (N), LA (N), NY (N), SF (N)].** Back when, as a Frank Sinatra song would have it, New York was the only "town with three ball teams," Duke Snider's credentials were such that he was included in the same breath with his opposite two numbers in New York uniforms, Willie Mays and Mickey Mantle. And the constant sidewalk argument was "Who's the best center fielder in New York, Willie, Mickey or the Duke?" Between 1954 and 1957, when the three were in flower and roaming their respective New York center fields, Snider had more RBI's and home runs than his two hometown rivals. With a power stroke that looked like it was made for the friendly confines of the band-box known as Ebbets Field, Snider, the only lefthanded regular in the predominantly righthanded Dodger line-up, led the major leagues in most RBI's and home runs for the decade of the fifties, six times batting in over 100 runs and five times hitting more than 40 home runs. During the course of his career Snider finished, at various times, in the top three places in batting, slugging, hits, runs, RBI's, doubles, triples, home runs and stolen bases. An all-around player, his speed and grace in the outfield earned him many accolades, *The Sporting News* naming him the Major League Player of the Year in 1955 in recognition of his overall play, and Stan Musial naming Snider, along with Mays and Hank Aaron, to his all-time National League outfield. Snider's excellence continued into the World Series as well, where twice he hit four home runs, the only player ever to accomplish that feat, and he set National League records for most home runs and runs batted in in Series competition.

223. YOGI BERRA *(Below)* **[Lawrence Peter Berra; OF; C; 1946–63, 1965*; NY (A), NY (N)].** To many, he was one of baseball's most loveable characters, possessing all the charm of Snow White's seven dwarfs rolled into one. To others, he was the founder of the school that made quotes known as "Yogi-isms"—quotes like "When you come to a fork in the road, take it," "It's déjà vu all over again," and "A nickel ain't worth a dime anymore"—part of the language. And to all, he was Yogi Berra, one of the greatest catchers ever to come down baseball's long winding road. But it hadn't always been thus. For the player whose notation in baseball record books reads "Yogi Berra, Catcher" had started out on that road as plain ol' Larry Berra, Outfielder. If he had a nickname back in his native St. Louis, it was "Lawdy," as in "Lawdy, Lawdy." That is, until one day when a fellow American Legion ball player described him, sitting on the grass, arms and legs crossed, as resembling a "yogi." And so, "Yogi" it became. The other part of the description took a little more time. Brought up by the Yankees in 1946 as a young 21-year-old outfielder-cum-catcher, Berra was put under the rather large wing of future Hall of Famer Bill Dickey, who, according to Berra, "learned me all his experiences." And, over the next 18 seasons, Berra put all those "experiences" into action, becoming, in the process, one of the nimblest catchers in baseball, one who could handle pitchers and a bat with equal ease. Reputed to be one of baseball's best bad-ball hitters (a reputation Warren Spahn challenged, saying that Berra "guesses with you"), Berra was the American League's leading RBI producer and second-leading home-run hitter during the '50s, three times its MVP—once back-to-back, in 1954 and '55—and only the second catcher in history to have 100 runs scored and 100 RBI's in a season. But it was in World Series play, 14 series in all, that Berra made his name and fame, ranking first in most games played, most at bats, most hits and most doubles, and second or third in most home runs, most runs scored and most bases on balls. Finishing out his illustrious career as a manager for both New York teams, Berra became only the second manager in history, after Joe McCarthy, to win pennants in both leagues. A heck of an achievement for a man who started as "Lawdy."

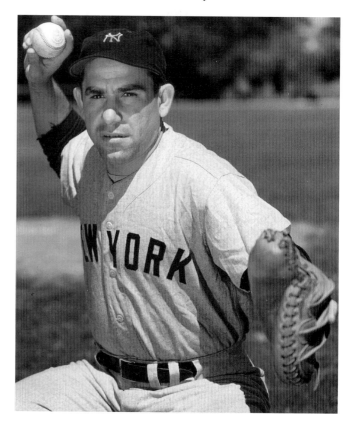

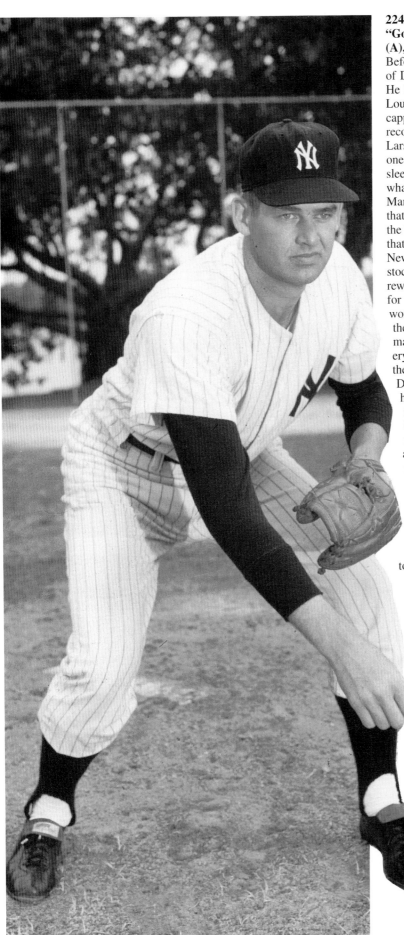

224. DON LARSEN *(Left)* **[Don James Larsen; "Gooneybird"; P; 1953–67; STL (A), BAL (A), NY (A), KC (A), CHI (A), SF (N), HOU (N), CHI (N)].** Before his moment in the sun, the most dazzling aspect of Don Larsen's career had been its total lack of luster. He had pitched in the minors without distinction, in St. Louis without a team and in Baltimore without a chance, capping his somewhat-career with an incredible 3-21 record in 1954, one of the worst ever. But one place Larsen had proven himself was in the Night Owl League, one of his managers noting, "The only thing Don fears is sleep." There was one observer, however, who was somewhat less jaundiced in his appraisal of Larsen, General Manager George Weiss of the Yankees, who remembered that, of Larsen's three wins in '54, two had come against the Yankees. And so Weiss engineered a two-tiered deal that involved no fewer than 18 players shuttling between New York and Baltimore, one of those pieces of rolling stock coming to the Yankees being Don Larsen. Larsen rewarded Weiss's judgment, winning nine and losing two for the pennant-winning Yankees. The next season he won 11 and lost five with a 3.26 ERA, second-best on the staff. Somewhere during the last month, Yankee manager Casey Stengel tampered with Larsen's delivery, making him pitch sans windup. And then gave him the ball for Game Two of the 1956 Series against the Dodgers. But Larsen, staked to a six-run lead, couldn't hold the fort, giving up four bases on balls and one hit in one-plus innings and was given the hook. Brought back after only three days' rest, Larsen took the mound in Game Five against Dodger ace Sal Maglie and the hard-hitting Dodgers. Amazingly, after 26 men, only Pee Wee Reese, the second batter up, had taken the no-windup Larsen to three balls. And he had gone out, as had the other 25 Dodger batters. Now there was but one out to go for the first perfect game in World Series history. Brooklyn manager Walter Alston sent up Dale Mitchell to pinch-hit for Maglie. Working carefully to Mitchell, Larsen went to a count of one-and-two and then, taking a deep breath, came in with another fastball, his 97th pitch of the game. The ball caught the outside corner of the plate, waist high. Mitchell made as if to slap at it, lunging with his bat, then held up. Plate umpire Babe Pinelli jabbed his right hand in the air, punctuating it with a "third strike and you're out." It was, as sportswriter Shirley Povich wrote, "A million-to-one shot," the only perfect game in World Series history. And it belonged to, of all people, Don Larsen. Larsen would go on to pitch for another ten years, the last active member of the St. Louis Browns, and get a chance to get in three more World Series—including one with the San Francisco Giants in 1962 in which he won game four, becoming one of but a handful of pitchers to win a World Series game in both leagues—but nothing, *nothing* he ever did before or after rivaled his performance that afternoon of October 8, 1956 when he authored the single greatest pitching performance in the history of baseball.

225. LUIS APARICIO *(Below)* **[Luis Ernesto Aparicio; "Little Looie"; SS; 1956–73*; CHI (A), BAL (A), BOS (A)].** A fixture at shortstop from the very first game he ever played, Luis Aparicio went on to play 18 years and record 2,581 games as if he invented the position. Bill Veeck, the owner of the White Sox, said of Aparicio: "He's the best I've ever seen. He makes plays which I know can't possibly be made, yet he makes them almost every day." And almost every day, playing an average of 148 games a season for the first 14 years of his career, Aparicio covered short like Sherwin-Williams Paint claims it covers the world, with a cannon-like arm and great range, leading the American League in fielding chances accepted, seven years; fielding average, eight; and putouts, five. Over the course of his career, he established major league records for most games, most assists and most double plays. Add to that his leading the American League a record nine consecutive years in stolen bases and you have one of the greatest shortstops in the history of the game.

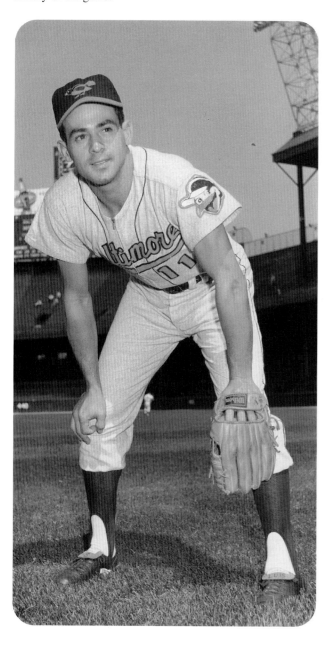

226. MONTE IRVIN *(Above)* **[Monford Merrill Irvin: OF; 1949–56*; NY (N), CHI (N)].** Monte Irvin's exploits are accorded no special place of prominence in the Macmillan *Baseball Encyclopedia,* with only eight lines chronicling eight years in the major leagues. Plus two lines for World Series appearances. But Monte Irvin's entire career is best recaptured in the incomplete and sketchy records of the Negro Leagues and in the personal reminiscences of those who saw him play in those years before he first made it to the majors. One of the greatest players in Negro League history—if not all of baseball's—"Cool Papa" Bell, said of Irvin: "Most of the black ball players thought Monte Irvin should have been the first black in the major leagues. Monte was our best young ball player at the time. . . . He could do everything." And so he could. A spray hitter, Irvin signed with his hometown Newark Eagles in the late '30s and led the league in batting twice, in 1941, with a .396 average, and in 1946, with a .389 average. In between he won the triple crown playing in the Mexican league and earned MVP honors in the 1945–46 Puerto Rican Winter League. In the 1946 Negro World Series, playing shortstop, Irvin led the Eagles to the championship, batting .462, hitting three home runs and scoring the winning run. Signed by the Giants for $5,000 after Branch Rickey had passed him up, Irvin debuted on July 8, 1949, and, after being farmed out, came back to lead the National League in RBI's with 121 and the Giants in hitting with .312 in their famous "Miracle of Coogan's Bluff" come-from-behind pennant win of '51. And then hit .458 in the Series, with 11 hits and four runs scored—including a steal of home in the first inning of the first game.

227. LARRY JANSEN *(Left)* **[Lawrence Joseph Jansen; P; 1947–54, 1956; NY (N), CIN (N)].** After a sensational 30-6 season in the Pacific Coast League, Jansen entered the big leagues as a 26-year-old rookie and proceeded quietly to make his mark with a 21-5 rookie year, leading the league in winning percentage. But then again, almost everything this big righthander with an outstanding overhand curve and excellent control did was overlooked—from his winning more games than more celebrated National League pitchers, like Johnny Sain, Ewell Blackwell and teammate Sal Maglie in his first five seasons to his sharing the major league lead in most wins with Maglie in 1951. In fact, few remember that it was Jansen who was the winning pitcher in the famous "Shot Heard 'Round the World" game won by Bobby Thomson's home run, with Jansen having come in in the top of the ninth and quietly retired the three Dodger hitters he faced.

228. SAL MAGLIE *(Right)* **[Salvatore Maglie; "The Barber"; P; 1945, 1950–58; NY (N), CLE (A), BKN (N), NY (A), STL (N)].** Sal Maglie came by his nickname naturally, not because of his perpetual five o'clock shadow, but because he shaved the batter's chins when they moved too close to the plate (which he claimed he "owned"). A 5-4 pitcher with the 1945 edition of the New York Giants, Maglie jumped to the Mexican League in '46 and was subsequently banned from baseball by Commissioner "Happy" Chandler. Returning to the majors in 1950 after the ban was lifted, Maglie rode his high hard one to an 18-4 record, leading the National League in winning percentage. In 1951 he led the Giants in their "Miracle of Coogan's Bluff" year to the National League pennant, winning a league-leading 23 games. By 1955 a sore back had reduced his overall effectiveness and he was dealt to the Indians. By the next year he had returned to the National League in the uniform of the "hated" Dodgers where his 13 wins down the stretch enabled the Dodgers to edge out the Milwaukee Braves by one game for the pennant. In the '56 Series, he bested Don Larsen in the first game and came back to pitch the fifth game, this time pitching a five-hitter. Only trouble was that his opposite number, again Larsen, made Series history by pitching a perfect game. Maglie closed out his ten-year career by pitching for the New York Yankees, one of only two pitchers—the other being Burleigh Grimes—who pitched for all three modern New York teams.

229. DON MUELLER *(Left, top)* **[Donald Frederick Mueller; "Mandrake the Magician"; OF; 1948–59; NY (N), CHI (A)].** The son and nephew of two major league outfielders of the twenties, Don Mueller had almost twice as many base hits as the two older Muellers combined, including a league-leading 212 hits in 1954 when he batted .342 to finish just three points behind teammate Willie Mays in the batting race. But his most famous hit came in the ninth inning of the third game of the 1951 playoffs between the Giants and the Dodgers and helped make the "Miracle of Coogan's Bluff" happen. With the Dodgers leading 4-1 and Alvin Dark on first by virtue of an inning-opening single, Dodger manager Charlie Dressen inexplicably directed first baseman Gil Hodges to hold Dark on. Mueller, nicknamed "Mandrake the Magician" after Lee Falk's comic-strip character for the good and sufficient reason that he wielded his bat like a wand, now found the man-made hole in the infield caused by Dressen's edict and magically stroked a seeing-eye single through the right side, past Hodges, enchained to first base. After Monte Irvin fouled out, White Lockman drove one of Don Newcombe's fastballs on a line to the opposite field for a double, scoring Dark. Mueller, off and running with the pitch, slid hard into third, spraining his ankle on impact. After attending to the fallen Mueller for several minutes, the Giant trainer called for the paramedics to bear Mueller to the clubhouse, giving sportswriter Red Smith the opportunity to call the moment "the corniest possible sort of Hollywood schmaltz—stretcher-bearers plodding away with an injured Mueller between them, symbolic of the Giants themselves." But the Giants were—or, according to Dressen's grammar, "was"—far from dead. For during the break in the action necessitated by Mueller's removal from the field, the Dodgers replaced pitcher Don Newcombe with Ralph Branca. And two pitches later Giant third baseman Bobby Thomson boomed his "Shot Heard 'Round the World" to win the game, the playoffs and the pennant for the Giants. Unfortunately, Mueller's injury kept him out of the '51 Series against the Yankees, but he did get to play in the Giants' 1954 sweep of the Indians, where he collected seven more hits and batted .389.

230. WES WESTRUM *(Left, bottom)* **[Wesley Noreen Westrum; C; 1947–57; NY (N)].** The very word "average" is part of the baseball lexicon, as in batting average, slugging average, earned run average, ad infinitum. And were it applied to Wes Westrum his statistics would come up far below such a standard—almost as if he were playing dominoes and he was a double zero. For Westrum, in his 11 years in the majors batted under .200 three times—the famed "Mendoza" line for underwhelming success at the plate. And yet that somehow, someway obscures the worth of the man who set a National League fielding-average record for catchers with a .999 in 1950, his first full year with the Giants. And who, in the "Miracle" year of 1951, walked 104 times—more than Hall of Fame catchers Roy Campanella, Bill Dickey, Johnny Bench or Ernie Lombardi *ever* in a season. And who had the most home runs of any Giant in the Polo Grounds, 14, during their comeback to catch the Dodgers at the end of the '51 season, the one climaxed by Bobby Thomson's "Shot Heard 'Round the World." And who caught every game in both the '51 and '54 World Series, setting the World Series record for most sacrifice hits in a Series with three in '54, including a record-tying two in the deciding fourth game. Nothing about Wes Westrum was "average," except maybe his batting average. But then again, there are other ways of measuring a player's worth.

231. BOBBY THOMSON *(Above)* **[Robert Brown Thomson; "The Great Scot"; OF; 1946–60; NY (N), MIL (N), CHI (N), BOS (A), BAL (A)].** Breathes there a man with memory so dead he doesn't recall the "Shot Heard 'Round the World," Bobby Thomson's three-run, ninth-inning come-from-behind home run that capped the 1951 New York Giants' miraculous climb from 13½ games back of the front-running Brooklyn Dodgers to win the pennant? This was the shot that left fans and broadcasters alike with powers barely those of respiration, especially Giant broadcaster Russ Hodges, who cried into the microphone: "The Giants win the pennant! The Giants win the pennant! The Giants win the pennant!" It was a moment carved forever into the landscape of baseball much as the Presidents' faces are carved into Mount Rushmore. And for Bobby Thomson it was the 32nd home run and 99th, 100th and 101st RBI's of an incredible season: to make way for Willie Mays in the outfield, he had been shifted over to third base earlier in the season where, ironically, he made two miscues in the eighth that allowed for two Dodger runs in the same game he won with one swing of his bat. And although he would drive in 100 runs in each of two more seasons—giving him four 100-RBI seasons in all—he would never again hit over 30 home runs in any of his remaining nine seasons in the "Bigs." Traded to the Milwaukee Braves after the '53 season in a six-player trade, Thomson would once again make room for another all-time great, Hank Aaron this time, by breaking his ankle in training camp. There is one last footnote to Thomson's great moment in "Baseball's Greatest Game": after the game the joyous Giants entered their clubhouse to a deafening silence; the press had congregated over on the Dodgers' side awaiting the triumphant return of the team that had gone into the ninth three runs to the good. But they soon realized their mistake and began to seep into the Giants' locker room, first in a trickle and then in a Niagara. It finally got so the players could hardly move. Through it all, Thomson noticed one small man struggling harder than the rest of the sea of invaders to get closer. Finally the man got close enough to shout, "Bobby, we want you to appear tonight on the Perry Como Show and we'll give you five hundred dollars." Thomson said he was sorry, but he wanted to spend the evening with his family and that the Series against the Yankees started the next day and he needed his rest. The little man, however, wouldn't take no for an answer and hollered back, "We can give you a thousand." Suddenly Thomson's Scottish ancestry got the better of him and he hollered back, "For a thousand my family can take care of themselves for the evening."

232. BOBBY SHANTZ *(Right, top)* **[Robert Clayton Shantz; P; 1949–64; PHI (A), KC (A), NY (A), PIT (N), HOU (N), STL (N), CHI (N), PHI (N)].** Although only five-foot-six and change, little Bobby Shantz used his knuckle and catlike fielding ability to cast a big shadow. But not at first. Seems that Shantz's first manager was the aging Connie Mack, who, at the advanced age of 86, not only had trouble handling his club, the Philadelphia Athletics, but, according to Shantz, "didn't even know my name." But what Mack *did* know was that he wasn't too fond of small pitchers and didn't like Shantz's "go-to" pitch, his knuckler. After two years of pitching losing ball under Mack, Shantz came into his own under new A's manager Jimmy Dykes, only the second manager in the long history of the A's. Early in the 1951 season Philadelphia catcher Joe Tipton called Shantz aside and said to the youngster, "You've got a helluva curveball, but you're going to have to learn to change speeds on that fastball. You learn to do that and I think you can win some games." Shantz did and did, experimenting with his fastball, taking something off it and throwing it without slowing up on his arm motion. And, in the process, won 18 games for the sixth-place A's. Nineteen fifty-two was to prove to be his career year as he won 24 games and led the American League in winning percentage and fewest walks per nine innings, winning the AL's Most Valuable Player Award. In the All-Star Game that year Shantz pitched one inning, the fifth and last in the rain-shortened game, striking out, in order, Whitey Lockman, Jackie Robinson and Stan Musial. Near the end of the '52 season, Shantz threw up his hands to protect himself from a Walt Masterson fastball sailing in at his head and broke two bones in his left wrist, ending his season. And almost his career. For in his very first 1953 start, favoring the wrist, Shantz tore his shoulder muscle and pitched in just 16 games. The next season was, if possible, worse as he tore his shoulder in his first outing and pitched just eight innings all season. Coming back, this time with the relocated A's in Kansas City, Shantz found that his once-snappy curve didn't possess its old snap. But he more than made up for it by resorting to craft, guile and off-speed pitches—most notably his knuckler, called by Ted Williams the best in the American League. And for the next ten seasons, Shantz was able to combine all of the above, becoming one of the best relievers in baseball.

233. GUS ZERNIAL *(Opposite, bottom)* **[Gus Edward Zernial; "Ozark Ike"; OF; 1949–59; CHI (A), PHI (A), KC (A), DET (A)].** One of the first times Fred Haney, then broadcasting the Hollywood Stars games, saw Gus Zernial, with a face full of youth and an understated virility, he dubbed him "Ozark Ike," after the popular 1940s comic-strip character. And "Ozark Ike" he became. That very same year, 1948, the free-swinging Zernial tore up the Pacific Coast League, hitting 40 home runs and leading the League in hits and RBI's. Brought up the next season by the light-hitting White Sox, who had been last in home runs in the majors the previous year, with just 43, Zernial was seen as their power hitter of the future. And, to accommodate him, Sox general manager Frank Lane, determined to build the club around his power, installed a makeshift chicken-wire fence in front of the warning track. However, Lane's interior decorating backfired as the weak-hitting Washington Senators beat the ChiSox twice in early May by scores of 14-12 and 8-7 and weaker-hitting Floyd Baker hit the only home run of his 13-year career over the chicken wire. And so, down the makeshift fence came. Still, Zernial more than justified his buildup, feeding off major league pitching as if it were catnip through the early part of the season. But on May 29, in Cleveland, Zernial broke his collarbone and was out for most of the rest of the season. In 1950 he picked up right where he had left off, setting a major league record for most homers in the month of October and a White Sox home run record going back to the year zip, with 29 for the season. Just four games into the '51 season, Zernial was gone, part of a blockbuster three-team trade as the Sox traded power for speed and began their "Go-Go" era with the acquisition of Minnie Minoso. Now a member of the Philadelphia A's, Zernial went on to lead the League in home runs (33) and runs batted in (129), the only player other than Braggo Roth— who won the home run crown back in 1915 after being traded in mid-season by the White Sox to the Indians for Joe Jackson—to win the home run title playing for two clubs in a season. After hitting 29 home runs in '52, he hit another 42 in 1953, one fewer than league-leader Al Rosen. He would hit a total of 232 homers during the decade of the fifties, the third-most in the American League, behind Mickey Mantle and Yogi Berra. Zernial would become one other piece of incidental trivia: the man who introduced Joe DiMaggio to Marilyn Monroe.

234. RED SCHOENDIENST *(Below)* **[Albert Fred Schoendienst; SS; 1945–63*; STL (N), NY (N), MIL (N), STL (N)].** A switch-hitter who normally did his heaviest hitting from the left side, Red Schoendienst is best remembered for his dramatic lefthanded home run in the fourteenth inning of the 1951 All-Star Game, a shot that soared high into the upper left field deck in Comiskey Park to give the National League the win in the first extra-inning All-Star Game in history. But such a remembrance obscures an appreciation of Red Schoendienst's other accomplishments, which were many. One of four Schoendienst brothers who played organized ball—once even appearing in an all-Schoendienst infield in an exhibition game—Red joined the Cardinals in 1945 as an outfielder and led the league in stolen bases, with 26. The next year, switched to second, he led all second basemen in fielding—the first of seven seasons he would do so, setting a National League record—and batted .281, the highest average for NL second basemen. He would go on to play second for the Cardinals for part of 14 more seasons, in the process playing 215 more games at the keystone sack than Rogers Hornsby, the Cardinal most identified with the position. In 1948 he set a major league record by hitting eight doubles in three consecutive games and making nine long hits during those same three games. In 1950 he led the league in doubles and in 1957, playing for both the New York Giants and the Milwaukee Braves, became the only National Leaguer to lead the league in hits playing for two clubs in one season. After the close of the 1958 season, Shoendienst was stricken with tuberculosis, was hospitalized and lost a lung. But that was only a prelude to one of the most remarkable comebacks in baseball history as Schoendienst went on to play for four more seasons and manage for another 13, twice winning the pennant for St. Louis and once, in 1967, the World Series.

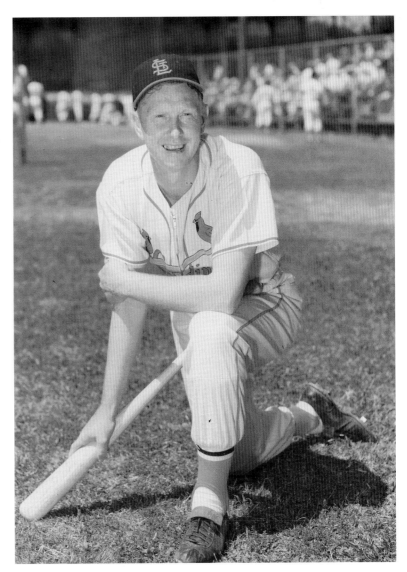

236. VIC WERTZ *(Below)* **[Victor Woodrow Wertz; 1B; 1947–63; DET (A), STL (A), BAL (A), CLE (A), BOS (A), MIN (A)].** Go figure! With 6,115 at-bats in 17 seasons, including 16 in one World Series, Vic Wertz is remembered for one at-bat. No, make that one swing of the bat. Wertz, who had bounced around like a parcel nobody wanted to pay postage on, had been picked up in mid-season by the Indians, his fourth major league team in three seasons, to bolster their bench as they made a run for the 1954 pennant. But his bat, and his .346 batting average, had been enough for him to displace Bill Glynn at first as the Indians won an American League–high 111 games and entered the Series a prohibitive favorite against the National League champion New York Giants. Having come to bat three times already in Game One and having three hits—a triple off a Sal Maglie fastball in the first inning, driving in two runs, a single off a little Maglie curve in the fourth and another single to right off a Maglie outside pitch in the sixth—Wertz now came to the plate in the eighth with men on first and second, none out and the score tied, 2-2. Giant manager Leo Durocher pulled Maglie in favor of his lefthander Don Liddle and quickly went through the "book" on Wertz: a lefthanded power hitter who swings a little late with most of his power through the middle, over second to center. Sure enough, on Liddle's very first pitch, Wertz caught the ball on the meat part of his bat and drove a heat-seeking missile on a line, straight into the deepest part of the Polo Grounds' center field. Most outfielders wouldn't have been able to strike up a waving acquaintance with the ball. But then again, most outfielders weren't Willie Mays. Momentarily looking back, in mid-stride, over his left shoulder as if trying to identify the object that was flying toward him, he then resumed his breakneck sprint. The ball now began its descent, heading for the green screen flanking the runway on the right side of center, some 489 feet from where it had started. Just as it did, Mays flashed into view. With his arms fully extended and hands cupped, Mays caught up with the ball and grabbed it, just a few feet shy of the screen. Not even bothering to come to a stop, Mays now uncoiled like an ancient shot putter and let fly the ball back to the infield, a mammoth throw equal to Wertz's mammoth hit. The play would forevermore be known as "The Catch." And despite the fact that his record would be impressive enough throughout his 17 major league seasons—with little sidebars like tying a World Series record in that very Series by getting one hit in every game and batting .500 for a losing team—Vic Wertz will be remembered for just one swing of the bat and for being the player who hit the ball that became "THE Catch."

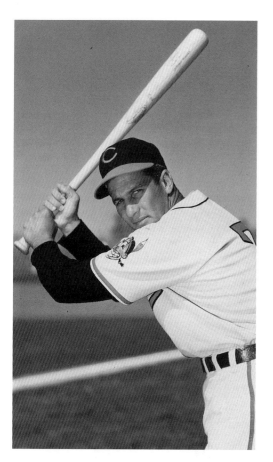

235. AL ROSEN *(Above)* **[Albert Leonard Rosen; "Flip"; 3B; 1947–56; CLE (A)].** One of only two major leaguers born on February 29th—the other being Pepper Martin—Al Rosen "leaped" up to the Cleveland Indians in 1947 after leading the Texas League in hits, doubles, RBI's and batting. However, wearing his glove as if he were merely baby-sitting it for a friend, he posed no threat to the slick-fielding Ken Keltner and was sent back down two more times. Finally, on his fourth trip to the "Bigs" and with Keltner sent packing to the Red Sox, Rosen took his place in the Indians' lineup and responded by leading the American League in home runs—his 37 setting the record for American League rookies—and in assists. In 1953 Rosen led the American League in home runs, runs batted in, runs scored and slugging average and came within one hit of the Triple Crown, losing to Mickey Vernon by .0016 in one of the closest batting races in history. For his efforts Rosen was unanimously named the Most Valuable Player, the first American League third baseman ever so honored. After three more seasons, Rosen, suffering from nagging injuries and the nagging of Cleveland fans, retired—ironically, in the leap year of 1956.

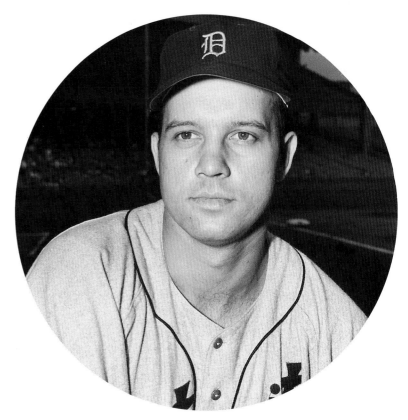

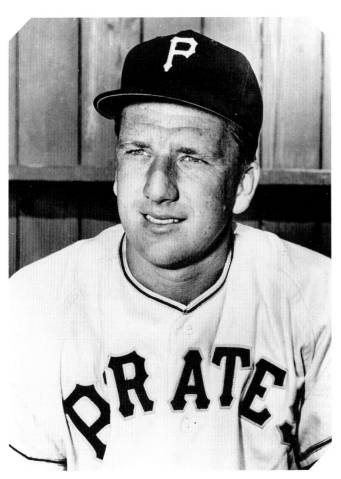

237. RALPH KINER *(Left)* **[Ralph McPherran Kiner; OF; 1946–55*; PIT (N), CHI (N), CLE (A)].** With a firm belief that "Cadillacs are down at the end of the bat," and an even firmer grip on the home run crown, Ralph Kiner was baseball's postwar home run king. From his very first year, when he became only the second rookie ever to lead his league in home runs (the other being the easily forgettable Harry Lumley, who led the NL back in the antediluvian days of 1904), Kiner owned the home run title, winning it seven straight times, more than any other player in history, including Babe Ruth—although, truth to tell, he had to share it twice with slugger Johnny Mize. Taking a bead on Forbes Field's friendly confines of "Kiner's Korner" out in left, Kiner hit 54 homers in 1949—the first time a National Leaguer had hit over 50 since Hack Wilson's 56 in '30—and another 47 the next season, becoming in the process the only National Leaguer ever to hit 100 round-trippers in back-to-back seasons. With the second-highest ratio of homers to at-bats (behind only Babe Ruth), Kiner established himself as one of the greatest sluggers of all time, although his efforts remained unappreciated by the general manager of the Pirates, Branch Rickey, who, after Kiner had hit 37 in 1952 for his seventh consecutive home run title, offered Kiner a contract calling for a 25% cut in salary, saying "The team would have finished last without you"—as it had with him.

238. HARVEY HADDIX *(Right)* **[Harvey Haddix; "The Kitten"; P; 1952–65; STL (N), PHI (N), CIN (N), PIT (N), BAL (A)].** On the evening of May 26, 1959, the improbable and the impossible merged in one of the greatest pitching exhibitions of all time: Harvey Haddix's 12-inning perfect game. Haddix, who had come F.O.B. Pittsburgh only the previous winter, was a smallish, wiry, jug-eared lefthander whose resemblance to another pitcher, Harry "The Cat" Brecheen, had won for him the nickname "The Kitten" from his Cardinal teammates. An ambiguous pitcher who threw something when he meant something else, Haddix had won 86 games during the previous seven-plus seasons in the majors. But nothing he had done—or anyone else had ever done for that matter—would become him more than his performance that Tuesday night when he pitched a perfect, 36-men-up-36-men-down game against the biggest bats in the National League, the two-time-pennant-winning Milwaukee Braves of Hank Aaron, Joe Adcock and Eddie Mathews. At Milwaukee County Stadium, no less. For 12 innings Haddix pitched the most perfect game in baseball history. But, in the bargain, he made history of another sort, by suffering the toughest loss in baseball history as well. That came in the bottom of the thirteenth when, after an error by Pirate third baseman Don Hoak on a Felix Mantilla ball to lead off the unlucky 13th, Joe Adcock hit one into the farthest reaches of County Stadium. Haddix would go on to win 136 games in his 14-year career and lose 113, but the loss of that one "perfect game" would give him timeless fame.

239. DALE LONG *(Below)* **[Richard Dale Long; 1B; 1951, 1955–63; PIT (N), STL (A), CHI (N), SF (N), NY (A), WAS (A)].** Although he played for ten years in the majors—and another 11 in the minors—Dale Long's career is best defined by eight games in May of 1956, eight games in which the powerful left-handed-hitting Long hit home runs in consecutive games to set a record, since equaled, but never eclipsed. Long started his consecutive-game streak with a home run off Jim Davis of the Cubs on May 18th. He hit number 2 off Ray Crone of Milwaukee in the first game of a May 20th doubleheader and followed up with number 3 off Warren Spahn in the nightcap. Then came number 4 off Herm Wehmeier of the Cardinals on May 22; number 5 off the offerings of Card pitcher Lindy McDaniel on May 23rd; number 6 off Curt Simmons of the Phillies on May 25th; number 7 off Phillie pitcher Ben Flowers the following day; and number 8 off Carl Erskine of the Dodgers on May 28th. All of which begot Long nationwide attention and a renegotiated contract from the Pirates calling for $16,500 a year, a raise of $2,500. Long would add other records to his list of achievements, including hitting consecutive home runs as a pinch-hitter in 1959 as a member of the Cubs and playing an important role for the pennant-winning Yankees of 1960, '62 and '63 as a pinch-hitter. But he will always be remembered for those eight days in May when the eyes of the baseball world were focused on him and on his eight home runs—in consecutive games.

240. TED KLUSZEWSKI *(Above)* **[Theodore Bernard Kluszewski; "Klu"; 1B; 1947–61; CIN (N), PIT (N), CHI (A), LA (A)].** So musclebound it even looked like his muscles had muscles of their own, especially when his tree trunk-like arms bulged out of his cutaway jersey—which broadcaster Frankie Frisch would marvel at, saying, "What arms! What arms!"—big "Klu" looked every bit the prototypical slugger, one who would corkscrew himself into the ground trying to smite the ball. But Kluszewski was more of a hitter than a slugger, batting .300 seven times, leading the league in hits once and striking out only 35 times in 1954, when he hit 49 home runs, the fewest strikeouts for anyone ever hitting over 40 homers. From 1953 through 1955, Klu averaged 43 home runs, 116 RBI's and just 36 K's a year. In '55 he also set the modern National League record by scoring in 17 consecutive games. The former Indiana football star was also deceptively agile afield, leading the NL in fielding five straight years, a major league record.

241. JOE NUXHALL *(Right)* **[Joseph Henry Nuxhall; P; 1944, 1952–66; CIN (N), KC (A), LA (A)].** Common wisdom would have it that the youngest ball player ever to appear in a major league game was young Joe Nuxhall, who came in to pitch in the ninth inning of a hopelessly lost game on June 10, 1944, just seven weeks shy of his sixteenth birthday. The peach-fuzz high school senior was rewarded for his efforts by giving up two hits and five bases on balls as the Cardinals scored five runs against his offerings in two-thirds of an inning for an embarrassing 67.50 ERA. However, common wisdom has always been an underdog and careful reading and rereading of the Macmillan *Baseball Encyclopedia* will unearth the name of a man-child named Fred Chapman who pitched nine full innings for the old-old Philadelphia team in the then major league American Association back in 1887 at the tender young age of 14 years and eight months. Nevertheless, Nuxhall *is* the youngest player to appear in a major league box score in modern history, and is the youngest lefthanded pitcher, Chapman or no. After his less-than-one-inning baptism of Cardinal fire, Nuxhall returned to the minors, honing his considerable skills for seven years before resurfacing with the Reds in 1952. In 1954 and '55 he had the best won-lost record on the Reds' staff. He would go on to pitch 16 seasons in the majors (15 of those as a major in age, playing until he was 38) and amass 135 career wins and an ERA of 3.90, his career a far cry from the future hinted at in his first start 22 years earlier.

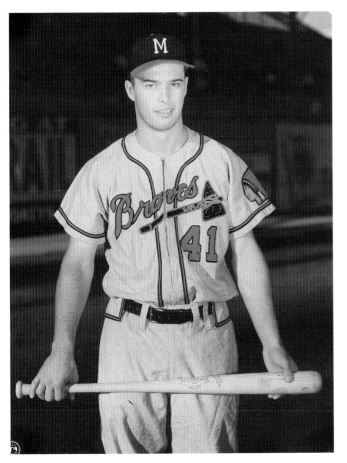

242. EDDIE MATHEWS *(Left)* **[Edwin Lee Mathews; 3B; 1952–68*; BOS (N), MIL (N), ATL (N), HOU (N), DET (A)].** Simply stated, Eddie Mathews was the best third baseman in the National League between Pie Traynor and Mike Schmidt. Coming up to the old-old Braves franchise, then in Boston, in 1952, the 20-year-old rookie immediately proved his worth, hitting 25 home runs, many of them cloud dusters, and impressing observers with his natural swing—so much so that even the crusty Ty Cobb, not normally given to praising players, especially modern ones, grudgingly acknowledged, "I've only known three or four perfect swings in my time. This lad has one of them." With the Braves moving lock, stock and franchise to Milwaukee the following year, Mathews moved too, up in all categories, hitting a league-leading 47 home runs, driving in 135 RBI's and batting .302—and becoming, in the process, Milwaukee's biggest bat in those pre-Aaron days, attested to by his picture on *Sports Illustrated*'s very first cover. During the Braves' 13-year sojourn in Milwaukee, the left-handed-hitting Mathews hit 452 home runs, more than any player in his twenties, with the sole exception of Jimmie Foxx who smote just six more, and more than any player in Milwaukee Brave history, Aaron included. Mathews was to pack up his bags yet again in 1966 to make the move with the Braves to Atlanta—making him the only player to play with all three Brave franchises. (Ironically, Mathews had also played minor league ball in both Milwaukee and Atlanta on his way to Boston.) When Mathews closed out his 17-year career he had set records for most games played by a third baseman, most assists for a third baseman, most chances handled by a third baseman, most consecutive seasons with 30 or more home runs and most home runs on the road for a season, almost all of which were subsequently eclipsed. But not before Eddie Mathews had his name writ LARGE in the record books—and baseball history.

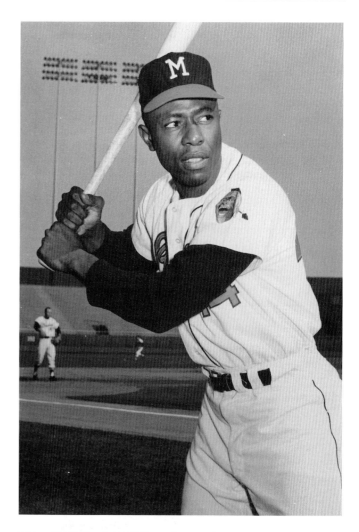

243. MICKEY VERNON *(Below)* **[James Barton Vernon; 1B; 1939–43, 1946–60; WAS (A), CLE (A), BOS (A), MIL (N), PIT (N)].** Mickey Vernon, whose career spanned parts of four decades, was one of the most durable in major league history, eight times playing 150 or more games a season. And, in the process, establishing American League records for first basemen for most games, most assists, most chances accepted and most putouts, and the major league record for most double plays. With 14 of his 20 years in a Washington Senators uniform, Vernon became the favorite not only of fans in the capital city, but also of President Dwight D. Eisenhower, who personally presented Vernon with his Silver Bat after he led the American League in batting in 1953. Vernon won two such trophies, leading the league in batting in 1946 with a .353 average and again in '53 with .337—beating out Al Rosen by just .0016 of a point. This two-time batting champion also made trivia history, of sorts, by having the lowest lifetime batting average of any two-time champion, .286.

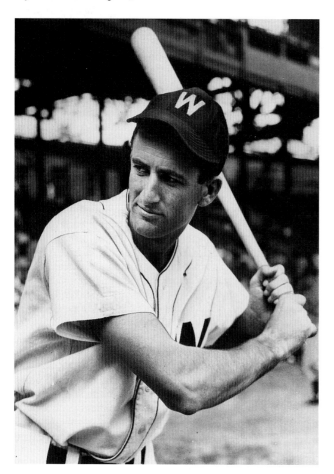

244. HANK AARON *(Above)* **[Henry Louis Aaron; "Hammerin' Hank"; OF; 1954–76*; MIL (N), ATL (N), MIL (A)].** Appropriately enough, the player whose name is alphabetically listed first in *The Baseball Encyclopedia,* Hank Aaron, is also listed first in several of baseball's all-time statistical lists—such as runs batted in, total bases and extra-base hits. But it's the fact that his name resides at the top of one of baseball's most cherished lists, that of all-time home-run leader, upon which his lasting fame rests. For 39 years Babe Ruth's mark of 714 home runs had served less as an atlas of his achievements than the outline of uncharted waters no man had ever traversed before. While other so-called "home run hitters" had tailed off far below the magic number, the man destined to replace him at the top of baseball's supposedly unattainable Everest was a wiry, trim line-drive hitter whose accomplishments lay elsewhere than in hitting home runs—like hitting .300 for 14 years, winning two batting titles, four home run titles and a reputation for quick wrists; so quick in fact that pitcher Curt Simmons said of him, "Throwing a fastball by Hank Aaron is like trying to sneak the sun past a rooster." But for 20 years, without any of those recognizable landmarks like "50 homers" that fans and press could wrap their minds around, Aaron, averaging 35-plus homers a season, had snuck up on Ruth's record in the virtual obscurity of Milwaukee and Atlanta. Without the fanfare of a Willie Mays, Aaron continued his steady, if unspectacular, assault on Ruth's record, until at 9:07 P.M. on April 8, 1974 he smote one of Al Downing's fastballs over the fence and into the Fulton County bullpen to surpass Ruth and become Number One on the all-time home run list—39 years after Ruth's last home run; which was only fair, Aaron having been born 39 years, less a day, after Ruth.

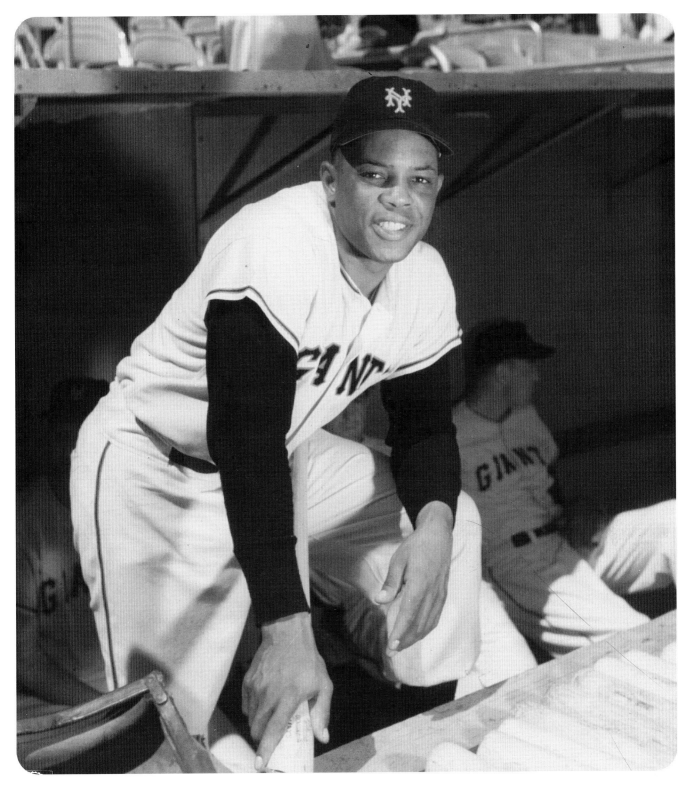

245. WILLIE MAYS *(Above)* **[Willie Howard Mays; "The Say Hey Kid"; OF; 1951–52, 1954–73*; NY (N [Giants and Mets]), SF (N)].** Tallulah Bankhead, noted actress, bon vivant and mistress of the bon mot, once said, "There have been two geniuses in the world . . . William Shakespeare and Willie Mays." And for anyone who ever saw this nearest thing to a complete player the majors has ever seen, hitting for average and power, running the bases with a devil-Mays-care verve and playing the outfield with a flashy grace, he was just that: a genius. Playing baseball like a truant schoolboy out on a romp, Mays gave meaning to Roy Campanella's definition of a ball player: "You gotta be a man to play baseball for a living. But you gotta have a lot of little boy in you, too." For Willie Mays was a thing of beauty. And a boy forever. From his "CATCH," all in caps, off the bat of Vic Wertz in the 1954 World Series, to his constantly racing out from under his one-size-too-small cap, to his rounding the bases with the derring-do of a Cobb or a Robinson, the image of Mays in the mind's eye is one of a player having fun. And that fun translated into 3,283 hits, 660 home runs, 2,062 runs and 1,903 lifetime runs batted in. And a place not only in the Hall of Fame and in the hearts of anyone who ever saw him play, but also on that tiny island of men who could be called geniuses.

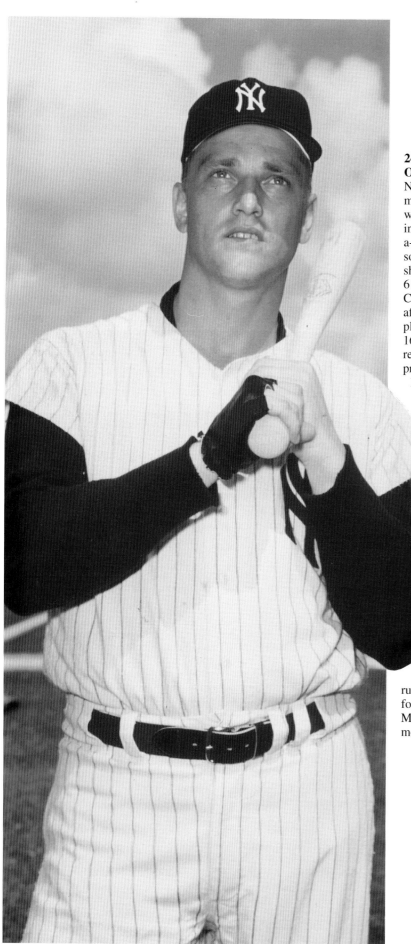

246. ROGER MARIS *(Left)* **[Roger Eugene Maris; OF; 1957–68; CLE (A), KC (A), NY (A), STL (N)].** No player has been undone by his accomplishments more than Roger Maris, a fiercely proud, private man who flew into the public flame in 1961 by overshooting baseball's Everest, Babe Ruth's 60-home runs-in-a-season mark, and was badly burned for daring to do so. With a swing tailor-made for Yankee Stadium's short right field porch, Maris less belted than stroked 61 home runs in 1961. But fans—and even Baseball Commissioner Ford Frick, who appended an asterisk after his accomplishment because Maris had accomplished his feat in the newly-expanded schedule of 162 games rather than the 154 it had taken Ruth—refused to accept Maris' new standard. Maris' own pride also caused him trouble. Signed by the Indians, he refused to report to the Class D club they assigned him to, instead demanding that Cleveland assign him to their Class C Fargo-Moorhead club. Yet the Indians gave in. Such demands became a part of the Maris persona, as he proudly continued to make demands on the management, the fans and himself. Still he was an all-around talent. Maris had set the all-time kickoff return record at his local high school. And he would later prove his versatility with the Yankees, who traded Woodie Held and Vic Power to their major league "farm club," the Kansas City Athletics, for his services in 1959. In his first year with the Yankees, Maris hit 39 home runs, led the American League in slugging average and won the league's Most Valuable Player award. More than just a home run hitter, Maris earned his MVP as much for his contributions with his glove and arm. And then came 1961, the year he broke Babe Ruth's record by hitting 61 home runs. And, as of this writing, Maris' record has stood for 35 years, one year longer than Ruth's had before Maris broke it—further testimony to Roger Maris' monumental achievement.

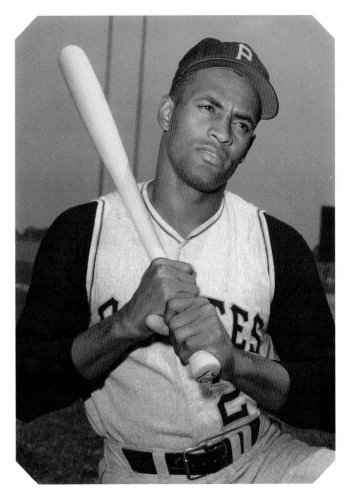

247. ROBERTO CLEMENTE *(Right)* **[Roberto Walker Clemente; OF; 1955–72*; PIT (N)].** "Roberto Clemente might have been as good a player as ever played the game," wrote sports poet laureate Jim Murray. And for one decade, the '60s, he was, playing with 100-watt excitement and lighting up the field as few before him. And leading the majors in most hits for the decade with 1,877 and the highest batting average for the decade, .328— including a league-leading .357 in 1967, the highest season batting average by a righthanded batter since Joe DiMaggio's .381 in 1939. But if he was sparkling in the batter's box, he was absolutely incandescent in the field, cutting off balls and cutting down runners with equal ease and setting the modern record for most assists by an outfielder.

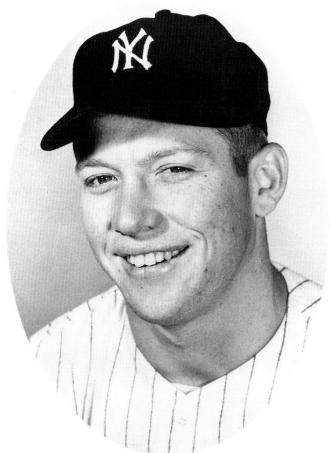

248. MICKEY MANTLE *(Left)* **[Mickey Charles Mantle; "The Commerce Comet," "Mick"; OF; 1951–68*; NY (A)].** If anyone was ever born to the purple of a future superstar, it was the multi-talented youth with boyish, tousled good looks who reported to the Yankee instructional camp in 1951, just two years out of high school. Bill Dickey, the Yankee batting coach, said, "I thought when I was playing with Ruth and Gehrig, I was seeing all I was ever going to see. But this kid . . . Ruth and Gehrig had power, but I've never seen anything like it. . . ." Brought up to take over center field when the resident New York legend, Joe DiMaggio, retired, Mantle gave a hint of his potential by delivering prodigious blast-after-prodigious blast, some of them cloudbusters that gave meaning to the expression "tape-measure home runs" from both sides of the plate. And, not incidental to his potential greatness, he had speed to burn, able to race down to first in 3.1 seconds. Inserted into the Yankee starting lineup in right field for the '51 Series, Mantle stepped into a drainage ditch and wrenched his right knee in the fifth inning of the second game, the first of a long laundry list of injuries that greatly compromised his speed and his greatness and laid a painful burden on his giant shoulders for the rest of his 18-year career. Still, with knees so dead you could wrap crepe around them, a remantled Mantle was able to lead the league in home runs four times, runs five and RBI's and batting once each. And set five World Series records. And become, in the minds of press and fans alike, the worthy successor of the great Yankees of yesteryear—Ruth, Gehrig and DiMaggio.

INDEX OF NAMES

The numbers are those of the illustrations.